Artists

from

Latin

American

Cultures

Artists

from

Latin

American

Cultures

A Biographical Dictionary

Kristin G. Congdon
and
Kara Kelley Hallmark

An Oryx Book

GREENWOOD PRESS
Westport, Connecticut • London

Library of Congress Cataloging-in-Publication Data

Congdon, Kristin G.
 Artists from Latin American cultures : a biographical dictionary / Kristin G. Congdon
and Kara Kelley Hallmark.
 p. cm.
 Includes bibliographical references and index.
 ISBN 0–313–31544–2 (alk. paper)
 1. Artists—Latin America—Biography—Dictionaries. 2. Hispanic American
artists—Biography—Dictionaries. 3. Art, Latin American—20th century—
Dictionaries. I. Hallmark, Kara Kelley. II. Title.
 N6502.5.C657 2002
 709'.2'368—dc21
 [B] 2001058345

British Library Cataloguing in Publication Data is available.

Library of Congress Catalog Card Number: 2001058345
ISBN: 0–313–31544–2

First published in 2002

Greenwood Press, 88 Post Road West, Westport, CT 06881
An imprint of Greenwood Publishing Group, Inc.
www.greenwood.com

Printed in the United States of America

∞™

The paper used in this book complies with the
Permanent Paper Standard issued by the National
Information Standards Organization (Z39.48–1984).

10 9 8 7 6 5 4 3 2 1

We dedicate this book to the artists in it. We have learned from you and grown from your wisdom. To this list of noted individuals we add unrecognized artists from Latin American cultures who also have created noteworthy art but have gone undocumented. We salute you all.

CONTENTS

CONTENTS

Contents

CONTENTS

A photo essay follows page 172

ACKNOWLEDGMENTS

This book came together with the help of numerous individuals. We would like to thank our Greenwood editors, Debby Adams and Rob Kirkpatrick, who proposed this book and supported our efforts. We would also like to thank Jennifer Debo and Penny Sippel, the production editors, and Beth Wilson the copyeditor. They have offered useful suggestions and astute editing advice.

Many individuals and organizations helped us with our research. Our thanks go to Dina Mitroni at the Bernice Steinbaum Gallery for her timely suggestions that guided our beginning steps. The Steinbaum Gallery generously gave us stacks of information on several key artists. Elayne Zorn, from the University of Central Florida, provided expertise on Latin American culture, especially Peru. The use of her personal library on countless occasions was most appreciated. Alberto Villanueva and José Fernandez, also from the University of Central Florida, readily assisted with translations and insights into specific cultures. Thanks also to Tina Bucuvalas, Division of Historical Resources, Florida Department of State, for help with contacts and for information on traditional culture. Steve Stuempfle, from the Historical Museum of South Florida, was a great help with Afro-Caribbean information, particularly in relation to African-based religions. Also, we thank the artist Catalina Delgado-Trunk for her knowledgeable guidance with the glossary. María de Jesús González reviewed and edited the glossary. Other useful information came from Andrew Connors, Bill Fidler, Lisa Ivorian-Jones, Kristen Kertosos, Antonio Ocaña, Andrés and Pamela Ocaña Pérez, Meredith Sutton, and Pablo Weisz-Carrington.

Several students from the University of Central Florida pitched in to help. José de Hoyos assisted with Peruvian correspondence, Stephanie

ACKNOWLEDGMENTS

Jones transcribed taped interviews, and Shannon O'Donoghue spent a semester researching artists and locating sources for photographs. As an honors student, she was funded for this work by the University of Central Florida LEAD Scholar Office. They sent us a top-notch helper who handled everything like a professional. We extend our deep appreciation to Shannon for digging in quickly, performing well with very little guidance, and caring enough about the project to continue working on it when the funding was gone.

For personal editing help, checking references, and reading over entries to make sure that they were written clearly and well, we thank Stephen Goranson and Lea Kelley Lowrance.

Photographs and research information came from many organizations to which we extend our gratitude. They are Andrea Rosen Gallery, New York City; Barbara Gladstone Gallery, New York City: Bellas Artes in Sante Fe, New Mexico; Bernice Steinbaum Gallery, Miami; Charles Cowles Gallery, New York City; Clara Diament Sujo from CDS Gallery, New York City; Fundación Forner-Bigatti, Buenos Aires, Argentina; Galerie Botello, Hato Rey, Puerto Rico; Galerie Lelong, New York City; George Adams Gallery, New York City; Jack S. Blanton Museum of Art, University of Texas at Austin; Leo Castelli Gallery, New York City; Marsha Orr Gallery in Tallahassee, Florida; Museo Rufino Tamayo, Mexico City; Museum of Fine Arts, Houston; National Museum of Women in the Arts, Washington, D.C.; New Museum of Contemporary Art, New York City; Robert Miller Gallery, New York City; Ronald Feldman Fine Arts, New York City; Sheldon Memorial Art Gallery, University of Nebraska, Lincoln; The Mennello Museum of American Folk Art, Orlando; Smithsonian American Art Museum, Washington, D.C.; Social Public Art Resource Center, Venice, California; Sperone Westwater Gallery, New York City; the WEB Gallery, New York City; and the University of Central Florida Library, Special Collections, Orlando.

A few of the photographs and artwork came directly from the artists. Our thanks go to Leonora Carrington, Coco Fusco, Guillermo Goméz-Peña, Ester Hernández, María Martínez-Cañas, Jesús Bautista Moroles, Andres Serrano, Maria Brito, and Kathy Vargas. For the photo of María Martínez-Cañas, we thank the photographer Elizabeth Cerejido; for the image of María Izquierdo, we thank María de Jesús González; and for the image of Mario Sánchez, our thanks go to Tina Bucuvalas.

The Fulbright-Hays Foundation provided Kristin Congdon with a research grant to study in Peru during the summer of 2000. This experience was useful, not only in identifying artists and seeing their works, but also in gaining a better understanding of Latin culture from a historical perspective.

Without the help of the University of Central Florida and the Florida State University libraries and librarians, this book would have been most

difficult to write. Special thanks go to Ellen Anderson from the University of Central Florida, who immediately located and ordered numerous books to help with our research.

So many people have assisted us with this project that we may have left out a name or two. If so, we apologize and send you our gratitude. But we cannot forget the assistance and support of our families, who tolerated long periods of absence as we wrote, and the household chores we often neglected. We especially thank our husbands, David Congdon and John Hallmark, for their repeated encouragement, enthusiasm, and day-to-day understanding. And to Kara Hallmark's stepsons, Josh and Jason Hallmark, for being such troupers at the library and photocopying during hot summer afternoons, we offer a special pat on the back.

INTRODUCTION

Artists from Latin American Cultures overviews the lives and works of more than seventy-five artists. Each artist has made a substantial contribution to the arts that continues to affect the way we understand the world. These biographical entries, organized alphabetically, chronicle the lives of the artist, list places to see his or her works, and provide a bibliography for further reading. Our intention is to inspire readers to seek additional information about an artist and to inspire a desire to experience the artist's work. Giving the reader an enhanced knowledge base about the work and the artist's intentions aids in a deeper understanding of the many layers of meaning in the work. It is our hope that this book not only will help educate the reader but also will encourage further exploration of the visual arts and the contributions that artists from Latin American cultures have made to our world.

The essays are not merely biographical; they also highlight societal influences such as politics, culture, language, and economics, especially when they inform the artist's work. When available, quotes have been added in an effort to give the artist a voice. Important works are described to help readers visualize each work with critical discussion and how it can be interpreted. We also have described how the artists and their work fit into the artistic movements and styles of their time and place. When artists are mentioned in an essay, and they are also the subject of an entry in the book, their names are in bold print. Terms related to artistic styles, religion, and political movements have been defined in a glossary. Many terms are also explained within an essay, in an effort to provide the reader with necessary information to understand the specific context in which the term is being used.

INTRODUCTION

This book has been written primarily for high school and college students who are seeking an introduction to artists from Latin American cultures. However, while the primary audience for this volume are those beginning the journey into the topic, others who are more educated in the topic will also find the book useful because it is dense with information relating to dates, works of art, artistic movements, and contemporary issues. This book should be viewed not only as an art historical resource, but also as a timely document that depicts changes in artistic focus that are taking place as we become a more global society.

Writing this book about artists from Latin American cultures has brought us both challenges and rewards. The rewards have been many. Among them has been the opportunity to recognize artists who have not had adequate exposure for their work. While many of the artists are well known, others have not been as visible to the general public as they should be. Many are underrated, and some are at the middle stage of their career. Many of the focal artists are contemporary and are not as well known as Diego Rivera or Frida Kahlo.

We chose the title *Artists from Latin American Cultures* to stress that cultural heritage is important in defining our scope of artists. Therefore, we have included artists like Leonora Carrington, who was born in England but spent much of her life in Mexico, and Tina Modotti, who was born in Italy but was deeply involved in Mexican culture. Because we live in a world where communication is valued, traveling is frequent, and the borrowing of ideas is pervasive, defining boundaries around a particular group of people becomes difficult.

In fact, the artists in this book are varied in the ways they identify themselves and their cultural heritage. Some say they are Hispanic; others, Latino or Chicano/Chicana; and still others reject ethnic titles because they come from multicultural backgrounds. Yet, as the art historian Shifra Goldman claims, they all have a common bond. This shared heritage comes from two major conquests that she describes as

> that of Europe over the New World, in which Spain was a primary participant; and the later conquest by the United States, which . . . took over the remnants of [the] Spanish empire in the late nineteenth century, absorbing the Philippines, Cuba, and Puerto Rico, to add to its earlier conquest of independent Mexican territory which now forms the U.S. Southwest. (412)

A result of these conquests is a rich synthesis of cultures that includes indigenous Indians, Euro-Americans, Africans, and Asians. In Latin American cultures, there has been both a mixing of cultures and an effort to maintain distinct ethnic traditions.

In identifying artists who live in the United States, we have used the term "American" to identify them. We use this term with the understand-

ing that Canadians and people from South and Central America are also Americans and that the word is, therefore, problematic. We acknowledge that this is not an entirely satisfactory use of the term, but as it is with other words that define boundaries, both geographical and ethnic, we are in many ways bound by the limitations of our language structures until we find, invent, and reconstruct our worlds differently.

Generally speaking, the term "Latin America" includes over twenty countries with a number of different languages and cultures even within each nation's borders. There are no homogeneous patterns of creative work. For example, one cannot categorically say "this design or idea is exclusively Puerto Rican, or this is Peruvian." Each culture is now too varied and mixed to make such overriding claims. Therefore, any effort to survey Latin American art that tries to impose these categorical absolutes would be fruitless. Furthermore, as Mari Carmen Ramírez claims, survey exhibitions will likely be ineffective if they pretend "to impose a linear approach or a particular narrative to the relativism that prevails in all artistic and historical manifestations" (15). The same could be said about books which state too categorically that ideas, styles, and approaches to art are confined within borders. The artists in this book instead demonstrate the borrowing and trading of ideas that traverses geographical, cultural, and psychological borders. Despite the dramatic diversity of artists in this volume, one thing that can be said about almost all of them is that they share what Susana Torruella Leval calls a "profound sense of themselves [that they have gained] by looking to their historical past" (69). Torruella Leval claims that this is their collective way to survive. By reclaiming a past and seeking to remove distortion, artists from Latin American cultures are able to move more purposefully into the future.

While this book identifies artists as coming from various Latin American cultures, the selected artists are different in other ways as well. We have attempted to work toward a balance of artists with respect to gender, geographical area, and artistic medium. This has not always been easy. For instance, most well-known artists from Latin American cultures (as can be said about most cultures) are male. Many major women artists have not had as much recognition as their male counterparts, and others have worked with materials, such as textiles, where their efforts were not valued equally with art constructed with paint, stone, or metal. But because educational opportunities and women's roles are changing, and notions about valuing more diverse art materials and artistic techniques are spreading, many exciting female artists are now emerging. This book, therefore, represents many women in midcareer. In addition, not because of poor economic situations, some countries have not had the resources to publish widely about their artists, and this has resulted in some difficulty in finding resources for our research. Most well-known artists are painters, and because we wanted a diverse representation of artists and works, some male

painters were passed over in an effort to include an emerging woman artist, or an artist who works in wood or even a traditionally less applauded medium like papier-mâché.

We have also attempted to represent artists from varying economic backgrounds who show the determination of all kinds of artists to find ways to follow their creative paths. In addition, we have purposely selected artists who are openly homosexual to add to our goal of diversity. In several cases, sexual identity has markedly affected the artist's work. We have been fortunate to have museums, galleries, collectors, scholars, and artists from all over Latin America and the United States assist us in making our book inclusive in terms of geography, gender, media, economic status, and sexual orientation.

Most of the research for this book was in literature written about the artists—books, catalogs, Web sites, and newspaper articles. However, information has also been obtained from lectures by artists, art historians, and art critics; viewing work in exhibitions; and asking for help from many friends, scholars, and acquaintances who are knowledgeable about a particular artist or who have a relevant area of expertise. In some cases, personal interviews or correspondence with the artist provided much of the information. E-mail correspondence to confirm a date, a spelling, or a reference was constant throughout the research for this book. In this respect, this publication is truly one of collaboration, and could not possibly have been completed without the enthusiastic support of many individuals and organizations. They helped us with facts, and encouraged us to include artists who need and deserve visibility.

We have attempted to provide bibliographic information that can easily be found for readers who want to learn more about an artist. In some cases, limited documentation was available and sources are more obscure. Often this was the case with women artists, who have frequently had fewer opportunities to establish themselves.

Many of these artists in this book will be new to art students and art lovers in the United States. Thankfully, the art world is changing, and more galleries, museums, and exhibitions are focusing on artists from Latin American cultures. For instance, a museum is planned for the National Mall in Washington, D.C., that will represent the art of thirty-five countries in the Western Hemisphere (Protzman 53). All this new activity and interest is encouraging and promising. We hope that the entries in this book will become part of the movement by enlightening readers about exceptional artists and their work. They speak to us about issues universal and specific, big and small, and experiences that confound, disturb, and delight. Their works entertain us, educate us, and ask us to change the ways in which we understand the world and move through it. These artists present us with ideas that help us define who we are and, perhaps more important, they ask who we want to become. While the works described

in this book are rooted, in part, in Latin American cultures, they speak across boundaries to audiences around the world.

Bibliography

Goldman, Shifra M. *Dimensions of the Americas: Art and Social Change in Latin America and the United States.* Chicago: University of Chicago Press, 1994.

Protzman, Ferdinand. "Latin Quarters." *Artnews* vol. 99, no. 2 (2000): 53.

Ramírez, Mari Carmen. "Constellations: Toward a Radical Questioning of Dominant Curatorial Models." *Art Journal* vol. 59, no. 1 (2000): 14–16.

Torruella Leval, Susanna. "Recapturing History: The (Un)official Story in Contemporary Latin American Art." *Art Journal* vol. 51, No. 4 (1992): 69–80.

Lola Álvarez Bravo
(1907–1993)
Mexican Photographer

Lola Álvarez Bravo is known for her poignant photographs of Mexican culture and the Mexican people, and especially her portraits of the Mexican painter **Frida Kahlo**. She was born in the small town of Lagos de Moreno in rural Mexico. Her mother, who died when she was just two years old, named her Dolores Martínez de Anda and called her Lola. Her father died of a heart attack five years later, while the two were traveling together. Lola and her brother were sent to Mexico City, to live with their older half brother, their father's son from a previous marriage. There she met and befriended a neighbor, **Manuel Álvarez Bravo**.

In 1925, she married Manuel and they moved to the artists' community of Oaxaca. While living there, they engaged in photography, shooting scenes in the streets and developing film in a makeshift darkroom at their home. Tension developed in their marriage when Lola became more interested in her own photography than in assisting Manuel with his (Sills 33). When she became pregnant, they decided to return to Mexico City, where their son, Manuel, was born in 1927. Their troubles persisted, and by 1934 they had separated; in 1948 they were legally divorced. Establishing herself as a photographer independent of Manuel, Lola retained her married name.

Just after her separation from Manuel, she went to work as an elementary school art teacher. One year later, she took a position at the Department of Education, inventorying photographs. In an opportune meeting with the minister of education, she was asked to photograph him. He was so pleased with her photographs that he showed them to many influential people, and as a result she was offered a job as the chief photographer for *El Maestro Rural* (The Country Teacher). Álvarez Bravo photographed

1

schools, factories, farms, orphanages, fire stations, and hospitals throughout Mexico to accompany articles for the magazine. These photographs led to other photojournalist assignments; often she was the only woman on the job and experienced sexist behavior from her colleagues. She recalled, "I was the only woman fooling around with a camera on the streets and the reporters laughed at me. So I became a fighter" (Sills 34).

Aside from photojournalism, Álvarez Bravo created portraits that are often filled with angst, fear, and sorrow. She wanted to show the heart of Mexico and the people who inhabit the land. In *Por culpas ajenas* (Due to the Fault of Others, c. 1945), a Mexican woman leans against a railing, grasping a blanket close with a desperate and pleading look while her mouth is agape, crying out in pain. Or is she crying for help? Álvarez Bravo had compassion for the Mexican people and their often difficult lives, particularly those affected by the violence after the Mexican Revolution (1910–1920). She said, "I never wanted to photograph to criticize people, only with love, to show they lacked attention and care" (Sills 31). *El Sueño de los Pobres 2* (The Dream of the Poor 2, 1949) is a staged portrait of a young boy lying asleep in an open market among dozens of pairs of shoes. Of the photo she said, "A rich boy would dream of cake and candy, but a poor child of *huarachitos* [sandals]" (Sills 32). The black-and-white photograph is visually rhythmic, with the rows of woven leather sandals encircling the boy. The pattern draws you in, and the simplicity of the boy's dream reminds the viewer about poverty and going without the most rudimentary needs, like shoes.

Álvarez Bravo is probably most noted for her photographs of Frida Kahlo, taken from 1944 to 1945. The women were close friends and confidantes. An extensive part of Kahlo's oeuvre is an intense and dramatic series of self-portraits that often depict her inner exploration of the pain she suffered after a bus accident and in her tumultuous relationship with the Mexican mural painter **Diego Rivera**. The art historian Olivia Lahs-González notes that the Kahlo portraits by Álvarez Bravo are quite different, revealing the painter's strength and self-assurance (36). At least a dozen of the most popular of these portraits show Kahlo with her own reflection in a double portrait, as in *The Two Fridas* (c. 1944). Álvarez Bravo often asked her subjects to move naturally through their space, waiting for the right moment to capture them with her camera. She explained the opportunistic moment that occurred when walking through Kahlo's garden one day:

> I didn't lead her into it. Walking on the patio she approached [the mirror] and I said "closer" until I felt it was the moment I was looking for. Suddenly I saw the mirror and I said yes, two Fridas. I wanted to show something of her internal life—I almost was thinking about her painting *The Two Fridas* when I photographed her with the landscape behind her in the reflection.

It seems as though there really is another person behind the mirror. (Grimberg 83)

Álvarez Bravo was hired as a professional photographer for commercial work, for shooting fashion and advertisement layouts, and as the director of photography at the National Institute of Fine Arts in Mexico City. At the Institute, Álvarez Bravo organized traveling photographic exhibitions to rural areas that did not typically have such exposure to art. In 1951 she opened an art gallery in Mexico City, where she hosted the first solo exhibition for Frida Kahlo in the city. She continued photographing until she lost her sight at age seventy-nine. Her photographs captured the essence of daily life and culture in Mexico. Late in her life, she spoke about the intent of her work: "If my photographs have any meaning, it's that they stand for a Mexico that once existed" (Sills 31).

Álvarez Bravo bequeathed her collection of papers, photographic materials, and artifacts to the Center for Creative Photography at the University of Arizona. Since then her son, Manuel Álvarez Bravo Martínez, has continued to add to the collection. The work of Lola Álvarez Bravo represents an expansive career ranging from photojournalism in Mexico's countryside to the faces of Mexico's most famous painters.

Places to See Álvarez Bravo's Work

Americas Society Art Gallery, New York City

Barry Singer Gallery, Petaluma, Calif.

Carla Stellweg Gallery, New York City

Center for Creative Photography, University of Arizona, Tucson

J. Paul Getty Museum ArtsEdNet: http//www.getty.edu/artsednet/resources/Maps/Women/Bravo/artist.html

Throckmorton Fine Art, New York City

Virtual Forum of Mexican Culture: http://www.arts-history.mx/lab/bravo2.html

Bibliography

Compañeras de México: Women Photograph Women. Riverside, Calif.: University Art Gallery, 1990.

Debroise, Olivier. *Lola Álvarez Bravo: In Her Own Light*. Tucson, Ariz.: Center for Creative Photography, 1994.

The Frida Kahlo Photographs. Dallas, Tex.: Salomón Grimberg and the Society of Friends of Mexican Culture, 1991.

Grimberg, Salomón. "Frida Kahlo: The Self as an End." In *Mirror Images: Women, Surrealism, and Self-Representation*. Edited by Whitney Chadwick. Cambridge, Mass.: MIT Press, 1998. Pp. 82–104.

Lahs-González, Olivia. "Defining Eye/Defining I: Women Photographers of the

20th Century." In *Defining Eye: Women Photographers of the 20th Century*. St. Louis Art Museum, 1997 Pp. 15–130.

"Lola Álvarez Bravo." http://www.food-leisure.com/story/oct97/images.html

Naggar, Carole, and Fred Ritchin, eds. *Mexico: Through Foreign Eyes, 1850–1990*. New York: W. W. Norton, 1993.

Sills, Leslie. *In Real Life: Six Women Photographers*. New York: Holiday House, 2000.

Tario, Francisco, and Lola Álvarez Bravo. *Acapulco en el Sueño*. Mexico City: Nuevo Mundo, 1951.

Manuel Álvarez Bravo
(b. 1902)
Mexican Photographer

The prolific career of Manuel Álvarez Bravo, extending nearly eighty years, represents the work of one of Mexico's most renowned photographers of the twentieth century. He was born in Mexico City and grew up there, where he went to a Catholic grade school. Álvarez Bravo had an early exposure to art because both his father and his grandfather were painters and photographers. At age fifteen, he began serious literary studies, and the following year, he started taking courses in music and painting at the National Academy of Fine Arts. As a teenager, he befriended a neighbor girl, Lola Martínez de Anda. They married in 1925 and moved from Mexico City to Oaxaca, where they both delved into photography. In 1927 they returned to Mexico City for the birth of their son, Manuel. Their union was increasingly difficult, because Manuel preferred his wife as an assistant rather than a photographer (Sills 34). By 1934, **Lola Álvarez Bravo**, now a photographer in her own right, had left Manuel, and in 1948, the two divorced.

Álvarez Bravo worked as a copy clerk at the Treasury Department, where he performed a variety of jobs until 1931. His job there paid the bills and motivated him to take accounting classes at night school. During these years at the Treasury Department he discovered his interest in photography through a friend's father (Sills 33), yet it is probable that his own father's experimentation with photography also inspired him. By 1924, he had purchased his first camera and had begun taking pictures of his co-workers. Although it is rarely noted, his relationship with Lola Álvarez Bravo surely influenced the early years of his photographic exploration.

His first job as a professional photographer was to take pictures of paintings and murals for *Mexican Folkways*, a periodical that illustrated contem-

porary Mexican culture. He got this job through his association with the Italian-Mexican photographer **Tina Modotti** and the American photographer Edward Weston, who had both immigrated to Mexico and worked at the magazine. In 1930, when Modotti was deported for political reasons, she offered Álvarez Bravo her job as a photographic editor for *Mexican Folkways*, and he gratefully accepted. During his years working at the Treasury Department and the magazine, he held many jobs, including teacher of photography at the Central School of Plastic Arts. While he was an instructor there from 1929 to 1930, the Mexican mural painter **Diego Rivera** was the school's director.

Álvarez Bravo was greatly influenced by the work of Weston and his innovative approach to photography, which challenged the art world to accept this relatively new medium as art. Weston isolated objects and artifacts in a creative way that set his photographs apart from mere documentation. Álvarez Bravo integrated this technique into his work by the late 1920s. The objects or artifacts he selected were those from the streets of Mexico and the lives of Mexicans. For instance, *Caballo de Madera* (Wooden Horse, 1928) depicts a child's toy in such a way that it brings the horse to life. The wooden toy peeks around a curtain and stares into the distance with a painted eye, grinning with carved lips and teeth. The partial shadow of a chair back leans in from the left, giving the composition a sense of scale, reducing the horse from a statuesque animal to the size of a handheld trinket.

In the first two decades, Álvarez Bravo experimented with content and composition. By the early 1930s, he shifted his lens from everyday items, toys, and other detached objects to the urban streets of what had become modern Mexico. The harsh reality of peasants selling fruit in the grueling heat is shown in his photograph *Trampa Puesta* (Placed Trap, 1930s). This is a black-and-white image of a man and woman sitting under a makeshift shelter to shield them from the sun's beating rays. Their faces are hidden by the striped blanket that stretches across two small trunks along the side of a building. Fruit lies on newspapers spread on the street so those passing can examine the merchandise.

Álvarez Bravo felt strongly that the intention and motivation for creating art should be about the people. He explained the difference between what he called "popular art" and "nonpopular art," that of the formally trained artist:

> Popular Art is art of the people. A popular painter is an artisan who, as in the Middle Ages, remains anonymous. His work needs no advertisement, as it is done for the people around him. The more pretentious artist craves to become famous, and it is characteristic of his work that it is bought for the name rather than for the work . . . The art called Popular is quite fugitive in character, of sensitive and personal quality, with less of the impersonal and

intellectual characteristics that are the essence of the art of the schools. (Coleman 7)

Photography offered a variety of opportunities for Álvarez Bravo. Through the 1940s and 1950s, he focused on cinematography and teaching at the Mexican Union of Workers in Motion Picture Production. With Leopoldo Mendez, Rafael Carrillo, and Carlos Pellicer, he founded the Mexican Foundation for Publishing in the Plastic Arts, a publishing company devoted to printing books about Mexican art. He was a director and chief photographer from its founding in 1959 until 1980. In 1980, he began the planning for the Mexican Museum of Photography, which opened on March 26, 1986, in Mexico City. Only in recent decades has the work of Álvarez Bravo received international acclaim. A major retrospective exhibition in 1997 at the Museum of Modern Art in New York City was the largest to date, with 185 of his photographs on display. He lives in Mexico City and is considered to be one of the greatest photographers of the twentieth century, for both the vastness of his oeuvre and his sensitive and personal portraits of Mexico.

Places to See Álvarez Bravo's Work

Barry Singer Gallery, Petaluma, Calif.

Museo de Arte Moderno, Mexico City

Museum of Mexican Photography, Mexico City

Museum of Modern Art, New York City

Pasadena Art Museum, Pasadena, Calif.

Philadelphia Museum of Art

Throckmorton Fine Art, New York City

Bibliography

Alexander, Darsie. "Manuel Álvarez Bravo." *The Museum of Modern Art Web Page.* 1997. http://www.moma.org/exhibitions/alvarezbravo/essay.html

Barnitz, Jacqueline. *Twentieth-Century Art of Latin America.* Austin: University of Texas Press, 2001.

Debroise, Olivier. *Lola Álvarez Bravo: In Her Own Light.* Tucson, Ariz.: Center for Creative Photography, 1994.

"The Indigenous Vision of Manuel Álvarez Bravo." In *Manuel Álvarez Bravo: Masters of Photography.* New York: Aperture Foundation, 1987.

Kismaric, Susan. "Manuel Álvarez Bravo." *The Museum of Modern Art Web Page.* 1997. http://www.moma.org/exhibitions/alvarezbravo/

Kismaric, Susan. *Manuel Álvarez Bravo.* New York: Museum of Modern Art, 1997.

Lahs-González, Olivia. "Defining Eye/Defining I: Women Photographers of the 20th Century." In *Defining Eye: Women Photographers of the 20th Century.*

By Lahs-González and Lucy Lippard. St. Louis, Mo.: St. Louis Art Museum, 1997. Pp. 15–130.

Peden, Margaret S. *Out of the Volcano: Portraits of Contemporary Mexican Artists.* Washington, D.C.: Smithsonian Institution Press, 1991.

Sills, Leslie. *In Real Life: Six Women Photographers.* New York: Holiday House, 2000.

Tarsila do Amaral
(1886–1973)
Brazilian Painter

Motivated by the growing influences of European ideology and artistic styles in Brazilian culture, Tarsila do Amaral created paintings with a distinctly tropical landscape that reflect her native country. Born to a wealthy family, she grew up on a ranch in Capivari, a small town near São Paulo (Guerrilla Girls 73). Around 1900 her family traveled to Europe, where she was exposed to Western art in museums. She also had formal art instruction while the family was in Barcelona. After the family returned to Brazil in 1906, she continued studies in art, first exploring sculpture (1916), then focusing on painting (1917), which would prove to be her favorite medium (Ades 338). At one of the earliest presentations of Brazilian modernism in a 1917 exhibition, she was profoundly affected by the work of the Brazilian artist **Anita Malfatti** (Lucie-Smith 40).

Amaral soon returned to Europe for further art education and to explore Cubism, the prevailing style in Europe. From 1920 to 1923 she settled in Paris, where she began to tackle Cubism, fighting to make a style all her own and frequenting the studio of the cubist painter Fernand Léger. This exposure to his work and artistic process is said to be the most prominent influence in her exploration of Cubism (Ades 134). Amaral felt that Cubism was a destructive movement, but one that was necessary in order to develop a strong sense of modernism (Ades 132). She wanted more for her canvases than the pure form and geometry of Cubism. For example, her painting *A Negra* (Black Woman, 1923) portrays a woman who fills the canvas; she has soft edges, round limbs, and large feet and hands, and one large breast hangs over her arm. The backdrop is divided by large stripes, placing the woman in a generic, free-floating space. This early work foreshadows her mature style, which maintains the round forms with soft edges while de-

veloping highly descriptive landscapes that reflect those in Brazil. During this time, Amaral felt as though she had found a place for her paintings, a sentiment she expressed in a letter written to her parents in 1923. In the letter, she explained how her experience in Paris inspired her to think of her roots and to proclaim her Brazilian heritage along with the desire to be known as a Brazilian painter (Lucie-Smith 42).

Amaral returned home, accompanied by the avant-garde poets Oswald de Andrade and Blaise Cendrars, shortly after that letter was written. The three traveling companions had many adventures in Brazil. Their visit to the small, historic towns of the state of Minas Gerais revealed the cultural connections Amaral was seeking. Rustic homes and eighteenth-century churches captured her interest. She wrote about her discovery, "I found in Minas, the colors I had adored as a child. I was later taught that they were ugly and unsophisticated" (Lucie-Smith 44). From this point forward, Amaral clung to her cultural roots in her paintings, depicting Brazilian tropical landscape and imagery.

Amaral developed a new style that spoke of her cultural condition: an individual who, growing up in one country, was forced to accept the traditions and cultural behaviors of another. She defined *Antropofágia*, or (cultural) cannibalism, as signifying the consumption of European ideology forced on Brazilian culture through colonization by the Portuguese in the nineteenth century, keeping the meaningful and destroying that which is not. Many other avant-garde Brazilian artists adopted this theory, making *Antropofágia* a significant movement expressed not only in the arts, but in the social sciences and politics as well (Catlin and Grieder 159). The Brazilian poet Oswald de Andrade, who later became Amaral's husband, wrote the "Manifesto Antropófago" (Cannibal Manifesto, 1928).

Stylistically, this movement represents a return to Amaral's Brazilian roots, which is evident in her depiction of the tropical landscape in much of her work (Goldman 352). Her painting *Abaporu* (1928) was the showpiece exemplifying this philosophy. *Abaporu*, a word in the Tupi-Guaraní Indian language, literally means "man who eats." Making direct reference to "cannibalism," the Brazilian man is eating the colonizing culture. The title gives the connection to Antropofágia, however, the size of the man literally engulfs or consumes the canvas. As in *Black Woman*, a central figure sits unclothed; a gigantic leg and arm, ending in an even larger foot and hand, rest on the green grass. A tiny head is level with the perfectly round, orange and yellow sun. The figure faces a smooth, green cactus, which also reaches the sun. The tanned skin of the figure, green grass, blue sky, warm sun, and huge cactus all refer to Amaral's homeland.

Amaral's paintings continued to garner attention from museums such as the Museum of Modern Art in New York City and the Museum of Modern Western Art in Moscow. Little did she know the impact of her fateful words, "I want to be the painter of my country" (Lucie-Smith 42). In an

exhibition at Americas Gallery in New York City, "Women Artists in Latin America," Amaral's paintings were praised as the "most outstanding pieces" in the show (Windhausen 89). The work of Tarsila do Amaral remains important in the history and development of Brazilian Modernism.

Places to See Amaral's Work

Acervo Artístico-Cultural dos Palácios do Governo do Estado de São Paulo: *Calm Sea* (1929)

Museu de Arte Contemporânea da Universidade de São Paulo: *Black Woman* (1923); *Central Railway of Brazil* (1924)

Museum of Modern Art, Rio de Janeiro

Museum of Modern Art, São Paulo

Museum of Modern Western Art, Moscow: *O Pescador* (1931)

Bibliography

Ades, Dawn. *Art in Latin America: The Modern Era, 1820–1980*. New Haven, Conn.: Yale University Press, 1989.

Catlin, Stanton L., and Terence Grieder. *Art of Latin America Since Independence*. New Haven, Conn.: Yale University Press, 1966.

Goldman, Shifra M. *Dimensions of the Americas: Art and Social Change in Latin America and the United States*. Chicago: University of Chicago Press, 1994.

Gotlib, Nadia B. *Tarsila do Amaral*. São Paulo: Brasiliense, 1983.

Guerrilla Girls Group of Artists. *The Guerrilla Girls' Bedside Companion to the History of Western Art*. New York: Penguin Books, 1998.

Leffingwell, Edward. "Latin Soliloquies." *Art in America* vol. 81, no. 12 (1993): 72–83.

Lucie-Smith, Edward. *Latin American Art of the Twentieth Century*. New York: Thames and Hudson, 1993.

Mesquita, Ivo. "Brazil." In *Latin American Art in the 20th Century*. Edited by Edward J. Sullivan. London: Phaidon Press, 1996. Pp. 201–32.

Windhausen, Rodolfo A. "Women Artists in Latin America." *Latin American Art* 5, no. 1 (1993): 89.

Felipe Benito Archuleta
(1910–1991)

Leroy Ramón Archuleta
(b. 1949)
Mexican-American Sculptors

Felipe and Leroy Archuleta are widely known as two of the best carvers working in the *bulto* tradition.

The oldest of six children, Felipe Archuleta was born in Santa Cruz, New Mexico, into a poor family with an absent father. After working as a migrant farmworker in Colorado, a cook, and then an orderly, he became a stonemason with the Works Progress Administration (Museum of American Folk Art 6). He was largely responsible for the support of his younger brothers and sisters, so his formal education was limited. Archuleta settled in Tesuque, New Mexico, where he worked for thirty years as a union carpenter. When there was no work, he would pray to God for guidance, because he needed a more stable way to make a living. According to Archuleta, in the mid-1960s God gave him the divine guidance to carve (Beardsley and Livingston 144). He began by making small toys and figures that could be sold to galleries and gift shops. As his carvings sold, the size of his pieces increased, until they were life-size (Hartigan 213).

Instead of making *santos* (saints), which are traditional to his Mexican-American community, he made animals. *Santos* carvers (known as *santeros*) in New Mexico have traditionally sold much of their work to wealthy customers (Glassie 235), but Archuleta chose to carve animals instead. The kinds of figures he made are sometimes referred to as *bultos*, which are fully rounded figures made in Mexico after the Spanish colonization. The golden age for these carvings in Mexico was between 1750 and 1900. The resurgence of *bulto* carving is now recognized as being centered in New Mexico (Panyella 44–45), and much of the credit for this resurgence belongs to Felipe Archuleta.

In the traditional way, Archuleta's sculptures are generally made from

12

cottonwood logs, Elmer's Glue, and house paint. Reportedly, when he finished a work, he said, "Bueno, it's done. Couldn't be better. God bless America. Thank you, Lord" (Museum of American Folk Art 6). This statement emphasizes his feeling that God guided him to make the work and that, because God had His hand in it, it was good work.

In 1979, Felipe Archuleta received the Governor of New Mexico's Award of Excellence and Achievements in the Arts (Museum of American Folk Art 6). He became so well known in his lifetime that he couldn't keep up with the demand for his work. He once complained to a collector, "I can't satisfy the whole world, amigo" (Beardsley and Livingston 144). When he couldn't keep up with the demand, he enlisted the help of those who wanted to learn. His son Leroy was one of his studio assistants, as was Alonso Jiménez; both became recognized carvers in their own right (Beardsley and Livingston 144).

Leroy Archuleta was born in Tesuque, New Mexico, where he went to high school and now lives. He worked elsewhere as a tree cutter, a laborer, and a factory worker before returning to his hometown in 1975 to help his father with his many orders. He soon began carving his own animals, developing his own style (Rosenak and Rosenak, 1990, 38–39). He explained how to tell his work from his father's: "I use sandpaper, for instance [and] he wouldn't take the time. Dad made animals his way—I make them mine" (Rosenak and Rosenak, 1990, 39). He has his own following and often makes carvings to order, such as watermelons and snakes. But he prefers to create the animal that is dictated to him by the wood, which, he claims, tells him the proper animal to carve (Rosenak and Rosenak, 1990, 39).

Both father and son began the large carvings with a chainsaw. Both artists added other materials to their animals for interest. Felipe Archuleta used uncarded wool, hemp, rubber, nails, brush bristles, and marbles for eyes. His *Fear with a Fish in His Mouth* (1987), his last major work, is a strong, latex-painted black bear with marble eyes. His open mouth holds a large, green speckled fish. Leroy has been known to attach bottle caps, hemp, wool, leather, skulls, and antlers. Leroy's *Leopard* (1988) is a brightly painted orange and white leopard with a wonderfully varied patterned coat. The spots represent a leopard and a jaguar, while stripes on the front and back legs are representative of a tiger (Rosenak and Rosenak, 1990, 36–39).

The works of both father and son are eagerly sought by collectors.

Places to See Felipe and Leroy Archuleta's Work

Albuquerque Museum of Art (Leroy Archuleta)

Mennello Museum of American Folk Art, Orlando, Fla. (Felipe Archuleta)

Milwaukee Art Center/Museum (Felipe Archuleta)

Museum of American Folk Art, New York City (Felipe and Leroy Archuleta)

Museum of International Folk Art, Santa Fe (Felipe Archuleta)

Smithsonian American Art Museum, Washington, D.C. (Felipe and Leroy Archuleta)

Bibliography

Beardsley, John, and Jane Livingston. *Hispanic Art in the United States: Thirty Contemporary Painters and Sculptors*. With an essay by Octavio Paz. Houston, Tex.: Museum of Fine Arts; New York: Abbeville Press, 1987.

Folk Carvings from the Collection of Christine and Davis Mather. Corpus Christi, Tex.: Art Museum of South Texas, 1986.

Glassie, Henry H. *The Spirit of Folk Art: The Girard Collection at the Museum of International Folk Art*. New York: Harry N. Abrams, 1989.

Hartigan, Lynda Roscoe, with Andrew Conners, Elizabeth Tisdel Holmstead, and Tonia L. Horton. *Made with Passion: The Hemphill Folk Art Collection in the National Museum of American Art*. Washington, D.C.: Smithsonian Institution Press, 1990.

http://askart.com/artist/A/felipe_benito_archuleto.asp

Mather, Christine, and Cavis Mather. *Lions and Tigers and Bears, Oh My! New Mexican Woodcarvings, the Animal Carnival Collection of the Museum of American Folk Art*. New York: Museum of American Folk Art, 1986. Catalog for the exhibition, December 10, 1985–February 16, 1986.

Museum of American Folk Art. *Ape to Zebra: A Menagerie of New Mexican Woodcarvings, the Animal Carnival Collection of the Museum of American Folk Art*. Catalog for the exhibition, December 10, 1985–February 16, 1986. New York: Museum of American Folk Art, 1986.

Panyella, August, ed. *Folk Art of the Americas*. Photographs by Francesc Català Roca. New York: Harry N. Abrams, 1981.

Rosenak, Chuck, and Jan Rosenak. *Museum of American Folk Art Encyclopedia of Twentieth-Century American Folk Art and Artists*. New York: Abbeville Press, 1990.

Rosenak, Chuck, and Jan Rosenak. *Contemporary American Folk Art: A Collector's Guide*. New York: Abbeville Press, 1996.

Sellen, Betty-Carol, with Cynthia J. Johnson. *Self Taught, Outsider, and Folk Art: A Guide to American Artists, Locations and Resources*. Jefferson, N.C.: McFarland, 1993; rev. and updated ed. 2000.

www.artcyclopedia.com/artists/archuleta_felipe.html.

Dr. Atl (Gerardo Murillo Cornado)
(1875–1964)
Mexican Painter

Dr. Atl, a leading political activist in the Mexican Revolution, is considered to be one of the first modern Mexican painters of his country's largest volcanoes and mountains (Velázquez Chávez 45). He was born in Guadalajara, Jalisco; the exact year of his birth is unknown, with various documents placing it from as early as 1875 to as late as 1887. As a young adult, he denounced his Spanish heritage and his relationship to the European colonialism of Mexico, claiming that the Spanish culture symbolized a European Christian perspective that was held over the Mexican pagan perspective as being elite and superior. He felt pride in his Mexican ancestry, which he preached in politics and expressed in paint. He adopted, and was subsequently known by, his Nahuatl Indian name, Dr. Atl (Water). His fervent devotion to Mexico and its native culture was the center of his identity, politics, and art.

As a young man Dr. Atl went to Mexico City, where he met with Mexico's dictator, General Porfirio Díaz, to request funding for travel and art studies in Europe (Velázquez Chávez 45). A few months later, he was in the mountains of Italy, enthralled by wall-size fresco paintings. Around 1909 he returned to Mexico. Dr. Atl convinced one of his students, **José Clemente Orozco,** along with other students and teaching colleagues, to join his association, the Artistic Center, a group who lived as equals in a communal environment. They painted murals on houses and garden walls located in small Mexican villages for money to purchase art supplies, but were forced to disband several months later, at the onset of the Revolution in 1910 (Helm 12). He joined the staff of a popular art school, the Academy of San Carlos, where he taught students about frescos and murals. Orozco remembered the fervor of his teacher's words: "The great murals!

The immense frescos of the Renaissance, incredible things, as mysterious as the pyramids of the Pharaohs, the product of a technique lost these four hundred years" (Orozco 16). Murals would not become widespread throughout Mexico until after the Revolution, at which time Dr. Atl's students **Diego Rivera**, **David Alfaro Siqueiros**, and Orozco became the "masters" of Mexican muralism.

From the beginning, Dr. Atl was involved in the Mexican Revolution primarily to search for artistic freedom. From 1911 to 1913, he led a student strike against the director of the Academy of San Carlos and the restrictive style guidelines of the school's curriculum (Lucie-Smith 78). Later, he taught at the National Preparatory School, where Rivera and Orozco were students.

Dr. Atl strongly influenced Orozco, especially through his political commitment to the Mexican Revolution. In his autobiography, Orozco dedicated a chapter to him and the role he played in the Revolution. Dr. Atl, a supporter of and leader for Álvaro Obregón, a political anarchist from northern Mexico, recruited many artists to join his quest for freedom of expression in the arts. Orozco and other painters became intensely involved in the movement as a direct result of Dr. Atl's persuasion. Acting as editor in chief, Dr. Atl organized and published a political newspaper, *The Vanguard*. Orozco recalled that Dr. Atl inspired the staff of the paper as he routinely preached the ideals of the Revolution (52). He characterized Dr. Atl as being very loyal to his passions:

> Dr. Atl, with rifle and cartridge belt, would be off to Vera Cruz to visit Obregón on the field of battle and collect money for our whole establishment; all the while conducting a ferocious political controversy with the engineer Félix P. Palavicini and resolving a thousand problems and still having time left over in which to write editorials, and books, and even poems, without once neglecting his magnificent collection of butterflies. (53)

His devotion to politics did not distract Dr. Atl from painting. His love for Mexico's ferocious yet tranquil volcanoes is revealed in his numerous portrayals of these natural wonders. Fascinated with both the scientific elements and the mystical qualities of Mexico's two largest volcanoes, Popocatépetl and Ixtaccíhuatl, he spent countless days observing and painting them over and over (Lucie-Smith 25). He even lived for a time in the foothills of Popocatépetl. His ink drawing *Popocatépetl* (1931) is stylistically rendered with hard edges and large areas of flat color much like the Tahitian landscapes painted by Paul Gauguin.

Dr. Atl's painting *Valley of the Rocks* (1942) is an expansive view of a sprawling landscape from a vantage point high on a hill; below, tiny grid lines resemble city streets in the valley. The blue green of the skies is the typical coloring Dr. Atl used in an effort to produce a "new plastic sen-

sation" or something synthetic and original (Veláquez Chávez 45). Although Porfirio Díaz had funded his education and time spent in Italy, Dr. Atl clearly opposed the "Porfirian style" of painting, characterized by dark colors and forms that were "out of touch with nature" (Helm 5). He strove to create a paint that would have lasting, vibrant color. He achieved this after much experimentation in his studio/laboratory, mixing wax, dry resins, gasoline, and oil pigments.

Not unlike many artists before him and since, Dr. Atl explored representing the self, but he never strayed from his favorite subject, for images of a volcano or mountains continued to appear in the background of his paintings. In *Self-Portrait in Blue* (1937), a bald, white-bearded Atl stares angrily at the viewer. The folds in the artist's shirt echo the lines in the mountain landscape. As the title suggests, the canvas is dominated by his usual shades of aqua.

Dr. Atl's panoramic works have been viewed from Rome, Paris, and New York to Mexico City. As a painter, he left a number of brilliant blue landscapes documenting Mexico's terrain. As a Mexican, he stood for his belief in traditional culture. Dr. Atl expressed his involvement with his country through both political activism and his faithful and poignant portrayal of the volcanoes and mountains that grace Mexico's landscape.

Places to See Dr. Atl's Work

CDS Gallery, New York City

Central Art Gallery, Mexico City: *Popocatépetl* (1931)

Mary-Anne Martin Fine Art, New York City

Mexican Art Gallery, Mexico City: *Clouds upon the Valley* (1932); *The Little Houses and the Sun* (1933)

Bibliography

Ades, Dawn. *Art in Latin America: The Modern Era, 1820–1980.* New Haven: Yale University Press, 1989.

Del Conde, Teresa. "Mexico." In *Latin American Art in the Twentieth Century.* Edited by Edward J. Sullivan. London: Phaidon Press, 1996. Pp. 17–50.

Goldman, Shifra M. *Dimensions of the Americas: Art and Social Change in Latin America and the United States.* Chicago: University of Chicago Press, 1994.

Helm, MacKinley. *Modern Mexican Painters.* 2nd ed. New York: Harper & Brothers, 1941.

Lamb, Ruth Stanton, and Louise Lodge, eds. *Una moneda de Oro, y Otros Cuentos Mexicanos Modernos.* New York: Harper & Brothers, 1946.

Lucie-Smith, Edward. *Latin American Art of the 20th Century.* New York: Thames and Hudson, 1993.

Orozco, José Clemente. *An Autobiography*. Translated by Robert C. Stephenson. Austin: University of Texas Press, 1962.

Velázquez Chávez, Agustín. *Contemporary Mexican Artists*. New York: Friede, 1937. Repr. Freeport, N.Y.: Books for Libraries, 1969.

Judith F. Baca

(b. 1946)

Mexican-American Mural Painter and Public Artist

Judy Baca is known for her public murals that depict issues of historical, social, and environmental importance. Working with others—often gang members and youth on parole—her large works of art extend the great Mexican muralist tradition into communities in the United States.

Born in Los Angeles, Baca was raised at a time, she says, when everyone tried to blend in, making separate ethnic groups disappear. Forbidden to speak Spanish in school, she worked hard to learn English. She wanted to be an artist from the time she was a young girl, but fearing economic difficulties and unable to answer questions about the function of an artist in her world, she studied history, philosophy, education, and art at college.

Baca graduated from California State University, Northridge, which during the 1960s had a predominantly white student body. Though she painted murals at college, she didn't learn about the great Mexican muralists (Baca 63–64). As the activism of the 1960s enveloped her, she began to develop ideas about how to make changes by making visible historical voices that had been ignored. Baca knew that, as an artist, she had a powerful tool: "If I were a carpenter, I'd go out and rebuild things. If I were an architect, I would redesign the architecture. But I have other skills. I simply use what tools I have at hand to address what I care about" (Baca 65). She eventually studied with **David Alfaro Siqueiros**, one of Mexico's great muralists, and was greatly influenced by the work of **Diego Rivera** and **José Clemente Orozco**. She calls these artists "los tres grandes," "the three great ones" (Zamudio-Taylor 326–27).

Like the Mexican muralists before her, Baca recognizes the importance of history and culture: "When you deny a people's culture you can make them disappear, you can control them. . . . My point simply is: if you deny

19

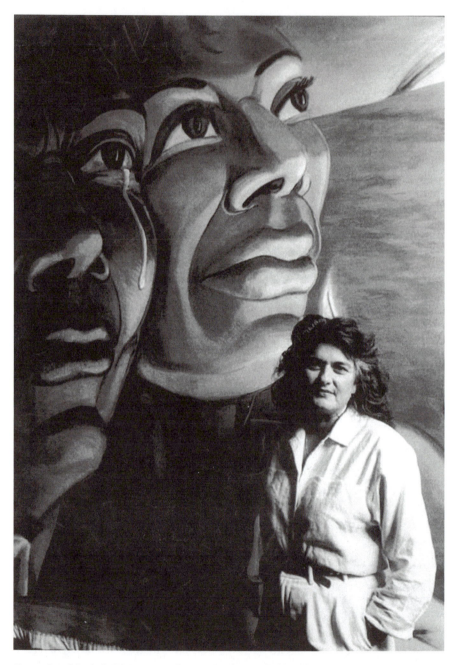

Portrait of Judith F. Baca in front of *Triumph of the Hearts*, one of eight panels to the *World Wall: A Vision of the Future without Fear*. Courtesy of the sponsoring organization, The Social and Public Art Resource Center (SPARC), Venice, California. © by SPARC. Used with permission.

the presence of another people and their culture and you deny them their traditions, you are basically committing cultural genocide" (Baca 63).

Baca is perhaps best known as the coordinator of *The Great Wall of Los Angeles*, the world's largest mural. It is a project, begun in 1976 and still continuing, that engages a diverse group of urban youth in painting the multicultural history of California (Angelo 72). It makes visible narratives that have been forgotten or made invisible by the dominant culture. This mural, 2,435 feet long and 13 feet high, is painted in acrylics on cast concrete and is located in the Tujunga Wash Flood Control Channel of the Los Angeles Flood Control District. Sections depict such historical events as the demolition of the Chavez Ravine barrio to build Dodger Stadium; the Spanish conquest; the immigration of various cultures including blacks, Chinese, Japanese, and Mexican; the zoot suit riots (a 1943 response to the Los Angeles court case that convicted seventeen youth who wore clothes fashioned for dancing); women's suffrage; and the Japanese internment camps (Zamudio-Taylor 327).

Another of Baca's major mural projects is *The World Wall: A Vision of the Future Without Fear*. Begun ten years after *The Great Wall*, it, too, is still a work in progress. However, it differs in that it is a traveling mural project, focused on transforming the world into a place of peace. It began with a dialogue that engaged scientists, military strategists, visionaries, artists, writers, and others. The goal of the talks was to determine what the future would be like without fear. When symbolism and narrative began to evolve, the murals were designed. Individual murals include *Triumph of the Hands*, which explores the need to change economies from war-based to peace-based, and *Triumph of the Heart*, which focuses on the need for individual transformation (Steinman 202–3).

As founder of both the Citywide Mural Project and the Social and Public Art Resource Center (SPARC), Baca places special emphasis on "artworks that reflect the history, concerns, and aspirations of America's many different races and ethnic groups" (Angelo 71). SPARC also strives to serve those groups of people who are often overlooked or neglected: youth, women, senior citizens, and working-class people. "Here art meets human needs by empowering people to learn skills and enlarge their sense of the world" (Angelo 71). Because painting murals is collaborative by definition, it demands time and energy from many people. Baca is well-known for the time she spends talking to people while preparing for a mural project. She gathers firsthand testimonies for the stories and historical documentation she incorporates on the walls. Baca stresses the need for people to come together in communities to solve problems and to understand neighbors' perspectives. She advocates that community members move outward from a strong home base (Lippard 171).

One of Baca's most successful murals is in Guadalupe, California. A small rural town in the north of Santa Barbara County, known by many

as the "broccoli capital of the world," it is largely populated by Mexican-Americans. The *Guadalupe Mural* (1988–90), was designed and painted by Baca, in collaboration with hundreds of the town's residents. It depicts the diverse history of the town, including the story of its founding, racial conflicts, notable historic buildings, movies that were shot in Guadalupe, and a typical harvest. It also portrays the town's dream for its future. Townspeople developed intense pride in and ownership of the mural, and as a result, participation in civic activities in Guadalupe has greatly increased (Doss 157–67). Doss claimed that Baca "creates public art that addresses collectivity, honors difference, and encourages dialogue" (181).

Baca is an expert at reading graffiti. She is also skillful in negotiating city hall (Baca 65). Lippard observed that her art is as much about organizing structures as about mural painting (171). In the end her talent transforms not only spaces but also people. Referring to the *Guadalupe Mural*, Baca makes clear her strong commitment to social reform:

> The deep-seated social issues, and problems, in Guadalupe are historic, and once one understands this history it is clear how they are derived. California—not just Guadalupe—has a history, a long history, of interracial struggle. It is essentially the American problem: How do people from very different places come together, and develop some kind of respect for one another's cultures and their differences? Perhaps this has been the central theme of my work forever, and maybe will be until it is over. (Doss 189)

Places to See Baca's Work

Ahmanson Theatre, interior lobby, North Grand Ave. near Temple St., Los Angeles: *History of Ahmanson*.

The Gas Company Tower, interior, 17th floor reception area, 555 South 5th St. (between Grand and Olive), Los Angeles: *Pieces of Stardust*.

Guadalupe, California: *Guadalupe Mural*.

Harbor Freeway (110) North at 4th St. exit, Los Angeles: *Hitting the Wall*.

Hotel and Restaurant Employees International Union Local 11, exterior, 321 South Bixel St. (near 3rd St.), Los Angeles: *Our Victories, Our Future*.

La Jolla Hotel, exterior front, 721 East 6th St. (between Crocker and Towne), Los Angeles: *The Street Speaks*

Mark Taper Forum Annex, Temple St. and Grand Ave., Los Angeles: *History of Mark Taper Forum*

National Museum of American Art, Washington D.C.: *Tres Marías*.

Pacific Bell, 1207 North Avenue 56 (at Meridian), Highland Park, Los Angeles: *History of Highland Park*.

Tujunga Wash Flood Control Channel of the Los Angeles Flood Control District, San Fernando Valley, Calif.: *The Great Wall of Los Angeles*.

Bibliography

Angelo, Nancy. "A Brief History of S.P.A.R.C." In *Cultures in Contention*. Edited by Douglas Kahn and Diane Neumaier. Seattle, Wash.: Real Comet Press, 1985. Pp. 71–75.

Baca, Judith Francisca. "Our People Are the Internal Exiles." In *Cultures in Contention*. Edited by Douglas Kahn and Diane Neumaier. Seattle, Wash.: Real Comet Press, 1985. Pp. 62–70.

Doss, Erika. *Spirit Poles and Flying Pigs: Public Art and Cultural Democracy in American Communities*. Washington, D.C.: Smithsonian Institution Press, 1995.

Gaspar de Alba, Alicia. *Chicano Art: Inside/Outside the Master's House. Cultural Politics and the CARA Exhibition*. Austin: University of Texas Press, 1998.

Goldman, Shifra M. *Dimensions of the Americas: Art and Social Change in Latin America and the United States*. Chicago: University of Chicago Press, 1994.

Griswold del Castillo, Richard, Teresa McKenna, and Yvonne Yarbro-Bejarano, eds. *Chicano Art: Resistance and Affirmation, 1965–1985*. Los Angeles: Wight Art Gallery, 1991.

Lippard, Lucy R. *Mixed Blessings: New Art in a Multicultural America*. New York: Pantheon, 1990.

Pohl, Frances. "Judith F. Baca: Site and Insights, 1972–1992." Essay for exhibition catalog *Judith F. Baca: Site and Insights, 1972–1992*. Claremont, Calif.: Montgomery Gallery, Pomona College, March 7–April 4, 1992.

Steinman, Susan Leibovitz. "Directional Signs: A Compendium of Artists' Works." In *Mapping the Terrain: New Genre Public Art*. Edited by Suzanne Lacy. Seattle, Wash.: Bay Press, 1995. Pp. 187–285.

Zamudio-Taylor, Victor. "Chicano Art." In *Latin American Art in the Twentieth Century*. Edited by Edward J. Sullivan. London: Phaidon Press, 1996. Pp. 315–29.

Myrna Báez
(b. 1931)
Puerto Rican Painter and Graphic Artist

Born in Santurce, Myrna Báez is one of Puerto Rico's most renowned artists. She depicts her country's landscapes and people in compositions ranging from skillfully executed graphic works to brilliantly colored paintings. Prior to her first formal instruction in the arts, she studied the natural sciences at the University of Puerto Rico, graduating with a bachelor's degree in 1951. Afterward, she spent six years studying painting at the Royal Academy of San Fernando in Madrid, earning a master's degree in art in 1957.

That same year, Báez returned to Puerto Rico and took courses in graphic arts from the well-known graphic artist Lorenzo Homar, at the Institute of Puerto Rican Culture. There, she experimented with such diverse media as linoleum blocks, woodcuts, Plexiglas, silk screen, and collograph. In the Puerto Rican tradition, Báez worked with one medium at a time until she had achieved technical proficiency (Benítez 91). For additional training in graphic art techniques and processes, she attended Pratt Institute in New York City. There, her graphic art was awarded a prize in the Pratt Graphics Center Competition of 1970. Pratt Institute honored her graphics for a second time in 1981.

Báez embarked on a career in education in 1957, the same year she became a student in graphic arts. Initially, she taught painting and drawing. From 1962 to 1987, she worked at various art schools in Puerto Rico, teaching painting, drawing, and graphic arts. Her final teaching post was at the Art Students League in San Juan, from 1981 to 1987.

The culture, people, and landscapes of her homeland have inspired the content and themes of Báez's work throughout her career. In the 1960s, she portrayed the everyday life of Puerto Rico's working-class people. For

Myrna Báez. Courtesy of Galerie Botello, Hato
Rey, Puerto Rico. Used with permission.

example, her acrylic painting *Barrio Tokyo* (1962) depicts a small, frail house
covered with chipped paint, set within a rickety, wooden fence. A tall,
narrow birdhouse with a similar façade is beside it, just inside the fence.
Expressive brush strokes suggest other homes and buildings filling the
background, evoking an overcrowded, low-income neighborhood.

In response to the political climate in Puerto Rico, Báez shifted her focus
from the masses to the middle class that developed as the result of radical
economic and social changes in the 1960s. She contemplated the uneasi-
ness of individuals with a newly acquired economic and social status, then
isolated them in a dreamlike, unknown place, situating them in an awkward
way or an uncomfortable setting. In *The Judge* (1970), a collograph on
paper, a man dressed in a suit and tie sits squarely at a table. His eyes are
masked by dark sunglasses and his face is minimally drawn, making him
anonymous. The figure pushes out of the canvas, which cuts off the top
of his head as if he does not quite "fit" in the space. The man appears
uncomfortable and nervous, fidgety hands folded in front of him. Ques-
tions arise as the painting is pondered. For instance, is this man a judge

or is he waiting to be judged? Báez seems to be expressing the unclear position or status of the individuals she portrays, as if they are unsure about their newly attained class position. She continued this theme throughout the 1970s, placing middle-class subjects in peculiar places painted with expressive color to elevate them from the mundane surroundings of everyday life (García-Gutiérrez 130).

Báez manipulates the space by developing a sense of multiple dimensions or spaces, such as an open window that lets warm white light into a cool, blue, dark room. Her painting *El Marco Dorado* (His Golden Frame, 1987), which won third prize in the first International Biennial of Painting held in Cuenca, Ecuador, reflects the use of hazy color and deceptive space to create an "unreal" atmosphere. A man faces a gold-framed scene in cool purples and blues while a nude woman with a characteristically unrecognizable face poses as if for an artist. She sits in front of an open window through which white light is shining, and a hint of blue green tropical foliage is just behind her. At first, it seems that the man is peering at the nude model, but he is actually regarding his own reflection, while the woman contained within the frame stares at the viewer. Here, Báez has constructed a confused sense of space. The viewer gazes at the man who peers inside the frame that contains the nude woman but also reflects the man. She is attempting to create the illusion of indefinite space. Is the composition a mirror or a picture?

Báez's painting *La Hora Azul* (The Blue Hour, 1993–1994), is another example of presenting various dimensions. An unclothed woman sits in a chair with her back to an open window that allows warm, bright light into the room and reveals a lush panorama. The interior of the room is dark blue and full of shadows reflecting off the woman's skin, except for a bright red, potted tropical flower on a table to the side of the light, contrasting strongly with the damp darkness. The woman is alone, isolated, and in the dark. Her anonymity makes it easier for the viewers to identify with her.

Báez, still living and working in Puerto Rico, has had a long and successful career in the arts. She has received honors and distinctions, taught art, and exhibited her work from New York to Philadelphia to Ecuador and throughout Puerto Rico. Báez draws from her own experiences living and working in Puerto Rico, illustrating the tropical landscape and diverse population in colorful and enchanting compositions.

Places to See Báez's Work

Centro Médico, San Juan: *Mural de la Casa de Salud* (1968–1969)

Fort Lauderdale Museum, Fort Lauderdale, Fla.

Galería Botello, Hato Rey, Puerto Rico

Instituto de Cultura Puertorriqueña, San Juan

Metropolitan Museum of Art, New York City

Museo de Antropología, Historia de Arte, University of Puerto Rico, Recinto Río
 Piedras: *The Judge* (1970)

Museo de Arte de Ponce, Ponce, Puerto Rico: *Barrio Tokyo* (1962)

Museo del Barrio, New York City

Museum of Modern Art, New York City

Taller Puertorriqueño, Lorenzo Homar Gallery, Philadelphia

University of Puerto Rico, San Juan

Bibliography

Benítez, Marimar. "The Special Case of Puerto Rico." In *The Latin American
 Spirit: Art and Artists in the United States, 1920–1970*. By Luís R. Cancel et
 al. New York: Bronx Museum of the Arts with Harry N. Abrams, 1988.
 Pp. 72–104.
García-Gutiérrez, Enrique. "Puerto Rico." In *Latin American Art in the Twentieth
 Century*. Edited by Edward J. Sullivan. London: Phaidon Press, 1996.
 Pp. 119–36.
Goldman, Shifra M. *Dimensions of the Americas: Art and Social Change in Latin
 America and the United States*. Chicago: University of Chicago Press, 1994.
Hermandad de Artistas Gráficos de Puerto Rico. In *Puerto Rico: Arte e identidad*.
 San Juan: Editorial de la Universidad de Puerto Rico, 1998.
"Myrna Báez." *LatinArt.com*. 2001. http://www.latinart.com/faview.cfm
Poupeye, Veerle. *Caribbean Art*. New York: Thames and Hudson, 1998.

Patrociño Barela

(1900–1964)

Mexican-American Wood-Carver

Patrociño Barela overcame harsh poverty, grew up motherless and uneducated, and later battled alcoholism, to skillfully create sensitive and thoughtful portraits of family, friends, saints, and depictions of religious themes. The exact date and place of his birth are unknown. His mother died when he was an infant, and his father's secrecy denied Barela any information about her or about his birth (Barela 1). Around 1908, in an effort to find a better life for his two boys, Manuel Barela left a small mining town on the U.S. border for northern New Mexico (Gonzales and Witt 4). Manuel purchased land there and set up a sheep ranch. At first, the boys attended the local school, but Manuel could not see how education would make his boys better sheepherders, so he soon pulled them from the classroom and sent them to the pasture. Barela was a shepherd into adulthood, then moved from one job to another, working on the railroads, in coal mines, and at a steel factory in Pueblo, Colorado, for seven years before he began to carve.

He was inspired to start whittling when a friend asked him to repair a wooden *santo* (saint) carving (Barela 2). That experience fueled his passion, and he cautiously began to carve: "I started easy. I make a little Santa Rita ... with one pocketknife and one single chisel. And that's the way I started" (Barela 2). He was enthralled with the *santo* carving for its form and meaning. The *santero* carving tradition of New Mexico, which inspired much of his work, originated when early Spanish settlers in the Southwest carved small Catholic saints for themselves. Because of the vast number of *santos* figures that he created, Barela is referred to as a *santero* (an artist who creates saints). His work is singled out for his use of cedar rather than

pine and for generally being carved from one piece of wood instead of several (Collins).

In his carving *El Santo Niño* (The Holy Child, 1930s), a small child holding a basket and wearing a hat sits in a simple chair. An angel and star are overhead, as if watching and protecting this precious child. *El Divino Pastor* (The Divine Shepherd, c. 1936) is another of his *santos*. A shepherd stands with staff in hand and a sacrificial lamb hangs overhead. Prominent marks outline rays of light coming from the figure, to denote holiness.

By 1935, Barela was working for the Works Progress Administration (WPA) Emergency Relief Administration, hauling dirt, gravel, and other building materials with his wagon and horses. A representative from the WPA Federal Arts Program saw his carvings, and brought them to the director of the New Mexico WPA division, Vernon Hunter. Hunter was impressed, and became one of Barela's strongest advocates. By the start of 1936, Barela had been hired by the WPA Federal Arts Program, and he resigned from the Emergency Relief Administration. His new position paid less, but he had the freedom to carve daily (Gonzales and Witt 35).

Soon after Barela joined the Federal Arts Program, a group exhibition was organized to solicit public support for the continuation of the government-funded program. In 1936, eight of his sculptures, the most works by any one artist, were exhibited at the Museum of Modern Art in New York City as part of the exhibition "New Horizons in American Art." This exhibition garnered much attention for Barela, making him the first Mexican-American artist to receive national acclaim (Gonzales and Witt 1).

In addition to carving saints, Barela made portraits of everyday people, including his family. He honored his father and his profession in one un-titled carving from 1936. He spoke of his father's herbal healings while describing the small sculpture:

> My father cures sickness by using the old method of making his own med-icines from leaves and roots of herbs. He learned to make these remedies many years ago. The part where the man is standing by the side of the tree, that denotes the plant from which the man makes his remedies into medi-cine. On the other side of this carving is the doctor and his patient . . . the carving represents part of the life of my father as I have seen him many a time making the remedies for his patients. (Gonzales and Witt 10)

In a review of the exhibition held at the Millicent Rogers Museum in Taos, New Mexico, Tom Collins stated that perhaps the one piece that best represents the artist is *El Profeta Aron* (Man Who Stands Alone, 1936). This small work, only eleven inches tall, portrays a man standing straight

and proud with his arm, outstretched toward the sky, ending in a flaming torch. The artist said of this work:

> This man stands on his own ground on his own particular place in this world. With half-closed eyes and upraised arm he declares this. This is what he holds which is his by natural right received from above. This is his own which is what he stands by. (Collins)

As an outsider in regard to the mainstream of society through his race, his lack of education, his economic status, and even his being an artist, Barela often felt that he stood alone. His hard life and his struggle with poverty led to a lifelong battle with alcoholism (Gonzales and Witt 151, 155).

Barela worked for the WPA Federal Arts Project until the program lost funding and dissolved in 1943. Several New York art galleries sought Barela's carvings after he lost the job with the WPA. Due to his use of slang Spanish and his inability to read or write, it was often difficult to understand his desires and intentions. As a result, Barela was often represented by Vernon Hunter or others, in an effort to ensure that he would not be exploited. However, communications among the parties were incomplete, if not confused, and Barela never received New York gallery representation during his lifetime (Gonzales and Witt 44–48). After he lost his job with the WPA, he could no longer support his family by making art, and had to return to shepherding.

Barela died in his studio when it caught fire in October 1964. He had two sons and one daughter. His gift is continued through two of his grandsons, Luis and Carlos, who carry on the tradition of carving and have been shown in some of the same museums as their grandfather. Barela's woodcarvings are often considered to be folk art because he was self-taught and worked in the *santero* tradition, yet his work is in both folk art and fine art collections. Since his death, his charming *santos* have been exhibited in many venues, receiving great attention and positive reviews (Collins).

Places to See Barela's Work

Albuquerque Museum, Albuquerque, N.M.: *El Santo Niño* (1930s); *Temptation of Christ and Confrontation of Evil* (date unknown)

Baltimore Museum of Art

Harwood Foundation Museum of the University of New Mexico, Taos: *El divino pastor* (c. 1936); *Figuration with Big Foot and Dog's Face on His Chest* (1950s); *Heavy Thinker* (c. 1936); *Hope or the Four Stages of Man* (1936); *Vagabond* (1934); *El Santo Job* (c. 1930s); *A Woman Whose Baby Is Dead* (1937)

Helene Wurlitzer Foundation, Taos, N.M.

Kit Carson Historic Museum, Taos, N.M.

Millicent Rogers Museum, Taos, N.M.

Museum of Fine Arts, Santa Fe, N.M.: *The Creation* (1940s); *The Garden of Eden* (1940s)

Museum of International Folk Art, Santa Fe, N.M.: *Angel and Four Heads* (date unknown); *Holy Family* (date unknown)

Museum of Modern Art, New York City: *Coronation of the Virgin Mary* (1936); *The Twelve Apostles* (1936)

Museum of Modern Art, San Francisco

Museum of New Mexico, Sante Fe: *The Holy Family* (1930s)

National Museum of American Art, Smithsonian Institution, Washington, D.C.: *Activity* (c. 1935–1943); *Australian and U.S. Parents* (c. 1935–1943); *David and Goliath* (c. 1935–1943); *Man in the Time of Solomon* (c. 1935–1943); *Progression in War* (c. 1935–1943); *Saint George* (c. 1935–1943); *War* (1942)

Panhandle-Plains Museum, Canyon, Tex.

Roswell Museum and Art Center, Roswell, N.M.

Taylor Museum, Colorado Springs

Thomas Jefferson Memorial Foundation, Charlottesville, Va.

University of Arizona Art Museum, Tucson

Bibliography

"Barela, Patrociño." *Millicent Rogers Museum Web Page*. 2001. http://www. millicentrogers.com/barela

Barela, Patrociño. *Interview with Sylvia Loomis*. July 2, 1964. http://sirismm.si. edu/aaa/transnda/BARELPAT.TXT

Collins, Tom. "Barela at Millicent Rogers Museum." http://taoswebb.com/ geronimo/february99/visualart.html

Crews, Mildred T., Judson Crews, and Wendell Anderson. *Patrociño Barela: Taos Wood Carver*. Taos, N.M.: Taos Recordings and Publications, 1955.

Gonzales, Edward, and David L. Witt. *Spirit Ascendant: The Art and Life of Patrociño Barela*. Singapore: Red Crane Books, 1996.

"Patrociño Barela." *The Collector's Guide: Patrociño Barela*. 2001. http://www. collectorsguide.com/fa/fao46.shtml

Sellen, Betty-Carol, with Cynthia J. Johnson. *Self-Taught, Outsider, and Folk Art: A Guide to American Art, Locations and Resources*. Updated and rev. ed. Jefferson, N.C.: McFarland & Company, 2000.

José Bedia

(b. 1959)
Cuban-American Installation Artist

Cuban-born José Bedia combines Amerindian and African traditions with popular culture to make art that powerfully expresses ritualistic experience. Well-grounded in anthropological research, Bedia's works ask the viewer to respond both intellectually and aesthetically.

Born in Havana, Bedia came to the United States in 1993 after spending almost two years in Mexico. Like many other artists, he left Cuba because of the fall of Russian communism and the difficult economic conditions. His formal art training in Cuba included study at the San Alejandro School from 1972 to 1976, as well as at the Advanced Institute of Art from 1976 to 1981. He then served with the Cuban army in Angola, where he expanded his knowledge of African culture.

Bedia accompanied his mother on visits to Alberto Goicochea, a respected Havana priest of Palo Monte (Trees of the Sacred Forest), a religion based in the classic Kongo (an African people) idea that special spirits or saints live in the forest outside the city. These visits drew him to Palo Monte song and dance, altars, and signs representing the cosmos. In 1985, on the Rosebud Lakota Reservation in South Dakota, Bedia met the well-regarded shaman Leonard Crow Dog. Here he learned ritual prayers, the making of medicine bundles, and the power of ceremonial pipe-smoking. These events were instrumental in the evolution of Bedia's spirituality and his making of art (Thompson, "Sacred-Silhouettes" 66–69).

Bedia's 1992 Museum of Modern Art installation (mixed-media environment), *Second Encounter, Segundo Encuentro*, contains an oversized torso of a shadow figure painted directly on the wall. It dons a hat in the form of a crucifix-masted battleship that is labeled "Sta. María." Three-dimensional arrows pierce the ship, referencing angry emotions resulting

32

José Bedia, 1998. Courtesy of George Adams Gallery, New York City. Used with permission.

from the commemoration of the five hundredth anniversary of Columbus's arrival in the Americas. This work clearly comments on the violence of colonialism, but it also makes reference to Cuban Santería piercing rituals (*Latin American Artists of the Twentieth Century* 49). Bedia is both a respected artist and an initiate of Palo Monte. While his art is deeply rooted in religion, he has said that he keeps art and religion separate, and that he is not able to place sacred religious elements in secular art exhibitions. This may seem like a contradiction, since religious rituals and symbolism inspire his art. However, Bedia claims that his work is not religious because it is not consecrated (Lindsay 216). Nonetheless, as a distinguished artist and a priest of the *Regala de Mayombe*, he depicts religious ritual in his work, thus showing deep respect for the power of his Afro-Cuban spiritual heritage (Thompson, *Face of the Gods* 63–66).

Cuba's most important painter, **Wifredo Lam**, played an important role in Bedia's life. When he was twenty-one years old, Bedia stayed by Lam's bedside for a month and a half, engaging him in conversation and

33

assisting him after a stroke. Lam critiqued his work, pointing to positive and negative aspects of Bedia's drawings with his one functioning hand. Lam recognized Bedia's talent, and suggested that he might lead the way in the next generation of African-influenced Cuban art (Thompson, "Sacred Silhouettes" 65–66).

Bedia's early work included realistically rendered archaeological finds combining fragments of authentic pieces and objects he created intended to be fakes. He then changed direction, commenting, "It is no longer a question of hatchets or hoes dating back to such-and-such culture, but rather hatchets and hoes born of his artistic imagination and yet fit to be used the same way the primitive ones were used" (Camnitzer 41).

Bedia's deeply rooted interest in African and Amerindian traditions has led him to be an avid collector of ceremonial artifacts. His admiration for these specific cultures is so strong that, Camnitzer claims, "It is not clear if he is a subject of the ritual or if the ceremony is the object of his analysis" (41). What is clear is that his work represents a kind of ceremonial eclecticism, based not in Western art but on the revitalization of very old traditions rooted in cultures before Eurocentric capitalism took over. Nonetheless, Bedia is well aware that he makes Western art; but he does it in a so-called Third World way for the benefit of the people living in Third World cultures (Camnitzer 44). It is the power embedded in the ancient rituals and ceremonies that makes Bedia's work so positive. There is an element of healing and balancing that is suggested even within the struggles that are often depicted.

In keeping with these goals, one of Bedia's most successful pieces is *The Indian Commission and the African Commission against the Material World* (1987), done for the Biennial of São Paulo. Camnitzer describes it thus:

> Third World symbols, placed on a wall, rule over a platform that extends into the room and is covered by cars drawn with chalk. In the best expressway tradition, they get lost in the vanishing point of a forced perspective. The presence of diverse "primitive" symbols, through a magic spell, is destined to save the world against its own self-destruction. (45–46)

Bedia's work is layered with meaning; his lines are clean and his colors are few. As Thompson puts it, there is too much going on in his work, conceptually, to confuse it with color and a profusion of lines. Bedia bases his work on a variety of cultural traditions, which he skillfully blends. For him, cultural clash represents a positive outcome (Thompson, "Sacred Silhouettes" 69). It is this power of optimism that so enriches his work.

Places to see Bedia's Work

Banco de la República, Bogotá, Colombia

Contemporary Art Museum, Monterrey, Mexico

Fogg Art Museum, Harvard University, Cambridge, Mass.

George Adams Gallery, New York City

Hirshhorn Museum and Sculpture Garden, Washington, D.C.

Indianapolis Museum of Art, Indianapolis, Ind.

Loeb Art Center, Vassar College, Poughkeepsie, N.Y.

Ludwig Museum, Aachen, Germany

Miami Art Museum

Museo Nacional de Bellas Artes, Havana: *Untitled*, from the series *Crónicas Americanas* (1982)

National Museum of Fine Arts, Caracas, Venezuela

National Museum of Fine Arts, Havana, Cuba

Philadelphia Museum of Art

Porin Taide Museum, Helsinki, Finland

Bibliography

Bettelheim, Judith, and Melissa Feldman. *Mi esencialismo*. Dublin: Hyde Gallery, Trinity College; Pori, Finland: Pori Art Museum; New York: George Adams Gallery, 1996.

Camnitzer, Luis. *New Art of Cuba*. Austin: University of Texas Press, 1994.

Fusco, Coco. *English Is Broken Here: Notes on Cultural Fusion in the Americas*. New York: The New Press, 1995.

Latin American Artists of the Twentieth Century: A Selection from the Exhibition/ Artistas Latinoamericanos del Siglo XX: Selecciones del la Exposición. New York: Museum of Modern Art, 1993.

Lindsay, Arturo. "Orishas: Living Gods in Contemporary Latino Art." In *Santería Aesthetics in Contemporary Latin American Art*. Edited by Arturo Lindsay. Washington, D.C.: Smithsonian Institution Press, 1996. Pp. 201–23.

Lindsay, Arturo, ed. *Santería Aesthetics in Contemporary Latin American Art*. Washington, D.C.: Smithsonian Institution Press, 1996.

Plagens, Peter, with Peter Katel and Tim Padgett. "The Next Wave from Havana." *Newsweek*, November 30, 1992, Pp. 76–78.

Thompson, Robert Farris. *Face of the Gods: Art and Altars of Africa and the African Americas*. New York: Museum for African Art: Munich: Prestel, 1993.

Thompson, Robert Farris. "Sacred Silhouettes." *Art in America* vol. 85, no. 7 (1997): 64–70.

Turner, Elisa. "Behind the Masks." *Artnews* vol. 99, no. 7 (Summer 2000): 178–79.

Jacobo Borges
(b. 1931)
Venezuelan Painter

Known for his mysterious paintings, Jacobo Borges has become one of the most recognized contemporary painters of Latin America. He was born in Catia, a small, rural town on the outskirts of Caracas. At the age of five, Jacobo was selected to be a student in an experimental class for children at the School of Political Arts in Caracas. Perhaps from this early experience, he was led to become an artist. From a poor family, Borges had to work odd jobs to pay for his art education at the Cristóbal Rojas School of Fine and Applied Arts in Caracas. Initially, he worked as a lithographer for a billboard company, and then as an illustrator for the advertising agency of McCann-Ericsson.

In 1949, Borges traveled to the remote Venezuelan beach town of Macuto, where he visited the reclusive painter **Armando Reverón** (Lucie-Smith 163). The grotesque, masklike faces of Borges's figures from the 1960s mimic Reverón's figures with their distorted features drawn from the dolls he used as models. Borges's paintings are very expressionistic with scribbled areas of color and broad brush strokes producing bold forms, as in *The Show Begins* (1964). This painting is saturated with figures depicting church officials, military personnel, a prostitute, and a skeleton representing the corruption of society (Barnitz 250).

After his visit with Reverón, Borges returned to school and soon began to search for his own artistic style. His years as a student were cut short when he was expelled in 1951 for criticizing the conservative realism that was taught at the Cristóbal Rojas School. However, his avant-garde style was appreciated by others, and that same year, he won a cash prize for painting in a contest sponsored by the Metro-Goldwyn-Mayer movie studio. He took his winnings and went to Paris, where he experienced Eur-

opean art until 1956. While there, he participated in the National Salon of Paris.

Though many critics have tried, Borges's paintings do not neatly fit into one categorical style. He appropriates his style from diverse sources, borrowing from Latin and European artists of the past and present. The content of his work is personal and much like that of the Surrealist painters, incorporating life experiences and dreams to create a world that can be described as existing somewhere between dreaming and being fully awake. He has said about his art and style, "Art today is truly without frontiers" (Maddicks 140).

During his 1959 participation in a group exhibition at the National Palace of Fine Arts in Mexico City, Borges came into contact with Mexican painting. Like many Mexican painters, he took a political stand in his art, particularly in the early 1960s. His goal was to create art that denounced the ruling classes (Barnitz 249). The end of the 1950s brought a new, democratic Venezuelan government, which caused much dissidence and tension between the economic classes. Having spent several years in Europe, Borges noticed that the city of Caracas had changed with the rise of a middle-class, bourgeois society into "a city without myths, separated from all historical continuity" (Barnitz 249). He painted scenes of life in Caracas that expressed his social concerns about the separation of people with money from the rest of the population. His approach to the content is similar to that of the Puerto Rican artist **Myrna Báez**, known for her dreamlike paintings of the recent development of the middle class in her homeland.

Driven by his desire to direct, Borges put his paintbrush aside for the five years it took him to complete *Imagen de Caracas* (Image of Caracas, 1966–71). This work is a collaborative, multimedia production with lights, props, sound effects, and projections of spliced and changing video images of life in Caracas. *Imagen de Caracas* expresses Borges's leftist political views and his affiliation with artists and writers who shared his politics. After a democratic government was established in Venezuela, conservative and liberal anarchist groups sprouted. In his production Borges wanted to portray ordinary citizens, and invited passersby to participate. He imagined that as the audience joined in, they would become engaged with the overall theme of the project: the social inequities among classes. However, he did not get the response expected, and within a few weeks the government closed down his exhibition, conceivably due to the nature of the work (Barnitz 250).

By the early 1970s, Borges was painting again. He played with the sharp-edged advertisements and logos of Pop Art, but this was short-lived. The most notable stylistic shift came in the late 1970s, when his work started reflecting the dark, shadowy, realistic canvases of the Spanish artists Francisco Goya and Velázquez (Lucie-Smith 163). He also borrowed the mon-

tage technique from his film project. By layering seemingly ambiguous images, he created a new meaning. For instance, in his acrylic painting *Paisaje en tres tiempos* (Landscape in Three Times, 1977), he links the progression of politics and government by depicting personalities from the past and present. Some men are hazy outlines while others have highly detailed faces; like the memory, some images are clear, while others have started to fade. Mount Ávila, a major landmark in Caracas, graces the landscape to situate the context. Mount Ávila also symbolizes things that have not changed through time.

Borges lives in the mountains of Venezuela with his wife, Diana, and their daughter, Ximena; his studio is in the city of Caracas. Though he is a busy artist, he takes the time to teach others. In 1994, he spent the summer in Salzburg, Austria, where he was a visiting professor at the International Summer School for Fine Art. In 1995 the Venezuelan government funded the project that became the Jacobo Borges Museum. The museum is located in his hometown of Catia, now a part of the sprawling metropolis of Caracas. When asked what he thought about the opening of the museum, he said:

> I am very happy, and this is not for vanity, or for pride, or because I owe a great debt to Catia. This museum is working with the community, and as it says on the door, in a quote lifted from Joseph Beuys, "Every Man is an Artist." This is a philosophy I can work with. (Maddicks 141)

Rising from humble beginnings, Borges worked long hours to pay for art classes and made his way in the art world. Today he is considered one of the leading contemporary painters in Latin America (Maddicks 141).

Places to See Borges's Work

Banco Central de Venezuela, Caracas: *Paisaje en tres tiempos* (1977)

CDS Gallery, New York City

Galería de Arte Nacional, Caracas: *The Show Begins* (1964)

Museo Jacobo Borges, Caracas online www.cyberven.com/museojborges

Bibliography

Barnitz, Jacqueline. *Twentieth-Century Art of Latin America*. Austin: University of Texas Press, 2001.

Campbell, Lawrence. "Jacobo Borges at CDS." *Art in America* vol. 75, no. 4 (1987): 222.

Carvajal, Rina. "Venezuela." In *Latin American Art in the Twentieth Century*. Edited by Edward J. Sullivan. London: Phaidon Press, 1996. Pp. 137–158.

Goldman, Shifra M. *Dimensions of the Americas: Art and Social Change in Latin America and the United States.* Chicago: University of Chicago Press, 1994.

Lucie-Smith, Edward. *Latin American Art of the 20th Century.* New York: Thames and Hudson, 1993.

Maddicks, Russell. "Venezuela, Jacobo Borges: Without Frontiers." *Artnews* vol. 95, no. 6 (1996): 140–41.

Traba, Marta. *Art of Latin America, 1900–1980.* Baltimore: Washington, D.C.: Inter-American Development Bank; Johns Hopkins University Press, 1994.

Fernando Botero
(b. 1932)
Colombian Painter and Sculptor

Fernando Botero's paintings and sculptures, full of inflated and voluptuous figures, can be seen throughout the world in highly visible places, including Park Avenue in New York City and the Champs Elysées in Paris (Weiler 72). His art is produced by a man who sees the world as full and overflowing. He depicts everything in a voluminous, spacious manner. Everything Botero creates is more bloated—or perhaps more full—than it is in real life; in his works there is, for instance, more cat, more orange, more eccentricity. The volume bursts into space, and everything seems enormous (Colle 35). This grandiose look might be considered grotesque, were it not for the humor involved.

Botero was born in Medellín, Colombia, in 1932. Of the town, he recalled, "Medellín was then a small mountain town, in the valley of Aburra. There was little means of communication, and the provincial mentality was very distinctive. Reality was a microcosm that apportioned to me a theatrically compressed society" (Escallón 9). His father, a traveling salesman, died of a heart attack in 1936, leaving his mother, two brothers, and himself in a tense and troubled household. Life became a struggle, both emotionally and physically. Botero has claimed that he paints the life he knows from his childhood and adolescent years (Escallón 9–10). "I have lived in the United States for many years and have never painted a North American subject. I have also spent time in France and Italy, and it has not occurred to me to paint a European landscape or subject" (Escallón 10). Poverty, he said, taught him valuable lessons. He enjoyed anything new that came into his life. He saw reproductions of a Juan Gris still life, Picasso's *Girl Before a Mirror*, and Giorgio de Chirico's *The Nostalgia of the Infinite*; and then he developed a passion for bullfighting (Escallón 10–

12), not because these works are about that sport, but because they were so richly about living. Both bullfighting and these paintings evoked an intense response and a kind of awakening.

"First, I wanted to be an architect, then an artist," Botero recalled (Escallón 13). In his early years, he became the local Toulouse-Lautrec, painting in the red-light district of Medellín. His first solo exhibition was in 1951, at the Leo Matiz Gallery in Bogotá. He received early attention as an artist, and a monograph was published about his work before he was twenty (Escallón 13–15).

In 1950, Botero earned his diploma from the Liceo de Antioquia in Medellín. In 1952 he enrolled in the San Fernando Royal Academy of Fine Arts in Madrid, and often went to the Prado to copy paintings by Goya and Velásquez. He studied fresco painting in Florence, and in 1956 he moved to Mexico City, then to New York. In 1957 Botero returned to Bogotá, and at the age of twenty-six was appointed professor of painting at the Bogotá Academy of Arts, a position he held for two years. He then returned to New York, and his work continued to gain worldwide exposure (Ades 340; Spies 27–28). From painting and drawing he eventually turned to sculpture. He gave as a reason: "I have the impression that it is necessary to do the same thing in very different ways, always searching for new effects; to produce a new vision, one never seen before, is one of he most important things for an artist" (Lambert n.p.).

In 1958, at a time when abstraction was synonymous with the avant-garde in the West, Botero claimed that "The real avant-garde is to be found in realism" (Traba 114). He looked to academic painting for his inspiration, and after the 1960s he eliminated brush strokes in favor of a smooth surface. His paintings evoked pleasure at a time when much of the celebrated art, such as that of Francis Bacon, was devoted to contorted and grotesque images. Botero's stays in Paris, Florence, and New York influenced him greatly. He admired Piero della Francesca for his large forms and focus on expressiveness, and took to playing with scale, either by using proportional discrepancies in the same figure or by oddly placing figures of varying sizes in the same painting. He created volume as Cézanne had, by adjusting color intensities. Texture is basically ignored; all objects appear to have the same rubberlike consistency (Barnitz 257–58). Barnitz described the effect produced by these proportional liberties as causing his figures to "appear compressed or stacked like mounds of whipped cream" (258).

The mountains in the background of the oil painting *The Presidential Family* (1967) suggest that Botero has painted a South American president and his family. It is based on Goya's *Family of Charles IV* (1800) and, like Goya, Botero places himself in the work, though instead of being clearly visible, he is behind an oversized canvas (Barnitz 260). The shape of the plump people in the scene repeats the shape of the mountains. Perhaps,

by metaphorically depicting this political family in a manner that makes them appear not unlike the difficult and dangerous Andes Mountains, Botero was making a subtle political statement (Chaplik 56). He produces stereotypical representations of Latin America, then parodies the stereotyping (Barnitz 260).

The consistency of Botero's approach to objects regardless of their content, abstracting them in the same light and airy manner, can be seen by comparing the pile of corpses in *Guerra* (War, 1973) and *Canasta de frutas* (Fruit Basket, 1972). The same amount of emotion is portrayed in the mound of fruit as in the mound of death. Both are equal in their sensuousness (Barnitz 259).

Botero has received many prestigious international awards, including the 1958 National Prize for Painting in Colombia (Traba 114); an award for the Colombian section of the 1960 Guggenheim International; and the cross of Boyacá from the government of Antioquia Department for services to Colombia (Ades 340).

Perhaps Colombian audiences more readily respond to Botero's work because it draws from both modernist European approaches and pre-Columbian figures (Barnitz 258). Critics have not always been kind to Botero—many claim that his art is silly, comical, or just plain bad—but everyone can agree on the fact that his art has been widely collected and exhibited.

Places to See Botero's Work

Art Institute of Chicago

Astrup Fearnley Museet for Moderne Kunst, Oslo, Norway

Ateneumin Taidemuseo, Helsinki, Finland

Baltimore Museum of Art

Birmingham Museum of Art, Birmingham, Ala.

Collezione d'Arte Religiosa Moderna, Monumenti, Musei e Gallerie Pontificie, Vatican City

Edwin A. Ulrich Museum of Art, Wichita State University, Wichita, Kan.

The Grey Art Gallery and Study Center, New York University Art Collection, New York City

Guggenheim Museum, New York City

Hiroshima City Museum of Contemporary Art

Hirshhorn Museum and Sculpture Garden, Smithsonian Institution, Washington, D.C.

Ho-am Art Museum, Yongin, Republic of Korea

Hood Museum of Art, Dartmouth College, Hanover, N.H.

Lowe Art Museum, University of Miami, Coral Gables, Fla.

Metropolitan Museum of Art, New York City

Milwaukee Art Museum, Milwaukee, Wis.

Museo de Arte Contemporáneo, Caracas, Venezuela

Museo de Arte de Ponce, Ponce, Puerto Rico

Museo de Arte Moderno de Bogotá, Bogotá, Colombia

Museo Nacional de Bellas Artes, Santiago, Chile

Museo Nacional de Colombia, Bogotá

Museum of Art, Rhode Island School of Design, Providence

Museum of Modern Art, New York City

Palmer Museum of Art, Pennsylvania State University, University Park

Pushkin State Museum, Moscow

Wallraf-Richartz-Museum, Cologne, Germany

Bibliography

Ades, Dawn. *Art in Latin America: The Modern Era 1820–1980*. New Haven: Yale University Press, 1989.

Arciniegas, German. *Fernando Botero*. Translated by Gabriela Arciniegas. New York: Harry N. Abrams, 1977.

Barnitz, Jacqueline. *Twentieth-Century Art of Latin America*. Austin: University of Texas Press, 2001.

Caballero Bonald, José Manuel. *Botero: The Bullfight*. New York: Rizzoli, 1990.

Chaplik, Dorothy. *Latin American Art: An Introduction to Works of the 20th Century*. Jefferson, N.C.: McFarland, 1989.

Colle, Marie-Pierre. *Latin American Artists in Their Studios*. With an introduction by Carlos Fuentes. New York: Vendome Press, 1994.

Escallón, Ana Maria *Botero: New Works on Canvas*. Translated by Asa Zatz. New York: Rizzoli, 1997.

Goldman, Shifra M. *Dimensions of the Americas: Art and Social Change in Latin America and the United States*. Chicago: University of Chicago Press, 1994.

Lambert, Jean-Clarence. *Botero Sculptures*. Bogotá: Villegas Editores, 1998.

Latin American Art in Miami Collections. Coral Gables, Fla.: Lowe Art Museum, University of Miami, 1994.

Lucie-Smith, Edward. *Latin American Art of the 20th Century*. New York: Thames and Hudson, 1993.

Ratcliff, Carter. *Botero*. New York: Abbeville Press, 1980.

Spies, Werner, ed. *Fernando Botero: Paintings and Drawings*. Translated by John William Gabriel, John Ormrod, and Alison Hughes. Munich: Prestel, 1992. With six short stories by the artist.

Sullivan, Edward J. *Botero Sculpture*. New York: Abbeville, 1986.

Sullivan, Edward J. *Botero: Aquarelles et dessins*. Madrid: Lerner & Lerner, 1992.

Sullivan, Edward J. *Fernando Botero: Drawings and Watercolors*. New York: Rizzoli, 1993.

Traba, Marta. *Art of Latin America, 1900–1980*. Washington, D.C.: Inter-American Development Bank; Baltimore: Johns Hopkins University Press, 1994.

Maria Brito

(b. 1947)

Cuban-American Painter, Sculptor, and Installation Artist

Maria Brito's installation work, which is often called architectural because it is recognizable as a particular *space*, relates more to her personal identity as a Cuban-American. Viewers are drawn into the psychological traps that she presents, which sometimes have to do with being female and confined.

Born in Havana, Maria Brito came to the United States, without her parents, in 1961. She was sent to a refugee camp in Miami, and later attended public schools. She visited exhibitions of abstract art as a teenager. Though Brito didn't explore creating art until later in her life, these experiences were important for her creative awareness (Fuentes-Pérez et al. 262). She received BFA and MS degrees from Florida International University and an MFA from the University of Miami (Limouze 36).

Brito's father wanted her to have a career because her widowed grandmother had had to work extremely hard as a seamstress while raising her family. She therefore became a teacher and taught school part time, years after receiving her teaching degree. This arrangement allowed her to take care of her young children. While working on her education, Brito took drawing lessons and moved on to ceramics, which sparked her creativity. It was then that she began taking art seriously (Fuentes-Pérez et al. 258).

Brito's work is often architectural and dreamlike. About her installation work she has said, "Like my work in general, I don't consider them reflective of my personal identity as a Cuban American. Rather, I see the installations as brackets in our reality, the reality that we all share . . . " (Congdon, personal correspondence with the artist).

In Brito's 1987 mixed-media *Altar*, a large, sad eye on the wall drips huge tears which are so large that a three-dimensional bucket with protruding spikelike sticks can't hold them. Like many of her works, it evokes

45

drama in domestic spaces (Lippard 153). Her installation piece *El patio de mi casa* (My Backyard, 1991) has many recognizable items in it, including a kitchen corner with a cabinet, pots and pans, and a towel. On the other side of a partition is a baby's crib. But other items, such as faucets, appear out of place, and the relationship between the baby's bedroom and the kitchen is unclear. Here, as in her other works, Brito sets up psychological situations for viewers to ponder. About this installation, she explains that she is exploring the mythical power of childhood images, a frequent theme for her. "Specifically *El Patio de mi Casa* (whose title also refers to that of a Spanish nursery rhyme) depicts the past on the side of the sculpture where the crib appears. The vertical wall is a freeze of an earlier stage, now abandoned and exposed to the elements. Painted shadows of tree branches on both the crib and the wall emphasize the concept of the out-doors. The past leads into the present-day kitchen around the corner, so that the viewer crosses a time threshold and enters a hearth of all human matter, the kitchen a metaphor for existential change and transformation" (Congdon, personal correspondence with the artist, May 16, 2002). Brito works intuitively, and the result is an invitation for discovery (Henkes 47).

A 1989 sculptural *Self-Portrait*, in mixed media, takes the form of a wheelchair with wooden wheels. A cage symbolizes the head, and a pot containing a simple, twisted branch is placed on the seat. The piece evokes frustration and difficulty (Henkes 48–49). While one is not sure how this piece reflects the artist's life, one can speculate based on her exile from Cuba as a child, and the often demanding roles of wife, mother, artist, and Catholic. Perhaps *The Juggler* (1989) is less elusive as a self-portrait. In this oil on wood with mixed media, Brito depicts a beautiful young woman wearing a headpiece that resembles a nun's. Troubled children surround her. The woman gestures with her hands, palms up, as if to open herself up to a religious calling. A three-dimensional mask hanging from the picture frame has the same eyes as the woman in the painting (Henkes 49, 51–52). Like these two, many of her works explore social traps, things that confine us as they also give life structure and provide meaning (Limouze 14).

Many critics have commented on how poetic Brito's work is. Though she employs both personal and specific cultural symbolism, her work also has a sense of universality. She enjoys images and ideas that transcend time and space. Limouze suggested that Brito's work invites the application of Carl Jung's archetypes and the collective unconscious (symbols shared by everyone), as well as mythological themes used by Joseph Campbell. For example, Brito often uses a chair, a small house, or a bed as a representation of the soul or the self. Triangles signify the supernatural and the afterlife; and masks represent an assumed self. But the links that are made to meaning seem to be as much a surprise to Brito as they are to viewers of her work, and her pieces take on their meanings gradually (Limouze 7–8).

Brito has been awarded many fellowships and grants, including a National Endowment for the Arts Visual Artists Fellowship Grant, a Pollock-

Krasner Foundation Grant, and a Florida Arts Council Fellowship (*Latino Art & Culture* 37). Her work is engaging, in part, because it is so layered and elusive. While it is autobiographical, it is also universally appealing.

Places to See Brito's Work

Archer M. Huntington Museum, Austin, Tex.

Art in Public Places, Metro-Dade Center, Miami, Fla.

Lowe Art Museum, Coral Gables, Fla.

Miami-Dade Community College, Miami, Fla.

Museum of Art, Fort Lauderdale, Fla.

Smithsonian American Art Museum, Washington D.C.

University of Florida, Gainesville

Bibliography

Bosch, Lynette M.F. "Maria Brito: Metonymy and Metaphor." *Latin American Art* 5, no. 3 (1993): 20–23.

Damian, Carol. "Maria Brito." *Art Nexus* 16 (April/June 1995): 124.

Fuentes-Pérez, Ileana, Graciella Cruz-Taura, and Ricardo Pau-Llosa, eds. *Outside Cuba/Fuera de Cuba: Contemporary Cuban Visual Artists/Artistas cubanos contemporáneos.* New Brunswick, N.J.: Office of Hispanic Arts, Mason Gross School of the Arts, Rutgers University; Coral Gables, Fla.: Research Institute for Cuban Studies, Graduate School of International Studies, University of Miami, 1989.

Goldman, Shifra. "Latin American Here." *Arte en Colombia—Internacional* 26 (February 1985): 42–44.

Gould Stoddard, Veronica. "Exiled Images." *Americas* 36 (November/December 1984): 55–58.

Henkes, Robert. *Latin American Women Artists of the United States: The Works of 33 Twentieth-Century Women.* Jefferson, N.C.: McFarland, 1999.

Latino Art & Culture: From the Series America Past and Present. Washington, D.C.: National Museum of American Art, Smithsonian Institution, 1996.

Limouze, Dorothy. *Maria Brito: Rites of Passage, Sculpture and Painting, 1988–1998.* Fort Lauderdale, Fla.: Fort Lauderdale Museum of Art, 1998. Exhibition catalog.

Lippard, Lucy R. *Mixed Blessings: New Art in a Multicultural America.* New York: Pantheon, 1990.

Morgan, Anne Barclay. "Maria Brito." *Art Papers* (November/December 1991): 96.

National Museum of American Art. *Latino Art & Culture.* Washington, D.C.: Smithsonian Institution, 1996. Video.

Plagens, Peter. "Report from Florida." *Art in America* vol. 74 (1986): 26–39.

Rubinstein, Charlotte, S. *American Women Sculptors: A History of Women Working in Three Dimensions.* Boston: G. K. Hall, 1990.

Smithsonian Archives of American Art. *Oral History Interview.* http://artarchives.si.edu/oralhist/brito97.htm

Thorson, Alice. "Colliding Realities." *New Art Examiner* 18 (May 1991): 34.

Luis Camnitzer

(b. 1937)

Uruguayan Printmaker, Sculptor, and Installation Artist

The compelling art of Luis Camnitzer is possibly the most important example of Uruguayan Conceptual Art to date (Haber 277). Born in Germany, Camnitzer was raised in Uruguay and is an Uruguayan citizen. He studied sculpture and architecture at the School of Fine Arts of the University of Uruguay in Montevideo. Later he returned to Germany, where he explored sculpture and printmaking at the Academy of Fine Arts in Munich. While in Munich, he participated in the 1958 VIII Centennial Exhibition at House of Art. Two years later he had his first solo exhibition at the Center of Arts and Letters Montevideo. He continued to receive recognition for his work, and by 1964 he moved to New York City.

Camnitzer, along with many of his Latin contemporaries, including the Brazilian sculptors **Cildo Meireles, Lygia Clark,** and **Hélio Oiticica**, and the Chilean sculptors **Alfredo Jaar**, embraces Conceptual Art. In Conceptual Art, the idea or concept is more important than the object, if there is an object at all. According to the art historian Jacqueline Barnitz, Conceptual Art is a likely choice for Latin American artists, who struggle with European artistic influences. Conceptual Art, by contrast, is not distinctively European or Latin, because thought has no boundaries (Barnitz 35). Since 1969, Camnitzer has focused exclusively on concepts addressing such political subjects as identity, language, freedom, ethical debates, and historical tragedy. For example, *Leftovers* (1970) is composed of 200 small boxes representing the containers of toxic waste that were shipped by the First World to be dumped in the Third World (Barnitz 44). Specifically, he is speaking of the horrific incident in Nigeria when the United States paid Nigeria to accept toxic waste in large steel barrels. These barrels were

Luis Camnitzer installing *Los San Patricios* at the Blanton Museum of Art in 1992. Photo Credit: George Holmes. Courtesy of the Jack S. Blanton Museum of Art, University of Texas at Austin. Used with permission.

placed along village streets where children run and play. Jaar represented this same incident through photographic documentation.

Camnitzer also looks to the past and challenges historical "truths" by searching for untold stories, like the legend of the San Patricio Battalions, which he discovered while reading *The Mexican War* by Edward Mansfield (1848). Camnitzer was intrigued with this sample of what he called "instant history." He felt compelled to reveal the untold story of the more than 200 men who comprised the San Patricio Battalions, a group of U.S. Army deserters from the Mexican War. When he began his research to learn more about the group, in all the documentation that he could locate, their story was dismissed or they were regarded as deserters who were crazy, reckless, and acting without any ideological basis. However, when Camnitzer reread the original materials, he found that many of these men were Irish-Americans who opposed the U.S. invasion of Mexico. They were united as Irish; they did not support the United States;

and they were proud to fight for Mexico's freedom (Camnitzer "Los San Patricios").

Camnitzer re-created the story of these men in *Los San Patricios* (1990–1992). This installation is composed of twenty-two stations of photo-etched brass plaques, color photographs, and miscellaneous objects. Each station is a montage of photographs, collage, and text emphasizing relationships between the "official" history and the adversaries of the San Patricio Battalions. There are also collages showing a relationship between past and present, such as a photo of Mexican President Santa Ana's cork leg that is preserved in a museum in the United States, next to a photo of a present-day sunTANAana tanning parlor. Camnitzer also uses this platform to reveal the discrimination that women experienced throughout the Mexican War (Ramírez 17).

A prolific writer, Camnitzer addresses issues of art, language, identity, and economics from the perspective of a Latin American artist living and working in the United States. In his essay "Wonder Bread and Spanglish Art," he speaks about cultural myths pervasive throughout the United States that perpetuate a sense of unity in a country that is greatly diverse. He uses the ubiquitous Wonder Bread to illustrate his point. While the bread is advertised as being white, nutritious, and wholesome, it is actually full of complex preservatives. From his personal point of view, he discusses how many Latin artists find themselves on the fringes of society, trying to "make it" in the art world. Many of these artists studied art in their home countries, then were "forced" to leave in order to be able to live and work as artists. Some artists will fully assimilate or conform to mainstream culture; others strive to mesh two or more cultures; and some react to the overwhelming U.S. culture by fervently clinging to their native culture. This last group, struggling to maintain cultural identity, creates a hybrid art while living in one place (the United States) and thinking about another (their native country). Camnitzer refers to creative expressions resulting from this cultural mix as Spanglish art:

> "Spanglish" art is probably the most authentic alternative for the uprooted Latin artist. It is a natural and unaffected expression representing with fairness the fact that one has come from one place to another, and it functionally bridges the abyss left by that journey. It is an individualistic solution that allows for release of the tension caused by the clash of two cultures, and it permits the integration of both experiences into one iconography. Inspired by the immediacy of individual experience, this art will tend to distinguish itself from art that either reflects a programmatic attitude or evinces political awareness. (159)

In another essay, "Access to the Mainstream," Camnitzer talks about an artist's economic success in the art market and how that success is defined by an elite few:

In reality, "mainstream" presumes a reduced group of cultural gatekeepers and represents a select nucleus of nations. It is a name for a power structure that promotes a self-appointed hegemonic [dominant] culture. For this reason the wish to belong to the "mainstream" and the wish to destroy it often arise simultaneously in the individuals who are or feel, marginal [on the outskirts] to it. Depending on origin and background, individual access is more difficult for some than for others. (218)

As the artists find places to fit into the mainstream art world, they inevitably become assimilated or conform to mainstream society.

In addition to his art and writings, Camnitzer is a supporter of art education. He extends the opportunity to develop artistic techniques and free thought and expression to young artists through his printmaking studio in New York, established in 1971. Courses are taught in Valdottaro, Italy, each summer for two months. The most sophisticated graphic arts techniques are demonstrated, and the goal of the school is to encourage the development of free expression (*Studio Camnitzer* 1). His art has been exhibited around the world: Hong Kong, Chile, the United States, England, France, Germany, Spain, Canada, Yugoslavia, Venezuela, and Uruguay. He has received a grant from the Academy of Munich (1957); a Guggenheim Fellowship for Creative Printmaking (1961); grants from the Memorial Foundation for Jewish Culture (1965–66) and the University of Pennsylvania (1968); a Guggenheim Fellowship for Visual Art (1982); and a grant from the Public Art Fund for his project *Messages to the Public*, a Times Square Spectacolor lightboard (1988). Camnitzer uses his media and words to tell stories previously untold, and to reveal the complexities of being a Latin American artist living and working in the United States.

Places to See Camnitzer's Work

Alternative Museum, New York City

Carla Stellweg Gallery, New York City

Exit Art/The First World, New York City

Jack S. Blanton Museum of Art, University of Texas, Austin: *Los San Patricios* (1990–92)

El Museo del Barrio, New York City

Whitney Museum of American Art, New York City

Bibliography

Barnitz, Jacqueline. "Conceptual Art and Latin America: A Natural Alliance." In *Encounters/Displacements: Luis Camnitzer, Alfredo Jaar, Cildo Meireles*. Edited by Mari Carmen Ramírez and Beverly Adams. Austin: Archer M.

Huntington Art Gallery, College of Fine Arts. University of Texas Press, 1992. Pp. 35–48.

Camnitzer, Luis. "Access to the Mainstream." In *Beyond the Fantastic: Contemporary Art Criticism from Latin America*. Edited by Gerardo Mosquera. Cambridge, Mass.: MIT Press, 1996. Pp. 218–24.

Camnitzer, Luis. "Los San Patricios (Artist's Statement)." In *Encounters/Displacements: Luis Camnitzer, Alfredo Jaar, Cildo Meireles*. Edited by Mari Carmen Ramírez and Beverly Adams. Austin: University of Texas Press, 1992. Pp. 73–77.

Camnitzer, Luis. "Wonder Bread and Spanglish Art." In *Beyond the Fantastic: Contemporary Art Criticism from Latin America*. Edited by Gerardo Mosquera. Cambridge, Mass.: MIT Press, 1996. Pp. 154–64.

Goldman, Shifra. *Dimensions of the Americas: Art and Social Change in Latin America and the United States*. Chicago: University of Chicago Press, 1994.

Haber, Alicia. "Uruguay." In *Latin American Art in the Twentieth Century*. Edited by Edward J. Sullivan. London: Phaidon Press, 1996. Pp. 261–82.

"Luis Camnitzer." In *XXIII Bienal Internacional de São Paulo*. 1996. http://www. uol.com.br/23bienal/universa/iuallc.htm

Ramírez, Mari Carmen. "Reinstalling the Echo Chamber of the Past." In *Encounters/Displacement: Luis Camnitzer, Alfredo Jaar, Cildo Meireles*. Edited by Mari Carmen Ramírez and Beverly Adams. Austin: Archer M. Huntington Art Gallery, College of Fine Arts, University of Texas Press, 1992. Pp. 9–24.

Studio Camnitzer. 2001. http://members.aol.com/camnitzer/htm/luis.htm

María Magdalena Campos-Pons
(b. 1959)
Cuban-American Painter and Installation Artist

María Magdalena Campos-Pons makes connections between herself, her family, and her Afro-Cuban roots in highly symbolic works that speak of feminism, domesticity, slavery, and religion. She was born in Matanzas, a Cuban slave town that later became a significant historical link in her work. At first interested in music, she was guided by one of her teachers in Matanzas to study art. She studied at the International School of Art in Havana, where the geometric abstractions of the Spanish painter Pablo Picasso initially influenced her experimentation with abstraction and color. However, like many other contemporary artists, Campos-Pons was unsatisfied with form alone, and searched for meaningful content to portray in her work. Before she graduated in 1985, her imagery started to represent content that was highly personal, speaking of women's experiences in her family and, more specifically, of Afro-Cuban culture.

After college, Campos-Pons went to the United States. There she became keenly aware of being displaced, and felt compelled to seek out her own heritage. The writer and artist **Coco Fusco** said of Campos-Pons and the development of her historical Afro-Cuban consciousness:

> Living abroad has brought into sharp relief her experiences as an uprooted black Cuban woman and has compelled her to consider the oral and performative traditions that constitute primary carriers of black identity in the diaspora. These influences complement Campos-Pons' renewed investigation of Santería ritual and symbology, through which she now struggles to find her new place by establishing connections with the past. (107)

Most significantly, Campos-Pons became engaged with the traditions of Santería, a New World African-based religion that combines a belief sys-

53

tem from the Yoruba tribe of Nigeria with Catholicism. Campos-Pons's relationship with Santería began as an artistic one (Camnitzer 211). Then, through her exploration of the religion, she realized a personal connection because her grandmother practiced Santería ritual regularly. Campos-Pons had been sheltered from this knowledge by her parents, because the religion has been considered controversial and mysterious.

Campos-Pons's shift from stylistically formal work to politically, culturally, and historically specific content has been reflected in her shift from "fine" art materials of oil, acrylic, and canvas to *amate* bark paper, video, furniture, photography, and other objects that are usually associated with documentation (Fusco 107). For instance, her installation *Umbilical Cord* (1991) consists of a group of photographs that depict Africa, herself, and other women in her family. They are hung next to one another, and a rope stretches across the photos, connecting one to the next. Here, she is associating her personal experience and that of the women in her family to their ancestral roots in Africa. Her words accompany the photographs:

> All of us women are the same. Identical wounds and accidents, equal havoc and recovery. An infinite number of roads and rivers of swirling waters have crossed our paths. All of us women are the same. We share our sudden burst of pain. A straight and narrow line connects us all into a single image. (89)

In her installation *The Seven Powers Came by the Sea* (1993), Campos-Pons links the Santería tradition to slavery. Seven figures adorned with brightly colored beads are painted with yellow, red, and brown mud. Leaning against the wall, the tall bodies represent the seven principal Yoruban deities. Diagrams of ships that carried enslaved Africans to the New World stand between the figures. Dozens of small painted portraits of present-day black Cubans sit at the gods' and goddesses' feet; some of the portraits are framed with the text "let us never forget." Campos-Pons reminds us that even though artists and curators throughout the Americas now embrace the tradition of Santería, the Cuban government once banned it as witchcraft (Fusco 107).

In 1994, she started a series of installations, *History of People Who Were Not Heroes*, chronicling the African slaves who worked on the plantations in the place of her birth, Matanzas. The first part of the installation, which she completed while a Bunting Fellow of Visual Arts at the Bunting Institute of Radcliffe College at Harvard was *History of the People: A Town Portrait* (1994), shown at Lehman College Art Gallery in New York City. The second part, *Spoken Softly with Mama* (1998), was displayed at the Museum of Modern Art in New York. *Spoken Softly with Mama* was constructed with video images, fabric, furniture, sound, and miscellaneous objects to represent her family and past slave families. Campos-Pons spoke about the installation and how it symbolizes the people and their stories:

A space can bear the imprint of its inhabitants even in their absence. An object can personify an individual even more than his or her portrait. This is the concept behind the selection of objects—furniture for the installation; a portrait of a family narrated through the voices of objects that constitute their environment. ("María Magdalena Campos-Pons," *AfroCubaweb*, 1)

Another important component in the work of Campos-Pons is her inspection of traditional gender roles. She participated in the consciousness raising exhibition at the 1997 Johannesburg Biennale, "Life's Little Necessities." For this all-female group exhibition, she presented her work *Folding Desires* (1997), which addresses the daily domestic chores of women in Cuba and elsewhere. Old wooden ironing boards hold stacks of carefully folded sheets finished with fine stitching and embroidered words that indicate who the linens were ironed for: *Para un Amigo* (For a Friend), *Para su Padre* (For her Father), *Para un Extrane* (For an Unknown). The repetitive task of ironing reminds us of the unrecognized work that women perform for their families; the embroidery is reminiscent of the handwork women created to beautify their homes that has been historically viewed as "craft" or "low art."

The work of Campos-Pons, who now lives in Boston, has been viewed by audiences around the world. She finds meaning and connection between her present-day situation and Afro-Cuban historical legacies.

Places to See Campos-Pons's Work

Creiger-Dane Gallery, Boston

Intar, New York City

María Magdalena Campos-Pons's Web page: http://www.coreconn.net/~schneideraga/CamposPons/CamposPons.html

Museum of Modern Art, New York City

William Benton Museum of Art, University of Connecticut, Storrs

Bibliography

Block, Holly, editor. *Art Cuba: The New Generation.* Translated by Cola Franzen and Marguerite Feitlowitz. New York: Harry N. Abrams, 2001.

Camnitzer, Luis. *New Art of Cuba.* Austin: University of Texas Press, 1994.

Campos-Pons, María Magdalena. "Umbilical Cord." *Heresies* 7, no. 3 (1993): 88–89.

Costa, Eduardo. "María Magdalena Campos-Pons at MoMA and Lehman College." *Art in America* vol. 87, no. 4 (1999): 149.

Fusco, Coco. "Magdalena Campos-Pons at Intar." *Art in America* vol. 82, no. 2 (1994): 106–107.

"The Latina Artist: The Response of the Creative Mind to Gender, Race, Class

and Identity." Center for Latino Arts and Culture Virtual Gallery. August 6, 1999. http://www.scils.rutgers.edu/~anazario/clac/virt.html

"María Magdalena Campos-Pons." *AfroCubaweb*. 1997. http://www.AfroCuba Web.com

"María Magdalena Campos-Pons." *Johannesburg Biennale: Life's Little Necessities*. 1997. http://www.dialnsa.edu/iat97/johannesburg/life/campos.html

Leonora Carrington

(b. 1917)

English-Mexican Painter, Sculptor, and Writer

Leonora Carrington is a leading Surrealist painter in Mexico. Born in South Lancaster, England, she grew up in an affluent family. Carrington says that dream imagery was important to her from the very start, and recalls her early interest in making art. "I started like most children. Immediately, as soon as I could scribble on the walls" (DeAngelis 2). After many transfers from school to school, her parents recognized her lack of interest in core academic subjects. Her father reluctantly financed art school, while her mother, an artist herself, offered emotional support and creative inspiration (Cutajar 1). After many family debates, she was allowed to attend the Chelsea School of Art in London.

While in London, Carrington also studied with the artist Amédée Ozenfant. In his garage studio, she learned the fundamentals of drawing. While still studying with Ozenfant, she was introduced to the prominent Surrealist painter Max Ernst (Cottenet-Hage 230). The two became inseparable, and Ernst soon left his wife to live with Carrington (De Angelis 4). In the 1930s, social tensions increased with Hitler's rise to power in Germany, causing many artists and radical thinkers, including Ernst and Carrington, to leave London for Paris. There, Ernst introduced her to such artists and writers as Marcel Duchamp, Salvador Dalí, and André Breton. Breton's essays and lectures on Surrealism brought many artists together in their exploration of dreams and the fantastic. Carrington's paintings are full of imagery and symbols from Celtic myths she heard as a child, an essential characteristic of her work that led to its being classified as Surrealist. Frequently, male Surrealist painters used female imagery to suggest the link between man and the unknown, mystical, or surreal. Carrington marked her own path into Surrealism by using animals and nature

to represent both the feminine and the masculine as gatekeepers of the fantastic (Chadwick, *Mirror* 13).

Carrington and Ernst influenced one another's work, as is evident in her *Portrait of Max Ernst* (1939). In this painting, Ernst stands tall in a vibrant red coat, filling the foreground of the canvas, with the silhouette of a white horse in the distant background. The white horse is a recurring symbol in her paintings, often making reference to Ernst and how he saved her from the social confines of the British aristocracy (Colville 163). The two artists also worked collaboratively. Ernst illustrated her first published story, "The House of Fear" (1938) (Colville 165). Their relationship ended in 1942 when Ernst, a German Jew, was imprisoned in France in a German concentration camp, and Carrington fled to Mexico.

Carrington seemed to find her home in Mexico. During her early years there, she developed a friendship with the Spanish-Mexican artist **Remedios Varo**. Her interests in dream imagery, magic, and fantasy continued to emerge through her exploration of the occult and study of Mayan myths (Cutajar 1). Her painting *Temple of the World* (1954) depicts Mexican architecture reminiscent of Mayan temples. Contemporary scholars have noted the changes Carrington made in the symbolism and exploration of mythical creatures over the course of producing her extensive oeuvre. Early paintings are filled with childhood memories of Celtic myths told by her Irish nanny. Later paintings and writings reflect more complex imagery influenced by Mexican culture and Mayan myth, intertwined with hybrid ideas of humans and beasts, male and female (Colville 162). She investigates the concept of borders in identity, such as male/female, reality/fantasy, in/out, and human/animal in her writing as well. Carrington's novel *The Stone Door* (1976) reveals this fascination through personality transfers, disguises and hybrid characters (Cottenet-Hage 78).

Although during her early years in Mexico, Carrington mostly worked in isolation or with Varo, she was closely associated with such Mexican artists and writers as **Frida Kahlo, Diego Rivera, José Clemente Orozco**, and Octavio Paz. However, accounts of her involvements reveal social and friendships bonds rather than artistic ones. After living in Mexico for a couple of years, she met and married the Hungarian photographer Chiqui Weisz. They have two sons, Gabriel and Pablo; the latter is an artist who lives in the United States.

As a white, European woman artist, Carrington worked and lived outside the mainstream of a male-dominated art world until the early 1960s, when she received critical acclaim as a painter (Chadwick, "Carrington" 101). In the mid-1940s, Carrington's first show was installed in a furniture shop (De Angelis 7). In 1947, the Pierre Matisse Gallery in New York City hosted her first one-person show in the United States. After the first few exhibitions, Carrington's reputation drew attention from the Mexican government, which in 1963 commissioned her to paint a mural for the new

Museum of Anthropology in Mexico City (Chadwick, "Carrington" 105). The mural *El Mundo Mágico de los Mayas* (The Magic World of the Maya) is full of imagery and symbolism drawn from her studies of the ancient Mayan culture and her visits to Chiapas. *Cocodrilo* (2000) a large-scale bronze sculpture of a crocodile, a gift from Carrington, was installed in the lake at Chapultepec Park in Mexico City. Her public art exemplifies her use of diverse scale and materials.

Like that of Kahlo and **Ana Mendieta**, Carrington's work is highly personal, focusing on her experiences of being a woman. Yet she also considers the historical through Celtic and Mayan cultures, and the position of women in various times and places (Colville 166). Her work is routinely grouped with that of Remedios Varo and the Argentine artist Lenor Fini because of their approach to identity exploration, which has been labeled "self-othering" by Whitney Chadwick:

> Identifying with moments prior to historical time and/or outside the "civilized" cultural spaces identified with patriarchy, they [Carrington, Varo, and Fini] sought the sources of the "feminine" and "woman" in epochs and places in which women were believed to have exercised spiritual and psychic powers later repressed under patriarchy. (*Mirror* 13)

Carrington is heralded as a role model by women artists for becoming a prominent member of the male-dominated discipline of Surrealism. An excerpt from Carrington's "What Is a Woman?" (1970) provokes thoughts about personal emotion, gender identity, and the power struggle of understanding such complexities:

> In order to unchain our emotions we must observe all the elements that are used to keep us enslaved, all the false identities that we unconsciously embrace through propaganda, literature, and all the multiple false beliefs that we are fed since birth. This is the only way to clear psychic territory for reality. Our emotions react mechanically to so much bunk that our own real emotions are practically impossible to decode. (Rosemont 374)

As a writer, sculptor, and visual artist, Leonora Carrington explores ideas regarding memories and dreams in her work, intermingled with Celtic and Mayan myths, and the experience of being a woman with diverse experiences. She still resides in Mexico, where she continues to explore Surrealist journeys, identity issues, and cultural histories through writing, painting, and sculpting.

Places to See Carrington's Work

Artists Rights Society, New York City: *Dog, Come Here into the Dark House. Come Here, Black Dog* (1995)

Brewster Arts Limited, New York City

Chapultepec Park, Mexico City: *Cocodrilo* (2000)

Kyron Gallery http://www.mexconnect.com: *Jinetes* (The Horsemen, 1977); *Mula's Ox* (1977); *Argument* (1978); *Domingo* (Sunday, 1978)

Latin American Masters Museum, Beverly Hills, Calif.

Mary-Anne Martin Fine Art Gallery, New York City

Museo de Arte Contemporáneo, Mexico City: *Temple of the World* (1954)

National Museum of Anthropology of Mexico, Mexico City: *El mundo mágico de los Mayas* (1963)

Pierre Matisse Gallery, New York: *Self-Portrait* (1937)

Bibliography

Carrington, Leonora. *The Oval Lady*. Translated by Rochelle Holt. Santa Barbara, Calif.: Capra Press, 1975.

Carrington, Leonora. *La Porte de Pierre* (The Stone Door). Paris: Flammarion, 1976.

Carrington, Leonora. *The Hearing Trumpet*. New York: St. Martin's Press. 1977.

Carrington, Leonora. *La Débutante: Contes et Pièces*. Translated by Yves Bonnefoy, Jacqueline Chénieux, and Henri Parisot. Paris: Flammarion, 1978.

Carrington, Leonora. *The House of Fear: Notes from Down Below*. New York: E. P. Dutton, 1988.

Chadwick, Whitney. "Leonora Carrington: Visual Narrative in Contemporary Mexican Art." In *A Woman's Gaze: Latin American Women Artists*. Edited by Marjorie Agosín. Fredonia, N.Y.: White Pine Press, 1998. Pp. 97–109.

———. "An Infinite Play of Empty Mirrors: Women, Surrealism, and Self-Representation." In *Mirror Images*. Edited by Whitney Chadwick. Cambridge, Mass.: MIT Press, 1998. Pp. 2–35.

Christensen, Peter. "The Flight from Passion in Leonora Carrington's Literary Work." In *Surrealism and Women*. Edited by Mary Ann Caws, Rudolf Kuenzli, and Gwen Raaberg. Cambridge, Mass.: MIT Press, 1991. Pp. 148–58.

Colvile, Georgiana M. M. "Beauty and/Is the Beast: Animal Symbology in the Work of Leonora Carrington, Remedios Varo and Leonor Fini." In *Surrealism and Women*. Edited by Mary Ann Caws, Rudolf Kuenzli, and Gwen Raaberg. Cambridge, Mass.: MIT Press, 1991. Pp. 159–81.

Cottenet-Hage, Madeleine. "The Body Subversive: Corporeal Imagery in Carrington, Preassinos and Mansour." In *Surrealism and Women*. Edited by Mary Ann Caws, Rudolf Kuenzli, and Gwen Raaberg. Cambridge, Mass.: MIT Press, 1991. Pp. 76–95.

Cutajar, Mario. *Leonora Carrington*. 1995. http://www.artscenecal.com/Articles File/Archive/Articles1295/Carrington.html

DeAngelis, Paul. "An Interview with Leonora Carrington." *El Paseante 17*. Trans-

lated by Cecilia Martinez. Edited by Nadien Van Hasseit. http://www.kalin.lm.com/carrint.html

Enríquez, Mary S. "Leonora Carrington." *Art News* vol. 94, no. 3 (1995): 146.

Rosemont, Penelope, ed. *Surrealist Women: An International Anthology*. Austin: University of Texas Press, 1998.

Suleiman, Susan Rubin. "The Bird Superior Meets the Bride of the Wind: Leonora Carrington and Max Ernst." In *Significant Others: Creative and Intimate Partnership*. Edited by Whitney Chadwick and Isabelle de Courtivron. New York: Thames and Hudson, 1993. Pp. 96–117.

Martín Chambi

(1891–1973)
Peruvian Photographer

Martín Chambi photographed landscapes, architectural ruins, and everyday life in the Andes of southern Peru, especially in the ancient city of Cuzco. Known as the "poet of light," he produced works important both for their documentary significance—especially those images depicting everyday Andean life—and as art with strong aesthetic qualities. Chambi changed the way photography was thought about in Peru by depicting the indigenous people without glorifying them, as well as people from the upper classes without ridicule (Castro 73).

Born in a village near Puno, on the edge of Lake Titicaca high in the Andes (Valcárcel 221), he was part of a traditional Indian family of humble means. Chambi became fascinated with photography at an early age. Curious about almost everything, one day in town he encountered a white tourist using a camera on a tripod. The photographer engaged the boy in conversation, took his picture, and, when it was developed, gave it to him. This photograph became a treasured possession. From that moment on, Chambi knew he wanted to be a photographer. At the age of fourteen he traveled to Arequipa to learn this skill, and was able to apprentice himself to a photographer. He married, and in 1920 he took his family to Cuzco to set up his own business. There he lived for the rest of his life (*Martín Chambi*).

Chambi was part of Cuzco's *indigenista* school, a group that centered on the life and culture of Peru's Indian majority (Valcárcel 221). Its members were intellectuals and artists who believed that the spirit of Peru resided within its Indian population. The movement's goal was to combat the Spanish colonial idea that Indians were second-class citizens. Chambi was a leading member of the group, giving numerous photographs to its news-

paper and fueling its foundational ideas with the thousands of images that he took of Indian life over the course of his career. He traveled to remote villages, making friends with the locals, who would then allow him to photograph them. Often his journeys were difficult and made at great sacrifice. Nonetheless, he continued to make these photographic trips because he believed so deeply in the importance of what he was doing (*Martín Chambi*).

Chambi began photographing Andean life at a time when Peru had just gone through an economic boom that peaked in 1920. The prosperity, however, affected only the upper classes, leaving the poor in extreme poverty ("Peru" 146). Indians were often regarded by the Spaniards as servants or, worse, slaves. But Chambi believed strongly, as did other members of the *indigenista* group, that Peru was best known by the relationship the Indian people had to the land. For him, the spirit of the people resided in the continuity of their rituals and traditions, and he successfully captured these images (*Martín Chambi*).

At the beginning of Chambi's career, mainstream newspapers were essentially controlled by the military regime, and photographs that had been created to liberate the poor were appropriated by the elite for their own political purposes. In this manner, photography that was intended to be subversive became art of the establishment. It was, therefore, a surprise to some viewers when Chambi's work was shown in the Secuencia Gallery in Lima during the 1920s. As an unknown photographer, he did not seem to be using his work to make an overt political statement. What he did portray in a beautifully hypnotic manner, was Andean life. The quality of the light and composition was striking. Viewing his photographs in a gallery space, critics and others had to rethink the nature of photography as being first and foremost politically motivated (Castro 73). At this time, photography came to be considered work composed by an artist. Viewers could approach it as they might a painting. Because his work was so hauntingly beautiful, Chambi changed the way photography was viewed in Peru.

Chambi did not photograph only landscapes and Indian life. He was also called upon to photograph the powerful. His quiet and controlled manner, coupled with his strong artistic reputation, gave him the ability to move across the boundaries between Indians (and mestizos) and the Spanish. Because of his ability to work with both groups of people, his collection of over 20,000 negatives constitutes a holistic picture of Cuzco and the southern Peruvian Andes in the first half of the twentieth century (*Martín Chambi*).

Works by Chambi vary in subject, but all are carefully composed, with that special quality of light for which he is so well-known. A 1941 landscape photo shows an image of the Inca ruins of Wiñay Wayna that is both mysterious and valued (Valcárcel 221). His photograph *La boda de los Gadea* (The Gadea Wedding, c. 1930) shows a young couple in wedding

finery. The light of the bride's white dress and long train sharply contrasts with the darks in most of the rest of the photograph. The light shines perfectly on the faces of both the bride and the groom, making for an extraordinarily rich and enticing composition. Wedding guests peer out from the background. The couple stares at the viewer, almost as if to say that they were ready to take on the challenges of marriage.

In *Luis Velásco Aragón Dirigiéndose al Sindicato de Carniceros* (Luis Velásco Aragón Speaking Before the Union of Butchers, c. 1928), several dozen well-dressed men meet in a courtyard. A table is at the far end of the cobblestones, repeating the horizontal line of railways and the rooftop. The arrangement of the men, seated on the sides of the open central space, echoes the lines of perspective created by the building's walls. This photograph portrays a historical moment informing the viewer about a meeting that took place in the 1920s. It is also a carefully composed work of art.

In 1949, Chambi was included, by invitation, in the First International Exhibition of Latin American Photography. This was the first effort of the Pan American Union (later the Organization of American States) in Washington, D.C., to present examples of Latin art to the United States. His three photographic works were *Samaritan*, *Meienda*, and *Andean Voyage*. Photographs came from Bolivia, Costa Rica, Guatemala, Mexico, Paraguay, and Venezuela, as well as Peru. The organizers noted how difficult it was to arrange for this exhibition because of the scarcity of photographic materials, and problems with communication and difficulty in transporting the works. For Peruvian artists, the National Tourism Corporation in Lima provided assistance (Sanjurjo 66–68).

Chambi trained several of his children to be photographers. One of his daughters now tends to his archive of photographs in Cuzco. He is respected and honored for many contributions, but perhaps the most important is that he created the first comprehensive photographic documents of the descendants of the Incas (*Martín Chambi*).

Places to See Chambi's Work

Latin American Library Photographic Archives, Tulane University, New Orleans: *Self-Portrait (Studio), Cuzco, Peru* (1928)

Martín Chambi and the Heirs of the Incas. Produced by Anthony Wall and Nigel Finch. Directed by Andy Harries and Paul Yule. 53 min. Cinema Guild, 1986. Videorecording.

Spencer Throckmorton Gallery, New York City

Bibliography

Arguedas, José María. "The Pongo's Dream." In *The Peru Reader: History, Culture, Politics.* Edited by Orin Starn, Carlos Iván Degregori, and Robin Kirk. Durham, N.C.: Duke University Press, 1995. Pp. 258–63.

Castro, Fernando. "Crossover Dreams: Remarks on Contemporary Latin American Photography." In *Image and Memory: Photography from Latin America, 1866–1994*. Edited by Wendy Watriss and Lois Parkinson Zamora. Austin: University of Texas Press, in association with FotoFest, 1998. Pp. 57–94.

Chambi, Martín. *Martín Chambi Photographs, 1920–1950*. Foreword by Mario Vargas Llosa. Introductions by Edward Ranney and Publio López Mondéjar. Translated by Margaret Sayers Peden. Washington, D.C.: Smithsonian Institution Press, 1993.

Martín Chambi and the Heirs of the Incas. Produced by Anthony Wall and Nigel Finch. Directed by Andy Harries and Paul Yule. 53 min. Cinema Guild, 1986. Videorecording.

"Peru: Modernity in the Southern Andes. Peruvian Photography, 1908–1968." In *Image and Memory: Photography from Latin America, 1866–1994*, Edited by Wendy Watriss and Lois Parkinson Zamora. Austin: University of Texas Press, in association with FotoFest, 1998. Pages 144–59.

Ranney, Edward, Pauline Antrobus, and Adelma Benavente García. *Peruvian Photography: Images from the Southern Andes, 1900–1945*. Photographs by Martín Chambi. Colchester, U.K.: University of Essex Press, 1996.

Sanjurjo, Annick, ed. *Contemporary Latin American Artists: Exhibitions at the Organization of American States, 1941–1964*. Lanham, Md.: Scarecrow Press, 1997.

Valcarcel, Luis. "Tempest in the Andes." In *The Peru Reader: History, Culture, Politics*. Edited by Orin Starn, Carlos Iván Degregori, and Robin Kirk. Durham, N.C.: Duke University Press, 1995. Pp. 219–22.

Lygia Clark
(1921–1988)
Brazilian Painter, Sculptor, and Sensory Environment Artist

Lygia Clark's career evolved from the forefront of the Brazilian Neo-Concretism movement to intermingling psychoanalysis with art environments for therapeutic use. She was born in Belo Horizonte, Minas Gerais, Brazil, in 1921. At the age of twenty-seven, Clark first pursued formal art instruction from the Brazilian landscape architect Roberto Burle Marx. From 1950 to 1952, she studied in Paris with the painters Fernand Léger, Dobrinsky, and Arpad Szènes. It was during these two years that Clark first received recognition as a visual artist. Her first solo exhibition, in 1952, at the Paris gallery L'Institut Endoplastique, garnered attention from both peers and critics (Catlin and Grieder 167).

Clark's work reflects her involvement in Neo-Concretism, Brazil's leading creative movement of the 1950s. The *Neo-Concrete Manifesto* (1959) proposed that artists create work that speaks of natural subject matter, resulting from an intuitive approach to art production, rather than following a formulaic representational style. "If we have to look for an equivalent to the work of art we will not find it in the machine, or even the object as such, but . . . in the living organism" (in Brett "Lygia Clark" 59). Clark's art aims to trigger a psychological response, in an effort to better understand the living organism or human condition.

After returning to Brazil in 1952, Clark was instrumental in the formation and continuation of the Neo-Concretist artists' group, Grupo Frente, headed by Ivan Serpa. The group members opposed traditional approaches to making art, particularly figuration. Instead, they focused on creating art that expressed ideas about space-time, movement, and matter. Along with the Brazilian artist **Hélio Oiticica**, Clark may be the best-known Brazilian artist of the Neo-Concrete movement (Mesquita 212).

She was strongly influenced by European Minimalism, especially the work of Piet Mondrian, whose pure geometric forms and blocks of color are present in Clark's early paintings. However, her intention to create an interactive space was quite different from Minimalism's detached art object. The audience becomes an integral part of her creative process as it is encouraged to interact with the object, evoking sensory happenings. As the work changes, the role of the viewer shifts from audience to artist, each time resulting in a new collaboration. Commenting on her early paintings, Clark says, "I began with geometry but I was looking for an organic space where one could enter the painting" (Brett, "Lygia Clark" 61). Her goal was to portray the illusion of three-dimensional space in a two-dimensional picture plane. This approach led to the development of two series, both started in 1958. *Casulos* (Cocoons) and *Trepantes* (Climbers) are flat paintings that unfold into three-dimensional objects, continually changing with the surrounding space.

Clark was the first Brazilian artist to use audience participation in her work, which becomes most evident in the *Bichos* (animals/Beasts) series, started in 1960 (Mesquita 215). The *Bichos* are constructed of sheet metal and hinged together in geometric forms intended to be picked up, played with, and/or stood on by participants. *Bicho: Caranguejo duplo* (Double Crab, 1961), a sculpture of multiple triangular forms fabricated from aluminum sheets, gracefully sits on the floor. Walking around the object to see all sides, the viewer becomes intertwined in the work as the aluminum reflects the fluid space. The work literally continues to be re-created each time someone engages with it (Mesquita 215). Here, Clark shifts the role of the artist from the creator of something for an audience to observe and understand to a facilitator of interactive experiences. She sets the stage for a multitude of connections to be made through the art experience. About the specific intentions of the *Bichos* series, she said:

> The Animal has his own and well-defined cluster of movements which react to the promptings of the spectator. He is not made of isolated static forms which can be manipulated at random as in a game: no, his parts are functionally related to each other, as if he were a living organism, and the movements of these parts are interlinked. The intertwining of the spectator's action and the Animal's immediate answer is what forms this new relationship, made possible precisely because the Animal moves—i.e., has a life of its own. (Brett, "Lygia Clark" 61)

Following the *Bichos* series, Clark further pushed the role of the audience by creating highly interactive and even therapeutic works of art that depend on the viewers to become participants and to "complete" each work. In addition to opposing traditional modes of making art, she rejected the confining spaces of museums and galleries. By moving the location of her

work from formal art institutions to less formal settings, such as classrooms and front lawns, she shifted the relationship between the viewer and the art beyond initial interaction to participants undergoing full body sensory experiences (Rolnik 1).

During her second stay in Paris, Clark experimented more intensely with viewer participation. She returned to Paris in 1968, at the onset of an oppressive dictatorship in Brazil that brought intense censorship in all forms. While in Paris, she taught art at the Sorbonne from 1970 to 1975. These years at the university gave her the opportunity to explore the interactions of students and participants resulting from her environments, involving various performances and happenings (Chiarelli 1).

During her later years in Paris, and for the remainder of her life, Clark worked as a psychologist and art became a therapeutic vehicle. In *Mandala* (1969), part of the series *L'Homme: Support vivant d'une architecture biologique et cellulaire* (Collective Body), people are linked by a web of elastic bands attached to their wrists and ankles. During the performance, Clark documented how people reacted—any movement would affect all other movements (Ades 282). She was concerned with activating participants' bodily senses along with their responses to those experiences. The art environment essentially became a sensory event, unique for each participant. For Clark, the work became complete only when someone came in contact with it (Rolnik 1). Eventually, the art's function became one of healing, through the connective experience, rather than simply play. From the late 1970s on, Clark devoted her work to psychoanalysis and art as therapy (Chiarelli 1). She returned to Rio de Janeiro in 1975 and lived there until her death in 1988.

Although Clark received critical acclaim and attention in Brazil throughout her career, only in recent decades has her work drawn increased international interest (Catlin and Grieder 167). Clark was included in several U.S.-based group exhibitions, among them one at the Museum of Modern Art in New York City in 1960. The Louise Alexander Gallery in New York City hosted her first solo exhibition in the United States in 1963. Clark won several prestigious awards, including the Abstract Art Prize in Petrópolis, the Frederico Schmidt Prize in Rio de Janeiro, and the major prize at the Fourth Bienal of São Paulo. The art and work of Lygia Clark continue to assert their universality and timelessness.

Places to See Clark's Work

XXIV Bienal de São Paulo. http://www.uol.com.br/bienal/24bienal/nuh/enuhclark01.htm *Caminhando* (Walking, 1964); *Trepante* (Crawler, 1959); *Baba Antropofágia II* (Cannibal Drool II, 1975); *Nostalgia do Corpo—Objectos Relacionais* (Nostalgia of the Body—Relational Objects, 1965–88); *Nostalgia do Corpo—Corpo Coletivo* (Nostalgia of the Body—Collective Body, 1986)

Lygia Clark home page: http://www.lygiaclark.org

Museu de Arte Moderna do Rio de Janeiro: *Mask with Mirrors* (1967); *Rubber Grub* (1964)

Museum of Modern Art, New York City

National Museum of Women in the Arts, Washington, D.C.

Pinacoteca do Estado, São Paulo: *Bicho: Caranguejo Duplo* (Beast: Double Crab, 1961)

Thread Waxing Space Gallery, New York City

Bibliography

Ades, Dawn. *Art in Latin America: The Modern Era, 1820–1980*. New Haven, Conn.: Yale University Press, 1989.

Basualdo, Carlos. "Sleeping Cure." *Trans* 1, no. 2 (1996). http://www.echonyc.com/~trans/lygia/clark3.html

Brett, Guy. "Hélio Oiticica: Reverie and Revolt." *Art in America* vol. 77, no. 1 (1989): 111–121.

Brett, Guy. "Lygia Clark: In Search of the Body." *Art in America* vol. 82, no. 7 (1994): 55–63, 108.

Cancel, Luis R. et al., editors. *The Latin American Spirit: Art and Artists in the United States, 1920–1970*. New York: Bronx Museum of the Arts in association with Harry N. Abrams, 1988.

Catlin, Stanton L., and Terence Grieder. *Art of Latin America since Independence*. New Haven, Conn.: Yale University Press, 1966.

Chiarelli, Taden. *Lygia Clark—Biography*. Berlin: Gerhard Haupt, 2000. http://www.universes-in-universe.de/doc/clark/e_clark4.htm

Leffingwell, Edward. "Latin Soliloquies." *Art in America* vol. 81, no. 12 (1993): 72–83.

Lucie-Smith, Edward. *Latin American Art of the 20th Century*. New York: Thames and Hudson, 1993.

Mesquita, Ivo. "Brazil." In *Latin American Art in the Twentieth Century*. Edited by Edward J. Sullivan. London: Phaidon Press, 1996. Pp. 201–32.

Rolnik, Suely. "Por um Estado de Arte: A Atualidade de Lygia Clark" (For a State of Art: The Actuality of Lygia Clark). *XXIV Bienal de São Paulo: Núcleo histórico*. 1994. http://www.uol.com.br/bienal/24bienal/nuh/expo_clark.htm

Olga de Amaral
(b. 1932)
Colombian Fiber Artist

Olga de Amaral's work has been displayed in numerous solo and group exhibitions all over the world (Constantine and Larsen, *Beyond Craft* 98), and she has achieved international recognition in a medium dominated by Europeans and Japanese. As of 1998, de Amaral was the only textile artist to receive a Guggenheim grant, which was awarded in 1973. Married, with two children, she has also been active in numerous organizations related to her art. From 1966 to 1976, she directed the weaving department at the University of the Andes. She also served for the World Craft Council, from 1968 to 1972 as the Colombian representative, and from 1970 to 1978 as the director for Latin America (Goin 55–56).

De Amaral was born in Bogatá. Her father was an engineer, and her mother, she recalls, enjoyed traditional tapestries, which she purchased in the markets. Her early university education was in architectural drafting and design because, she stated, she has the mind of an engineer: "I like geometry, math, things that repeat" (Goin 56). Because women were not architects in the 1950s, she went to the United States to study at the Cranbrook Academy of Art in Bloomfield Hills, Michigan. She began her weaving studies there. "I discovered my whole life through yarn," she has said (Goin 56).

She married a U.S. citizen, the artist Jim Amaral. Together they started a design studio in Colombia. Jim designed furniture, and Olga designed rugs and fabrics. The studio was so successful that de Amaral had built her own looms and explored new textile techniques. The structural possibilities of large-scale works, which she called "woven walls," fascinated her. And, according Chelsea Miller Goin, she began to experiment with new materials, including gold leaf that she placed on fabric, a reminder of

the use of gold leaf in Colombian history and culture. De Amaral now has trained assistants who help with her work. This collaborative approach helps her to keep pace with the varied demands of her life.

De Amaral's *Woven Wall* (1970) is representative of her early years of exploring techniques and materials. Made of horsehair and wool, it is a wall-size plaited piece that loops at the bottom (Traba 98). *Cal y Canto* (Stone Masonry, 1977) also is plaited and uses horsehair, but is different in several respects, including the incorporation of gesso, a white primer ordinarily used by painters on canvases. The white carries the viewer's eye from the natural colors of the materials to the gesso.

Many of de Amaral's works are inspired by indigenous textiles. For example, she repeatedly uses the technique of oblique interlacing at a steep angle that is found in bags and purses made by the Indians of Colombia (Constantine and Larsen, *The Art Fabric* 81–82). The recent scholarship on pre-Columbian textiles, especially those woven in Peru, helped intensify her interest in past techniques. Combining new and old characteristics of textile work assists her in weaving the past together with the present (Goin 60).

De Amaral is known for the architectural scale of many of her pieces, which work well in public buildings with high ceilings. Her use of scale is a search for space. She has claimed that her monumental pieces are "part of my anxiety to find and control my personal space" (Goin 59). Producing large art objects was also part of the artistic scene during the 1960s and 1970s. *El Gan Munro* (1976), commissioned for the Peachtree Plaza Hotel in Atlanta, combines dramatic scale, color, and texture. Eight panels, each seven feet by one foot, two inches, can be seen from any level of the atrium. The yellow, orange, beige, and white wool and horsehair fibers contrast beautifully with the building's concrete (Constantine and Larsen, *The Art Fabric* 216–17).

De Amaral's works are important for their monumentality, revolutionary techniques, and utilization of old and new materials. She is noted for the changes she has caused in the art world by making visible the aesthetic possibility of fiber arts. Her woven pieces work especially well when designed for specific spaces. About her art, she said:

> The need to create textures that clearly show the materials has led me to form my woven walls for architectural spaces with my own materials. These materials allow me to realize the structures in larger dimensions. Their function is very clear and of great importance to the proportions of my work. The strength of the elements of constructions previously made and the construction of the texture itself facilitate their integration in architecture with self-sustaining bold strength. (Constantine and Larsen, *Beyond Craft* 102)

De Amaral's large-scale works Modernist aesthetics and also, in her mind, arise naturally from traditional Colombian culture, drawing on the

Andean landscape and colonial architecture. Her early works, created with wood, sisal, and coarse wool, refer to rugged landscape, whereas her current works, contrasting gold and silver with reds and blues, are more associated with Colombia's built environment, especially stucco walls (Goin 61). If, as de Amaral says, "weaving is a way of constructing your own way of life" (Goin 57), then she has visually done so in ways that are deeply rooted in her Colombian culture.

Places to See de Amaral's Work

Bellas Art Gallery, Santa Fe, N.M.

Chicago Art Institute

Embarcadero Center, San Francisco

Fort Worth National Bank

Hyatt House, Chicago

Instituto Colombiano de la Cultura, Bogatá

Museo de Arte Moderno, Bogatá, Colombia

Museum of Modern Art, New York City

National Museum of Art, Kyoto, Japan

Peachtree Plaza Hotel, Atlanta, Ga.

Omaha Public Library, Omaha, Neb.

La Tertulia Modern Art Museum, Cali, Colombia

Bibliography

Constantine, Mildred, and Jack Lenor Larsen. *Beyond Craft: The Art Fabric*. New York: Van Nostrand Reinhold, 1973.

Constantine, Mildred, and Jack Lenor Larsen. *The Art Fabric: Mainstream*. New York: Van Nostrand Reinhold, 1981.

Damien, Carol. "Olga de Amaral y Jim Amaral." *Art Nexus* 11 (January/March 1994): 165–66. (English trans., 240–241.)

Goin, Chelsea Miller. "Textile as Metaphor: The Weavings of Olga de Amaral." In *A Woman's Gaze: Latin American Women Artists*. Edited by Marjorie Agosín. Fredonia, N.Y.: White Pine Press, 1998. Pages 54–63.

Larsen, Jack Lenor, with Betty Freudenheim. *Interlacing: The Elemental Fabric*. New York: Kodansha International, 1986.

Olga de Amaral: Woven Sculpture. New York: André Emmerich Gallery, 1974. Exhibition catalog.

Rodriguez, Martha. "Olga de Amaral: Cuatro tiempos." *Art Nexus* 12 (April/June 1994): 76–79. (English trans., 166–68).

Scarborough, Jessica. "Olga de Amaral: Toward a Language of Freedom." *Fiberarts* 12 (July/August 1985): 51–53.

Soto, Juliana. "Olga de Amaral: Fantasies of Fiber." *Artnews* vol. 93, no. 12 (1994): 112–13.

Tally, Charles. "Olga de Amaral." *American Craft* 48, no. 2 (April/May 1988): 38–45.

Tally, Charles. "Impersonal Suspension: Olga de Amaral Woven Works at Allrich Gallery." *Artweek* (14 December 1989): 10–11.

Tally, Charles. "Olga de Amaral." *Latin American Art* 4, no. 1 (Spring 1992): 46–48.

Traba, Marta. *Art of Latin America, 1900–1980*. Washington, D.C.: Inter-American Development Bank; Baltimore: John Hopkins University Press, 1994.

Edouard Duval Carrié

(b. 1954)

Haitian-American Painter and Installation Artist

Edouard Duval Carrié's art, which comments on Haiti's history and sociopolitical realities, often focuses on the Vodou religion that is ever present in Haiti's daily affairs (Poupeye 89). His style also reflects his Haitian heritage. Duval Carrié was born in Port-au-Prince, but when he was a child, the violence of the Duvalier regime caused his family to relocate to Puerto Rico. They lived there for several years, and he became fluent in Spanish. Although Edouard wanted to study art, he could not, at first, tell his father that with a "straight face," since his father wanted him to follow in his footsteps, running a construction company (Congdon and Bucuvalas). In 1978 he received his B.A. degree in geography and urban studies from the University of Loyola Montreal in Quebec, Canada, and from 1988 to 1989 he studied at the Ecole Nationale Supérieure des Beaux Arts in Paris. Duval Carrié also studied at McGill University and at the University of Montreal, both in the province of Quebec. He lived in France for many years, but currently lives and works in Miami ("Edouard Duval Carrié—Artist").

Duval Carrié often makes bold statements in his work that are aimed directly at political leaders. For example, *J. C. Duvalier en Folle de Marié* (J. C. Duvalier as Mad Bride, 1979) makes a daring comment about Haiti's controversial leader, "Baby Doc" Duvalier, and his questionable character and sexual preferences. In this early painting, "Baby Doc" fills the large vertical space, wearing a frilly white wedding dress and long gloves. On his right arm is a gold bracelet, and his left hand holds a gun to his head. Polished shoes and gray trousers show beneath the long dress. The landscape in which he is centered is clearly Caribbean with its blue sky and tropical vegetation (Poupeye 127, 130). "Baby Doc" is again featured in a

Edouard Duval Carrié. Courtesy of Bernice Steinbaum Gallery, Miami. Used with permission.

similar wedding dress in the painting *Mardigras at Fort Dimanche* (1992–95). Here he is surrounded by his family at Fort Dimanche, which was the torture chamber of the political regime. Beside him, in dark contrast to "Baby Doc's" white garment, are an army general, his in-law Archbishop Ligonde, and Bawon Samdi, the Vodou Lord of Death. In this case, the dress may allude to rumors of Duvalier's homosexuality and to his mother's reputed Vodou initiation (Mintz and Trouillot).

While Vodou enters tangentially into Duval Carrié's political paintings, some of his works are more directly about the religion. For example, *Ayida Wèdo* (1994) depicts the female divinity who is the wife of Danbala, a serpent deity associated with water, the rainbow, and wisdom. Both spirits come from West African traditions. Ayida Wèdo's body is covered with religious markings called *vèvè* that are used to evoke the *lwa* (spirits). A snake arches from one hand to the other, perhaps representing Danbala (Beauvoir-Dominique 154). The snake is ancient, and also represents the continuity of generations. The palm tree near the female deity is a natural

poto-mitan (the sacred pole) that is placed in Vodou temples and is the route by which the *lwa* are said to arrive (Hayes and Robinson 30).

Although Duval Carrié's art often revolves around Haiti, he feels comfortable living in Miami because he can "mingle locally with the Haitians. . . . I didn't want to go back to Haiti because of the turmoil there. I have two kids." Further, there is a political agenda in Miami that is related to Haiti, and he finds himself more involved with that: "So I'm becoming more a part of the cultural landscape" of Miami. He feels American now and plans to become a citizen. However, because his parents moved back to Haiti, he returns often for visits. His "ties are very much with that nation," and he has invested so much of his spirit and energy in Haiti that he cannot abandon it (Congdon and Bucuvalas).

More recently, Duval Carrié's work has become more three-dimensional, and installation work has been more prevalent. He makes ships, for example, that tell the tales of the "boat people" who take the dangerous voyage to the United States on makeshift rafts. But no matter what form his artwork takes, it is always narrative, and it is intended to make Haitian life visible. By telling the rest of the world about Haiti's culture and history, he ensures the visibility of his island ancestors, their beliefs, joys, and struggles. He is interested in aesthetics and styles of creating art, but this is not what best defines him. Rather, he says, his work is a "call to tolerance. . . . There are people around who are different, they represent different things, [and] they have different gods. And, okay, they're different. Accept them for who they are" (Congdon and Bucuvalas). Duval Carrié's artwork not only intrigues because of its visual qualities; it asks viewers to understand its narratives and to become more accepting as a response.

Places to See Duval Carrié's Work

Bernice Steinbaum Gallery, Miami

Davenport Museum of Art, Davenport, Iowa

Miami Art Museum

Polk Museum of Art, Lakeland, Fla.: *Atoum Guidi* (King of Angola, 1996); *Baron Samedi* (Leader of the Gedes, 1996); *La Cour miraculée du Dagbo Hou Non* (1995); *Erzulie Dantor* (Mother Figure, 1996); *La Main Divine* (The Divine Hand, 1996); *Marassa Boumba* (Sacred Twins, 1996)

Bibliography

Avins, Lyn, and Betsy D. Quick. *Sacred Arts of Haitian Vodou: A Curriculum Resource Unit.* Los Angeles: University of California-Los Angeles, Fowler Museum of Cultural History, 1995.

Beauvoir-Dominique, Rachel. "Underground Realms of Being: Vodoun Magic."

In *Sacred Arts of Haitian Vodou*. Edited by Donald J. Cosentino. Los Angeles: UCLA, Fowler Museum of Cultural History, 1995. Pp. 152–77.

Brown, Karen M. *Tracing the Spirit: Ethnographic Essays on Haitian Art*. Davenport, Iowa: Davenport Museum of Art, 1995.

Congdon, Kristin G., and Tina Bucuvalas. Interview with Edouard Duval Carrié. Miami, August 29, 2000.

"Edouard Duval Carrié—Artist." June 18, 2001.http://www.edouard-duval-carrie. com/edouard-docs/statement.htm

Hayes, Anne Marie, and Michelle Robinson. "Instructional Resources: Haitian Art. Exploring Cultural Identity." *Art Education* 54, no. 1 (January 2001): 25–32.

Mintz, Sidney, and Michel-Rolph Trouillot. "The Social History of Haitian Vodou." In *Sacred Arts of Haitian Vodou*. Edited by Donald J. Cosentino. Los Angeles: UCLA, Fowler Museum of Cultural History, 1995. Pp. 122–47.

Poupeye, Veerle. *Caribbean Art*. New York: Thames and Hudson, 1998.

Raquel Forner

(1902–1988)
Argentine Painter

The imaginative and colorful creatures of Raquel Forner's *Space Series* paintings brought her international acclaim and established her as one of the first artists to explore outerspace (Negri 67–73). She was born in Buenos Aires to a Spanish father and an Argentine mother of Spanish descent. Her parents frequently traveled to Europe, and as a result, Forner spent much of her childhood in Spain. As a child and young adult, she remained connected to Spain and had a personal interest in the Spanish Revolution, which was later revealed in her art. In 1922, Forner became a drawing teacher at the National Academy of Fine Arts in Buenos Aires. Soon, she was participating in major exhibitions and art competitions, and in 1924 she won third place at the National Salon of Fine Arts. Her first solo exhibition, in 1928, was hosted by the Galería Müller in Buenos Aires and was the first of several held at this gallery.

In 1929, seeking a European art education, Forner went to Paris, where she attended classes at the Scandinavian Academy. While in Paris, she entered her work at the 1930 Annual Salon of Paris. She also sent work to be included in the inaugural Annual Salon of Modern Painters in Buenos Aires. Forner returned to Buenos Aires in 1931, and one year later opened an art school. With the painters Alfredo Guttero and Pedro Dominguez Neira, and the sculptor Alfredo Bigatti, she founded the Independent Courses of Fine Arts. Forner became friends with Bigatti, and by 1936, the two were living together.

Forner experimented with Surrealism in the 1940s. She borrowed its distorted perspective and figures, but was not interested in re-creating her dreams. Forner's themes were often grounded in contemporary societal conflict. Her early paintings often contain graphic imagery that is directly

related to the Spanish Revolution. Scenes of war and global tragedy are depressed and somber, with muted colors and often gruesome imagery. Like other women Surrealists, such as the Mexican painters **Frida Kahlo, Leonora Carrington**, and **Remedios Varo**, Forner portrayed strong female subjects. Yet Forner's women are not explorations of gender roles; instead, they are portrayals of fighting women as great sufferers and humanitarians (Barnitz 106). In her oil painting *Victoria* (Victory, 1939), a severed head bleeds at the neck of a concrete, classical female torso. Her gigantic size in relation to the other figures in the painting suggests that she is a goddess or a figurehead. Even though the limbs are painted to resemble broken pieces of concrete, they are gory, sitting in blood. A foot tramples and soils the pages of a book in the foreground, symbolizing the end of culture/religion as the book with the words and laws of a people is wrecked. Next to the foot is a hand holding a sheaf of wheat, symbolizing the ruin of land (the wheat as the remains of a devastated crop). Miniature figures in the background look at the fallen, statuesque goddess with anguish and horror.

In her oil painting *El drama* (The Drama, 1942), complex imagery is composed to convey an urgent message about the tragic affects of war. This painting is one of a series with the same title. Women in the foreground fearfully look up to the sky, watching enemy paratroops land close by. A skeleton stands just behind the women in the center and points to a seven-headed monster. A young girl holds a dead bird while looking to her mother for protection. A miniature torso and classical bust in the left background may symbolize the destruction of civilization. A cracked self-portrait of the artist lies on the ground with a fallen globe, a severed hand (with the stigmata of Christ's crucifixion), and a book (possibly the Christian Bible), all alluding to the self-sacrifice of war (Barnitz 107).

Forner was one of the first visual artists to use imagery reflecting humans' initial encounters with outer space. In 1957, she started a group of inventive paintings, *Space Series*, which brought her exhibitions and recognition in Europe (Negri 68). Her painting *Conquest of the Moon Rock* (1968) is lively and bright, with animated, playful creatures that resemble a television cartoon or a child's comic book. When asked about the motivation for her futuristic paintings, Forner replied, "[I wanted] to express the anguish of modern man [society], who is compelled to answer to an eternal question in the labyrinth of space, who is trying to find his [their] own truth in other worlds and through other possibilities" (Negri 67–68). Photographs and television scenes of astronauts partly inspired the free-floating animated monsters (Lucie-Smith 153). Stylistically, this painting is an example of Forner's Expressionist work, which was influenced by Pablo Picasso's misshapen and overlapping figures.

Forner had a successful career, exhibiting worldwide, receiving numerous awards and grants, and teaching. In 1942, she was awarded the first

prize at the Argentine National Salon. In 1995, she was included in an important exhibition in the United States, "Latin American Women Artists (1915–1995)," that traveled from the Milwaukee Art Museum to the Phoenix Art Museum, the Denver Art Museum, the National Museum of Women in the Arts in Washington, D.C., and the Center of Fine Arts in Miami. Raquel Forner carved her own path in painting with a highly personal, yet intensely social, commentary on life, from the altering affects of war to the mystery of outerspace.

Places to See Forner's Work

Fundación Forner-Bigatti, Buenos Aires: http://www.forner-bigatti.com.ar/: *Victoria* (Victory, 1939).

Galería Arroyo, Buenos Aires: http://www.galarroyo.com

Jack S. Blanton Museum of Art, University of Texas, Austin: *Astronauta y Testigos, Televisados* (1971).

Museo Nacional de Bellas Artes, Buenos Aires: *Dirección General de Cultura* (1953); *El Drama* (The Drama, 1942); *Retablo del Dolor* (1944).

Raquel Forner home page: http://www.asombrarte.com/artistas/pintores/forner/ forner.htm. *Amanecer* (1944); *Eclipse* (1952); *La Flor Roja* (1943); *Luna* (1960).

Bibliography

Barnitz, Jacqueline. *Twentieth-Century Art of Latin America*. Austin: University of Texas Press, 2001.

"Biografia de Raquel Forner." Fundación Forner-Bigatti Web page. 2001. http: //www.forner-bigatti.com.ar/biog_rf.htm

Goldman, Shifra. *Dimensions of the Americas: Art and Social Change in Latin America and the United States*. Chicago: University of Chicago Press, 1994.

Lucie-Smith, Edward. *Latin American Art of the 20th Century*. New York: Thames and Hudson, 1993.

Negri, Tomás Alva. *Arte Argentino y Crítica Europea*. Buenos Aires: Ediciones Bonino, 1975.

Pacheco, Marcelo. "Argentina." In *Latin American Art in the Twentieth Century*. Edited by Edward J. Sullivan. London: Phaidon Press, 1996. Pp. 283–300.

Traba, Marta. *Art of Latin America, 1900–1980*. Washington, D.C.: Inter-American Development Bank, Baltimore: Johns Hopkins University Press, 1994.

Coco Fusco

(b. 1960)
Cuban-American Performance Artist and Author

Although Coco Fusco is primarily known as a performance artist and author, she is also a critic, a curator, and a teacher. From the perspective of a "mixed-race individual of Afro-Caribbean descent" (Fusco, "Fantasies" 63), she produces works that ask the audience to participate in and analyze difficult issues related to cultural identity.

Born in New York City, Fusco experienced a variety of cultural experience. She grew up with a grandmother who had come from Madrid via Havana and was encouraged by her parents to speak both English and Spanish at home. As a child she made daily visits to Washington Square Park, went to Mass with the Irish, and attended a mostly Jewish school. The family had many immigrant visitors, who often stayed at their house for weeks at a time (Fusco, *English* vii–viii). Reflecting on the newcomers, Fusco said, "As kids, we might have believed that we were better because of our command of English, but people and things from far away attracted us" (Fusco, *English* vii). These multicultural experiences convinced Fusco that to be truly educated, one had to know about European ways, so she spent a college semester in Paris, where she learned to speak French. Because her father had died when she was young, and one of her brothers died in 1984, as a result of the U.S. involvement in Honduras (Fusco, *English* vii–xi), she decided that "I . . . wanted to make sense out of the clashes between cultures that cause so many of us so much trouble and pain, but I chose to do so within the realm of art. . . . I ceded to the impulse to become the kind of cultural translator that life seemed to be preparing me for" (Fusco, *English* x).

In 1982, Fusco graduated from Brown University, magna cum laude, with a B.A. in semiotics and literature and society, and in 1985 she earned

Coco Fusco. Photo Credit: Irina Padva. Courtesy of
the artist. Used with permission of Video Data
Bank, Chicago.

her M.A. degree in modern thought and literature from Stanford University. She has written numerous articles and four major books: *The Bodies That Were Not Ours and Other Writings*; *Corpus Delecti: Performance Art of the Americas* (which she edited); *English Is Broken Here: Notes on Cultural Fusion*, for which she received a Critic's Choice Award from the American Educational Studies Association, and *The Bodies that Were Not Ours and Other Writings*. She is currently a professor at the Tyler School of Art of Temple University in Philadelphia. She has lectured and performed in museums and universities all over the world (Fusco, *Resume*). For over ten years, **Guillermo Gómez-Peña** was both her collaborator and her partner. They clearly influenced one another's work, although they no longer work together.

Fusco's work focuses on political commentary about colonialism, race, class, and gender. Often it exposes the display of people who did not wish to be on exhibit. In other words, Fusco focuses on people whom curators

and writers have made exotic and different. In various media, she gives many examples of such people, including Pocahontas, who was taken to England in order to promote tobacco; the African woman Saartje Benjamin (known more popularly as Hottentot Venus), who was thought to embody raw sexuality due to her large buttocks; and the Mexican bearded woman Julia Pastrana, who, now embalmed, is still on exhibition as an oddity. She has explained how this kind of presentation, which accommodates the common tourist desire to see cultural authenticity as exotic oddities, increases a fascination with otherness in the Western mind.

Using these ideas, in 1992 (the quincentenary celebration of Columbus's discovery of America), to commemorate 500 years of this negative way of thinking that is connected to displays promoting multiculturalism, Fusco and Gómez-Peña undertook a series of site-specific performances titled *Two Undiscovered Amerindians Visit the West*. Presenting themselves as a couple from an island in the Gulf of Mexico that had somehow been overlooked by Columbus, they dressed as stereotypical aboriginal inhabitants. They engaged in "traditional, authentic" activities (really negative stereotypes), such as watching television and sewing Vodou dolls. They mixed these perhaps expected activities with using a laptop computer and doing exercises. Viewers were invited to pay for an "authentic" dance, a story, or the privilege of having a photograph taken with them. This piece was performed in a gilded cage for three days in each location, including the Columbus Plaza in Madrid, Covent Garden in London, the Smithsonian Institution, the Field Museum in Chicago, and the Australian Museum in Sydney. Though they intended these presentations to be bogus, to Fusco's horror many visitors assumed they were real (Fusco, "The Origins" 21). In *Year of the White Bear* (1992), Fusco and Gómez-Peña built on the previous work, experimenting with radio soundtracks. They performed the work at the Mexican Fine Arts Center Museum in Chicago and the Otis Gallery in Los Angeles. It was broadcast on National Public Radio and Pacifica radio throughout the United States (Fusco, *Resume*).

From 1996 to 1999, Fusco did a performance, called *Stuff*, with Nao Bustamante, an artist from a Chicano immigrant family which toured to cities including London, Glasgow, Los Angeles, Stockholm, Philadelphia, and Helsinki. Using fast-paced music, the performance explored cultural myths that link Latin women and food to the erotic in the Western mind. The piece includes sex guides, fast-food menus, and hip-gyrating dances. As they mingle with audience members, the performers engage in bawdy border humor. The point of this work was to confront the European colonial fear of the indigenous other while exposing the commodification of Latin culture, particularly Latin women. In the end, they seek their revenge (Lippard, *On the Beaten Track* 53), which is, of course, partly accomplished by exposing negative attitudes.

Over the years, Coco Fusco has been amazingly prolific as an artist and a writer. In her collaborations and her solo work, she has created a context for important, and often challenging, analyses of race, class, and gender issues.

Places to See Fusco's Work

Because Fusco's work is performance-based, when not seen live, it is best documented in videos, such as those listed below, and in her books.

Havana Postmodern, the New Cuban Art, prod. Robert Knafo, Coco Fusco, and Andras Mesz. 54 min. Cinema Guild, 1988. Spanish with English subtitles.

Fighting the Fundamentalist Fig Leaf. Paper Tiger Television Probes Censorship in the Arts. Panelists: David Avalos, Phillip Brookman, Coco Fusco, Allen Ginsberg, Leon Golub. 29 min. Paper Tiger TV, 1989. English.

Public Access: Spigots for Bigots or Channels for Change. Pts. 5–8 includes "La conversación." Coco Fusco, Guillermo Gómez-Peña. 112 min. Deep Dish TV, 1990.

The Couple in the Cage: A Guatinaui Odyssey, Coco Fusco and Paula Heredia. 31 min. Third World Newsreel, 1993.

Pochonovela: A Chicano Soap Opera. 27 min. Video Data Bank, 1995.

Bibliography

Fusco, Coco. "The Origins of Intercultural Performance in the West." *Heresies* 7, no. 3 (1993): 21.

Fusco, Coco. "Passionate Irreverence: The Cultural Politics of Identity." In *The 1993 Biennial Exhibition*. New York: Whitney Museum. Harry N. Abrams, 1993. Exhibition catalog.

Fusco, Coco. *English Is Broken Here: Notes on Cultural Fusion in the Americas*. New York: The New Press, 1995.

Fusco, Coco. "Fantasies of Oppositionality." In *Art, Activism, Oppositionality: Essays from Afterimage*. Edited by Grant H. Kester. Durham, N.C.: Duke University Press, 1998. Pp. 60–75.

Fusco, Coco, ed. *Corpus Delecti: Performance Art of the Americas*. New York: Routledge, 2000.

Fusco, Coco. *Resume*. June 4, 2001. http://www.artswire.rg/cocofusco/resume.html.

Fusco, Coco. *The Bodies That Were Not Ours and Other Writings*. New York: Routledge, 2002.

Lippard, Lucy R. *On the Beaten Track: Tourism, Art, and Place*. New York: The New Press, 1999.

Lippard, Lucy R. "At Your Service: Latina Performance in Global Culture." In *Re-verberations: Tactics of Resistance, Forms of Agency. Trans/cultural Practices*. Edited by Jean Fisher. Maastricht, Netherlands: Jan van Eyck Akademie, 2000. Pp. 105–15.

Julio Galán
(b. 1959)
Mexican Painter

Julio Galán's engaging autobiographical canvases have made him one of the best-known young Mexican artists (Leffingwell 79). He was born into a family of wealthy land and mine owners in Múzquiz, a town in the northern state of Coahuila. He spent most of his childhood on his grandfather's estate. Perhaps one of his earliest artistic influences came from the gifts given to him by his grandfather, who was a frequent traveler. He brought the young Julio souvenirs from around the world, such as uniformed miniatures resembling the guards at Buckingham Palace in London, and sailor suits (Nieto 1). Galán recalls that at age eight or nine the family chauffeur drove him to visit Sepúlveda's Gallery that later exhibited his paintings (Adams 65). At the request of his father, he studied architecture before turning his full attention to painting while studying in Monterrey (1978–1982). Early on, Galán's paintings drew the interest of local galleries, and in 1980 he had his first solo exhibition, at Guillermo Sepúlveda's Galería de Arte Actual Mexicano in Monterrey.

In 1989, Galán emerged as an important international artist in the group exhibition "Magiciens de la Terre" at the Centre Georges Pompidou in Paris. His painting in the show, *China Poblana* (1989), is a self-portrait that shows him in traditional Mexican dress in a manner reminiscent of the Mexican painter **Frida Kahlo**, who produced many self-portraits in which she wears folk costume. Like Kahlo, Galán puts himself at the center of his work, even if not in such an overt context. Objects (including toys, dogs, dolls, lace, and roses) from his childhood appear in painting after painting in an autobiographical way. He uses this imagery to suggest themes that deal with homosexuality, Catholicism, and the mysterious.

Galán's work has been called Surrealist, particularly similar to the imag-

inative works of the Spanish painter Salvador Dalí and the Mexican painter **Remedios Varo**. Galán plays with space and perspective, often portraying figures and objects grossly out of proportion. For instance, in his painting *Donde Ya No Hay Sexo* (Where There Is No Sex, 1985), Surrealist space is created by irregular perspective. An opening in the floor reveals a staircase that leads down to an unknown place. The sky, or what looks like a flat wall, is full of gray clouds, and just under the central figure is a misshapen shadow that looks like a hole in the ground.

Catholic imagery is an integral component of *Donde Ya No Hay Sexo*. The central female figure points to a cross painted on her dress, and her white-skinned face radiates glowing rays, which suggests that she is an angel or saint. A male dressed in a business suit (again Galán puts himself in the composition) is much smaller and upside down, virtually floating next to her. He is wrapped in roses and also holds roses in his hand. Both the roses and the church bind him. On the other side of the female figure is an urn full of roses just like the ones that bind the male figure. Galán seems to be making a statement here about homosexuality being a sin in the Catholic Church.

Galán's painting *Si y No* (Yes and No, 1990), an androgynous self-portrait, is a large diptych constructed with paint, glass, aluminum pins, leather belts, and paper on canvas. The two panels, approximately ten by seventeen feet, are connected by three leather belts. Their background is divided by irregularly shaped squares. A young man (Galán) stands bare-chested, wearing only a striped skirt with an actual leather belt cutting through the canvas at the waist, echoing the belts that connect the panels. Opposite the self-portrait is a diamond pattern with painted hands holding leather belts. What do the leather belts symbolize? Are the belts restricting the hands from free expression? Or do the belts tie the hands in an act of punishment? The belts likely represent an oppressive society or religious system that is keeping the young man bound by laws.

While sexuality lies just beneath the surface of all Galán's paintings, a few of his works are much more explicit. Possibly the most explicit is *Pensando en Ti* (Thinking About You, 1992). A young male sits casually in a chair with his arms bent, his hands folded in his lap; his head is lazily cocked and his eyes are closed. His flowing hair, rounded limbs, and soft breasts feminize him. He wears only shoes and socks. Transparent stripes divide the painting like delicate wallpaper, creating a barrier between the composition and the outside, making the viewer feel as if he or she is "looking in."

Galán has this to say about his work:

> The themes of my paintings are abstract. I play not with sorrow, but with the unknown, the occult, the mysterious, life and death, sex, frustrated love. I like to think that there's an army of angels and other spirits that perhaps

are helping me to concentrate, to give me the clue to the painting or paint-
ings, because there's a point where it's super difficult, when you need a click,
only one and it's precisely there where the work acquires it all. (Nieto 1)

Galán's work, internationally acknowledged and praised, has been shown
in the Barbara Farber Gallery in Amsterdam, the Centre Georges Pom-
pidou in Paris, the Robert Miller Gallery in New York City, and the Mu-
seum of Modern Art in Mexico City. One of Mexico's leading
contemporary painters, Galán presents controversial content, crossing sex-
ual boundaries through his exploration of the self, the mysterious, and the
religious.

Places to See Galán's Work

Annina Nosei Gallery, New York City

Centre Georges Pompidou, Paris

Chac-Mool Gallery, West Hollywood, Calif.

Galería de Arte Actual Mexicano, Monterrey

Museum of Modern Art, Mexico City

Robert Miller Gallery, New York City

Bibliography

Adams, Brooks. "Julio Galán's Hothouse Icons." *Art in America* vol. 82, no. 7
(1994): 64–69.

Costa, Eduardo. "Julio Galán and Ray Smith at Sotheby's and Ramis Barquet."
Art in America vol. 88, no. 9 (2000): 148–49.

Del Conde, Teresa. "Mexico." In *Latin American Art in the Twentieth Century*.
Edited by Edward J. Sullivan. London: Phaidon Press, 1996. Pp. 17–50.

Hollander, Kurt. "Art of the '80s in Monterrey." *Art in America* vol. 79, no. 10
(1991): 47–53.

Leffingwell, Edward. "Latin Soliloquies." *Art in America* vol. 81, no. 12 (1993):
72–83.

Lucie-Smith, Edward. *Latin American Art of the 20th Century*. New York: Thames
and Hudson, 1993.

Monsiváis, Carlos. "Shall I Tell It to You Again?" *Update Mexico*. October 1998.
http://www.demon.co.uk/mexuk/update/oct98/jgalan.html

Nieto, Margarita. "Julio Galán." *Chac-Mool Gallery Web page*. 1999: http://www.
artscenecal.com/Listings/WestHwd/ChacMoolFile/ChacMoo . . . /Jgalan
0999Essay.htm

Peden, Margaret Sayers. *Out of the Volcano: Portraits of Contemporary Mexican Art-
ists*. Washington, D.C.: Smithsonian Institution Press, 1991.

Gunther Gerzso
(1915–2000)
Mexican Set Designer and Painter

Gerzso's Minimalist paintings are often considered abstract, yet the artist contended that he painted what he saw, the landscapes of Mexico (Lucie-Smith 142). Gunther Gerzso was born in Mexico City to European immigrants; his father was born in Budapest, Hungary, and his mother in Berlin, Germany. His father soon died, and his mother quickly remarried and moved back to Europe. Gunther was just one year old when he was sent to live with his uncle, Hans Wendland, in Lugano, Switzerland. His uncle was an art historian, collector, and dealer, and through his uncle's associations, he met many writers, art critics, and artists, including the painter Paul Klee (Kamps 168). The influence of Klee on Gerzso's paintings is seen not only in the use of blocks of color but also in the use of delicate line to outline forms and of varying shades of a single hue to create warmth and depth.

While studying architecture as a young teenager, Gerzso met the Italian set designer Nando Tamberlani, who urged him to consider studying interior design. In 1931, after his uncle's art gallery went out of business, Gerzso and his mother returned to Mexico City. There he enrolled at the German high school, Colegio Alemán. His interest in design intensified, and by 1934, with the help of the theater producer Fernando Wagner, he created his first set. In 1941, Gerzso went to California, where he created sets for motion pictures. Later he worked at the Cleveland Playhouse as a stage designer (Lucie-Smith 142). Throughout the 1940s and 1950s, Gerzso designed over 150 sets for films.

While working as a set designer, Gerzso painted on the side. In 1950, he had his first solo exhibition at the Galería de Arte Mexicano, but not until 1962 did he devote his full time to painting. Gerzso painted sections

of warm colors to reflect the brilliant skies and horizons of his homeland. Though his subject remained the same, his hues and arrangement of forms changed and evolved throughout his career (Del Conde 43). His painting *Blue-Red Landscape* (1964) is a purely geometric canvas, almost all straight-edged squares and rectangles, except for one small corner that has been cut out with a simple curve. The overlapping planes and colored slabs are reminiscent of the work of the Minimalist Piet Mondrian. However, the color is not flat as in Mondrian's midcareer painting; rather, it is expressive, emanating warmth and depth, more like the paintings of the Uruguayan artist **Joaquín Torres-García**. Critics have linked Gerzso's work to Torres-García and Abstract Constructivism. However, Gerzso disputed such a connection, claiming that his work was not an abstraction, rather he painted real life as he saw it in Mexico (Lucie-Smith 142).

Gerzso's painting *Southern Queen* (1963) is a quiet composition of light blues and soft browns. The tints are nearly transparent, like thin sheets of tissue paper gently placed on top of each other with carefully cut edges, creating a fragility unique to this work. In *Naranja-Azul-Verde* (Orange-Blue-Green, 1972), the color is opaque and textured, varying in shades throughout one blocked area. The squares and rectangles overlap but are flat; three-dimensional space is created by use of color rather than the shape.

In 1970, a major retrospective of Gerzso's work was held at the Phoenix Art Museum. His paintings have been exhibited in Mexico, the United States, Canada, Brazil, Sweden, France, Japan, Venezuela, and Germany. He was honored with a Guggenheim Fellowship in 1973 and with a National Prize of Arts and Sciences in 1978, the highest artistic/scientific distinction awarded by the Mexican government. The Mary-Anne Martin Fine Art Gallery in New York City honored Gerzso with a major retrospective and celebration for his eightieth birthday in 1995. The artist attended, and the exhibition was a critical success ("Gunther Gerzso" 1). Gerzso was a successful set designer for years, then left the security of the theater and films to paint the landscapes of his country for the rest of his life.

Places to See Gerzso's Work

Adani Gallery, Dallas, Tex.

Art Cellar Exchange, San Diego, Calif.

Galería de Arte Mexicano, Mexico City: *Blue-Red Landscape* (1964)

Jack Rutberg Fine Arts, Los Angeles

Latin American Masters, Beverly Hills, Calif.

Mary-Anne Martin Fine Art, New York City

The Mexican Museum, San Francisco

Bibliography

Barnitz, Jacqueline. *Twentieth-Century Art of Latin America*. Austin: University of Texas Press, 2001.

Cardoza y Aragón, Luis. *Gunther Gerzso*. Mexico City: Dirección General de Publicaciones, Universidad Nacional Autónoma de Mexico, 1972.

Del Conde, Teresa. "Mexico." In *Latin American Art in the Twentieth Century*. Edited by Edward J. Sullivan. London: Phaidon Press, 1996. Pp. 17–50.

"Gunther Gerzso's 80th Birthday Show." *MAM/FA*. Winter 1996. http://www. mamfa.com/news/win96/gerzso.htm

Kamps, Toby. *Frida Kahlo, Diego Rivera, and Twentieth Century Mexican Art: The Jacques and Natasha Gelman Collection*. New York: Distributed Art, 2000.

Lucie-Smith, Edward. *Latin American Art of the 20th Century*. New York: Thames and Hudson, 1993.

Peden, Margaret S. *Out of the Volcano: Portraits of Contemporary Mexican Artists*. Washington, D.C.: Smithsonian Institution Press, 1991.

Traba, Marta. *La Zona del Silencio: Ricardo Martinez, Gunther Gerzso, Luis García Guerrero*. Mexico City: Fondo de Cultura Económica, 1975.

Guillermo Gómez-Peña

(b. 1955)

Mexican-American Performance Artist

Primarily labeled as a performance artist, Guillermo Gómez-Peña is also well known for his writing, radio shows, and cultural activism. He explores issues of race, gender, class, colonization, and internationalism, often using the metaphor of borders. The exploration of borders (e.g., United States/Mexico, black/white, conqueror/conquered, male/female, young/old) and the systems of power they create, causes the viewer to collapse or restructure the categorical entities in alternative ways. His works are often cited in debates on cultural diversity and U.S.–Mexico relations.

Born and educated in Mexico, Gómez-Peña studied at the California Institute of the Arts in Valencia (Steinman 221). Being affected by both Mexican and United States culture, he centers himself on the places—the borderland—where categories or opposing entities converge. The critic Scott Cummings calls him both a shaman and a trickster who "combines pop culture, guerrilla theatre, provocative iconography, political satire, ethnic stereotypes and a touch of dada . . ." (50).

Among Gómez-Peña's collaborators are Sara-Jo Berman, **Coco Fusco**, James Luna, Keith Antar Mason, Papo Colo, Rubén Martínez, and Roberto Sifuentes. His works have appeared as performance, installation art, radio shows, CD ROMs, films, books, poetry, and journalism. Gómez-Peña regularly contributes to "Latino U.S.A.," a national radio program, and from 1985 to 1990 he was a contributor to the national radio program "Crossroads." He received a MacArthur Fellowship and the American Book Award for his 1996 publication *The New World Border*.

From 1981 to 1985 Gómez-Peña facilitated a "neotribalist" group brought together for experimentation called Poyesis Genética with choreographer Sara-Jo Berman and a small group of artists. Of mixed back-

Guillermo Gómez-Peña performance-provocateur *El Multi-Lingual Vato*. Photo Credit: Eugenio Castro. Courtesy of the artist. Used with permission.

grounds and ethnic groups, they sometimes utilized multiple languages to explore the politics of culture. Gómez-Peña wrote the scripts, but the content was clearly collaborative. When this group disbanded, Gómez-Peña and Berman founded Border Art Workshop/*Taller de Arte Fronterizo*, which focused on the geopolitical border between Mexico and the United States (Steinman 222). Citizens of both countries were interviewed, and huge staples were placed in the ground with one prong rooted in the soil of each country, connecting the two nations. This action functioned to deconstruct borders as it connected people and places (Cummings 51). Gómez-Peña's language continually reflects change and movement as borders are deconstructed. In *The New World Border*, he explains who he is in relationship to these ever-changing borders:

> I am a nomadica Mexican artist/writer in the process of Chicanization, which means I am slowly heading North. My journey not only goes from South to North, but from Spanish to Spanglish, and then to English; from ritual

art to high-technology; from literature to performance art; and from a static sense of identity to a repertoire of multiple identities. Once I get "there," wherever it is, I am forever condemned to return, and then to obsessively reenact my journey. (p. i)

One of Gómez-Peña's best-known works, repeatedly performed with Coco Fusco, is *The Year of the White Bear*, which premiered at Madrid in 1992. Caged behind bars and ostentatiously dressed in stereotypical Amerindian costumes, they surrounded themselves with museum artifacts, popular culture, and technology. They were hand-fed through the bars and placed on a leash to be taken to the bathroom. Visitors could pay for authentic dances, stories, and posed pictures. Through such interactive performances, the artists asks the viewer to rethink the colonial fantasy taught in school. This work, like many others, critiques the place of the "outsider" and challenges the politics of identity. This performance brought diverse groups of people together to explore the fictional representation of the Amerindian in American myth (Sherlock 31–32; Steinman 222). According to Sherlock, " 'The Year of the White Bear' orchestrated an extraordinary range of objects and events which linked 500 years of history to the daily political struggles and brought together the diaspora of several continents" (36).

Beginning in 1994, Gómez-Peña joined with Roberto Sifuentes in the performance piece *Temple of Confessions*, which focused on the global trend toward religious fundamentalism. A blood-red gallery houses a temple adorned with memorabilia, icons, and trinkets. Gómez-Peña and Sifuentes sit in two Plexiglas altar-booths costumed as "a fantastic aboriginal shaman ('San Pocho Aztlaneca') and a Chicano low rider ('El Pre-Columbian Vato') from East L.A" (Cummings 51). In Gómez-Peña's enclosed altar-booth are live crickets, taxidermy animals, a ghetto blaster, and varied tribal musical instruments. Sifuentes shares his space with fifty cockroaches and a four-foot-long iguana. His "tools" are a whip, weapons, and drug paraphernalia. A pre-Columbian temple, made of Styrofoam, is propped behind him. Visitors kneel before the artists and make confessions verbally or in writing. This work was performed in several cities across the United States and in Mexico, in settings including established museums, alternative art spaces, festivals, university campuses, and a convent in Mexico City. These performances are documented in a book and an accompanying CD ROM. It is appropriately titled *Temple of Confessions: Mexican Beasts and Living Santos* (Gómez-Peña and Sifuentes 14–22).

A major focal point of all of Gómez-Peña's work is to change the position of the audience and the artist as the position of historical identity is re-created. In the past, Chicanos and Latinos (along with other people of color) danced and sang for audiences in order to be better understood and

accepted. Gómez-Peña has elected to engage in a different kind of interchange:

> We are pushing you to the margins. We are making your culture exotic and unfamiliar. We are adopting a fictional center and speaking as if we were there. We are proclaiming "Spanglish" the official language, so to speak. We are abolishing the U.S. Mexican border, conceptually, and we are creating a new kind of art in which we are observing you. In a sense, we are doing reverse anthropology. (Cummings 51)

Guillermo Gómez-Peña's performance work is raw, confrontational, politically driven, and highly intellectual.

Places to See Gómez-Peña's Work

Because Gómez-Peña's work is performance-based, it is best documented in the books by the artist listed below.

Bibliography

Cummings, Scott, T. "Guillermo Gómez-Peña: True Confessions of a Techno-Aztec Performance Artist." *American Theatre* 11 (November 1994): 50–51.

Gómez-Peña, Guillermo. *Warrior for Gringostroika: Essays, Performance Texts, and Poetry*. Saint Paul, Minn.: Graywolf Press, 1993.

Gómez-Peña, Guillermo. *The New World Border*. San Francisco: City Lights, 1996.

Gómez-Peña, Guillermo, and Roberto Sifuentes. *Temple of Confessions: Mexican Beasts and Living Santos*. New York: PowerHouse Books, 1996.

Sherlock, Maureen. "The Year of the White Bear." *Art Papers* 18 (May/June 1994): 31–37.

Steinman, Susan Leibovitz. "Directional Signs: A Compendium of Artists' Works." In *Mapping the Terrain: New Genre Public Art*. Edited by Suzanne Lacy. Seattle, Wash.: Bay Press, 1995. Pp. 193–285.

Luis González Palma
(b. 1957)
Guatemalan Photographer

Luis González Palma creates emotion-filled portraits that challenge current stereotypes of Mayan Indians and racism in Guatemala. Born and raised in Guatemala, he chose to study architecture because it was the only discipline in art at the local university that offered the skills to earn a living and the opportunity to study art history. Today, he rarely uses his architectural skills, occasionally designing a house for a friend (Hooks 102). He had some training in painting, but in the medium for which he is best known, photography, he is self-taught.

González Palma is interested in the Mayan Indians, their culture, and their experience of violence and racism. He is a mestizo, of European and Native American ancestry, and therefore identifies himself as a member of the dominant race. Because of his privileged position in Guatemalan society, he feels compelled to portray the Mayan Indians in an atypical fashion. When the interviewer Elizabeth Culbert asked about the people in his photographs, he replied:

> Usually the Indian people are outsiders who have to look up at the people who look down. For me it's very important to place these portraits in the horizontal view—to create horizontal levels in communication, so you can see the person's face directly. I think in the beginning it was a little political, but mostly my interest is to bring people to the same level. I come from a very racist country. The Indians are a marginal people in Guatemala just like I am a marginal person in the first world. So I try to balance things. (2)

González Palma adds that although his models are Indian, their faces could be the faces of anyone, and his real aim is to excite emotion in the viewer (Culbert 3). While his works interlace Mayan myth and imagery

95

with various contemporary styles and techniques in photography, the photographs are symbolic, meaning more than what is revealed (Tager 110). They are cryptic, with their own coding system that is withheld from the viewer. Instead of wearing brightly colored costumes or being depicted in an overwhelmed state of poverty or violence, González Palma's Mayan subjects are proud and dignified. His props often include crowns of roses, thorns, or laurels, steel helmets, or a pair of wings.

He is married to a Peruvian ballerina, so theatrical dance is an important component in González Palma's work—models wear ballet costumes and skirts. He is also fascinated with the Guatemalan circus, and many of his works have a playful, stagelike quality. The models' attire ranges from beautiful, traditional ballet skirts to satin suits of the harlequin. The young man in *Milagros* (Miracles, 1994) wears a tailored jacket made from fine fabric patterned with diamonds. A delicate, silver crown rests atop his head, but it is his deep stare that captures and holds the viewer's attention. He is beautiful and eloquent.

The sepia tone of González Palma's paintings has become a signature characteristic. He paints over a standard black and white photograph with asphaltum, a blackish brown solution of oil or turpentine mixed with asphalt. He then selectively removes the brown to reveal white areas, such as the eyes. For instance, in his photograph *Lotería I: La Rosa* (Lottery I: The Rose, 1989), the eyes of the young model are highlighted with white, as are four roses in the wreath that encircles his face.

His creativity with photography is not limited to costumes, lighting, and sepia tone. By the middle of the 1980s, González Palma began to manipulate the printed photograph in a collage-like manner by cutting, tearing, and scratching the surface, then embellishing it with text, tape, film, and ribbons (Hooks 102). An example of this technique is his *La Unica Esperanza* (The Only Hope, 1998), in which the photograph and brown paint are not the only media. The composition is divided into three sections. The bottom half is painted solid red, and the upper half is washed in the usual sepia tone. The upper right side is a photograph of a stern-faced Mayan with bright eyes. The upper left side is a collage of text, a scratched photograph of dice, and overlaid images of crowns of thorns. The dice represent the random chance of luck, and the red area beneath becomes a sea of fear and imminent violence. The underlying theme of González Palma's work is directly related to the violence inflicted on the Mayans for decades by the Guatemalan government.

His Mayan subjects are local workers, dancers, and friends. When asked why his models often appear in multiple works, he said that the people in his photographs work with him in a collaborative way, which often kindles a special relationship between artist and subject (Hooks 102).

González Palma talked about the conflict between violence and religion in his country, and how it affects what he feels and how he works:

I live in a country where there is so much mysticism and so much violence at the same time, where you are enjoying nature, the helicopters are flying overhead and you know they are going to bomb some region; where you know that as you are working, someone is being killed or someone is being baptized. (Wood 5)

He describes his work as "poetic realism," often accompanying his work with poetry. He uses poetry not to explain the photograph but to intensify the level of felt emotion, which can never be expressed in words. Critics have mistakenly referred to his work as magical. González Palma contends that his work is not magic at all. The people are real, not mysterious or magical; the props and sepia-washed surface are used to romanticize the image (Culbert 3).

As an artist with contacts and opportunities around the world, and a privileged Guatemalan, González Palma feels that it is part of his mission to share his good fortune. He extends artistic opportunities to Guatemalan artists through his program Colloquia (the name refers to the Greek definition of dialogue, which describes much of what is taking place between artists and artists and their communities). He wants to build a structure very different from the traditional artists' foundation, eliminating the curator and the museum setting. Colloquia gives money directly to the artists. Artists are frequently invited to his studio to work with him, to converse about art, and to simply have fun. He wants to connect with artists on an emotional level that is unattainable at a formal gallery reception. Public projects like sculpture gardens and murals are also supported. In addition, Colloquia prints a small artists' newspaper that is distributed to marginalized areas of Guatemala, to lower-income areas, and to people who do not usually have access to such literature (Culbert 4).

González Palma is astonished that he is the highest-paid contemporary Latin American photographer; some of his works fetched as much as $12,000 in 1994 (Hooks 102). His photographs are intimate and emotional; his elegant and dignified portrayal of Guatemalan Mayans is an attempt to lift up this oppressed cultural group by giving them the dignity and respect they deserve.

Places to See González Palma's Work

The Art Institute of Chicago

Barry Singer Gallery, Petaluma, Calif.

The Berlin Museum, Berlin, Germany

Fogg Museum, Harvard University, Cambridge, Mass.

Jackson Fine Art, Atlanta Ga.

Joel Soroka Gallery, Aspen, Colo.

John Stevenson Gallery, New York City

Los Angeles County Museum, Los Angeles

Museum of Fine Arts, Houston, Tex.

Nina Menocal Galería, Mexico City

Santa Barbara Museum of Art, Santa Barbara, Calif.: *Lottery I* (1989–91)

Stephen Cohen Gallery, Los Angeles

Throckmorton Fine Art, New York City

Wessel & O'Connor Gallery, New York City

Bibliography

Bulmer, Marge. "Luis González Palma." 1999. http://artscencecal.com/Articles File/Archive/Articles1999/Articles0299/LGPalmaA.html

Culbert, Elizabeth. "Interview with Luis González Palma." *Rain Taxi*. 1998. http://www.raintaxi.com/palma.htm

González Palma, Luis, comp. *Poems of Sorrow*. Santa Fe, N.M.: Arena Editions, 1999.

Hooks, Margaret. "Tearing, Cutting, Hammering." *Artnews* vol. 96, no. 6 (1997): 102.

Kupfer, Monica. "Central America." In *Latin American Art in the Twentieth Century*. Edited by Edward J. Sullivan. London: Phaidon Press, 1996. Pp. 51–80.

Tager, Alisa. "Luis González Palma." *Artnews* vol. 92, no. 2 (1993): 110.

Wood, John. "The Death of Romanticism, the Birth of New Science, and the Poet of Sorrows." In *Poems of Sorrow*. Compiled by Luis González Palma. Santa Fe, N.M.: Arena Editions, 1999. Pp. 5–29.

Félix González-Torres

(1957–1996)

Cuban-American Conceptual and Installation Artist

Known for his large-scale, politically charged installations and conceptual art, Félix González-Torres is also acknowledged for producing art with layered significance, intelligence, and wit. A cultural activist, he was a member of ACTUP (an activist homosexual group) and the artists' collaborative Group Material. He described his work as "a comment on the passage of time and on the possibility of erasure and disappearance. . . . It is about life and its most radical definition or demarcation" (Lippard 201).

Born in 1957 in Guáimaro, Cuba, he sought refuge in the United States at the age of eleven. He left a culture that valued the collective spirit, and came to one that defined ideas and acts in terms of the individual. While he enjoyed the rights granted him by the U.S. Constitution to speak with his personal artistic voice, his reinvention of the art system—including marketing techniques, display, preservation, and dissemination—focused on the public (Weintraub et al. 110). He explained, "I need the public to help me, to take responsibility, to become part of my work, to join in" (Weintraub et al. 109).

González-Torres received his formal education through the Whitney Museum Independent Study Program. He earned a B.F.A. from Pratt Institute in Brooklyn and an M.F.A. from the International Center for Photography and New York University (Weintraub et al. 110). His work draws on Marcel Duchamp's play on the meanings of signs and on his readymades, everyday objects that an artist presents in a gallery space as works of art. Works by González-Torres have included such everyday items as jigsaw puzzles, electric lights, bead curtains, and various kinds of multiples, such as photographs and stacks of bordered paper. The work is not simply playful, although it may at first appear to be so. On the contrary, González-

Torres entices the viewer/participant to engage in some of the more difficult facts of life (Storr 73).

As a 1979 founder and core member of Group Material, González-Torres helped stage exhibitions such as "The People's Choice" (later called "Arroz con Mango"), which consisted of valued objects collected from New York City's East Village neighborhood. They included family souvenirs, photographs of weddings and First Communions, personal treasures, china dolls, handicrafts, and special gifts (Stiles 815–16). The purpose of this exhibition was to rethink art from the ground up, thereby making it relevant again. Recognizing that art had been removed from everyday life, Group Material acted to place it back in the social and political realities of day-to-day living. Like the rest of González-Torres's art, work from this collective challenged the status quo of the object being valued over the idea, and it questioned the worth of art because it was attributed to an individual artist over collaborative producers (Avgikos, "Group Material Timeline" 94–103). González-Torres emphasized that making art and art appreciation generally happen in groups, and the group's creative process, which builds community, should be recognized and valued.

One of González-Torres's two-dimensional works, *1987*, produced in the same year as the title, is 8½ inches by 11 inches, with white type on the lower part of a black piece of acetate, that says, "Alabama 1964 Safer Sex 1985 Disco Donuts 1979 Cardinal O'Connor 1987 Klaus Barbie 1944 Napalm 1972 C.O.D." This is a Minimalist work with complex interpretations. Viewers are challenged to make connections as time and space collapse. In *1987* González-Torres refers to multiple kinds of death scenarios, all resulting from hatred that appears and reappears. He points out that what we reap is what we sow, one interpretation of Collect on Delivery (C.O.D.) (Lippard 201).

One of his more striking installation works is *Untitled (Placebo)* (1995), which was exhibited at the Guggenheim Museum in New York City and toured internationally. This was the year before González-Torres's death from AIDS. Storr described the work thus: "A shimmering silver carpet stretches along the institutionally white floor. It measures some 6 by 12 feet and is made of hundreds upon hundreds of foil-wrapped candies" (70). Visitors are allowed to take pieces of the candy, thereby involving themselves in the work. A guard explains that the weight of the candy equals the combined weight of the artist and his lover. This work addresses life, death, AIDS, the lack of a cure, and our relationship to these issues (Storr 70–71). As viewers become participants in the work, they engage in conversations and, it is hoped, in activism that will change the course of both art and life.

The sculpture *Untitled (Perfect Lovers)* (1987–1990) consists of two identical battery-operated clocks. Hanging side by side on the wall, they show exactly the same time, minute by minute. This is a relationship of same-

ness; they are homosexual. Men look like men, women look like women, and the clocks look like each other. Together, time ticks away on them, reproducing the artist's experience watching his partner succumb to the HIV virus. The years 1987–1990 are the years that his lover was ill. This piece poses the question of how much time is left. About this sculpture González-Torres said, "Time is something that scares me . . . or used to. The piece I made with the two clocks was the scariest thing I have ever done; I wanted to face it. I wanted those two clocks right in front of me, ticking" (Weintraub et al. 111).

His Cuban roots can be observed in González-Torres's work. The artist Ernesto Pujol said, "I have always been struck by his use of the Caribbean's overwhelmingly blue sky; by the abundance of sugar, so Cuban, in his work; and by his notion of romantic love and very dramatic sense of mourning, so reminiscent of Federico García Lorca's plays and poetry" (100). Pujol went on to say that González-Torres's work creates a space that acknowledges its colonization, but is also transcendent (100).

González-Torres has had many important solo exhibitions, even after his death. From 1990 to 2000 they were held in London; Caracas; Hanover, Berlin, and Kassel, Germany; Paris; Santiago de Compostela, Spain; Vienna; Stockholm; Milan; Los Angeles; and New York City. His presence and importance as an artist appears to be growing. Apart from his work with Group Material, González-Torres's solo career lasted a mere nine years. However, because of the importance of the issues he addressed, the significance of his work will last well into the future.

Places to See González-Torres's Work

Andrea Rosen Gallery, New York City

Astrup Fearnley Museet for Modern Kunst, Oslo, Norway

Frankin Furnace Archive, New York City

Guggenheim Museum, New York City

New Museum of Contemporary Art, New York City

Museum of Contemporary Art, Los Angeles

Museum of Modern Art, New York City

Walker Art Center, Minneapolis, Minn.

Whitney Museum of American Art, New York City

Bibliography

Avgikos, Jan. "This Is My Body: Felix Gonzalez-Torres." *Artforum* 29 (February 1991): 79–83.

Avgikos, Jan. "Group Material Timeline: Activism as a Work of Art." In *But Is it*

Art?: The Spirit of Art as Activism. Edited by Nina Felshin. Seattle, Wash.: Bay Press, 1995. Pp. 85–116.

Bartman, William S., ed. *Felix Gonzalez-Torres.* Los Angeles: A.R.T. Press, 1993. Essays by Susan Cahan, short story by Jan Avgikos, and interview by Tim Rollins.

Deitcher, David. "What Does Silence Equal Now?" In *Art Matters: How the Culture Wars Changed America.* Edited by Brian Wallis, Marianne Weems, and Philip Yenawine. New York: New York University Press, 1999. Pp. 92–123.

Lippard, Lucy. *Mixed Blessings: New Art in a Multicultural America.* New York: Pantheon Books, 1990.

Nickas, Robert. "Felix Gonzalez-Torres: All the Time in the World." *Flash Art* 24.161 (November/December 1991): 86–89.

Pujol, Ernesto. "Notes on Obsessive Whiteness." *Art Journal* 59, no. 1 (Spring 2000): 98–100.

Spaid, Sue. "In the Spirit of Félix González-Torres." *Art Journal* 58, no. 1 (Spring 1999): 84–86.

Spector, Nancy. "Félix González-Torres: Travelogue." *Parkett* 39 (1994): 24–39.

Stiles, Kristine. "Introduction" (to section "Language and Concepts"). In *Theories and Documents of Contemporary Art: A Sourcebook of Artists' Writings.* Edited by Kristine Stiles and Peter Selz. Berkeley: University of California Press, 1996. Pp. 804–16.

Storr, Robert. "Setting Traps for the Mind and Heart." *Art in America* vol. 84, no. 1 (1996): 70–79.

Wallis, Brian, ed. *Democracy: A Project by Group Material.* Discussions in Contemporary Culture 5. Seattle, Wash.: Bay Press, 1999.

Watney, Simon. "In Purgatory: The Work of Félix González-Torres." *Parkett* 39 (1994): 52–55.

Weintraub, Linda, Arthur Danto, and Thomas McEvilley. "A Hispanic Homosexual Man: Félix González-Torres." In their *Art on the Edge and Over: Searching for Art's Meaning in Contemporary Society 1970s–1990s.* Litchfield, Conn.: Art Insights, 1996. Pp. 109–16.

Ester Hernández
(b. 1944)
Mexican-American Printmaker

Rooted in California's migrant culture, Ester Hernández's artwork most often addresses issues related to the difficulty of farmwork, its poverty, and the community culture. The media she chooses, usually the printmaking process, is deliberate, because it provides a low-cost way to reach many people about the social conditions and injustices plaguing her people.

Writing about her early life, Ester Hernández commented on her artistic heritage:

> It was through family and community involvement that I learned to nurture and develop a great respect for, and interest in, the arts. My mother carried on the family tradition of embroidery from her birthplace in North Central Mexico; my grandfather was a master carpenter who made religious sculptures in his spare time; and my father was an amateur photographer and visual artist. (Hernández n.p.)

Born in the San Joaquin Valley of California, of Yaqui and Mexican descent, Hernández was the sixth child of farmworker parents. From an early age, she was commited to work for the empowerment of her community. Her work is full of images that are rooted in the Chicano experience. They not only depict the strength of her ancestry, but also work to transform it so that Mexican-Americans can take a more equal place in society: "My background has taught me that we Chicanos must continually strive for beauty and spirituality. This beauty—found in both nature and the arts—is the seed that uplifts our spirit and nourishes our souls" (Hernandez n.p.). Her work is about her own life and struggles. Being both Chicana and a lesbian informs her art.

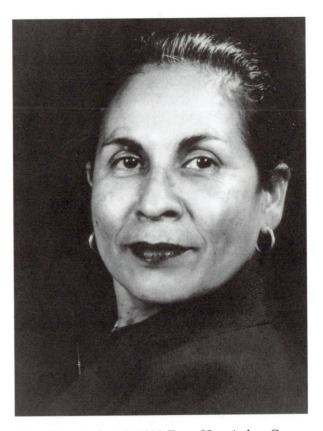

Ester Hernández. © 1998 Ester Hernández. Courtesy of the artist. Used with permission.

Education was stressed as Hernández was growing up: "Even though my parents had to leave school, they continued to learn on their own. They were determined that we receive the education they were denied" (Mesa-Bains, *Art of Provocation* n.p.). In 1965 she witnessed a farmworker march, led by the civil rights leader César Chávez, in her hometown. This was a turning point in her life. She remembers that police, ranchers, and dogs greeted the marchers. Chávez and a small group of farmworkers stood proudly, knowing their rights. Such events were instrumental in her educational process.

Hernández graduated in 1976 with a B.A. in practice in art from the University of California at Berkeley (Mesa-Bains, *Art of Provocation* n.p.). She chooses to work primarily in the printmaking tradition because it makes her artwork more accessible to others (Zamudio-Taylor 318). However, in the 1970s she also worked with the Mujeres Muralistas creating murals, and more recently she has used oil pastels in some of her works (Mesa-Baines, "El Mundo Femenino" 136).

The work for which Hernández is best known is her screen print *Sun Mad* (1982). Angered at the pesticides that contaminated the water at her birthplace, she made this screen print depicting a traditional box of Sun Maid raisins, but replaced the central figure with a skeletal young woman harvesting grapes. It is a strong statement about the unsafe conditions under which farmworkers, including her family members, labor. It also refers to Mexico's Day of the Dead, on which skeletal figures are often depicted performing everyday tasks, thus making visible Mexican beliefs about the enmeshment of life and death (Zamudio-Taylor 318).

At first glance, Hernández's silk screen *Tejido de los Desaparecidos* (Weaving of the Dead, 1984) looks like a pleasant pattern of folkloric weaving. But further study reveals that it blends skeletons with helicopters and blood. Here, as in so many of her works, Hernández juxtaposes unlikely images with horrifying results (Mesa-Baines, "El Mundo Femenino" 136–37).

Hernández's social commentary is not restricted to her Mexican heritage. She also brings lesbian content into her work. Her silkscreen *La Ofrenda* (1990) portrays a Chicano woman with a large tattoo of the Virgin of Guadalupe on her back, an unusual depiction of a strong female. A hand of another woman offers a rose to both the Virgin and the Chicana, melding sexuality with race and gender (Hammond 112). The woman is Hernández's partner, Renee. This work has been controversial, not only for its lesbian content but also because it "blurs the line between the human and the divine" (Mesa-Bains, *Art of Provocation* n.p). This image was reproduced on the cover of *Chicana Lesbians: The Girls Our Mothers Warned Us About* (Hammond 112).

Other works also reflect on and expand women's identities. In *La Virgen de Guadalupe Defendiendo los Derechos de los Xicanos* (The Virgin of Guadalupe Defending the Rights of the Chicanos, 1975), she presents the viewer with a Virgin of Guadalupe who is a karate fighter. Again she breaks the rules, presenting an image of an active Virgin, wearing pants, who moves out of her aura to fight the oppressors of the world. In keeping with this goal, Hernández has worked in social service agencies to help people who are elderly and disabled, and her commitment to farmworkers is ongoing (Mesa-Bains, "El Mundo Femenino" 137).

Hernández has received many grants and awards, including a 1998 grant from the Serpent Source Foundation in San Francisco, and 1996 and 1990 fellowships from the Brandywine Institute in Philadelphia. In 1992 she was presented with a National Endowment for the Arts award for a visual-theater arts collaboration.

The life and work of Ester Hernández are known for activism, breaking down barriers, empowerment, and affirmation. She is an artist who makes powerful statements that both educate and change the world.

Places to See Hernández's Work

The Bronx Museum, New York City

Frida Kahlo Studio-Museum, Mexico City

Mexican Fine Art Museum, Chicago

Mexican Museum, San Francisco

Mural Resource Center, San Francisco

Museo del Barrio, New York City

National Museum of Art, Smithsonian Institution, Washington, D.C.: *La Ofrenda*;
Sun Mad

San Francisco Museum of Modern Art

University of California-Santa Barbara, Department of Special Collections of the
Library: Ester Hernández Personal Archives. http://www/library.ucsb.edu/
speccoll/cema/hernandz.html

Wight Art Gallery, University of California-Los Angeles

Bibliography

Battersea Art Gallery. *International Women Artists*. London: Battersea Art Gallery,
1985.

Broude, Norma, and Mary D. Gerrard, eds. *The Power of Feminist Art: The American Movement of the 1970s. History and Impact*. New York: Harry N.
Abrams, 1994.

Gaspar de Alba, Alicia. *Chicano Art: Inside/Outside the Master's House. Cultural Politics and the CARA Exhibition*. Austin: University of Texas Press, 1998.

Goldman, Shifra M. *Dimensions of the Americas: Art and Social Change in Latin America and the United States*. Chicago: University of Chicago Press, 1994.

Hammond, Harmony. "A Space of Infinite and Pleasurable Possibilities." In *New Feminist Criticism: Art, Identity, Action*. Edited by Joanna Frueh, Cassandra
L. Langer, and Arlene Raven. New York: IconEditions, 1994. Pp. 97–131.

Hernández, Ester. *Biographical Statement*, which was sent to the authors, Summer
2000. n.pag.

Lippard, Lucy R. *Mixed Blessings: New Art in a Multicultural America*. New York:
Pantheon Books, 1990.

Lucie-Smith, Edward. *Race, Sex and Gender in Contemporary Art: The Rise of Minority Culture*. New York: Harry N. Abrams, 1994.

Mesa-Bains, Amalia. "El Mundo Femenino: Chicana Artists of the Movement—
A Commentary on Development and Production." In *Chicano Art: Resistance and Affirmation, 1965–1985*. Edited by Richard Griswold del Castillo,
Teresa McKenna, and Yvonne Yarbro-Bejarano. Los Angeles: Wight Art
Gallery, University of California-Los Angeles, 1991. Pp. 131–140.

Mesa-Bains, Amalia. *The Art of Provocation: Works by Ester Hernández*. Brochure
for the exhibition "The Art of Provocation: Ester Hernández." October
10–November 17, 1995. C. N. Gorman Museum, Native American Studies,
University of California-Davis.

Moore, Sylvia, ed. *Yesterday and Tomorrow: California Women Artists*. New York: Midmarch Arts Press, 1989.

Raven, Arlene, Cassandra Langer, and Joanna Frueh, eds. *Feminist Art Criticism: An Anthology*. Ann Arbor, Mich.: UMI Research Press, 1988.

Roth, Moira. *Connecting Conversations: Interview with 28 Bay Area Women Artists*. Oakland, Calif.: Mills College Press, 1988.

Trujillo, Carla Mari, ed. *Chicana Lesbians: The Girls Our Mothers Warned Us About*. Berkeley: Third Woman Press, 1991.

Zamudio-Taylor, Victor. "Chicano Art." In *Latin American Art in the Twentieth Century*. Edited by Edward J. Sullivan. London: Phaidon Press, 1996. Pp. 315–29.

Hector Hyppolite
(1894–1948)
Haitian Painter

Hector Hyppolite was a Surrealist painter whose work was influenced by the Vodou religion. The son and grandson of Vodou priests (Rodman, *Where Art Is Joy* 49), Hyppolite was born in St. Marc, Haiti. Hyppolite never married, because he claimed to be wedded to Sirène, the goddess of the sea (Barnitz 124). He was a shoemaker's apprentice, but took more interest in inexpensive prints displayed in waterfront shops, which he copied and sold to U.S. Marines who visited Haiti. He also worked harvesting sugarcane in Cuba, but did not find the experience pleasant enough to repeat it (Rodman, *Where Art Is Joy* 49).

Although Hyppolite's work is based on everyday life and the Vodou religion, André Breton, French leader of the Surrealists (whose images and ideas came from the unconscious and dreams), interpreted his work as Surrealist, and included him in his famous book *Surrealism and Painting* (1928). However, formally speaking, Hyppolite knew little about the movement. The works of Hyppolite, perhaps Haiti's most legendary painter (Stebich 160), meld Christian and Vodou imagery (Hurbon 198).

Hyppolite was encouraged to paint by Dewitt Peters, an American schoolteacher and watercolorist sent to Haiti for alternative service after being disqualified from U.S. military duty. Before he came to Haiti, there were no galleries or museums. Peters founded the Centre d'Art in Port-au-Prince and distributed free art materials to anyone who wanted to paint. This is not to say that art did not exist in Haiti before Peters arrived; but he was able to give it an exhibition space and provide the opportunity for artists to use such materials as oil paints and brushes. Before Peters gave Hyppolite brushes, he painted with chicken feathers and his fingers, applying one color at a time to flattened-out cardboard boxes (Barnitz 124).

Peters first saw Hyppolite's work in 1943 when driving through the seaside village of Mont Rouis. His attention was drawn by a colorful sign on the bar door that said "Ici la Renaissance" (Here is the Renaissance) (Barnitz 124–25). A year later, remembering how delighted he was by the sign, he looked for Hyppolite. He found a man who sometimes painted houses and decorated furniture, painting with chicken feathers. Peters persuaded him to come to the capital to begin a career as an artist. In Hyppolite's mind, his recognition as a painter had been ordained by the *lwa* (Vodou deities), so he readily agreed. In Port-au-Prince, Hyppolite set himself up in a palm-frond hut near the waterfront and created a sign that said "Ici Station Peniture" (Painting Depot Here). Here he painted with great inventiveness (Rodman, *Where Art Is Joy* 47–49).

In 1945, André Breton traveled with Cuban artist **Wifredo Lam** to Haiti and saw Hyppolite's work at the Centre d'Art (Barnitz 124). Enchanted by it, he not only wrote about Hyppolite's paintings, but also purchased and exhibited them throughout Europe (Stebich 160).

One of Breton's favorite purchases was *Ogoun Ferraile* (1944). An *ogoun* is a Vodou warrior-god and healer whose attribute is a thunderbolt. In the painting he is depicted in a room with a table. Items related to magic are everywhere: a gourd, a snake, candles, playing cards, bottles, a saber, and a machete (Barnitz 125).

By the fall of 1946, Hyppolite had become well known. His paintings were being collected and written about by art critics and connoisseurs in both Europe and the United States. In January 1947, his works created a sensation at the UNESCO exhibition in Paris. They were praised for ignoring the technical aspects of perspective that the Italian Renaissance had prescribed (Rodman *Where Art Is Joy* 51). The writer Truman Capote visited Hyppolite and found his art likable "because there's nothing in it that has been slyly transposed." Capote went on to say that Hyppolite used "what lives inside of him; his country's spiritual history" (Rodman, *Where Art Is Joy* 54). Hyppolite applied intense, sensuous colors to cardboard in a free and bold style. Working on more than one painting at a time, he often finished several paintings in one day (Stebich 161).

In *Flowers on Table* (1946–48), a bouquet fills the cardboard. The flowers are associated with the vitality of Haitian life and religious worship, and they are part of the realm of Erzulie, the goddess of love (Stebich 75). *The Great Master*, created at about the same time, portrays a majestic figure with three eyes and two noses that stares at the viewer from the center of the work. This is probably the chief god of the Vodou pantheon. Hyppolite liked to paint romantic scenes and still lifes, but his works were usually about Vodou. He said he worked in a state of possession, guided by instructions from John the Baptist (Poupeye 82).

At one point, however, Hyppolite saw his role as a Vodou priest conflicting with his role as an artist. Near the end of his life, he confessed to Rodman:

I haven't practised vaudou [Vodou] for a while. I asked the spirits' permission to suspend my work as a *houngan* [priest], because of my painting . . . The spirits agreed that I should stop for a while. I've always been a priest, just like my father and grandfather, but now I'm more an artist than a priest. (Rodman *Where Art Is Joy* 53).

Hyppolite, a tall, thin man who walked with grace and an air of mystery, was a prolific artist, painting between 250 and 600 works in the last three years of his life alone (Stebich 160). It was his painting that introduced Haitian art to the rest of the world. A visionary and a mystic, he said that he had been told in a dream that five of his paintings would be taken abroad, carrying his message to the outside world (Rodman *Where Art Is Joy* 47). As it turned out, five paintings (purchased by Breton) were just the beginning of his fame. Today he is known throughout the world for his art, the beginning of a huge wave of vibrant Haitian painting.

Places to See Hyppolite's Work

Herbert F. Johnson Museum of Art, Cornell University, Ithaca, N.Y.

Milwaukee Art Museum, Milwaukee, Wis.: *La Dauration l'amour*

Musée d'Art Haïtien, Port-au-Prince: *Damballa Helmeted; Self-Portrait; Triple-Eyed Magician*

Bibliography

Barnitz, Jacqueline. *Twentieth-Century Art of Latin America*. Austin: University of Texas Press, 2001.

Breton, André. *Surrealism and Painting*. Translated by Simon Watson Taylor. New York: Harper & Row, 1972. First published as *Le Surréalisme et la Peinture*. Paris: Gallimard, 1928. New ed., rev. and corrected. Paris: Gallimard, 1965.

Hurbon, Laënnec. "American Fantasy and Haitian Vodou." In *Sacred Arts of Haitian Vodou*. Edited by Donald J. Cosentino. Los Angeles: Fowler Museum of Cultural History, University of California Los Angeles, 1995. Pp. 181–204.

Poupeye, Veerle. *Caribbean Art*. New York: Thames and Hudson, 1998.

Rodman, Selden. *The Miracle of Haitian Art*. Garden City, N.Y.: Doubleday, 1974.

Rodman, Selden. *Where Art Is Joy: Haitian Art: The First Forty Years*. New York: Ruggles de Latour, 1988.

Stebich, Ute. *Haitian Art*. New York: Brooklyn Museum of Art, 1978.

Graciela Iturbide

(b. 1942)
Mexican Photographer

An accomplished photographer with more than twenty solo exhibitions and eight photography books, Graciela Iturbide is known for her striking images of Mexico's rituals and everyday life, especially those of her hometown of Juchitán, in the state of Oaxaca (Kandell 88). She is able to capture elusive experiences, those extraordinary moments that happen in a fraction of a second. Her works are set in the context of Mexico's ritualistic theatrical practices, religious ceremonies, carnivals, and everyday Indian life (Silao 16).

When Iturbide decided to become a film director, she was already married and had three children. That dream changed to becoming a still photographer when, in 1969, she studied at the National Autonomous University of Mexico with **Manuel Álvarez Bravo**, one of Mexico's Modernist master artists. She was his assistant for a year and a half, and, according to the art critic Vicki Goldberg, his influence can be seen "in her lighting, in occasional compositions and in a general tenor of sweet, melancholy poetry." However, she differs in the fact that "she is far more committed to staged tableaus and symbolic gesture than he, and her voice is her own" (37). Iturbide has said that Álvarez Bravo's main influence was that he taught her how to discover Mexico. Also, he is more poetic, and "I realized early on that I preferred photo-essays" (Kandell 89).

Indian traditions are most important to her now. Yet it was not always so: "My family was bourgeois, conservative, deeply Catholic. I was sent to a nuns' school. It wasn't a social environment that encouraged a great admiration for our national reality. It emphasized Hispanic over Indian culture" (Kandell 90). Because it is the Indian past and present that interests her, she can be placed with artists such as **José Guadalupe Posada, Diego Rivera, Frida Kahlo**, and **Rufino Tamayo** (Kandell 90).

111

In her 1979 photograph *Mujer Ángel* (Angel Woman, 1979), an Indian woman walks away from the viewer into the Sonoran Desert. Dressed in traditional clothing, she carries a boombox, and the ordinary moves toward the surreal (Kandell 86). Critics such as Reya Silao feel that Iturbide's work blurs the boundaries between what you think you know and what you see. Fantasy and fact are melded (17). The art critic Vicki Goldberg explained Iturbide's resourceful ability to portray her subject matter:

> She finds ways to photograph transitions, ambiguities and inferences, as in images of transvestites who present themselves as women and seem so for a moment. She works with states of becoming and of vanishing, such as a woman playing a piano in a cemetery while totally veiled in mist as if she were a ghost, or a man whose upper body has turned to a mere swipe of gray, as if a region of shadows were progressively taking him over. (37)

Iturbide's hometown of Juchitán has the most varied indigenous population in Mexico. Although it has an extremely low standard of living and high unemployment, malnutrition, and illiteracy, none of these aspects of her subjects' living circumstances overpower the main message, which transcends the specificity of the context. Iturbide's images are more essays about Mexico's cultural identity than documents about poverty. Partly because Juchitán is organized like an ancient Mesoamerican matriarchal society, the Western outsider sees the individuals portrayed as inhabiting a distinctly alien place, one that is compelling in its narration perhaps because it grants so much power to women. But the artist does not intend her work to be seen by Westerners as representative of "otherness," and she doesn't photograph to be part of a dialogue on how people are different. Instead, her work is about her dialogue with the people she photographs. Goldberg explained that Iturbide's photographs "write a personal fable of a country that seems to be continually in process, continually negotiating its way between one kind of existence and another, where people who are not resigned to the way things are opt for transformation instead" (39).

In order to capture the intensity revealed in her photographs, she spends time with her subjects. In Juchitán, Iturbide shares meals with them and participates in celebrations. She has her hair braided and goes to the local markets with the villagers (Lahs-Gonzales 24).

In her photograph, *Nuestra Senora de las Iguanas* (Our Lady of the Iguanas, 1979), she captures a Zapotec woman from Juchitán who is selling iguanas at a local market and is wearing a crown of her wares. The expression on her face mirrors, in some ways, the expression of the iguanas (Silao 16). It is an extraordinary image that demonstrates the richness of Mexican improvisation. Iturbide captures people who do not settle for a

mundane world; rather, they look for a kind of existence that powerfully transforms them into another space and time (Goldberg 39).

Mujercita (Young Woman, 1981) shows a young girl strongly holding onto a small dog. The dog can be seen as a represention of an absent mother, in that it has become her protector. The girl is both isolated, as shown by the aerial viewpoint, and powerful because of her companion dog, the power she holds within the frame of the photograph (Lahs-Gonzales 24).

Issues of gender and racial identification, within the broader scope of social and aesthetic concerns, are important to Iturbide. Her series on Juchitán—perhaps her best works—portrays women with extraordinary dignity. They are beautiful in ways that defy a Western standard of beauty. There is a sensuality in their stocky figures, their braided hair, and their aging faces. They are depicted inside their homes, preparing food, and interacting with their altar spaces; they have meaningful friendships with other women; and they possess a striking spiritual radiance (Fusco, *English Is Broken Here* 105–08).

Graciela Iturbide's work conveys the power of living a life that is rooted in tradition, yet transcends the mundane. There are no conclusive answers to what she depicts, only explanations that offer potential conclusions (Silao 17). About her art, she said, "I don't pretend to make my photographs speak the truth of what Mexico is all about, but in its villages I can feel the way culture is changing, and it's fascinating to live through it and try to capture it on camera" (Silao 18).

Places to See Iturbide's Work

Gallery of Contemporary Photography, Santa Monica, Calif.

International Center of Photography Collection, New York City

Mexican Fine Arts Center Museum, Chicago

Museo del Barrio, New York City

Museum of Fine Arts, Houston, Tex.

Philadelphia Museum of Art

Polk Museum of Art, Lakeland, Fla.

St. Louis Art Museum, St. Louis, Mo.

San Jose Museum of Art, San Jose, Calif.

Bibliography

Binford, Leigh. "Graciela Iturbide: Normalizing Juchitán." *History of Photography* 20, no. 3 (Autumn 1996): 244–49.

Connor, Celeste. "Images of Identification: Encountering Difference, Four Mex-

ican Photographers. Falkirk Cultural Center, San Rafael, CA." *Artweek* 24 (August 19, 1993): 18.

Contreras, F. "Dancing with the Iguanas." *Artnews* vol. 98, no. 2 (1999): 96–97.

Fusco, Coco. "Essential Differences: Photographs of Mexican Women." *Afterimage* 18 (April 1991): 11–13.

Fusco, Coco. *English Is Broken Here: Notes on Cultural Fusion in the Americas*. New York: The New Press, 1995.

Goldberg, Vicki. "Arranging to Capture Ambiguous Moments." *New York Times*, December 10, 2000, "Arts and Leisure," 37, 39.

Kandell, Jonathan. "Images of the Spirit: The Evocative Vision of Graciela Iturbide." *Smithsonian* (June 1998): 86–93.

Lahs-Gonzales, Olivia. "Defining Eye/Defining Women Photographers of the Twentieth Century." In *Defining Eye: Women Photographers of the Twentieth Century. Selections from the Helen Kornblum Collection*. By Lahs-Gonzales and Lucy Lippard. With an introduction by Martha A. Sandweiss. St. Louis, Mo.: St. Louis Art Museum, 1997. Pp. 15–29.

Silao, Reya. "Graciela Iturbide's Images of the Spirit." *Women in the Arts* 18, no. 2 (Summer 2000): 16–18.

María Izquierdo
(1902–1955)
Mexican Painter

María Izquierdo portrayed the everyday life of Mexico through portraits, scenes with farm animals, and playful circus scenes from her childhood memories. She was born María Cenobia Izquierdo in San Juan de los Lagos, Jalisco; her parents were Rafael Izquierdo Montoya and Isabel Gutiérrez de Izquierdo. After her father died in 1907, she spent the majority of her childhood with grandparents in the small towns of Aguascalientes, Torreón, and Saltillo. In Saltillo, she received her first art training at the Ateneo Puente, at the age of thirteen. Her daily life, outside of academic and art classes, revolved around the Catholic Masses that were central to the lives of her grandmother and aunt (Ferrer 10).

At the age of fourteen, Izquierdo was forced to marry an army colonel, Cándido Posadas; before she was twenty, she had borne three children. When her husband moved the family to Mexico City, she was enthralled with the progressive social environment (Ferrer 11). Exposed to liberal thought and witness to the lives of independent women in Mexico City, she divorced Posadas in 1927 (Lucie-Smith 107). Within a year, she had enrolled at the National School of Fine Arts, where the Mexican mural painter **Diego Rivera** was the director.

Rivera recognized Izquierdo's "natural talent" and organized her first exhibition of student artwork in 1929. He wrote a glowing introduction for the exhibition catalog:

The talent of this young artist is well balanced and fiery, but reserved and contained, and develops more at depth than at the surface. In the few years she has lived, the current of life must have left much sediment in the subconscious depths of her mind; if one gazes into her eyes or at her paintings,

115

one perceives, deep down, particles of flint and dust, of iron and gold. (Ve-lázquez Chávez 117)

Some classmates, however, were outraged at the attention she received from Rivera, and commented that her work was unsophisticated (Ferrer 10).

In 1929, Izquierdo met the Mexican painter **Rufino Tamayo** when he became a teacher at the National School of Fine Arts. She had a four-year relationship with him, sharing a home and studio space. During this time, the two artists influenced one another's approach to painting. Izquierdo's form and style influenced Tamayo to further develop his own style, and she was persuaded by his attitude toward the content of art. Tamayo's approach to painting was to portray the Mexico of the people, not political concerns or historical narratives. Since Izquierdo was essentially shut out of the male-dominated domain of mural painting because she was a woman, she adopted Tamayo's everyday genre in smaller easel painting (Ferrer 12).

In 1947, Izquierdo explained her devotion to Mexican culture and her artistic pursuit:

> I try to make my work reflect the true Mexico, which I feel and love. I avoid anecdotal, folkloric and political themes because they do not have expressive or poetic strength, and I think that, in the world of art, a painting is an open window to human imagination. (Lucie-Smith 108)

She fondly recalled her time spent at the circus, often the only freedom in her strict Catholic childhood (Lucie-Smith 108). The circus was a re-curring theme in her work for many years, as in the painting *Entre-Acte* (Between Acts, 1934). It depicts a female performer at the center of a stage, wearing a long, fashionable evening gown and smiling proudly at the au-dience, while another performer exits behind the curtain. *Escena de circo* (Circus Scene, 1940) depicts three horses galloping around a ring, with a female performer riding one of them. A trumpet player on the sidelines is blowing her horn. Izquierdo uses horses again in the painting *The Circus Riders Lolita and Juanita* (1945). Here, she portrays two ballerinas dancing on top of performing horses that are adorned with feathered hats and harnesses lined with bells.

Izquierdo was the first Mexican woman to have a solo exhibition in the United States, in 1930, at the Art Center in New York City. Later that year, her work was included in a traveling group exhibition that originated at the Metropolitan Museum of Art in New York City. Nevertheless, her greatest recognition came from her native country. Izquierdo was highly visible in the art community, active in the artists' group Liga de Escritores y Artistas Revolucionarios (League of Revolutionary Writers and Artists),

a politically radical union. Her activism increased in intensity, and a year later she organized the women's group Carteles Revolucionarios del Sector Femenino de la Sección de Artes Plásticas, Departamento de Bellas Artes (Revolutionary Posters by Painters of the Women's Section of the Visual Arts Section, National School of Fine Arts) (Ferrer 13). The group made and distributed posters that supported revolutionary efforts.

After her relationship with Tamayo ended, Izquierdo met and married a Mexican painter and diplomat, Raúl Uribe Castille, whom she divorced in 1953. She worked hard to overcome the social restrictions of her childhood and an early, arranged marriage, and to attain the independence and strength necessary to be a major force in Mexican art. She was a role model for the young women she encouraged to be free and strong as individuals and artists.

Places to See Izquierdo's Work

Americas Society Art Gallery, New York City

Mary-Anne Martin Fine Art, New York City

University of Guadalajara, Mexico: *Mis Sobrinas* (1952)

Bibliography

Del Conde, Teresa. "Mexico." In *Latin American Art in the Twentieth Century*. Edited by Edward J. Sullivan. London: Phaidon Press, 1996. Pp. 17–50.

Ferrer, Elizabeth. *The True Poetry: The Art of María Izquierdo*. New York: Americas Society Art Gallery, 1997.

Goldman, Shifra M. *Dimensions of the Americas: Art and Social Change in Latin America and the United States*. Chicago: University of Chicago Press, 1994.

Kamps, Toby, ed. *Frida Kahlo, Diego Rivera, and Twentieth Century Mexican Art: The Jacques and Natasha Gelman Collection*. New York: Distributed Art, 2000.

Leffingwell, Edward. "Latin Soliloquies." *Art in America* vol. 81, no. 12 (1993): 72–83.

Lucie-Smith, Edward. *Latin American Art of the 20th Century*. New York: Thames and Hudson, 1993.

Tarver, Gina M. *Issues of Otherness and Identity in the Works of Izquierdo, Kahlo, Artaud, and Breton*. Albuquerque, N.M.: University of New Mexico Press, 1996.

Velázquez Chávez, Agustín. *Contemporary Mexican Artists*. New York: Friede, 1937. Repr. Freeport, N.Y.: Books for Libraries, 1969.

Alfredo Jaar

(b. 1956)
Chilean Photographer, Installation Artist, and Printmaker

The Chilean artist Alfredo Jaar transforms photojournalism from detached reporting to emotionally charged messages. He was born in Santiago, where he spent most of his childhood. With his family, he frequently traveled to Martinique while growing up. He earned degrees from the Chilean North American Institute of Culture in filmmaking (1979) and the University of Chile in architecture (1981). Soon after graduating, he moved to the United States. A resident of New York City since 1982, Jaar is a self-proclaimed "citizen of the world" (Vine 90). This perspective on his place in the world helps to shape his vision and compassion for humanity worldwide, which is revealed through his art.

Jaar is sensitive to oppressed cultures and social injustices, primarily in economically developing countries (often referred to as Third World countries). His poignant photographs of individuals who are confused, abandoned, and tortured are presented to the audience as faces of the "other" or "them," those who are often seen by people of social privilege as far removed from themselves. Jaar presents their horrors in such a way that viewers cannot separate their emotions from those of the photographs subjects, even if what is felt is just a fraction of the actual pain.

Jaar juxtaposes his photographs with other materials in order to create room-size installations. He manipulates the space, directing the viewer to engage with the photographs from a variety of angles and positions. He often sets the stage so that gallery visitors must walk around, bend, stretch, lean, or stoop to view the art. These positions are physical reminders of a particular vantage point when peering into the faces of others (Vine 93). For example, *Frame of Mind* (1986) documents the vast numbers of Brazilians who were mining gold in the eastern Amazon Basin during the

middle 1980s. The miners were working under extremely hard conditions for very little pay. In the exhibition of these photographs at the Grey Art Gallery in New York City, Jaar's dark photographs of tired, dirty miners were reflected onto mirrors set in heavy, ornate gold frames. Gold lamé fabric was draped throughout the room, and nails painted gold and black lay in conspicuous piles on the floor. The miners are set apart from the viewers in such a way that the differences between "us" (as viewer) and "them" (as miners) are highlighted. At the same time, Jaar provokes his audience to reach new conclusions about the ways that we distance ourselves from others (Princenthal 145).

Walking on Water (1992), commissioned by the Archer M. Huntington Gallery at the University of Texas, is a collection of photographs depicting Mexicans crossing the Rio Grande from Juárez, Mexico, to El Paso Texas. Again, Jaar captures events and entices viewers to reconsider their ideas about the immigration of Mexicans to the United States. The photographs show Mexicans of all ages walking through the shallow river. Here, the Río Grande represents the division between two hugely different worlds. The crossing of the river signifies leaving an impoverished and restrictive state for the freedoms and riches of another—but in reality, migrants face prejudice, discrimination, and low wages (Ramírez 14).

Jaar's sympathy for the worldwide plight of humanity keeps him constantly learning about contemporary crises around the world. When speaking about his approach to his subject matter, he said, "I am obsessed with information. . . . All of my projects have more or less the same plan. I find out about a situation, I inform myself as much as possible through the press, and lastly, I travel" (Gallo 1). Although his work is categorized as installation art and photography, it resembles photojournalism, documenting real people in the midst of real tragedy.

Jaar's *Real Pictures* (1994), a photo journal of his trip through Rwanda, Zaire, and Uganda after several massacres, is the record of a difficult journey. When asked how he and his crew were able to detach emotionally and proceed with their project, he said, "We were not able to escape our emotions. In fact, we were often not able to take pictures, and had to limit ourselves to looking, talking with people, and trying to understand the situation. There were many times when we let our feelings control the situation, but we couldn't help it, nor did we want to" (Gallo 1). He is especially concerned about African societies, and condemns the general lack of world attention for their dire situations. He specifically spoke about Rwanda:

I noticed a terrible lack of reaction on the part of the international community, and that concerned me very much. I have always had the sense that the world has abandoned Africa. What was taking place in Rwanda interested no one, because Rwanda is a small and very poor country, with no strategic

interest for the great powers. Approximately one million people died. . . . This was a truly terrible event, so I decided to travel to Rwanda to document it and see what was happening there with my own eyes. (Gallo 1)

A vast amount of Jaar's work is clearly aimed at causing viewers from more privileged societies to have new compassion and understanding for the tragedies of people in less fortunate circumstances. He also points a finger at the overt decadence in most Western societies and states that his art is "critical of the system" (Adams 25). He is addressing Western capitalism and consumption, which can skew one's perspective to the point of greed and indifference toward others. In *Hé Ram* (Oh God, 1991), an 8 × 8-foot-square mirror is inscribed with the seven social sins, as stated by Mohandas Gandhi, against self-satisfaction:

Politics without principle

Wealth without toil

Pleasure without conscience

Knowledge without virtue

Commerce without morality

Science without humanity

Adoration without sacrifice. (Vine 93)

Standing in front of the mirror while reading these corruptions of the human condition, viewers are faced with their own reflections; their thoughts are driven to self-analysis about each statement.

At a relatively young age, Jaar has secured a place for his work in the most prestigious art institutions. He has exhibited in numerous one-person and group exhibitions around the world. In addition, he has received a New York State Council of the Arts grant (1985), a Guggenheim Fellowship (1985), a National Endowment for the Arts Fellowship (1987), and a MacArthur Fellowship (2000). Alfredo Jaar is recognized for his achievement as a visual artist, as well as for his ability to profoundly move viewers to engage in his mission, which is to consider the plight of humanity through a different set of eyes and then to take action for change.

Places to See Jaar's Work

Alternative Museum, New York City

Archer M. Huntington Gallery, University of Texas, Austin: *Walking on Water* (1992)

Center for the Fine Arts, Miami, Fla.

Galerie Lelong, New York City

Hosfelt Gallery, San Francisco

La Jolla Museum of Contemporary Art, La Jolla, Calif.

The Light Factory: www.lightfactory.com

Museo del Barrio, New York City

Museum of Contemporary Art, Chicago

Museum of Modern Art, New York City

Museum of Modern Art, Stockholm

New Museum for Contemporary Art, New York City

Pergamonmuseum, Berlin

Whitechapel Art Gallery, London

Bibliography

Adams, Beverly. "Installations." In *Encounters/Displacements: Luis Camnitzer, Alfredo Jaar, Cilde Meireles*. Edited by Mari C. Ramírez and Beverly Adams. Austin: Archer M. Huntington Art Gallery, College of Fine Arts, University of Texas, 1992. Pp. 25–34.

Gallo, Rubén. "Alfredo Jaar: The Limits of Representation." *Echo*. December 3, 1999. http://www.echonyc.com/~trans/Telesymposia3/Jaar

Hollander, Kurt. "The Caracas Connection." *Art in America* vol. 82, no. 7 (1994): 78–83.

Latin American Art in Miami Collections. Coral Gables, Fla.: Lowe Art Museum, University of Miami, 1994.

Princenthal, Nancy. "Fragments and Frames." *Art in America* vol. 75, no. 5 (1987): 144–145.

Ramírez, Mari C. "Reinstalling the Echo Chamber of the Past." In *Encounters/Displacements: Luis Camnitzer, Alfredo Jaar, Cildo Meireles*. Edited by Mari C. Ramírez and Beverly Adams. Austin: Archer M. Huntington Art Gallery, College of Fine Arts, University of Texas, 1992. Pp. 9–24.

Vine, Richard. "Images of Inclusion." *Art in America* vol. 81, no. 7 (1993): 90–95, 117.

Luis Jiménez
(b. 1940)
Mexican-American Sculptor

At the age of six, Jiménez began helping his father in his sign business. His father, a Mexican immigrant, worked as a carpenter before starting his own business, which makes huge neon signs for shopping centers and Las Vegas hotels. One of Jiménez's first projects was a white concrete and neon polar bear created for a dry cleaner; when he was sixteen, he made two ten-foot roosters for a chain of drive-in restaurants (Beardsley and Livingston 190).

Jiménez's fiberglass sculptures reflect his Mexican heritage, his father's occupation, his personal history, and his love of popular culture, especially the low rider, a customized vehicle with hydraulic jacks that allow it to be lowered closer to the ground. Born in El Paso, Texas, Jiménez studied architecture and art at the University of Texas, Austin, earning his B.A. degree in 1964. After graduation, a scholarship from the National University of Mexico enabled him to study in Mexico, where he strengthened his pride in his Mexican heritage. Shortly after that, he moved to New York City, where he stayed for five years. ("Biographies" 319; Beardsley and Livingston 190).

The story of how Jiménez got his first big break in New York is so striking that it is told and retold. After repeatedly showing slides to gallery personnel and receiving no strong response, he took three of his sculptures to the Castelli Gallery. Finding it empty, he boldly placed his work in the gallery space. When Juan Karp, the gallery director, saw the sculptures, he was impressed, and suggested Jiménez try the Graham Gallery. This tip resulted in solo exhibitions in 1969 and 1970. His early subjects include a motorcycle rider, a sunbather with a magazine over his head, and a female barfly posed as the Statue of Liberty.

In spite of the 1969 and 1970 exhibitions, economic success eluded Jiménez in New York, and in 1971 he moved to Roswell, New Mexico, where he spent six years. Here he produced his *Progress* sculptures, which are large depictions of southwestern images (Beardsley and Livingston 193).

In 1974 Jiménez had his first one-person museum exhibition at the Contemporary Arts Museum in Houston. Reflecting on this exhibition, Benito Huerta offered reasons why it was so important:

> For one, the work was ambitious in scale and content, and dynamic in its use of materials and color, with an exciting mix of popular culture and high art. Secondly, this unique, flashy smorgasbord of pop imagery had been created by a Chicano from El Paso, instead of the usual mainstream artist from New York or Los Angeles. This one-person exhibition in Houston of Jiménez's work established him as an important role model for people in and outside of the Latino community. (7)

What is so different about Jiménez's sculpture is that while it appeals to museum audiences, it is also public art that easily appeals to the general population, and can be successfully displayed in public spaces (Hickey 22). While Jiménez claims that he has no specific agenda, he also clearly states that he makes his sculptures primarily for the Chicano working class. There is a certain violence to much of his work; it is also part kitsch, part stereotype, and part historical revisionism (Mitchell 100). His sculptures depict cultural narratives, folklife, and historical information as seen by an insider—a Mexican-American perspective.

One of Jiménez's most powerful pieces is his ten-foot 1989 sculpture *Cruzando el Río Bravo* (Border Crossing), which is dedicated to his father and his paternal grandmother, who in 1924 entered the United States illegally. Depicting a man carrying on his shoulders a woman who holds a small child, it is made of a urethane-coated fiberglass that seems still wet. One image seems to flow into another, giving the viewer the idea of family connectedness. The crossing is clearly a struggle (Mitchell 100). In his earlier piece *Man on Fire* (1969), a red-orange, oversized burning man, with long hair flowing to the side, reflects on both historical and contemporary themes. It pays homage to **José Clemente Orozco**'s fresco that depicts the Aztec leader Cuauhtémoc, and it also refers to Vietnamese monks who set themselves on fire to protest the war in Vietnam (Shields 140).

Jiménez's sculpture *Vaquero* (1977), now in the collection of the National Museum of American Art, receives prominent display because it is such an important symbol. Elizabeth Broun, director of the NMAA, observed: "We believe this *Vaquero* sculpture makes many points that are key to our program: that American art began in the Hispanic Southwest, that Latinos are the most rapidly growing segment of the population, that the

traditional American symbol of the cowboy began with Latinos in the Southwest" (Gaspar de Alba 185).

In many ways, Jiménez exemplifies the contemporary American artist. Now living with his family in Hondo, New Mexico, he draws his inspiration from various popular and "fine art" traditions as he reexamines his historical roots and reflects on them in artistic terms. He gives voice to the aesthetic traditions of low riders, urban graffiti, neon lights, and the struggle (and pleasure) of the Mexican-Americans to live, work, and celebrate life in the United States. He proudly announces, "I'm a Chicano" (Brenson 11), and his work echoes that announcement.

Places to See Jiménez's Work

Albuquerque Museum, Albuquerque, N.M.

Anderson Museum of Contemporary Art, Roswell, N.M.

Bronx Museum of the Arts, New York City

Chicago Art Institute

Denver Art Museum, Denver, Colo.

El Paso Museum of Art, El Paso, Tex.

Grand Rapids Art Museum, Grand Rapids, Mich.

Hirshhorn Museum and Sculpture Garden, Washington, D.C.

Long Beach Museum of Art, Long Beach, Calif.

Metropolitan Museum of Art, New York City

Museum of Fine Arts, Santa Fe, N.M.

Museum of Modern Art, New York City

National Collection of Fine Arts, Washington, D.C.

National Museum of American Art, Smithsonian Institution, Washington, D.C.

Plains Art Museum, Moorhead, Minn.

Roswell Museum and Art Center, Roswell, N.M.

Sheldon Memorial Art Gallery, University of Nebraska, Lincoln

Spencer Museum of Art, University of Kansas, Lawrence

Ullrich Museum, Wichita State University, Wichita, Kan.

University Art Museum, Arizona State University, Tempe

University of New Mexico Art Museum, Albuquerque

University of Texas at El Paso Library

University of Texas at San Antonio

Bibliography

Baker-Sandback, Amy. "Signs: A Conversation with Luis Jiménez." *Artforum* 23 (September 1984): 84–87.

Beardsley, John, and Jane Livingston. *Hispanic Art in the United States: Thirty Contemporary Painters and Sculptors*. Houston, Tex.: Museum of Fine Arts; New York: Abbeville Press, 1987.

Brenson, Michael. "Movement's Knowledge." In *Luis Jiménez: Working-Class Heroes. Images from the Popular Culture*. Kansas City, Mo.: ExhibitsUSA, 1997. Pp. 11–20.

Cameron, Dan. "Luis Jimenéz." *Artnews* vol. 83, no. 9 (1984): 164–65.

Eklund, Lori, and Jerry Medrano. "Community and Contemporary Chicano Art: Four El Paso Artists." *Journal of Art Education* 53, no. 4 (July 2000): 26–31.

Frank, Peter. "Luis Jimenéz." *Artnews* vol. 74, no. 9 (1975): 112.

Gaspar de Alba, Alicia. *Chicano Art: Inside/Outside the Master's House*. Austin: University of Texas Press, 1998.

Goldman, Shifra M. "Homogenizing Hispanic Art." *New Art Examiner* 15 (September 1987): 30–33.

Goldman, Shifra M. *Dimensions of the Americas: Art and Social Change in Latin America and the United States*. Chicago: University of Chicago Press, 1994.

Griswold del Castillo, Richard, Teresa McKenna, and Yvonne Yarbro-Bejarano, eds. *Chicano Art: Resistance and Affirmation, 1965–1985*. Los Angeles: Wight Art Gallery, UCLA, 1991.

Hickey, Dave. "Luis Jiménez and the Incarnation of Democracy." In *Luis Jiménez: Working-Class Heroes. Images from the Popular Culture*. Kansas City, Mo.: ExhibitsUSA, 1997. pp. 21–27.

Huerta, Benito. "Introduction: Working Class Heroes." In *Luis Jiménez: Working-Class Heroes. Images from the Popular Culture*. Kansas City, Mo.: Exhibits USA, 1997. Pp. 7–10.

The Latin American Spirit: Art and Artists in the United States, 1920–1970. Essays by Luis R. Cancel, Jacinto Quirarte, Marimar Benítez, Nelly Perazzo, Lowery S. Sims, Eva Cockcroft, Felíx Angel, and Carla Stellweg. New York: Bronx Museum of the Arts in association with Harry N. Abrams, 1988. Pp. 313–26.

Mitchell, Charles Dee. "A Baroque Populism." *Art in America* vol. 87, no. 3 (1999): 100–105.

Phillips, Patricia. "Luis Jimenéz." *Artforum* 22 (Summer 1984): 94–95.

Shields, Kathleen. "Luis Jimenez at the Albuquerque Museum." *Art in America* vol. 82, no. 11 (1994): 139–40.

Sullivan, Edward, J., ed. *Latin American Art in the Twentieth Century*. London: Phaidon Press, 1996.

Frida Kahlo
(1907–1954)
Mexican Painter

Known for her physical and emotional pain and suffering, passionately displayed on canvas in self-portraits, Frida Kahlo lived a life that is increasingly of interest to the art world. Her works describe her tempestuous relationship and two marriages to the famous muralist **Diego Rivera**, as well as her ongoing malaise after being in a trolley-bus accident at the age of eighteen that crippled her for life. Kahlo is also recognized for her ties to the Communist Party and Mexico's indigenous culture, as well as for her elaborate dress and her flamboyant personality. Although she was not well known when she died in 1954, she has since achieved superstar status among art lovers and critics. Though she had only two solo shows during her lifetime (Tully 130), her works are now exhibited around the world.

One of six daughters, Kahlo was born in 1907 in Coyoacán, a residential area in southwestern Mexico City. Her birthplace, now the Museo Frida Kahlo, was also her studio and residence as an adult (Herrera, *Frida* 3–9). Her mother was Mexican and her father, a jeweler and photographer, was a Hungarian Jew. Kahlo shared her father's passion for books, photography, and nature (Herrera, *Frida* 10, 18). She loved to dress as if going to a grand party, and her self-portraits depict this love of elaborate self-decoration (Herrera, *Frida* 112).

Kahlo's 161-page diary, which she kept during the last ten years of her life, was published in 1995. It gives keen insight into many aspects of her life that affected her striking images. In these pages, she not only wrote her intimate thoughts, but also sketched ideas for paintings, using colored pencils, inks, crayons, and gouache.

Numerous books and articles have been written about Kahlo, exploring issues surrounding her disability, politics, bisexuality, and marriage, all of

Frida Kahlo. Courtesy of and © Bettman/CORBIS.
Used with permission.

which have relevance to her paintings. Her art, which now commands multimillion-dollar prices, uses bold images to convey her life experiences. Many scholars celebrate her work because it speaks readily to so many women. With the rise of issues relevant to the feminist movement in the 1970s, it helped fill the need for women's autobiographies to be told. Many agree that her work was especially courageous because it portrays a private and physical pain that had not been made visible before (Tully 127).

Kahlo's diary details some of her thirty-five surgical operations and describes the plaster corsets she had to wear to keep her spine together. Her paintings depict these experiences. Other paintings and diary passages concern longings for her unfaithful mate, Diego Rivera. She once said, "I suffered two grave accidents in my life, one in which a streetcar knocked me down. . . . The other accident is Diego" (Herrera, *Frida* 107). In one painting, *Self-Portrait with Cropped Hair* (1940), she depicts herself in a man's baggy suit, perhaps Rivera's, with piles of her shorn hair at her feet. Cutting off the hair that Diego loved was her revenge for his infidelity with her sister Cristina.

Despite the tumultuous nature of Kahlo's relationship with Rivera, he was, in many ways, Kahlo's soul mate. She could not tear herself away from him. She sometimes painted his face in the middle of her forehead, as if he were ever present in her mind. They shared many things, including politics, art, and even boredom with classical music (Herrera, *Frida* 163). But Rivera was often cruel to Kahlo. He was both repeatedly unfaithful and often verbally unkind.

Kahlo suffered in other ways as well. Although she loved children, her physical health prevented her from carrying a child to full term; she had three unsuccessful pregnancies (Herrera, *Frida* 324). Her inability to have a healthy body, a child, a faithful husband, or even a sister she could trust, contributed to her anxiety.

Perhaps three of Kahlo's most famous paintings are *My Birth* (1932), *My Nurse and I* (1937), and *The Broken Column* (1944). *My Birth* is a shocking image of a mother, her upper body and face covered with a sheet, giving birth to a baby/adult Frida. We wonder if the sheet-draped mother is dead and if the baby is dead as well (due to its lifeless depiction). Above the bed is a portrait of a grieving woman, perhaps the Virgin of Sorrows. The bed, Kahlo once said, is the bed in which she and her sister Cristina were born. Kahlo's connection to Mexico's Indian culture is illuminated in *My Nurse and I*. This painting shows Frida, again as a baby/adult, feeding from the breast of a dark Indian wet nurse. Because her mother became ill after her birth, this depiction not only captures something that actually happened but also metaphorically describes the heritage she loved being passed from one generation to another. *The Broken Column* is probably her most powerful image describing her physical pain. It was painted soon after one of her many surgeries when she had been given an "apparatus," as it was called, to wear. The open body, suggesting surgery, shows a broken and crumbling spine. Nails penetrate her body and tears roll down her face. Even the ground around her, dry and barren, is broken (Herrera, *Frida* 76–77, 157, 219–20, 222).

In a way, these paintings were a form of therapy for Kahlo. They helped her deal with her pain and reflected back to her a strong identity. In all her self-portraits, Kahlo paints herself as a complex woman, with heavy, dark eyebrows that join at the bridge of the nose and a faint mustache. Her long dark hair is also part of her signature. Although she painted fewer than 150 pictures in her short life, some critics claim that most of her work done before the mid-1930s is not as good as her late work, and paintings done in the last few years of her life are weak because she was so adversely affected by drugs and alcohol (Tully 130). Her best works display fastidious attention to details and a strong awareness of compositional elements.

Although the French Surrealist and essayist André Breton, as well as many others, called Kahlo a Surrealist, she thought the term did not fit her. According to her biographer Hayden Herrera, Kahlo explained that

her work "was not the product of a disillusioned European culture searching for an escape from the limits of logic by plumbing the subconscious" (258). Rather, any fantasy portrayed in her works, she claimed, should be seen as part of her reality. Her paintings are intended to be accessible to others, as murals are. Few would now argue against the accessibility of Kahlo's art, for it is perhaps this aspect of her work that has made her so loved by millions.

Places to See Kahlo's Work

Museo Dolores Olmedo Patina, Mexico City: *A Few Little Slashes with Dagger* (1935); *The Flying Bed* (1932); *Portrait of Daña Rosita Morrillo* (1944)

Museo Frida Kahlo, Coyoacán, Mexico City

Museum of Art, San Francisco: *Frida Kahlo and Diego Rivera* (1931)

Museum of Fine Arts, Boston: *Self-Portrait* (1930)

Museum of Modern Art, Mexico City: *The Two Fridas* (1939)

Museum of Modern Art, New York City: *Fulong Chang and I* (1937)

National Museum of Women in the Arts: *Itzcuintle Dog with Me* (1938); *Self-Portrait Dedicated to Leon Trotsky* (1937)

Bibliography

Cruz, Barbara C. *Portrait of a Mexican Painter*. Berkeley Heights, NJ: Enslow, 1996.

The Diary of Frida Kahlo: An Intimate Self-Portrait. Introduction by Carlos Fuentes. Essays and commentaries by Sarah M. Lowe. New York: Harry N. Abrams, 1995.

Herrera, Hayden. "Frida Kahlo: Her Life and Art." *Artforum* 14 (May 1976): 38–44.

Herrera, Hayden. *Frida: A Biography of Frida Kahlo*. New York: Harper & Row, 1983.

Lindauer, Margaret A. *Devouring Frida: The Art History and Popular Celebrity of Frida Kahlo*. Middletown, Conn.: Wesleyan University Press, 1999.

Rivera Marín, Guadalupe, and Marie-Pierre Colle. *Recipes and Reminiscences of Life with Frida Kahlo*. New York: Clarkson Potter, 1994.

Tully, Judd. "The Kahlo Cult." *Art News* vol. 93, no. 4 (1994): 126–33.

Zamora, Martha. *Frida Kahlo: The Brush of Anguish*. Translated by Marilyn Sode Smith. San Francisco: Chronicle Books, 1990.

Kcho (Alexis Leyva Machado)

(b. 1970)
Cuban Sculptor and Installation Artist

Kcho (Alexis Leyva Machado) is a political artist who produces provoca-tive, often rebellious sculptures and installations or environmental gallery exhibitions. Water is often an important point of departure for his work; his installations have included all kinds of items that have washed up from the ocean, such as boats, rafts, oars, inner tubes, and parts of docks. These items comment on issues related to travel and migration, experiences rel-evant to Cuba at this time in history (Lowinger 124).

Born on Isla de la Juventud, Cuba, in 1970, Kcho received his art ed-ucation at the National School of Plastic Arts in Havana, but was not accepted at the Higher Institute of Art, the university-level art school. Nonetheless, his career took off early (Lowinger 126–27). Lowinger de-scribed him as a man in constant motion, with a dominating presence (126). His father, a carpenter, gave him his nickname; he had always wanted to name a son Cacho (meaning "chunk" or "piece"). His mother, however, rejected the idea and named him Alexis Leyva. Nonetheless, the nickname stuck, and he changed the spelling in high school. He once wrote, "Crooks had aliases, I wanted one too" (Lowinger 126). Both his parents were creative: his father worked with wood and his mother was in charge of the decorations for the island's annual carnival.

Kcho's works, politically engaging, can cause controversy over sensitive but pressing topics. His sculptures have sometimes been large, irreverent maps of Cuba. In *La Peor de las Trampas* (The Worst of Traps, 1991), a ladder has steps made of machetes with the sharp edges facing up (Cam-nitzer 293). At the Fifth Havana Biennial in 1994, at the height of the period when Cubans were leaving their country on precarious rafts bound for the United States, he created *Regatta*. A room was filled with miniature

boats, made of wood and paper, egg cartons, and old shoes, reminding viewers just how improbable these constructions were (Poupeye 190).

Boats appear often in Kcho's work. For example, *Lo Mejor del Verano* (The Best of the Summer) was created in 1994 for the Madrid exhibition "Cocido y Crudo" (Cooked and Raw). Boats, fishing nets, and baskets were suspended from the ceiling and reflected on a slick, black floor. It looked like a shipwreck had taken place, and the viewer was witnessing it from below. Again the artist conjured up the tragic fate of so many Cubans leaving their country in small, often makeshift boats. In 1995, Kcho won the $50,000 grand prize at the Kwangju Biennale in South Korea for *Para Olvidar* (To Forget). In this installation he placed a rowboat on top of a pile of empty and half-empty beer bottles (Lowinger 125).

The titles of his works are important. He said that when phrases come to him, he writes them in a notebook. "Sometimes it takes me a year or more to do something with them, but my process always begins with the title" (Lowinger 126).

Kcho reassembles objects that have meaning in other contexts, to give them new meaning as art, an approach several contemporary Cuban artists use. It is a way of not using art materials (pencils, paper, paint), as in making signs but, instead, of presenting the sign itself. The recontextualization of the objects gives them a fresh message because it draws on the original meaning. The works become like a physical diary with an archaeological nuance (Molina 29–30). In addition, because Cuba is such a poor country, salvaging and recycling objects reflects on the everyday practice of many Cubans, who must make use of whatever they can, to get by (Lowinger 125).

While Kcho roots his work in the Cuban experience, he also refers to important figures in art history. In doing so, he subverts prevailing cultural codes. For example, in *Infinite Column I and II* (1996), consisting of wood, metal, and C-clamps, he stacks frame upon frame of rowboats, canoes, surfboards, and kayaks, mimicking Constantin Brancusi's motif in his *Endless Column* (Marcoci 20). Brancusi's monumental piece rises ninety-six feet, with repeating modular units of form, seemingly never ending (Hunter and Jacobus 80). While Brancusi intended his work to be about transcendence, Kcho's is more specifically about exodus, escape, freedom, and a migratory mentality. Kcho's endless column of boats successfully functions as a metaphor to overturn the idea that our existence can be separated from other things. This idea speaks to Cuba, seen incorrectly, as an isolated island (Marcoci 20–21).

Kcho is perhaps the most internationally celebrated Cuban artist since **Wifredo Lam**. In a few years, he has been featured in more than fifty group exhibitions and biennials around the world. He also has had fifteen solo exhibitions at such impressive venues as the Museum of Contemporary Art in Los Angeles (1997), the Jeu de Paume in Paris (1998), and the

Palacio de Cristal at the Reina Sofia in Madrid (2000). Though his works repeatedly use images of boats and make references to the sea, each time a work is completed, it seems fresh and new. Although his art clearly evokes political meanings, Kcho claims it does more. He stresses the universal themes of travel, loss, impermanence, and nostalgia (Lowinger 125, 127).

Places to See Kcho's Work

Arizona State University Art Museum, Tempe

Centro Cultural Arte Contemporáneo, AC Fundación, Mexico City

Centro Cultural de Arte Contemporáneo, Mexico City

Cultural Televisa, Mexico City

Ludwig Forum für Internationale Kunst, Aachen, Germany

Museo Nacional Palacio de Bellas Artes, Havana

Museum of Contemporary Art, Chicago

Van Reekum Museum, Apeldoorn, Netherlands

Bibliography

Ashton, Dore. "Fifth Havana Biennial." *Artforum* 33 (October 1994): 110.

Camnitzer, Luis. *New Art of Cuba*. Austin: University of Texas Press, 1994.

Hunter, Sam, and John Jacobus. *Modern Art: Painting, Sculpture, Architecture*. 3rd ed. New York: Prentice-Hall and Harry N. Abrams, 1992.

Lowinger, Rosa. "Making Waves." *Artnews* vol. 99, no. 6 (2000): 124–27.

Marcoci, Roxana. "The Anti-Historicist Approach: Brancusi, Our Contemporary." *Art Journal* 59, no. 2 (Summer 2000): 18–35.

Molina, Juan A. "Cuban Art: The Desire to Go on Playing." In *Utopian Territories: New Art from Cuba*. By Eugenio Valdés Figueroa, Juan Antonio Molina, Scott Watson, and Keith Wallace. Vancouver: Morris and Helen Belkin Art Gallery; Contemporary Art Gallery; Havana: Ludwig Foundation of Cuba, 1997.

Poupeye, Veerle. *Caribbean Art*. New York: Thames and Hudson, 1998.

Zeitlin, Marilyn A., ed. *Contemporary Art from Cuba: Irony and Survival on the Utopian Island*. Essays by Gerardo Mosquera, Tonel (Antonio Eligio Fernandez), and Marilyn A. Zeitlin. New York: Arizona State University Art Museum and Delano Greenidge Editions, 1999.

Guillermo Kuitca

(b. 1961)
Argentinean Painter and Sculptor

Guillermo Kuitca communicates his feelings and thoughts on themes ranging from overcrowding in urban dwellings to traditional Argentine culture, using forms of expression as varied as technical drawing, assemblage, and dance. The grandson of Russian-Jewish immigrants, he was born in Tango, Argentina. He showed artistic interest and skill as a boy, painting regularly from the age of six. He recalls being moved by the dramatic and agonizing paintings of Francis Bacon, who borrowed and then transformed imagery from Renaissance paintings, photography, news clippings, and X-rays. When he was thirteen, the Lirolay Gallery in Buenos Aires hosted his first solo exhibition (1974). His portraits, presented in that show, were critical and commercial successes, and all the paintings were sold (Greenlees 95). Encouraged by his parents, Kuitca spent the next ten years developing his art through instruction he received in Buenos Aires. During that time, he had three more solo exhibitions at local galleries.

In 1980, Kuitca came into contact with the theater, an experience that changed the direction and content of his art. The German performance artist Pina Bausch and her troupe came to Buenos Aires to perform. Her play *Bandoneón*, named for the classic tango instrument, mesmerized the nineteen-year-old Kuitca. Purchasing a plane ticket with money from the sale of two paintings, he followed the troupe back to Germany. There, he worked with Bausch as a stagehand and was energized by her brilliant set design and performance, which was a mixture of dance, vaudeville, and comic political commentary (Thompson 93). A few months later, he returned to Argentina, where he wrote and directed two plays: *Nadie Olvida Nada* (Nothing Is Ever Forgotten) and *El Mar Dulce* (The Sweetwater Sea).

His plays mimic the titles and themes of his paintings. Commenting on

133

Guillermo Kuitca. Courtesy Sperone Westwater,
New York City. Used with permission.

the intermingling of elements from painting and theater in his art, Kuitca said that he strived to "paint as if [I] were directing a play" (Thompson 93). For example, his first play, *Nadie Olvida Nada* (c. 1982–83), has the same name and central theme as a series of paintings from 1982 in which empty beds line up across the canvas, taking on a variety of meanings depending on the viewer's perspective. Kuitca explained that these beds could symbolize the kidnapping of Argentines, who were randomly taken from their homes by the government because they were perceived as a political threat (Thompson 94).

As a result of his time spent with the theater troupe, Kuitca became preoccupied with the relationship between people and space. Because he lived and worked in Buenos Aires, he wanted to express urban themes on a stagelike set in his art. Living in an apartment led him to explore the isolation that occurs in a city of millions. He has said that David Leavitt's novel *The Lost Language of Cranes* (1986) inspired his close inspection of loneliness in urban dwellings (Lucie-Smith 197). The novel features a family living in tight quarters in New York City. As the family struggles with

intimate issues, the apartment becomes a metaphor for a womb and also a prison, the space compounding their feelings of alienation from each other and from the outside world.

Kuitca addresses the same concerns regarding apartment life in his work. His sparse drawings evoke unsettling feelings, reminding us that millions of people inhabit the city, and thousands suffer from feelings of loneliness and despair within their small homes. Kuitca stated, "I started [to create] the apartment as a consequence of the theater" (Greenlees 95). He explained the natural expansion from portraying a bed to drawing the universe: "I imagined the apartment in a city, and after that I imagined the city in a country. It was a very trivial approach to space—to take a bed, afterwards, a plan of the country, including, ultimately maps of the stars" (Greenlees 94). In pursuit of universal meanings in his art, Kuitca expands the setting from the intimacy of a small bed to the star-filled sky.

An example of the apartment floor plans is an untitled work from 1996, with delicately stenciled rooms that reveal a generic sense of their function. Here, it is clear that Kuitca is not trying to portray a space specific to one culture or another; it could be an Argentine apartment, a Latin American apartment, a New York apartment, a Tokyo apartment, or any other designated dwelling. He wrote, "There is a bathtub, a piano, a desk, a bar, a conference table, a toilet, school desks. But the set doesn't satisfy any recognizable demand" (Loescher 11). When the artist's description is read and his intention is revealed, the penciled circles and lines form the image of the room, becoming spaces many people are familiar with.

Kuitca has kept a journal for many years, translating his sketches of unknown rooms and places into words. His words breathe life into the empty spaces:

> The apartments are not inhabited, not even decorated. My spaces are places to get to or to leave. I would say that people have been there. They aren't there right now, but there is no doubt that they were there not long ago! I think that there is a very strong sensation in my paintings of not knowing what happened or what will happen. The trail is fresh. One arrives at a scene where something has happened. The viewer got there too soon or just a second too late to catch the action. I would say the people abandoned the painting just a second ago. (Loescher 9)

In 1988, Kuitca shifted from painting to mixed media sculpture, painting maps on mattresses that hang on the wall. In an untitled triptych from 1989, three mattresses of equal size (approximately 86 inches by 55 inches) hang side by side, each covered in imitation leather. The mattress on the far left is painted white and has red and gold maplike roads corresponding to what was formerly West Germany. Kuitca purposely chooses maps for how they look or for a city's name that appeals to him (Thompson 96).

The other two mattresses are dark, and cities are marked with buttons, so that they look more like a sky full of stars than a road map. This piece represents the bed, the city, and the stars.

The Argentine tango inspired a series of paintings that pays tribute to the artist Andy Warhol. In *Naked Tango (After Warhol)* (1994), Kuitca literally danced the tango across a blank canvas, his feet dipped in paint. This series mimics Warhol's series of dance diagrams in which black outlines of footprints mark each step. However, Warhol's feet are neatly drawn, whereas Kuitca's feet are expressionistic—the paint is smeared from one step to the next, suggesting his every movement. This work also refers to the automatic or drip paintings created on the floor by the Abstract Expressionist painter Jackson Pollock. The art historian Robert Ferris Thompson states that this work "fuses Argentinean culture with echoes of postwar American painting in a genial, self-confident way" (93). Possibly, Kuitca was also drawing inspiration from Bausch's play about the tango or the fact that he was born in the town of Tango.

Though he has lived in Buenos Aires all his life, Kuitca has received most of his income from international sales since the late 1980s, and he continues to attract international audiences and patronage. His paintings cannot be categorized as distinctly Argentine or even as Latin American, for they communicate the universal theme of the loneliness of urban life (Lucie-Smith 196). Like other contemporary Latin American artists, such as the Chilean **Alfredo Jaar**, Kuitca is concerned with expressing sensitivity to the global community:

> I feel a personal responsibility . . . to comment in my works on the human condition: to try to say something on that. To give order to everything that surrounds me. To try to understand the world in which I live. To assume myself incapable of understanding why, so I can look for an answer. Like other artists. I would like to see the people in front of my work making questions about themselves and not about me. I want them [to] learn something about . . . [themselves] and not about me. (Loescher 20)

Guillermo Kuitca depicts the psychological spaces in which we live, from the intimacy of bedrooms and mattresses to the expansiveness of the galaxy.

Places to See Kuitca's Work

Annina Nosei Gallery, New York City

Art Gallery of Ontario, Toronto: *St. John's Head* (1991)

Arte Contemporânea, Rio de Janeiro: *Triptych of Mattresses* (1989)

Galerie Barbara Farber, Amsterdam

Joan Prats Gallery, New York City

Nohra Haime Gallery, New York City

North Carolina Museum of Art, Raleigh: *People on Fire* (1993)

Sperone Westwater, New York City

Bibliography

Greenlees, Don. "Guillermo Kuitca: How to Map the Universe." *Artnews* vol. 90, no. 10 (1991): 94–95.

Latin American Art in Miami Collections. Coral Gables, Fla.: Lowe Art Museum of Miami, 1994.

Leffingwell, Edward. "Latin Soliloquies." *Art in America* vol. 81, no. 12 (1993): 72–83.

Loescher, Robert J. *Guillermo Kuitca: Beds, Theaters, & Drawings*. Chicago: Arts Club of Chicago, 1999.

Lucie-Smith, Edward. *Latin American Art of the 20th Century*. New York: Thames and Hudson, 1993.

Pacheco, Marcelo. "Argentina." In *Latin American Art of the Twentieth Century*. Edited by Edward J. Sullivan. London: Phaidon Press, 1996. Pp. 283–300.

Thompson, Robert F. "Kuitca's Stagecraft." *Art in America* vol. 87, no. 12 (1999): 90–99.

Wifredo Lam
(1902–1982)
Cuban Painter

Possibly the most prominent Cuban Surrealist painter, Wifredo Oscar de la Concepción Lam y Castilla was born in Sagua la Grande, the youngest of nine children. Lam's cultural heritage is diverse; his father, Lam Yam, a Chinese immigrant, owned a shop in Sagua la Grande, and his mother was of European and African descent. As a young boy, Lam encountered racism as he struggled to understand his identity: "From childhood I didn't know what was the basis of my ethics or my joy. I was not considered an African nor a Chinese nor a Spaniard nor a Creole, because I was a crossbreed with many races" (Fletcher 168). Lam's multicultural heritage and search for identity were reflected later in his multistyle approach to painting. By the age of twelve, he had begun to show great drawing skill. Since his family had substantial economic resources, Lam obtained the best art education in Cuba. He was sent to live with relatives in Havana in 1916 so that he could attend the School of Fine Arts. At his next school, San Alejandro, many other Cuban artists, including **Amelia Peláez**, had studied (Camnitzer 153).

Like several other Latin countries in the first half of the twentieth century, Cuba had strict guidelines and censorship regarding the visual arts. The administration of San Alejandro complied with the prevailing laws, and as a result its students rebelled. Lam strongly opposed the Cuban establishment, and sought alternative venues to exhibit his work. The Association of Painters and Sculptors, founded in 1915, provided a liberal platform for expression. Lam showed his work there while he was a student at San Alejandro (Camnitzer 153). By 1923, Lam had left Cuba for Europe, fleeing the restrictive guidelines for artists and searching for a more liberal and multicultural environment. Later, he noted the irony that whereas

many people fled the cruel discrimination and extermination of people by the Nazis, "I went to Europe to escape from my father, the symbol of 'father' [establishment]. I thought this journey would resolve everything. But in Europe I encountered other problems as oppressive as those I left behind" (Sims 213–14).

Lam lived in Madrid and Cuenca, Spain, for the next fourteen years. In 1929, he met and married a Spanish woman, Eva Piriz. Two years later, their son was born; later that year, Eva and their baby died of tuberculosis (Fletcher 169). Lam stayed in Spain and continued to paint until Hitler's threat caused him to move to Paris in 1937. There, he met and became friends with Pablo Picasso. Lam was particularly impressed with Picasso's African art collection, and he studied African art while in Paris. This choice would prove to have long-lasting effects on his work.

Artistically, Lam was more drawn to Surrealism than to Picasso's Cubism (Weiler 75). The instability in Europe caused by Hitler's regime and invasions led many to leave Europe. In 1939 Lam and his companion, Helena Holzer, a German chemist whom he married in 1944, traveled to Marseilles, France. On this journey, he met the Surrealist writer André Breton. They spent time together once they reached Marseilles, and Lam was exposed to the automatic and spontaneous painting techniques of Surrealism. From 1941 to 1946, Lam lived in Cuba. It was during this time that he painted *La Jungla* (The Jungle, 1943), which is a good example of Lam's fusion of Cubism and Surrealism. Mystical characters, part animal and part unidentifiable, hide in the jungle. They stand tall, the full length of the canvas, with limbs the same size as the trees in the distance. At first glance, it is difficult to tell the difference between the two. Large feet with fingerlike toes ground the painting. The composition is startling, holding viewers in a trance while they attempt to translate this visual conundrum. The painting does not actually reflect the Cuban landscape, for Lam intended it for an audience outside of Latin America, offering viewers a rich, lush dream of a faraway place.

> When I was painting it [*La Jungla*], the doors and windows of my studio were open and the passers-by could see it. They used to shout to each other: "Don't look, it's the Devil!" And they were right. Indeed, a friend of mine says that in spirit it is very close to certain medieval representations of hell. In any case the title has nothing to do with the real countryside in Cuba, where there is no jungle, but woods, hills, and open country, and the background of the picture is a sugarcane plantation. My intention was to communicate a psychic state. (Lucie-Smith 86)

This painting is full of imagery linked to Lam's Cuban heritage, combining Santería and other New World African religions. Santería originated with Nigeria's Yoruba people, who carried the religion with them

when they were enslaved and brought to Cuba. Forced to practice Catholicism, the Africans secretly retained belief in traditional deities, whom they combined with Catholic saints. Eventually, Santería became publicly accepted and embraced by non-African Cubans. As a child, Lam had first hand experience with Santería. His godmother, Mantonica Wilson, was a leader of the religion and encouraged Lam to follow the same career path (Sims 213).

As an adult, Lam's interest in Afro-Caribbean imagery was sparked by four months he spent in Haiti, where he regularly attended Vodou ceremonies (Lucie-Smith 88). Lam was deeply impressed with Haitians' intensity and commitment to ritual.

> The Negro ceremonies of Cuba could not compare with these, which were prodigious. One of them began at dusk and ended at nearly five o'clock in the morning. It included sacrifices of animals and the calling forth of the dead. Unforgettable. Women dressed in white danced in a state of trance. Enormous drums almost deafened us. What a wild, savage beauty! A non-intellectual beauty, skin-deep, an absolutely naked human emotion. (Fletcher 183)

Lam's use of Surrealism focusing on religious imagery can be seen in his painting *The Idol* (1944). It is filled with disturbed, mystical figures resembling a bird, a pig, papayas and palm fronds; a round-headed rooster; figures with horned heads; and masklike faces, all referring to Santería (Sims 219). There is so much in this canvas that the viewers can discover something new each time they see it.

After World War II, Lam lived in Havana, Paris, and New York. Shortly after he divorced Helena in 1950, he settled in Paris. Lam continued to travel the world, spending most of his time between Paris and Havana until his death in 1982.

He continued to paint in Surrealist style, borrowing from Cubism and using religious and cultural symbols. His work was well received throughout his lifetime. He exhibited internationally, from New York to Europe to Havana. Today, the work of Wifredo Lam represents the fusion of Surrealism and Cubism, and the fused cultures of Europe and the Latin Caribbean.

Places to See Lam's Work

CDS Gallery, New York City

Galerie Lelong, New York City

Hirshhorn Museum and Sculpture Garden, Smithsonian Institution, Washington, D.C.: *The Siren of the Niger* (1950)

Latin American Masters, Beverly Hills, Calif.

Lowe Art Museum, University of Miami, Coral Gables, Fla.: *Retrato de Helena* (Portrait of Helena, c. 1940); *Retrato de Lydia Cabrera* (Portrait of Lydia Cabrera, 1941)

Mary-Anne Martin Fine Art, New York City

Moderna Museet, Stockholm: *Tropical Vegetation* (1948)

Museo de Bellas Artes, Caracas: *Light of Clay* (1950)

Museo Nacional, Palacio de Bellas Artes, Havana: *Figure on Green Ground* (1943); *Obba* (1967)

Museum of Modern Art, New York City: *La Jungla* (The Jungle, 1943); *Moths and Candles* (1946)

Pierre Matisse Gallery, New York City

Robert Henry Adams Fine Art, Chicago

Solomon R. Guggenheim Museum, New York City: *Rumblings of the Earth* (1950)

University of Central Florida, Special Collections, Orlando

Wifredo Lam Center of Contemporary Art, Havana

Bibliography

Ades, Dawn. *Art in Latin America: The Modern Era, 1820–1980*. New Haven, Conn.: Yale University Press, 1989.

Camnitzer, Luis. *New Art of Cuba*. Austin: University of Texas Press, 1994.

Catlin, Stanton L., and Terence Grieder. *Art of Latin America Since Independence*. New Haven, Conn.: Yale University Press, 1966.

Chaplik, Dorothy. *Latin American Art: An Introduction to Works of the 20th Century*. Jefferson, N.C.: McFarland, 1989.

Fletcher, Valerie. "Wifredo Lam." In *Crosscurrents of Modernism: Four Latin American Pioneers*. Edited by Valerie Fletcher. Washington, D.C.: Hirshhorn Museum and Sculpture Garden in association with the Smithsonian Institution Press, 1992. Pp. 167–89.

Hunter, Mark. "The Cuban Counterfeits." *Artnews* vol. 97, no. 11 (1998): 148–55.

Latin American Art in Miami Collections. Coral Gables, Fla.: Lowe Art Museum, University of Miami, 1994.

Lucie-Smith, Edward. *Latin American Art of the 20th Century*. New York: Thames and Hudson, 1993.

Sims, Lowery S. "Syncretism and Syntax in the Art of Wifredo Lam." In *Crosscurrents of Modernism: Four Latin American Pioneers*. Edited by Valerie Fletcher. Washington, D.C.: Hirshhorn Museum and Sculpture Garden in association with the Smithsonian Institution Press, 1992. Pp. 213–25.

Sullivan, Edward. "Fantastic Voyage: The Latin American Explosion." *Artnews* vol. 92, no. 7 (Summer 1993): 134–37.

Linares Family

Pedro Linares (1906–1992); Enrique Linares (b. 1933); Felipe Linares (b. 1936); Miguel Linares (b. 1946)
Mexican Papier-Mâché Artists

The internationally known Linares family, and their ancestors before them, have created papier-mâché art for over a hundred years (Masuoka 121). Known as *cartoneros*, makers of *cartonería* objects, they produce traditional works used during various celebrations. *Cartonería* objects are intended to last only as long as the ritual for which they are made; they are often destroyed or burned during the celebration or shortly afterward (Masuoka 1–4). Following the fiesta calendar, *cartoneros* create objects used in Mardi Gras, Holy Week, Mexican Independence Day, the Day of the Dead, Christmas, and various saints' days. Their works are constructed from paper, cardboard, and wheat-flour paste. When the surface is dry, it is covered with a base coat of paint or gesso (a white paste) and carefully painted in bright colors (Masuoka 1–2). Objects include Roman helmets, swords, and shields for reenactments of the crucifixion of Christ; various kinds of masks; piñatas; and *alebrijes*, which are strange and fantastic animals that come from the artist's imagination. But the Linares family is perhaps best known for its three-dimensional *calaveras* (skulls or, more generally, skeletons), most often used in Day of the Dead ceremonies, which generally take place on November 1 and 2.

The most celebrated member of the family is the patriarch, Pedro Linares. As a child he placed papier-mâché over clay pots to make piñatas. His family created papier-mâché Judases for Easter celebrations (Masuoka 9). Pedro died in 1992, and the family work is carried on by his three sons—Enrique, Felipe, and Miguel—and three grandsons—Leonardo, Ricardo, and David—(Masuoka 17–18). Female family members also help with the business, but their responsibilities mostly involve assisting when the orders stack up and deadlines are pressing (Masuoka 27–33). Recog-

nizing the importance of Pedro's legacy, when he died, his son Miguel remarked, "My father was not a rich man, so he did not leave us money. Our inheritance is this 'school' of art he left us" (Masuoka 145). Both traditional artistic content and innovative creative processes are valued; each member of the family makes his own own individual statements and creations.

In keeping with traditional practices, the Linares artists use whatever they can find to make their art, thus demonstrating their inventiveness. Molds for many of the pieces are made from plaster of Paris, and larger one-of-a-kind pieces are built on bamboo armatures. Objects such as plastic dolls may be purchased from local markets to help form the pieces. Brushes are made from the fur of their own cats; the artists claim they are better than store-bought brushes (Masuoka 12–15).

The *calaveras*, with which the Linares family is most strongly identified, mimic the sugar skulls that are widely available during Day of the Dead celebrations (Pomar 41). Much of the family's work is deeply rooted in Mexican ideas about death. These are exemplified by the artist **José Guadalupe Posada** (1852–1913), who became famous for his drawings and etchings of *calaveras* created for the popular press. These clothed skeletal figures mocked upper-class society with biting political criticism, in an effort to equalize them with the lower classes in death (Ades 122–23). Drawn to Posada's images and messages, Pedro Linares re-created many of Posada's scenes in three-dimensional papier-mâché installations. Like Posada, the Linares family uses humor as a way of mocking death while also mocking the living. The *calaveras* are used in celebrations that help construct meaning in Mexican life. These celebrations recognize loved ones who have died, connecting families as they dissolve the border between the living and the dead (Garciagodoy 186).

Sometimes members of the Linares family depict prominent political figures in *calavera* form. They often select politicians who have, in some way, violated the public's trust. For example, in the mid-1980s, Arturo "El Negro" Durazo was depicted by Felipe Linares. This political figure illegally spent public funds and was involved in massive payoffs. His crimes were so extravagant that many Mexicans besides the Linares satirized him. By creating images like this one, the Linares family demonstrates concern for their community as they enjoy participating in public dialogues (Masuoka 59).

Environmental disasters have also provided subject matter for the Linares family's work. For example, in response to Mexico City's 1986 disaster, they created *Earthquake Scene*. In this piece, large skeletons are trapped under the debris from fallen buildings as a figure attempts a rescue. Soldiers try to stop a looter while a coffin is carried away, and a woman carries water in a bucket because the plumbing in her home doesn't work. All figures are *calaveras* with wide-toothed grins. Another scene depicting

the earthquake was made for the celebration of the Day of the Dead the year following the disaster. Close to fifty skeletal figures were displayed at the Instituto Nacional Indigenista y Museo de Arte e Industrias Populares in downtown Mexico City (Masuoka 60–64).

The Linares family draws inspiration from popular culture. Everyday events and mass media reports inspire them. They watch Mexican films in their workshops, and they fill their walls with newspaper images. Felipe Linares's studio wall, for example, has photos of boxing scenes, cartoons, logos from canned food, and World War II Japanese airplanes. He also collects matchbook covers with images of dinosaurs on them (Masuoka 68–69, 103).

It is difficult for the Linares family to keep up with the demand for their work. Their participation in the Paris exhibition "Magiciens de la Terre" in the spring summer of 1989 "was a watershed for Mexican folk art in general and for the Linares family in particular" (Masuoka 122). After this exhibition, more and more collectors requested work, and the family began to reap more economic rewards. Patronage and at least moderate economic stability have allowed them to be more innovative with their images. Many people who now purchase their work want it for art collections and not for use in traditional rituals. This changing function means that the artists can be less concerned, for example, that an image look like a traditional Judas, which allows them to play more creatively with the images (Masuoka 126). As they continue to gain international recognition, the Linares family's papier-mâché works are increasingly becoming desirable collector's items throughout the world.

Places to See the Linares Family's Work

Disney World, EPCOT Center, Orlando, Fla.: *Skeletal Mariachi Players*

Fowler Museum of Cultural History, University of California, Los Angeles

Modern Art Museum of Fort Worth, Tex.: *A Dream of a Sunday Afternoon in Alameda Park*

Museum of Modern Art, Chapultepec Park, Mexico City

Bibliography

Ades, Dawn. *Art in Latin America: The Modern Era, 1820–1980*. New Haven, Conn.: Yale University Press, 1989.

Beezley, William H. *Judas at the Jockey Club and Other Episodes of Porfirian Mexico*. Lincoln: University of Nebraska Press, 1987.

Canales, Victor Inzúa. *Artesanaías en Papel y Cartón*. Mexico City: Fondo Nacional para el Fomento de las Artesanías, 1982.

Canales, Victor Inzúa. *El Imaginativo Mundo de los Linares*. Mexico City: Escuela Nacional de Trabajo Social, UNAM, 1987.

Espejel, Carlos. *Las Artesanías tradicionales en México*. Mexico City: Secretaría de Educación Pública-Setentas, 1972.

Garciagodoy, Juanita. *Digging the Days of the Dead: A Reading of Mexico's Días de Muertos*. Niwot: University Press of Colorado, 1998.

Lamadrid, Enrique R., and Michael A. Thomas. "The Masks of Judas: Folk and Elite Holy Week Tricksters in Michoacán, Mexico." *Studies in Latin American Popular Culture* 9(1990): 191–208.

Masuoka, Susan N. *En Calavera: The Papier-Mâché Art of the Linares Family*. Los Angeles: Fowler Museum of Cultural History, UCLA, 1994.

Pomar, María Teresa. *El Día de los Muertos: The Life of the Dead in Mexican Folk Art*. Forth Worth, Tex.: Fort Worth Museum, 1987.

Carmen Lomas Garza

(b. 1948)
Mexican-American Painter, Sculptor, and Writer

Carmen Lomas Garza is a storyteller. Vibrantly painted scenes of family and community illustrate her experiences as a young girl in Kingsville, Texas, near the Mexico border. During the Mexican Revolution (1910–1917), when her father was an infant, her grandparents left Mexico for Texas (Beardsley and Livingston 169). The men in the family worked as *vaqueros* (ranch hands) and on the railroads. Her mother, who raised five children, was a florist and a painter. Art was central in the home; her mother painted *lotería tablos* (playing cards used in a game similar to bingo) with watercolors, and her grandmother embroidered from her own drawings, crocheted, and made paper flowers. Carmen was encouraged to make art, and knew by the age of thirteen that she would be an artist.

Her childhood was filled with family gatherings, rituals, and the development of community pride. As a Chicana, Lomas Garza confronted obstacles that led to a reevaluation of her Mexican-American cultural identity in positive terms. She remembers with pain the punishment she received for speaking her native language, Spanish, in school (Shaw-Eagle D1). However, this did not deter her from succeeding in school, nor did she abandon her cultural identity.

After high school, Lomas Garza studied art and art education at Texas Arts and Industry University in Kingsville (founded 1917), now a branch of Texas A&M (founded 1876, College Station), receiving her teaching certificate in 1972. In 1973, she earned her master's degree in education from Juárez-Lincoln/Antioch Graduate School in Austin, and her master's degree in art from San Francisco State University in 1980.

While in college, Lomas Garza became deeply involved with the Chicano movement, an offshoot of the 1960s civil rights movement. She has

Carmen Lomas Garza, 1990. Photo by Hulleah Tsinhnahjannie. Courtesy of Bernice Steinbaum Gallery, Miami. Used with permission.

said that this period "inspired the dedication of my creativity to the depiction of special and everyday events in the lives of Mexican Americans based on my memories and experiences in South Texas" (Lomas Garza *Carmen Lomas Garza*, 1). Goals of the Chicano movement included acknowledgment of the Mexican heritage and the recognition by the rest of society that Chicanos had experienced, and continued to experience, inequities.

The Cuban-American artist **Coco Fusco** recognizes the cultural fusion that has taken place with the interaction between Mexicans and other U.S. citizens, but also observes that there are differences in the ways that these two groups approach life. She suggests that for the Chicano/a, the Spanish language represents the private life in the home and with family, while the English language represents the social, public life in the United States (Self 2). Lomas Garza's interest lies with rituals and celebrations that are more private, family-oriented, and culturally rooted. By depicting these gatherings in her art, she has made them more public, and in this way she fulfills

the goals of the Chicano movement. To reach both English- and Spanish-speaking people, the titles of her works are presented in both languages.

Lomas Garza deconstructs negative stereotypes of Mexican-Americans. In a shallow picture space, she creates brightly colored images that portray family life, community dances, wedding celebrations, and birthday parties. The painting *Barbacoa para Cumpleaños* (Birthday Barbecue, 1993), for example, shows the celebration of her sister Mary Jane's birthday (Walkup 27). Family and friends of various ages are dancing, laughing, playing with an orange piñata, cooking on the grill, and communing in the backyard.

Lomas Garza strives to fight racism, separatism, and isolationism by presenting a positive perspective of the Chicano community. While honoring her Mexican-American ancestry, she portrays family themes that speak to audiences outside of her community (Walkup 27). Lomas Garza aims to express ideas that are relevant to everyone. She hopes that "people who are not Mexican American or Latino can see my artwork and get a better idea of who we are as Mexican Americans, and also see similarities from their own cultures" (Thorson D1). In regard to her 1997 exhibition, "Monitos," at the Kemper Museum of Art, Dana Self wrote about the implicit intent emanating from the work of Lomas Garza:

> Through her *monitos* (little figure) paintings, Carmen Lomas Garza reclaims family stories, memories, healings, ceremonies, and everyday life so that viewers inside her culture may engage in a shared history, and viewers outside of Chicano culture may witness a familial history of the largest Spanish-speaking group in the United States. (1)

Lomas Garza is conscious of her role as a woman artist and acts on the opportunity to honor women in traditional roles through her painting. The artist **Amalia Mesa-Bains**, considering the work of Lomas Garza from a feminist perspective, sees the construction of a new kind of representation of women outside the framework of patriarchy. These are active women, empowered by traditional knowledge they have received from generations of female ancestors. Mesa-Bains points out that "the instructive gaze of Lomas Garza's women asserts a locus of control and becomes central to the action of the painting" (Taylor 5). Lomas Garza, speaking about the women she paints, said, "I wanted to depict in fine art form all the things of our culture that are important or beautiful or very moving" (Beardsley and Livingston 172).

Early in her career, Lomas Garza developed a playful, bright style without much regard for what she had learned in art school. She explains the deliberate abandonment of academic art for a colorful, narrative quality in her paintings as an effort to reach larger audiences (Thorson D1). She feels that her ideas can best be communicated in this manner. Her style is

often referred to as "folklike," similar to the work of Grandma Moses (1860–1961), and the highly personal content of her work is compared to that of **Frida Kahlo**. Lomas Garza portrays her childhood memories, expressing a positive perspective on her culture, whereas Kahlo worked out her most intimate and personal experiences through her paintings.

Lomas Garza has received many awards, including the VIDA Award, Arts category (1995); California Arts Council Artist-in-Residence grants (1979, 1982, 1984, 1986); and a National Endowment for the Arts Fellowship in printmaking (1981), and many others. She currently lives in San Francisco and teaches at San Francisco State University. Lomas Garza reaches children through bilingual books that she writes and illustrates. The stories are told from the perspective of a young girl from South Texas. For example, *Cuadros de Familia/Family Pictures* is filled with stories that resemble those told in her paintings. Her words come to life with the joyful illustrations of birthdays, parties, dances, and town gatherings. Through her books, she is able to send positive messages about the Chicano culture in the United States. Her art and activism depict and strengthen the Chicano movement and the women's movement, and reflect progress toward change and enlightenment.

Places to See Lomas Garza's Work

Bernice Steinbaum Gallery, Miami, Fla.

El Paso Museum of Art, El Paso, Tex.

Federal Reserve Bank of Dallas: *Barbacoa para Cumpleaños* (Birthday Barbeque, 1993)

Hirshhorn Museum and Sculpture Garden, Washington, D.C.

Kemper Museum of Contemporary Art and Design, Kansas City, Mo.

Laguna Gloria Art Museum, Austin, Tex.

Mexican Fine Arts Center Museum, Chicago

National Museum of American Art, Smithsonian Institution, Washington, D.C.: *Lotería-Primera Tabla* (1972); *Lotería-Segunda Tabla* (1972); *Lotería-Tercera Tabla* (1972); *Ofrecendo Flores* (1987); *Lotería-Tabla Llena* (1972); *La Crandera* (c. 1974); *Camas para Suerios* (1985); *Tamalada* (1990)

Oakland Museum, Oakland, Calif.

San Francisco Art Commission

Shields Library, University of California-Davis

Smith College Museum of Art, Northampton, Mass.: *La Bendición en el Día de la Boda* (The Blessing on a Wedding Day, 1993)

University of Texas Library, Austin

Bibliography

Beardsley, John, and Jane Livingston. *Hispanic Art in the United States: Thirty Contemporary Painters and Sculptors*. Houston, Tex.: Museum of Fine Arts; New York: Abbeville Press, 1987.

Cockcroft, Eva Sperling. "Chicano Identities." *Art in America* vol. 80, no. 6 (1992): 84–91.

Cruger, R. D. "Like a Virgin Mother." *Tacoma City Paper*, January 15, 1998, p. 5.

Filler, Marion. "Art Shows Put Latinos on Exhibit." *Daily Record* Morris County, N.J., January 27, 1996.

Hackett, Regina. "Tacoma Show Celebrates the Virgin of Guadalupe as a Cultural Star." *Seattle Post Intelligencer*, December 19, 1997, p. 16.

Jones, Joyce. "All in the Familia." *Washington Post*, December 8, 1995, p. A2.

Lomas Garza, Carmen. *Cuadros*. San Francisco: Children's Book Press, 1990.

Lomas Garza, Carmen. *Carmen Lomas Garza: Pedacito de mi Corazón*. Austin, Tex.: Laguna Gloria Art Museum, 1991.

Lomas Garza, Carmen. *Family Pictures/Cuadros de Familia*. San Francisco: Children's Book Press, 1993.

Lomas Garza, Carmen. *A Piece of My Heart/Pedacito de mi Corazón: The Art of Carmen Lomas Garza*. New York: The New Press, 1994.

Lomas Garza, Carmen. *Magic Windows/Ventanas-Mágicas*. San Francisco: Children's Book Press, 1999.

Lomas Garza, Carmen. *Making Magic Windows: Creating Cut Paper Projects with Carmen Lomas Garza*. San Francisco: Children's Book Press, 1999.

Lomas Garza, Carmen. *In My Family/En Mi Familia*. San Francisco: Children's Book Press, 2000.

Lomas Garza, Carmen. *Carmen Lomas Garza*. 2002. http://tlaloc.sfsu.edu/~clgarza

Self, Dana. *Carmen Lomas Garza: Monitos*. Exhibition catalog, Kemper Museum of Contemporary Art, June 21–September 7, 1997. http://www.kemperart.org

Shaw-Eagle, Joanna. "Rich Heritage Fills Joyful Pictures from Childhood." *Washington Times*, December 17, 1995, p. D1.

Taylor, Victor Zamudia. *Carmen Lomas Garza*. New York: Whitney Museum of American Art, 1995.

Thorson, Alice. "Such Are the Expressions of Everyday." *Kansas City Star*, July 21, 1997, pp. D1, D2.

Walkup, Nancy. "Carmen Lomas Garza: A University Tribute to Family, Heritage, and Community." *School Arts* 9 (1997): 27–30.

George T. López
(1900–1993)
Mexican-American Sculptor

George López was an expert *santero*, a carver of saints, as was his father, José Dolores López, who had learned to carve from his father, Nasario López (Siporin 63). George followed in the family tradition, working with his father and further developing his skills after his father's death in 1937 (Rosenak and Rosenak 194). His fame as a traditional artist was so great that in 1982 he was awarded a National Heritage Fellowship by the National Endowment for the Arts. His work reflects the traditional practices of both his father and his extended community (Siporin 59). The santos, originally made for community members, primarily conform to a local aesthetic (Dewhurst et al. 8).

López, whose ancestors settled in northern New Mexico in 1590, was born in the small town of Córdova, New Mexico, a tiny agricultural town in the mountains on the road from Santa Fe to Taos. Most of its inhabitants had small farms and raised sheep. López's father was a carpenter who made furniture in the Santa Fe style (which has a heavy, chip-carved look) as well as finely carved santos. A religious man, José Dolores López was responsible for making and caring for the objects in his church. He also carved for other churches in the area, as well as for home altars. Father and son were initiated into the Brothers of Jesus of Nazareth, sometimes known as the Penitentes, but George left this group, which was not approved by the Catholic Church, after several years, without taking part in their secret ceremonies.

Before turning to the carving of saints full-time, López worked in road construction, which took him away from home much of the time. However, by 1952, he was home in Córdova, making exquisite statutes of saints to fill numerous orders from collectors and placing his work in local

churches (Rosenak and Rosenak 192–94). López is one of many carvers in the Córdova area who was influenced by the work of his father, and this carving tradition is being passed on to the younger generations.

In Córdova's traditional carving community, the old teach the young. Sometimes work is collaborative. The folklorist Henry Glassie noted that López's wife, Silvianita, often finished carvings that George had begun by decorating them with small animals she carved (99). There is a family style; and various duties, such as selling the work, generally stay in the family. However, people from outside the family who wish to learn have been welcomed.

López generally used aspen, but also made saints from willow, juniper, pine, cedar, and cottonwood that he found in the Sangre de Cristo Mountains. They were never painted, allowing the beauty of the wood to speak for itself (Rosenak and Rosenak 194). He sold his works both to locals, who used them for religious purposes, and to collectors, who liked them because of their beauty and expressiveness. But in López's mind, the works sold to the two groups were different. They were not holy unless a priest blessed them. Many of the works, mostly those sold to collectors outside the community, were not blessed, and therefore cannot be called *santos* (Haritgan 169).

López's first major piece portraying Adam and Eve was a Tree of Life, carved in 1937 (Siporin 66). He repeated this theme many times, along with a depiction of the expulsion of Adam and Eve from the Garden of Eden (Ardery 114). But López is best known for his carvings of saints. His works make innovative use of their subject matter, have a complex, action-oriented composition, and are animated and unified (Johnson and Ketchum 171).

The well-known folk art collector Herbert Hemphill remembered a visit to López's house in 1972: "He would make souvenir things which he sold in his front room. In the back room were the more elaborate big things. . . . That's where I bought the devil under the foot of St. Michael" (Hartigan 56). This carving was later given to the Smithsonian American Art Museum as part of Hemphill's folk art collection. In *Saint Michael the Archangel and the Devil* (c. 1955–1956), López depicts Satan's opponent, the protector of children and the patron saint of soldiers. Saint Michael is a popular saint in Hispanic New Mexico, and this portrait of him is particularly expressive. He stands upright and victorious, with one foot placed firmly on the devil's chest. A sword in one hand reaches toward the sky, and a long, sharp weapon in Saint Michael's other hand is held at the victim's neck, carefully keeping him immobile. The devil, too, communicates an expressive essence; he is half snake and half insect-dragon, with sharp claws and long horns (Hartigan 169).

George López is an important artist, not only because he produced wonderfully expressive carvings but also because he links past religious prac-

tices with the present. Córdova continues to be known as a town where artistic practices and life blend, making López's body of work more than beautiful objects for aesthetic contemplation.

Places to See López's Work

Museum of International Folk Art, Santa Fe, N.M.

Smithsonian American Art Museum, Washington, D.C.: *Saint Michael the Archangel and the Devil*

University of Nebraska Art Galleries, Lincoln: *San Rafael*

Bibliography

Ardery, Julia S. *The Temptation: Edgar Tolson and the Genesis of Twentieth-Century Folk Art*. Chapel Hill: University of North Carolina Press, 1998.

Briggs, Charles L. "The Role of *Mexicano* Artists and the Anglo Elite in the Emergence of a Contemporary Folk Art Form." In *Folk Art and Art Worlds*. Edited by John Michael Vlach and Simon Bronner. Ann Arbor, Mich.: UMI Research Press, 1986. Pp. 195–224.

Briggs, Charles L. *The Wood Carvers of Córdova, New Mexico*. Knoxville: University of Tennessee Press, 1980.

Dewhurst, C. Kurt, Betty MacDowell, and Marsha MacDowell. *Religious Folk Art in America: Reflections of Faith*. New York: E. P. Dutton in association with the Museum of American Folk Art, 1983.

Glassie, Henry. *The Spirit of Folk Art: The Girard Collection at the Museum of International Folk Art*. New York: Harry N. Abrams in association with the Museum of New Mexico, 1989.

Hartigan, Lynda Roscoe, with Andrew Conners, Elizabeth Tidel Holmstead, and Tonia L. Horton. *Made with Passion: The Hemphill Folk Art Collection in the National Museum of Art*. Washington, D.C.: Smithsonian Institution Press, 1990.

Hunt, Marjorie, and Boris Weintraub. "Masters of Traditional Arts." *National Geographic*, January 1991: 74–101.

Johnson, Jay, and William C. Ketchum, Jr. *American Folk Art of the Twentieth Century*. Foreword by Robert Bishop. New York: Rizzoli, 1983.

Oppenhimer, Ann. "Sabinita Lopez Ortiz: A Tradition Continues." *Folk Art Messenger* 14, no. 2 (Summer 2001): 15–19.

Rosenak, Chuck, and Jan Rosenak. *Museum of American Folk Art Encyclopedia of Twentieth-Century American Folk Art and Artists*. New York: Abbeville Press, 1990.

Siporin, Steve. *American Folk Masters: The National Heritage Fellows*. New York: Harry N. Abrams in association with the Museum of International Folk Art, 1992.

Yolanda M. López

(b. 1942)
Mexican-American Printmaker, Videographer, and Installation Artist

Yolanda López is best known for her *Guadalupe* series (1978), in which she removes the traditional Virgin figure and replaces it with liberating images of family members and herself. Her work is both politically involved and rooted in the aesthetic of her community. She works in a variety of media, examining Mexican stereotypes, exploring family stories, and analyzing Mexican kitsch (Mesa-Bains 137–38).

She acknowledged that when she was growing up in San Diego, "the ideal was white, and I was not. . . . So I never considered myself pretty or anything like that" (Mesa-Bains 137). As an adult she became a leader of the Chicana movement and a role model for Chicanas seeking political awareness and empowerment. López said of this time: "In 1969 I consciously declared myself a Chicana artist, without knowing anything about what that meant, fully realizing that it was an act of invention" (Gaspar del Alba 260).

López's grandmother, a Mexican immigrant, looked after her and her three sisters while her mother worked in a hotel laundry and, later, at San Diego's Naval Training Center, to support the family. Because she spoke Spanish at home, school was difficult at first, and she had to repeat the first grade. In her later childhood, political activism was strong; Chicanos were fighting for civil rights, and César Chávez was leading a farmworkers' strike. As a young adult, she studied art, but was also active in neighborhood clinics and settlement houses (LaDuke, *Women Artists* 103–04; Martin and Meyer 136). López received her B.A. in painting and drawing in 1975 from San Diego State University, and her M.F.A. in visual arts from the University of California at San Diego in 1979. Mixing art with working for the empowerment of Chicanos, she was the director of the Mission

Cultural Center in San Francisco, where she still resides, for several years in the 1980s (Lippard 41).

The *Guadalupe* series celebrates hardworking, energized, and politically active working-class women. These powerful images set the Virgin of Guadalupe free by actively reconstructing her in a way that identifies her with Mexican women, as assertive and present in time and space (Mesa-Bains 137). In an oil pastel on paper, *Margaret F. Stewart: Our Lady of Guadalupe* (1978), the figure (López's mother) sews a star-patterned fabric with a sewing machine. The altering of an outfit represents the altering of the Guadalupana icon (Gaspar del Alba 16). In *Portrait of the Artist as the Virgin of Guadalupe* (1978), the Virgin Mary is a marathon runner wearing running shoes and stomping on an evil angel, a middle-aged man with wings of red, white, and blue who represents patriarchy. She holds a serpent in her hands, indicating that she has power (Gaspar del Alba 140–141). The third work in this series is *Grandmother: Our Lady of Guadalupe* (1978). Here López's grandmother sits in a chair. In her hand she holds a snakeskin and a knife, indicating her connection to food and the soil from which it comes. A winged angel presents flowers to her, holding them over her head (LaDuke, *Women Artists* 106). Explaining how she felt about the Virgin of Guadalupe and how she, as an artist, changed the image, López said:

> I was interested in her visual image as a role model. Essentially she is beautiful, serene, passive. She has no emotional life or texture of her own. She exists within the realm of magical mythology sanctified as a formal entity by religious tradition. She remained the Great Mother, but her representation is as plastic as our individual fears and aspirations. Because I feel living, breathing women also deserve the respect and love lavished on Guadalupe, I have chosen to transform the image. (Goldman 208)

López's work has provoked anger. When an image of the Virgin of Guadalupe, dressed like a working-class Mexican woman, was placed on the cover of *Fem* magazine, the publication's office received a bomb threat (LaDuke, *Women Artists* 110–112). In other instances, her manipulation of the traditional image of the Virgin has raised questions and concerns, especially among Catholics.

López was inspired by her son to do a work that incorporated his art. For *Rio's Room* (1985), a two-room installation at the Centro Cultural de la Raza in San Diego, she made mural-size enlargements of his drawings. Critics noted the undercurrent of violence in the art, as is common in children's art. To emphasize her point, López scattered flash cards on the floor. Some were traditionally used in school, but others concerned topics such as political terrorism (LaDuke, *Women Artists* 107).

López collected numerous slides related to advertising, film, and the

media that portrayed negative images of the Mexican. These images were converted to videotape, becoming her production *When You Think of Mexico: Commercial Images of Mexicans* (1986) (Goldman 229). In this half-hour videotape, a male and a female narrator use humor and indignation to confront stereotypes. These range from the Frito Bandito to images of the lazy, harmless Mexican with an oversized sombrero, sleeping under a cactus (Lippard 41).

Yolanda López's work is about changing identities and questioning stereotypes. It confronts and questions how Chicanos are represented and controlled. López claims that her community needs to develop visual literacy as a survival skill (Lippard 42). Her art has both challenged and changed the way viewers from varying cultural backgrounds think about people from Mexico. For López, "Art is important. The artist is the person in society who dreams out loud" (López 137).

Places to See López's Work

Cover of *Fem* magazine, June/July 1984: http://143.235.10.10/English/nchick/lopez1.html

Los Angeles County Museum of Art

M. H. de Young Memorial Museum, San Francisco

University of California at Santa Barbara Library, California Ethnic and Multicultural Archives: Yolanda M. López Papers

Bibliography

Blanc, Giulio V. "When You Think of Mexico: Latin American Women in the Decade Show." *Arts Magazine* 64 (April 1990): 17–18.

Gaspar del Alba, Alicia. *Chicano Art: Inside/Outside the Master's House. Cultural Politics and the CARA Exhibit.* Austin: University of Texas Press, 1998.

Goldman, Shifra. *Dimensions of the Americas: Art and Social Change in Latin America and the United States.* Chicago: University of Chicago Press, 1994.

LaDuke, Betty. *Women Artists: Multi-cultural Visions.* Trenton, NJ: Red Sea Press, 1992.

LaDuke, Betty. "Yolanda Lopez: Breaking Chicana Stereotypes." *Feminist Studies* 20 (Spring 1994): 117–22.

Lippard, Lucy. *Mixed Blessings: New Art in a Multicultural America.* New York: Pantheon, 1990.

López, Yolanda M. "Artists' Voices: Yolanda M. López." In *Contemporary Art and Multicultural Education.* Edited by Susan Cahan and Zoya Kocur. New York: Routledge, 1996. P. 137.

Martin, Elizabeth, and Vivian Meyer. *Female Gazes: Seventy-five Women Artists.* Toronto: Second Story Press, 1997.

Mesa-Bains, Yolanda. "El Mudo Femenino: Chicana Artists of the Movement—A Commentary on Development and Production." In *Chicano Art: Resis-*

tance and Affirmation, 1965–1985. Los Angeles: Wight Art Gallery, UCLA, 1991. Pp. 131–40.

Palmisano, Joseph M., ed. *Notable Hispanic American Women*. Volume 2. Foreword by Elisa María Sánchez. Detroit: Gale, 1998.

Peterson, Jeanette Favrot. "The Virgin of Guadalupe: Symbol of Conquest or Liberation." *Art Journal* 51, no. 4 (Winter 1992): 39–47.

Steinman, Susan Leibovitz. "Directional Signs: A Compendium of Artists' Works." In *Mapping the Terrain: New Genre Public Art*. Edited by Suzanne Lacy. Seattle, Wash.: Bay Press, 1995. Pp. 187–285.

Anita Malfatti
(1889–1964)
Brazilian Painter

Anita Malfatti, who first exhibited her work in 1914 and 1917 in São Paulo, Brazil, was largely responsible for the beginnings of the Modernist movement in Brazil. In keeping with Expressionist theories of the time, her work emphasized subjectivity, using brilliant colors, exaggerated form, and unrealistic perspective to portray emotion (Barnitz 56; Mesquita 203).

Born in Brazil, she lived from 1911 to 1914 in Germany, where, in Berlin, she had the opportunity to study with Lovis Corinth, an established artist. She attended exhibitions and saw Impressionist and Postimpressionist work that inspired her to use bright colors. During 1915 and 1916, she lived in the United States, where she met the artists Juan Gris and Marcel Duchamp (Barnitz 56–57) and discussed art and war with the European exiles among whom she lived. The subjects of her paintings were usually immigrants and outsiders. Canton, describing Malfatti's subjects, said that they "seem to strain against the edges of the canvas; her colors are raw although they are painstakingly built up; her tortured backgrounds recall Van Gogh's" (189).

In New York City, Malfatti attended the Art Students League but, finding it too conservative, she moved to Maine. Many of the brightly colored works displayed in the 1917 São Paulo exhibition were done during this time (Barnitz 57). Her teacher in Maine was Homer Boss, who encouraged her to continue her use of bright colors, to evoke emotion rather than objectivity (Mesquita 203). Some of her best-known paintings displayed in the 1917 exhibition include *O Homen Amarelo* (Yellow Man), *A Boba* (The Fool), and *A Mulher de Cabelos Verdes* (Woman with Green Hair), all painted while she was in New York (Canton 189).

This early work was seen as very daring. Malfatti painted blue and green

shadows on the faces of her subjects and distorted perspective, flattening it out on the canvas. In *A Boba* (1915–16), a woman sits awkwardly on a chair. Her face and body are angular, colored in an exaggerated manner. Although it was not as radical as work of the German Expressionists, *A Boba* nevertheless broke the rules as it explored new boundaries (Mesquita 203). This approach to painting did not appeal to many critics; they attacked it, as they did much modern art of the time. For example, Monteiro Lobato, a São Paulo art critic, wrote an article in the daily newspaper *O Estado de São Paulo*, titled "Paranoia or Deception," comparing her work to that of insane artists. It was such an influential review that purchasing requests were withdrawn, and, for a few years, collectors sought out works by more conservative artists (Barnitz 56).

In 1920 Malfatti become a member of the Modernist Group of Five, along with **Tarsila do Amaral**, Menotti del Picchia, and Mário de Andrade and Oswald de Andrade (who are unrelated) (Traba 54). The two latter members of the group were avant-garde poets who became major figures in the Modernist movement, and Mário, who also wrote art criticism, was an ardent supporter and collector of Malfatti's work. Malfatti painted him in *Mário de Andrade* (1922) partly in appreciation for his support (Barnitz 57).

In 1922, a Modernist group exhibition in São Paulo had a profound effect on Brazilian art by firmly establishing Modernism. It was closely followed by lectures, concerts, and poetry readings, and Malfatti was credited with its success. The manifesto of this movement, *Anthropophagic Manifesto* (1928), proposed a kind of cannibalism, in that Brazilian artists should both "eat" and "digest" foreign cultural trends (Canton 187).

Negative press coverage eventually caused Malfatti to become more restrained in her work. She gradually changed her style, creating compositions that were less dramatically related to the avant-garde of the time (Mesqita 203). Especially from 1923 to 1927, when she lived in Paris, her work became more reserved. For example, *Port of Monaco* (1925–1926) is a delicate, well-balanced landscape.

When Malfatti returned to Brazil, she found a vibrant Modernist movement that she had helped to create, but was not involved in, partly because of the negative press she had previously received. Consequently, her late paintings depict centered figures in subtle colors. In fact, before she died, her paintings were "wholly unmodernist," reverting to more realistic conventions used in earlier times (Canton 189).

While Anita Malfatti is credited with the development of Modernist painting in Brazil, it is **Tarsila do Amaral** who blended Modernist ideas with Brazil's cultural roots (Barnitz 62). What is amazing is that these two women were able to make such a difference in a male-dominated country. They laid the groundwork for other women artists to flourish in Brazil. In fact, some say that women artists in Brazil have made such a substantial

contribution to the visual arts in the twentieth century that "there is no longer a sexual distinction made among the country's most powerful artists" (Amaral 18). Malfatti is remembered for her inventive painting, as well as for paving the way for other Brazilian women artists to become successful.

Places to See Malfatti's Work

Museu de Arte Contemporânea da Universidade de São Paulo

Museu de Arte de São Paulo

Pinacoteca do Estado, São Paulo

Bibliography

Amaral, Aracy. "Modernist Period (in Brazil)." *Art and Artists* 11 (April 1976): 32.

Amaral, Aracy A. "Brazil: Women in the Arts." In *Ultramodern: The Art of Contemporary Brazil*. Aracy A. Amaral and Paulo Herkenhoff. Washington, D.C: National Museum of Women in the Arts, 1993. Pp. 17–34.

"Anita Malfatti on the Internet." http://artcyclopedia.com/artists/malfatti_anita. html

Barnitz, Jacqueline. *Twentieth-Century Art of Latin America*. Austin: University of Texas Press, 2001.

Canton, Katia. "São Paulo: Anita Malfatti at the Museum of Modern Art." *Art in America* vol. 78, no. 6 (1990): 187, 189.

Lucie-Smith, Edward. *Latin American Art of the 20th Century*. New York: Thames and Hudson, 1993.

Mesquita, Ivo. "Brazil." In *Latin American Art in the Twentieth Century*. Edited by Edward J. Sullivan. London: Phaidon Press, 1996, Pp. 201–32.

Traba, Marta. *Art of Latin America, 1900–1980*. Washington, D.C.: Inter-American Development Bank, Baltimore: Johns Hopkins Press, 1994.

Marisol (Escobar)
(b. 1930)
Venezuelan-American Sculptor

Born in Paris to upper-class Venezuelan parents (Chaplik 117), Marisol (she dropped her last name early in her career) is best known for her humorous sculptures, her beauty, and her eccentricity. Some critics identify her as a Pop artist; others claim she has little in common with that movement, and that her sculptures are more influenced by pre-Columbian pottery, Mexican boxes with pictures inside, and early North American folk art. According to Félix Angel, at its best her work, made of wood, plaster, and synthetic materials, satirizes social and political attitudes (Angel 274).

Marisol's father, who encouraged her to be an artist, gave her both emotional and financial support (Nemser, *Art Talk* 156). Marisol's educational background is varied. Early on, she drew well and earned prizes for her work (Chaplik 117). She studied at the Jepson School in Los Angeles from 1946 to 1949, and from 1949 to 1950 she attended the School of Fine Arts and the Julien Academy in Paris. She later studied in New York City at the Art Students League and the New School for Social Research, as well as with the well-known painter Hans Hofmann (*Latin American Spirit* 320). Her skills in sculpture were developed mostly through trial and error, by calling a factory to get instructions on how to do something, or requesting advice from her sculptor friends (Chaplik 117).

A member of the Beat generation, Marisol spent time in New York City's Greenwich Village in the 1950s. Her early work depicts all kinds of people, from migrant workers in *Family from the Dust Bowl* (ca. early 1960s) to socialites in *The Party* (1965–66). In *LBJ* (1967) she portrayed an oversized Lyndon B. Johnson holding three little women, his wife and

daughters, a depiction of male chauvinism made early in the feminist movement (Nemser, *Art Talk* 155).

Many stories have been told about Marisol. It was said that she didn't talk, was often reclusive and mysterious. Andy Warhol claimed she was the first "glamorous girl artist" (Martin and Meyer). She claimed that many of these tales and descriptions were the result of her not being taken seriously as an artist. In other words, she felt that she attracted attention as a personality, and not for her work. However, she acknowledged that she went along with much of the mythmaking, because she enjoyed the various personas: "I like to do lots of different things. So at one point I was like a beatnik; then at one point I wanted to be a society girl; then a diver, a skier. I'm very curious. But it is not that I really believe in all these things" (Nemser, *Art Talk* 158). Besides making sculpture and prints, Marisol performed in Andy Warhol films, including *The Kiss* (1963) and *The 13 Most Beautiful Women* (1964).

Sometimes Marisol's lectures are like performances. Once, when she arrived to give a presentation, she appeared in a Japanese mask. The art historian Dorothy Chaplik reported that when audience members asked her to remove it, she did so, revealing her face painted exactly the same as the mask (117). To call attention to the masks we wear, and all our many identities, she has cast her face numerous times, creating masks. About this process, she said:

> There comes a point where you start asking, "Who am I?" I was trying to find out through my sculpture. That's why I made all those masks and each one of them is different. Every time I would take a cast of my face it came out different. You have a million faces. It's like photography: it's spooky. (Nemser, *Art Talk* 157)

Her *Self-Portrait* (1961–62) shows her as many different people, all joined together by blocks of wood that serve as the torso. Though she has seven faces, she has only six legs and even fewer arms (Chadwick 310–11).

Marisol's work is marked by the repeated use of her own body parts and by the variety of materials and techniques she uses. Though she makes use of traditional sculptural materials, she also selects materials from everyday life, including pieces of clothing (Chaplik 117). In a portrait of the writer William Burroughs, she suspends a lightbulb over his head, giving an eerie presence to the figure. Multiple sets of hands are present in several of her portraits. The artist Willem de Kooning has three sets, and Picasso has four (Simon 121).

In 1964 an exhibition of Marisol's work included *The Wedding, Andy Warhol, John Wayne, Double Date*, and *The Babies*, all works done in the early years. Women were encased in wooden blocks, indicating their restrictive and repressive social roles. There were monstrous babies and pop

heroes. Parts of her own image were repeatedly incorporated into these sculptures (Chadwick 337).

More recent work focuses on the life of the sea. Marisol has attached her own features to mahogany sea forms, such as the barracuda and the shark. They appear to be dangerous creatures. However, as a scuba diver, she claims that she is comfortable being under the water; but she understands that most people aren't. She likes the fact that when you dive, everything changes, and there are all kinds of things going on (Nemser, *Art Talk* 166–67).

Marisol refers to many of her works as homages, especially those which depict famous artists and people she knows. In her portraits of artists, mostly from the late 1970s and early 1980s, the subjects sit in chairs as if they were in familiar spaces. Working from memory (many subjects are friends), photographs, and magazine pictures, she carefully carves the heads, the most detailed part of the sculpture, in high relief. The torsos are blocky, abstract, and stylistically different from the heads and hands, which usually are either carved or cast. A bit of painting or drawing on the wood enhances the rendering. Each artist is posed in a way that reveals the talent or character of the individual. For example, *Virgil Thomson* (1981) straddles his piano bench; one hand rests on a knee, the other, dismembered from the body, lies on top of a baby grand piano. It is as if he is ready to turn to the piano and begin playing. The "Steinway & Sons" logo is carefully drawn on the plywood piano (Simon 120–21).

Marisol's sculptures explore changing identities. Because her art represents her interpretation of the world, it is certainly autobiographical, but it can also easily be considered social commentary.

Places to See Marisol's Work

Albright-Knox Art Gallery, Buffalo, N.Y.

Arts Club of Chicago

Brooks Memorial Art Gallery, Memphis, Tenn.

Hawaiian Statuary Hall, Honolulu

Museum of Modern Art, New York City

Smithsonian American Art Museum, Washington, D.C.

Whitney Museum of American Art, New York City

Worcester Art Museum, Worcester, Mass.

Bibliography

Andre, Michael. "Marisol at Marlborough: New York Exhibit." *Art in America* vol. 83, no. 12 (1995): 91–92.

Angel, Félix. "The Latin American Presence." In *The Latin American Spirit: Art*

and Artists in the United States, 1920–1970. Essays by Luis R. Cancel, Jacinto Quirarte, Marimar Benítez, Nelly Perazzo, Lowery S. Sims, Eva Cockcroft, Félix Angel, and Carla Stellweg. New York: Bronx Museum of the Arts in association with Harry N. Abrams, 1988. Pp. 222–83.

Campbell, Lawrence. "Marisol's Magic Mixtures." *Artnews* vol. 63, no. 3 (1964): 38–41.

Chadwick, Whitney. *Women, Art, and Society.* New York: Thames and Hudson, 1990.

Chaplik, Dorothy. *Latin American Art: An Introduction to Works of the 20th Century.* Jefferson, N.C.: McFarland, 1989.

The Latin American Spirit: Art and Artists in the United States, 1920–1970. Essays by Luis R. Cancel, Jacinto Quirarte, Marimar Benítez, Nelly Perazzo, Lowery S. Sims, Eva Cockcroft, Félix Angel, and Carla Stellweg. New York: Bronx Museum of the Arts in association with Harry N. Abrams, 1988. Pp. 313–38.

Loring, John. *Marisol: Prints 1961–1973.* New York: New York Cultural Center in association with Fairleigh Dickinson University. 1973.

Martin, Elizabeth and Vivian Meyer. *Female Gazes: Seventy-five Women Artists.* Toronto: Second Story Press, 1997.

Museum of Modern Art. *Latin American Artists of the Twentieth Century: A Selection from the Exhibition.* New York: Harry N. Abrams, 1992.

Nemser, Cindy. "A Conversation with Marisol." *Feminist Art Journal* 2 (Fall 1973): 1, 3–6.

Nemser, Cindy. *Art Talk: Conversations with 15 Women Artists.* Rev. ed. New York: HarperCollins, 1995.

Simon, Joan. "Chers Maîtres." *Art in America* vol. 9, no. 10 (1981): 120–21.

María Martínez-Cañas
(b. 1960)
Cuban Photographer

María Martínez-Cañas makes maps that explore and analyze routes, jour-
neys, and heritage. When she was three months old, Martínez-Cañas's
family moved from Cuba to Puerto Rico. Her parents collected Latin
American art, so she was keenly aware of how art could visually represent
cultural traditions. In 1978 she enrolled at the Philadelphia College of Art,
where she received a B.A. degree in 1982 in photography. She also earned
an M.F.A in photography at the School of the Art Institute of Chicago in
1984.

Although raised in Puerto Rico, Martínez-Cañas claimed to feel far
more Cuban than Puerto Rican. When she moved to Philadelphia, where
she had no Latin friends, she continued to feel out of place. This experi-
ence started to change, however, when she moved to Chicago and realized
the importance of her Cuban culture. But it was during a visit to Spain
(1984) that she first felt at home. In Spain, she began to use photographic
mapmaking processes to aid her journey through her identity issues. Sup-
ported by a Fulbright Fellowship, she worked with maps that Columbus
sketched on his voyages of discovery. His maps of Cuba were a way for
her to find her roots (Fuentes-Perez et al. 312).

Martínez-Cañas's identity, explored through her photographs, has been
the major focus of her work (Goldberg n.p.). She described her working
process, which incorporates drawing, thus:

I have always been fascinated by the blank piece of paper, a white space
whose basic structure I can alter. I always prepare brief proposals as work
plans, and I mold the idea to my interests, although I may not always ac-
complish everything I wish as fast as I want. The camera is an integral part

María Martínez-Cañas. Photo Credit: Elizabeth Ce-
rejido. Courtesy of Elizabeth Cerejido. Used with
permission.

of my art; I have tried to separate it from me, to do my work in drawings;
but nothing comes of it. I am, therefore, an artist whose mode of expression
is photography. (Fuentes-Perez et al. 312)

For over twenty years, Martínez-Cañas has made art by combining her
handmade graphic designs and photographs to explore contemporary ideas
about Cuba and how it is perceived. Her images most frequently reflect
maps, which stand for voyaging, traveling across life, and traveling into
the past. She has said that, for her, they become a way of locating herself.
With them she is able "to find who I am" (Goldberg n.p). Goldberg de-
scribes them as "montages of moments and monuments, signs and discov-
eries, sharp focus and blurred edges" (n.p).

Her images are often densely packed. Like maps, they must be looked
at up close, slowly, and carefully. In *Free Me: Figure with Totem* (1991),
Martínez-Cañas presents the viewer with a junglelike photograph of ab-

stracted forms and drawing. The image is reminiscent of the work of the Cuban Surrealist **Wifredo Lam** (Turner 140). Both artists examine a fictional Cuba, one that is primordial, mysterious, and surreal. It is a space in the imagination (Kuspit n.p.). This work, like others, is created by using many photographic images, flipping and turning them to create a disorienting mirror effect. The shots she uses to make her large, complex works are from her travels throughout Spain, Latin America, and the southern United States. They include landscapes, images of the man-made environment, and nudes. Ornate windows and doors seem to symbolize openings and closings—that which is both revealed and hidden. These kinds of contrasts, used often in her work, create tension and leave viewers perhaps with more questions than answers. We are not sure of the identity of the place or the artist. Partly because of this fact, her work becomes formalist, and we learn to see it as enticing composition (Turner 140).

The imagery for Martínez-Cañas's photographs generally comes from sources that are somehow related to Cuba, including old maps and customs documents. But in her 1999 exhibition "Traces of Nature," she looked to her own backyard in Miami, where she now lives. Here she displayed photograms, which are made by placing objects—in her case, leaves and other plant forms—between light-sensitive paper and a light source. This process, used in mapmaking since World War II, provides the artist with a technique that is, in a different way, still connected to taking journeys, since maps are indicative of travel. The result is abstract and shadowy, hovering between a two- and a three-dimensional look (Spring 146).

María Martínez-Cañas' work is about discoveries, perhaps ones that cannot be fully explored. Her maps have to do with searches and searching (Goldberg n.p.). As the artist looks for her own routes and takes her own journeys, we are perhaps reminded about our own need to explore the past.

Places to See Martínez-Cañas's Work

Asociación Puertorriqueña de la UNESCO, San Juan, P.R.

Bibliothèque Nationale, Paris

Center for Creative Photography, University of Arizona, Tucson

Chase Manhattan Bank, New York City

Chrysler Museum, Norfolk, Va.

City of Orlando Permanent Collection, Orlando, Fla.

Haverford College, Haverford, Pa.

Ibero-Amerikanisches Institut, Berlin

International Center of Photography, New York City

International Museum of Photography, George Eastman House, Rochester, N.Y.

Lehigh University, Bethlehem, Pa.

Los Angeles County Museum of Art

Lowe Art Museum, University of Miami, Miami, Fla.

Miami Art Museum, Miami, Fla.

Musée d'Art Moderne de la Ville de Paris

Museum of Art, Fort Lauderdale, Fla.

Museum of Contemporary Art, Chicago

Museum of Latin American Art, Washington, D.C.

Museum of Modern Art, New York City

San Francisco Museum of Modern Art

Smithsonian American Art Museum, Washington, D.C.

Southeastern Museum of Photography, Daytona Beach, Fla.

Tampa Museum of Art, Tampa, Fla.

The Saint Louis Art Museum, St. Louis, Mo.

Universidad Católica de Ponce, Ponce, P.R.

Bibliography

Barnes, Nancy. "María Martínez-Cañas." *Artnews* vol. 100, no. 1 (2001): 159.

Barrett, Terry. *Criticizing Photographs: An Introduction to Understanding Images.* 3rd ed. Mountain View, Calif.: Mayfield, 1999.

Damian, Crol. "Transcending the Borders of Memory." *Artnews* vol. 94, no. 3 (1995): 139.

Fuentes-Pérez, Ileana, Graciella Cruz-Taura, and Ricardo Pau-Llosa, eds., in collaboration with Ana Hernández-Porto, Inverna Lockpez, and Ricardo Viera. *Outside Cuba/Fuera de Cuba: Contemporary Cuban Visual Artists/Artistas Cubanos Contemporáneos.* New Brunswick, N.J.: Office of Hispanic Arts, Mason Gross School of the Arts, Rutgers University; Coral Gables, Fla.: Research Institute for Cuban Studies, Graduate School for International Studies, University of Miami, 1989.

Goldberg, Vicki. *María Martínez-Cañas: Voyage to the Past.* Chicago: Catherine Edelman Gallery, 1944. N.p. Catalog for "María Martínez-Cañas: 'Imagen Escrita.' "

Harper, Paula. "Report from Miami: Banking on Art." *Art in America* vol. 88, no. 5 (2000): 78–79.

Kuspit, Donald. *Cuba of Her Mind: María Martínez-Cañas' Photographic Constructions.* Los Angeles: Iturralde Gallery, 1994. N.p. Catalog for "María Martínez-Cañas: Cronologias, 1990–1993."

Lueza, Cecilia E. "María Martínez-Cañas." *Art Nexus* 35 (February–April 2000): 141.

Spring, Justin. "Maria Martínez-Cañas: Julie Saul Gallery." *Artforum* 3 (November 1999): 146.

Turner, Elisa. "María Martínez-Cañas: Barbara Gillman." *Artnews* vol. 91, no. 3 (1992): 140.

Roberto Matta
(b. 1911)
Chilean Painter

Roberto Sebastian Antonio Matta Echaurren, better known as either Roberto Matta or simply Matta, is the most famous Latin American Surrealist at the beginning of the 21st century. Although born and raised in Chile, he is viewed as a "citizen of the world." He has spent much of his adult life in Europe and North America, and his work has been influenced by numerous cultures. Matta was born into an upper-class family of Basque, French, and Spanish heritage (Lucie-Smith 88–89). According to the Latin American art expert Dorothy Chaplik, he once told a story about the effect his Spanish lineage had on him as an artist. The story was about a well-dressed thief who walked along the Barcelona wharves. He would steal lemons and throw them into the river. He was arrested and had to explain his actions to the judge. The thief said that he had never seen the river so black and the lemons so yellow. The explanation made so much sense to the judge that he was set free (Chaplik 118). This kind of response, which represents a particular artistic way of thinking, Matta stated, could have happened only in the Catalunia region of Spain, for it is there that people could so intensely appreciate their environment and the effect of yellow lemons in a black river.

Nonetheless, Matta rejected much of his heritage. After studying with the Jesuits at the University in Santiago, Matta rebelled against both his family and his education. Chile was in disarray at this time, having had ten governments in eighteen months after the exile of the dictator Carlos Ibáñez del Campo in 1931 (Lucie-Smith 89). In 1933, having received his architecture degree in 1931, he moved to Paris to work in the studio of Le Corbusier, the French Modernist architect. But by 1937 Matta had abandoned architecture to join the Surrealists, a group of artists led by

the French poet and critic André Breton. Surrealist ideas, which explored the unconscious and dream imagery, fascinated Matta. His descriptions of what he thought living spaces should be like were published in 1938 in the Surrealist journal *Minotaure*. Later he translated and expanded these ideas on numerous canvases as he dealt with notions that "blended science with myth and magic and ultimately . . . [creating] a space of the mind as well as of the cosmos" (Barnitz 118).

Matta's electrifying inner landscapes, or pictures of the unconscious, were presented at the 1938 International Surrealist Exhibition in Paris. Traba described the works that were created after this exhibition as an " 'antisystem' of concentric lines, spirals, transparent planes, floating objects, bulbs, and sprouts" (70). These works include *The Disasters of Mysticism* (1942), *The Heart of Man* (1942), and *The Vertigo of Eros* (1944).

Though deeply involved with Surrealist experimentation, Matta eventually avoided Breton's patronage, and in 1948 he was expelled from the Surrealist movement because of personal conflicts (Traba 71–72). Nonetheless, his exploration of automatic techniques remained Surrealist. His paintings are marked by pouring, wiping, and sponging on thin glazes, creating layer upon layer of color. These techniques are especially visible in the work he did from 1939 to 1948, while he lived in New York City (Barnitz 118). Because he had openly opposed Hitler, he feared reprisal, and left Paris with his young American bride, hoping to join New York's growing art scene (Chaplik 119).

Works from Matta's early years in New York are shadowy and translucent, with floating organic shapes. They are also turbulent and chaotic. Paintings bearing the overall title *Psychological Morphologies* look like underwater seascapes. *Prescience* (1939) for example, depicts odd biological shapes in a watery substance. Some shapes look like sea creatures swimming, while others could be shells or coral. In 1941 Matta traveled with Robert Motherwell to Mexico a journey that greatly affected his work (Barnitz 119). There he became interested in Aztec and Mayan art. He was especially taken with pre-Columbian astrological calenders, making a connection between them and the structure of the universe and how it is ruled by divine beings. Upon his return to New York, his work became more linked with modern science and pre-Columbian gods. According to Lucie-Smith, Matta "evolved a personal mythology reminiscent of Science Fiction (then just starting to emerge in the United States as a grass-roots literary form) and opposed to the nostalgic refinements of standard bourgeois culture" (91). Waldberg claims that Matta's 1941 and 1942 paintings are so powerful that it would be appropriate to apply the following words from Victor Hugo, describing an unearthly spectacle, to them: "Everywhere gold, scarlet, avalanches of rubies, a rustling of flames. . . . One would have said that the dawn had suddenly set fire to this world of darkness" (Waldberg 41).

In *La Vertige d'Eros* (The Vertigo of Eros, 1944), the French title is a play on the way words sound. It can be understood as *les verts tiges des roses* (the green stems of roses). The reference probably also relates to Marcel Duchamp's alter ego, Rrose Selavy. The work is full of thin light lines, and whirlpools, as well as male and female genitalia. According to Barnitz, the painting, in psychoanalytic terms, refers to "a passage in which Freud located all consciousness as falling between Eros and the death wish—the life force and its antithesis" (Barnitz 120).

In 1948 Matta left the United States to live in Paris, Rome, and London (Lucie-Smith 92). Abstract Expressionism had taken over, and although his work made contributions to this movement, he did not want to give up representation entirely. His paintings continued to suggest biological shapes and vegetation, as well as fantastic machinery and electronic gear. During these years, he reestablished some contact with Chile and supported the socialist program of Salvador Allende, Chile's president from 1970 to 1973. In later years, along with **Wifredo Lam**, he explored Caribbean lore and religion, in an effort find a more cosmic realm of expression (Barnitz 120–21). The effects of Matta's work were felt in Cuba, where his energetic atmospheres, or creation of space, influenced younger artists (Traba 90). Since the 1960s, his work has reflected the influence of comic strips, which he combines, with his earlier Mexican influences (Lucie-Smith 91).

As much as Matta's work has changed throughout his career, his animated use of space is consistent. Matta is well known not only as an important Surrealist artist but also as a strong influence on many major artists, including Arshile Gorky and other Abstract Expressionists (Traba 72).

Places to See Matta's Work

Art Institute of Chicago
Baltimore Museum of Modern Art
Guggenheim Museum, New York City
Musée National d'Art Moderne, Centre Georges Pompidou, Paris
Museum of Contemporary Art, Chicago
Museum of Modern Art, New York City
Philadelphia Museum of Art
San Francisco Museum of Modern Art
Smart Museum of Art, University of Chicago
Stedelijk Museum, Amsterdam
Tate Gallery, London
University of Central Florida Library, Special Collections, Orlando

Wadsworth Atheneum, Hartford, Conn.

Williams College Museum of Art, Williamstown, Mass.

Yale University Art Gallery, New Haven, Conn.

Bibliography

Barnitz, Jacqueline. *Twentieth-Century Art of Latin America*. Austin: University of Texas Press, 2001.

Chaplik, Dorothy. *Latin American Art: An Introduction to Works of the 20th Century*. Jefferson, N.C.: McFarland, 1989.

Colle, Marie-Pierre. *Latin American Artists in Their Studios*. New York: Vendome Press, 1994.

Enríquez, Mary Schneider. "Review of Roberto Matta." *Artnews* vol. 96, no. 6 (1997): 124.

Fletcher, Valerie, ed. *Crosscurrents of Modernism. Four Latin American Pioneers: Diego Rivera, Joaquín Torres-García, Wifredo Lam, Matta*. Essays by Olivier Debroise, Adolfo M. Maslach, Lowery S. Sims, and Octavio Paz. Washington, D.C.: Hirshhorn Museum and Sculpture Garden in association with the Smithsonian Institution Press, 1992.

Lucie-Smith, Edward. *Latin American Art of the 20th Century*. New York: Thames and Hudson, 1993.

Scott, John F. *Latin American Art: Ancient to Modern*. Gainesville: University of Florida Press, Florida, 1999.

Traba, Marta. *Art of Latin America, 1900–1980*. Baltimore: Washington, D.C.: Inter-American Development Bank, Johns Hopkins University Press, 1994.

Waldberg, Patrick. *Surrealism*. 2nd ed. New York: Thames and Hudson, 1997.

Felipe Archuleta, *Sow*. (Courtesy of Orlando Public Art Collection, Menello Museum)

Myrna Baez, *El pueblo/Gurabo* (1996), acrylic and oil on linen, 58" x 45". Private Collection. (Courtesy of Galeria Botello)

José Bedia, *Segundo Encuentro* (1992) (above), polymer paint, carved wood, found objects, variable size installation. (Courtesy of George Adams Gallery, New York)

Maria Brito, *Self-Portrait as a Swan* (2001) (left), oil on wood wall construction, h 30" x w 18" x d 4". (Courtesy of Bernice Steinbaum Gallery, Miami, Florida)

Edouard Duval Carrié, *Mardi-gras au Fort Dimanche* (1992), oil on canvas in artist frame, 65" x 65". (Courtesy of Bass Museum Collection)

Coco Fusco and Nao Bustamante, *Stuff* (1996–1997), performance. (Photo by Hugo Glendinning. Courtesy of the artist)

Julio Galan, *Brilette* (2001), oil, acrylic, mixed media on canvas, 74½" x 51⅛". (Copy-right Julio Galan. Courtesy of Robert Miller Gallery, New York)

Ester Hernández, *La Ofrenda/The Offering* (1990). (Courtesy of the artist)

Graciela Iturbide, *Portrait of Julio Galan*. (Copyright Graciela Iturbide. Courtesy of Robert Miller Gallery, New York)

Frida Kahlo (Mexican, 1907–1954), *Self-Portrait Dedicated to Leon Trotsky* (1937), oil on masonite, 30" x 24". (The National Museum of Women in the Arts, Gift of the Honorable Clare Boothe Luce)

Guillermo Kuitca, *Gran corona de espinas* (1989) (left); acrylic on canvas, 117" x 78½" (297.2 x 199.4 cm). (Courtesy of Sperone Westwater, New York)

María Martinez-Cañas, *Libérame: Figura con Totem* (1991) (below), gelatin silver print, edition of 2. (Courtesy of the artist)

Ramón Oviedo, *Autorretrato en Azul* (Self-Portrait in Blue) (1999). (Courtesy Oviedo Foundation. Photo by Max Pou)

Cildo Meireles

(b. 1948)

Brazilian Conceptual and Interactive Sculptor and Installation Artist

Through his room-size, walk-in interactive environments, the Brazilian artist Cildo Meireles challenges audiences to consider social conditions relating to power struggles, economics, and cultural change. Born in Rio de Janeiro, he began making art as a young boy. Meireles's artistic influences include a gift from his father, a book on the Spanish artist Francisco Goya, that he received when he was twelve or thirteen years old (Farmer 37). In addition, many young Brazilian art students of his generation were interested in filmmaking. In an interview in 2000, Meireles discussed the impact of the filmmaker Orson Welles on his life and work—he even named his son Orson. He was impressed when Welles traveled to Brazil to shoot a feature-length film. He was profoundly moved by Welles's radio broadcast *The War of the Worlds* (1938), particularly with its depiction of a seamless connection between art and life (Farmer 35). Meireles adopted this approach and strives to mesh life and art in his own work. He passionately wanted to study film, but in his early years only had access to drawing classes in Brazil. First he studied art at the National School of Fine Arts, then engraving at the Museum of Modern Art in Rio de Janeiro.

In the late 1960s and early 1970s, Brazil was under an intensely repressive dictatorship; the situation motivated Meireles to centralize political themes in his art (Museum of Modern Art). At age twenty-one, he encountered censorship and even exclusion from exhibitions because of the overt, controversial political messages in his work. He stated his creative method for communicating politically charged statements to the public:

By 1969 and 1970, for example, the regime was strictly monitoring all the standard means of communication—television, radio, newspapers, book pub-

173

lishing, galleries. So that in my earliest work I set myself the task of inventing alternative methods of communication—or rather, taking advantage of some of the alternate systems of circulation that already existed. . . . I began rubber-stamping political messages onto the faces of paper money that I happened to procure in the course of my day and which I then proceeded simply to spend. (Weschler 95–96)

Stamping money with messages was one of two acts in *Insercões em Circuitos Ideológicos* (Insertions into Ideological Circuits, 1970). The rubber-stamped money functions as the insertion, and the economy serves as the ideological circuits. The other insertion is a manipulation of an icon in U.S. popular culture, the Coco-Cola bottle. He painted messages such as "Yankee Go Home" and "Who Killed Herzog?" (referring to the Brazilian government detention of political journalist Wladimir Herzog, whose subsequent death was mysteriously pronounced a suicide on empty, recyclable Coca-Cola bottles) (Leffingwell 82). When the bottle is empty, the message, in white paint, is barely visible. When the bottle is refilled with Coca-Cola, the message is revealed for the next consumer to read (Weschler 96). To Meireles, the product and symbol of Coca-Cola function as a metaphor for money and consumption, representing economic imperialism (Museum of Modern Art 2). Documentation and photographs of these socially interactive works were presented in 1970 at the Museum of Modern Art in New York City, in the exhibition "Information," organized by Kynaston McShine.

Meireles expresses his thoughts in written text as well as in visual form. His essay "Cruzeiro do Sul" (The Southern Cross) was included in the catalog of the "Information" exhibition. He abstractly discusses the oppressive conditions in Brazil, including references to European missionaries and Portugal's treaty occupation in the late fifteenth century (Leffingwell 80). "Cruzeiro do Sul" is based on actual events in Brazil and other oppressed countries. Meireles speaks about the divisions of people, land, and culture. He uses the concept *toresillas* (borders) to represent multiple meanings, starting with a country that becomes divided when outsiders come to conquer and force cultural assimilation on indigenous peoples. He also speaks of the borders that divide reality and imagination, and the division between the high culture of the "other civilized" people and the wild side of the indigenous culture (Herkenhoff et al. 106).

In his first installation, *Eureka/Blindhotland* (1970), Meireles invites the audience to interact with the art, using multiple senses. It is the viewer's interaction that makes the work complete. *Eureka/Blindhotland* is one of the works in which Meireles reflects on systems of power, pulling the viewer inside to question political concerns and the physical laws of nature (Mesquita 225). The installation consists of a room filled with spheres of various weights, sizes, and materials. The audience is summoned to handle

the spheres, reflecting on their mass, volume, and feel, while a tape recording plays in the background, sending out subliminal messages about space and weight. As you walk through the environment, Meireles asks that you sense the following simultaneously: (1) yourself as an enormous person holding a tiny pencil; (2) yourself as a tiny person holding an enormous pencil; (3) yourself as a enormous person holding a enormous pencil; (4) yourself as a tiny person holding a tiny pencil. Another integral component of *Eureka/Blindhotland* is the insertion of images and text messages in newspapers.

Meireles's style is described as minimal, conceptual, and environmental, yet he rejects the Modernist notion of being classified with a categorical style (Museum of Modern Art 1). He remarks on the categorization of his work as "installations":

> They are not really installations. . . . They are models of corners of a room, in which I deformed the logic of Euclidean space. They are interactive works, because you have to search for a means of perceptually organizing the spaces so that they become coherent. (Farmer 37)

Although Meireles's art is specific to his own historical and present perspective on conditions in Brazil, his work can have multiple interpretations. The installation *Olvido* (Oblivion, 1990) was orchestrated at the Museum of Modern Art in New York City. The materials were limited to candles, cow bones, and paper money from the United States, Canada, Mexico, Guatemala, Costa Rica, Colombia, Peru, Chile, and Brazil, but the message was complex. A circular fence built from 60,000 candles enclosed thousands of cow bones. A tepee made of paper money stood in the center of the bones. Meireles stated that the deliberate use of various currencies became the central idea in this work; there are "bills from every country in this hemisphere where Indians once predominated, although in the years since, for the most part, they've all been wiped out" (Weschler 95). He is speaking of the cultural domination and forced assimilation in Brazil and many other Latin American and North American countries. Today, as one of Brazil's leading artists, Meireles continues to provoke thoughts about land, country, time, space, and environment.

Places to See Meireles's Work

Archer M. Huntington Art Gallery, University of Texas at Austin: *Missō/Missões* (How to Build Cathedrals, 1987); *Zer Centavo* (1978); *Zero Cruzeiro* (1974–1978)

Council House, Glasgow, Scotland: *John Street Arch* (1990)

Los Angeles County Museum of Art: *Malhas da Liberdade (Mallas de la Libertad)* (1976)

Museo del Barrio, New York City

Museum of Modern Art, New York City: *Glove Trotter* (1991)

New Museum of Contemporary Art, New York City: *Camelo* (1998); *Insertion into Ideological Circuits: Bank Note Project* (excerpt 1970–90); *Rhetorical Image* (1991); *Insertion into Ideological Circuits: Coca Cola Project* (excerpt, 1970–90); *Zero Cent Coin* (1978); *Zero Dollar Bill* (1978)

Bibliography

Bronx Museum of Arts. *The Latin American Spirit: Art and Artists in the United States, 1929–1970.* New York: Bronx Museum of Arts in association with Harry N. Abrams, 1988. Exhibition catalog.

Farmer, John A. "Through the Labyrinth: An Interview with Cildo Meireles." *Art Journal* 59, no. 3 (2000): 35–43.

Herkenhoff, Paulo, Gerardo Mosquera, and Dan Cameron. *Cildo Meireles.* London: Phaidon Press, 1999.

Leffingwell, Edward. "Unspoken Stories." *Art in America* vol. 88, no. 7 (2000): 80–87.

Lucie-Smith, Edward. *Latin American Art of the 20th Century.* London: Thames and Hudson, 1993.

MacAdam, Barabara A. "Cildo Meireles." *Art News* vol. 96, no. 8 (1997): 132–33.

Mesquita, Ivo. "Brazil." In *Latin American Art in the Twentieth Century.* Edited by Edward J. Sullivan. London: Phaidon Press, 1996. Pp. 201–32.

Museum of Modern Art. *Projects: Cildo Meireles.* New York: Museum of Modern Art, 1990. Exhibition catalog.

Ramírez, Mari C., and Beverly Adams. *Encounters/Displacements: Luis Camnitzer, Alfredo Jaar, Cildo Meireles.* Austin, Tex.: Archer M. Huntington Art Gallery, College of Fine Arts, University of Texas, 1992.

Vetrocq, Marcia E. "Conceptualism: An Expanded View." *Art in America* vol. 87, no. 7 (1999): 72.

Weschler, Lawrence. "Cildo Meireles: Cries from the Wilderness." *Art News* vol. 89, no. 7 (1990): 95–97.

Ana Mendieta

(1948–1985)

Cuban-American Body, Earth, and Performance Artist

Although her life ended tragically at the age of thirty-seven, the work of Ana Mendieta continues to provoke thought and insight across cultures and generations. Mendieta was born on November 18, 1948, to an affluent family in Havana, Cuba. As a child, she lived in an enormous house with her parents, sister, and several servants. Mendieta's biographer Alex Katz states that kitchen servants introduced Mendieta and her sister to Santería, an Afro-Cuban religion. They loved to hear about "magical" rituals, even though their upper-middle-class parents referred to such practices as "witchcraft" (Katz 36). This early exposure to Santería influenced Mendieta's later choice of materials, including blood, hair, feathers, flowers, fire, and water (Katz 144).

Mendieta's family has a long political history in Cuba. Carlos Mendieta, her great-uncle, was president of Cuba in the 1930s. Her grandfather was the president of the Veterans of the 1895 War of Independence, and her great-grandfather was a general in the War of Independence. Her father, an attorney, was an early supporter of Fidel Castro, but later was imprisoned when he opposed Castro's political tactics (Horsfield et al.). The family feared Castro so much that in 1961, at the age of twelve, Mendieta and her older sister were sent to the United States. The young girls were among as many as 8,000 Cuban children who were sent to the United States without their families, under the care of the Catholic Church, to escape Castro's reign in Cuba. The Mendietas planned to join their daughters within a few months, which became years, and the girls were placed in foster care (Horsfield et al.). In 1966, just before Mendieta entered college, her mother joined the girls in Iowa. In college, she took art classes in which she discovered her passion for making art (Horsfield et al.). She

Ana Mendieta. Courtesy of the Estate of Ana Mendieta and Galerie Lelong, New York City. Used with permission.

continued her study of art in graduate school, receiving an M.A. in painting (1972) and an M.F.A. in multimedia and video (1977), both from the University of Iowa (Camnitzer 90).

Mendieta utilized video and photography with performance to express politically charged messages about women's issues (Horsfield et al.). *Rape-Murder* (1973) is an early performance and photographic exploration in which she re-created a highly visible and emotional rape/murder that occurred on the campus of the University of Iowa. She invited friends and other students to her apartment, where they witnessed Mendieta as the victim, stripped and smeared with fake blood, lying bound and lifeless. Photographs of this performance are poignant and realistic, with a forensic quality (Duncan 112). Through this performance, Mendieta showed the viewer the act of rape from a female perspective while speaking out against violence to women. Shifra Goldman compares Mendieta with **Frida Kahlo**: "Both make references to the lives of women, Frida to birth and miscarriage, Ana to rape and menstruation" (Camnitzer 94).

Mendieta maintained the body as the central content of her art as she shifted to working more closely with the environmental elements of air, water, earth, and fire. Commenting on her work with nature, Mendieta

said, "I have thrown myself into the very elements that produced me, using the earth as my canvas and my soul as my tools" (Duncan 154). Mendieta's sister, Raquelin, recalls playing with Ana at the beach in Cuba. The young girls used sand and water to build shapes resembling their bodies. This carefree play foreshadowed Mendieta's future work. Mendieta continued to have strong emotional ties to Cuba even after spending many years in the United States. Camnitzer describes her as a political voice for Cuba and states that she affectionately signed personal correspondence "Tropic-Ana," connoting a tropical origin (93).

Before Mendieta was able to return to Cuba, she frequently visited Oaxaca, Mexico. In a constant search for her geographic and ethnic roots, Mendieta found Mexico to be similar to Cuba; according to her, most people there were "her height and had the same color of skin as her" (Katz 144). Her work done in Mexico, the *Silueta* series (1973–1977), is possibly the best-known of her oeuvre. It consists of photographs of indentions made in the earth by Mendieta's body and outlined with materials including carved stone, molded earth or snow, fake blood, fire, rocks, leaves, and flowers (Duncan 111). A concious seeker of the land of her birth through the use of specific materials and contexts, Mendieta was also an artist with formal training in U.S. schools, and successfully linked the two cultures in her artwork (Camhi 127).

Anima (Alma/Soul) (1976), a work in the *Silueta* series, was constructed of bamboo in the shape of Mendieta's body, then set on fire and photographed. Joanna Frueh, who links the significance of the body to fire and the process of changing physical states, observed, "Soul on fire and impassioned, martyred body, *Anima* faded into the night to become part of the atmosphere" (201). Mendieta is grouped with other 1970s feminist artists who dealt with issues centering on the female body, such as Joan Semmel, Hannah Wilke, and Alice Neel.

After graduate school, Mendieta moved to New York City, where she was soon immersed in the art scene. Artists in Residence Gallery represented her, along with other contemporary women artists (Camnitzer 91). Later, Galerie LeLong became the primary gallery to represent Mendieta, and still does so today. While in New York, she became involved with Carl Andre, a high-profile Minimalist sculptor. Both of them were passionate artists, each working in a different sphere of the art world. The New York artistic community seemingly was split, pro-Ana or pro-Carl, in terms of artistic agendas and loyalties (Horsfield et al.). While Mendieta's art is connected to the female experience and her own personal cultural experiences, Andre's art is disconnected from the personal and concerned only with formal elements, in the spirit of Modernism.

The couple married a few months before Mendieta mysteriously fell to her death from the window of their bedroom (Katz 6). The relationship between Mendieta and Andre was tumultuous at best. Andre was charged

with her murder but never convicted. After several hung trials and hearings, the details surrounding Mendieta's death are still debated. Her death stunned and saddened the art world, and continues to intrigue and perplex students of her life and work. Mendieta, much like Frida Kahlo, lives on in her work and the memory of her life, inspiring the work of many young artists.

Places to See Mendieta's Work

Exit Art/The First World Gallery, New York City

Galerie Lelong, New York City

Laura Carpenter Fine Art, Sante Fe, N.M.

Museum of Contemporary Art, Los Angeles: *Earth/Body Figure*, *Silueta* series (1973–1977)

Smithsonian National Museum of American Art, Washington, D.C.: *Untitled*, from the *Silueta* series (1980); *Anima (Alma/Soul)* (1976–1977)

Bibliography

Blanc, Giulio, and Gerardo Mosquera. "Cuba." In *Latin American Art in the Twentieth Century*. Edited by Edward J. Sullivan. London: Phaidon Press, 1996. Pp. 81–102.

Camhi, Leslie. "Ana Mendieta." *Art in America* vol. 80, no. 9 (1992): 127.

Camnitzer, Luis. *New Art of Cuba*. Austin: University of Texas Press, 1994.

Duncan, Michael. "Tracing Mendieta." *Art in America* vol. 87, no. 4 (1999): 111–13, 154.

Euclaire, Sally. "Ana Mendieta." *Art News* vol. 92, no. 4 (1993): 140–41.

Enriquez, Mary S. "Ana Mendieta." *Art News*, vol. 97, no. 5 (1998): 168–69.

Frueh, Joanna. "The Body Through Women's Eyes." In *The Power of Feminist Art: The American Movement of the 1970s. History and Impact*. Edited by Norma Broude and Mary D. Garrard. New York: Harry N. Abrams, 1994. Pp. 190–207.

Horsfield, Kate, Nereyda Garcia-Ferrax, and Brenda Miller. *Ana Mendieta: Fuego de Tierra*. New York: Women Make Movies, 1987. Videotape.

Katz, Robert. *Naked by the Window: The Fatal Marriage of Carl Andre and Ana Mendieta*. New York: Atlantic Monthly Press, 1990.

Leffingwell, Edward. "Latin Soliloquies." *Art in America* vol. 81, no. 12 (1993): 72–83.

Orenstein, Gloria F. "Recovering Her Story: Feminist Artists Reclaim the Great Goddess." In *The Power of Feminist Art: The American Movement of the 1970s. History and Impact*. Edited by Norma Broude and Mary D. Garrard. New York: Harry N. Abrams, 1994. Pp. 174–89.

Amalia Mesa-Bains

(b. 1950)
Mexican-American Installation Artist

Amalia Mesa-Bains's art and writing grow from her need to celebrate, explain, make visible, and critique the history and belief systems of her Chicano community. Her installation work, often in the form of altars, speaks about memory and visual language (Morgan 24). While her work is rooted in folk traditions inspired by Chicano mothers, aunts, and grandmothers, Mesa-Bains is also influenced by years of academic study. She has many titles, including "artist, critic, author, psychologist, lecturer, political activist, cultural historian, teacher, and researcher" (Weintraub et al. 92). She has a B.A. in painting from San Jose State University, an M.A. in interdisciplinary education from San Francisco State University, and an M.A. and a Ph.D. in clinical psychology from Wright Institute in Berkeley, California. She also has received a MacArthur Fellowship, which rewards highly talented individuals in a variety of disciplines. Mesa-Bains's career is all about activism. Often her political activity presents itself in her art, but her energies have also been spent working as a psychologist with the San Francisco Unified School District's integration office (Alba 27).

The work of Mesa-Bains, who was born in Santa Clara, California, often centers on autobiography and ideas related to her family and the Latino community. Mesa-Bains's parents, who were resident aliens, helped form her communal identity. Her father crossed the border between Mexico and California in 1916, during the Mexican Revolution, and her mother came in the 1920s (Weintraub et al. 92–93). While Mesa-Bains's altars and installation works speak to her specific world, they also clearly transcend her individual space and life by treating more generalized topics, such as Catholicism, colonialism, ritualistic practices, economics and class, goddesses, women of courage, and the reclamation of history.

Amalia Mesa-Bains. Courtesy of Bernice Steinbaum
Gallery, Miami, Florida. Used with permission.

Mesa-Bains's altars often honor women who have broken social barriers. As she makes these women visible, she also pays tribute to the manner in which her ancestors created, and continue to create. With a profusion of ornamentation that is lavish, rich, and layered, she bridges ancient and contemporary ways of thinking. Mesa-Bains refers to this aesthetic approach as "rasquachismo," which means creating with everyday items that are often tattered and used, presenting them with dignity and style. Although Anglos have called the result "kitsch," in a devaluing manner, Mesa-Bains elevates the aesthetic in a way that transforms the activity, the art form, and her maginalized ancestors (Lippard 82–84). She is both attached to and confrontational of the ideas she presents. Mesa-Bains refers to this kind of conflicting emotion as "domestic tension" (*Amalia Mesa-Bains*), which adheres to family and community values while questioning them at the same time. Consequently, her art critiques patriarchy as it affirms the lives of women who managed to survive difficult and oppressive experiences. Mesa-Bains claims it is important to speak about the lives of Latin women because there is so little documented history on them.

One of her most analyzed works is *Grotto of the Virgins* (1987), which honors three women in separate altars. Displayed on **Frida Kahlo's** altar were dried leaves, rocks, pre-Columbian ceramic fragments, and references

to the Mexican popular arts, which Kahlo loved. Mesa-Bains's connections with Kahlo are many, but her attraction intensified when she was forced to have a hysterectomy, an operation that united the two artists in their inability to have children. A second altar paid tribute to Dolores del Rio, the famous Mexican film star. Lush pink satin, mirrors, and tinsel were used to create a glamorous dressing table, questioning and reflecting on ideas of identity, fame, acceptance, and tribute. The third altar was dedicated to the artist's Indian grandmother, who labored in the fields and worked as a domestic to raise seven children. Recognizing that this woman never received the respect she deserved, Mesa-Bains constructed a confessional booth out of her memorabilia. The space invites visitors to kneel in the booth as if seeking absolution. In doing so, they place themselves in a position to recognize the injustice and humiliation inflicted upon this woman and so many others like her (Lippard 82–83; Weintraub et al. 94–95).

In *Emblems of the Decade: Borders and Numbers* (1990), created with Victor Zamudio-Taylor, the artist combined text and images to relay information about Chicano living. These numbers included life spans and the population affected with AIDS, numbers of illegal entrants, and dates of conquest, liberation, and annexation. While viewers learned about history, they experienced transformation in the form of ritual as a dresser top was made into a powerful altar space.

Mesa-Bains's works are not directly religious because they function apart from the church. She recognizes that the act of creating altars in private spaces has given women the freedom and opportunity to draw on their own belief systems while utilizing a spiritually understood aesthetic form (Weintraub et al. 95). Working with the form of the altar allows Mesa-Bains to communicate with her own Chicano community as well as outsiders. She acknowledges the need that Chicanos have to access Anglo-dominated resources and power. She is also cognizant of a spiritual deprivation that exists in the general population, and believes that perhaps a reconnection to spirituality is the most important contribution Latin cultures have to offer other groups of people.

Places to See Mesa-Bains's Work

Mesa-Bains had exhibited her work internationally, but because she does installation work, it is not permanent. She is represented by the Bernice Steinbaum Gallery (3550 North Miami Ave., Miami, Florida), where her work can be seen.

Bibliography

Alba, Victoria. "Amalia Mesa-Bains." *Image* 20 (May 1990): 27–28.
Amalia Mesa-Bains: Cihuatlampa, the Place of the Giant Women. 1997. Produced by Steinbaum Krauss Gallery, 30 min. Videotape.

Gómez-Peña, Guillermo. "A New Artistic Continent." *High Performance* 35 no. 3 (1986): 24–31.

Goodman, Jonathan. "Amalia Mesa-Bains at Steinbaum Krauss." *Art in America* vol. 85, no. 11 (1997): 130–31.

Lippard, Lucy. *Mixed Blessings: New Art in a Multicultural America*. New York: Pantheon, 1990.

Morgan, Anne Barclay. "Amalia Mesa-Bains." *Art Papers* 19, no. 2 (1995): 24–29.

Weintraub, Linda, Arthur Danto, and Thomas McEvilley. *Art on the Edge and Over: Searching for Art's Meaning in Contemporary Society, 1970s–1990s*. Litchfield, Conn.: Art Insights, 1996.

Tina Modotti
(1896–1942)
Italian-Mexican Photographer

Tina Modotti is classified as both an Italian and a Latin American artist because she was born in Udine, Italy, but she lived much of her adult life in Mexico. In her lifetime, she was recognized for her photography, her acting, and her strong Communist views. A beautiful woman, she is also well-known as the model for many of Edward Weston's (1886–1958) photographs. Weston promoted a way of looking at photographs that made mundane objects, such as a pepper, take on a life beyond the ordinary. Because she was such an inspiration to so many poets and artists, including Weston, she has been overlooked as a photographer, according to Timothy Cahill (13).

Modotti was the third child in a large working-class family. Her father, a factory worker and a labor organizer, influenced her thinking about class issues. She went to work in the local sweatshops at an early age, an experience that later caused her to identify with laborers (Loos 24). One of her earliest memories was of her father lifting her high on his shoulders during a May Day rally so she could hear the songs and speeches (Hooks 5). When Modotti was a teenager, she went with her father to San Francisco, where he looked for better employment. She experienced extreme poverty there, and at the age of fourteen, she was the only wage earner, working in a silk factory, in the family (Hooks 6).

Later, Modotti acted in local theater and designed her own clothes. She began a bohemian life with the artist Roubaix de l'Abrie (Robo) Richey, whom she married around 1916. Artists came to visit in their home, and among them was Edward Weston. She became his model and then his lover. Weston was also her photographic mentor, exerting a strong influence on her life and art. As Weston's student, Modotti learned photog-

Tina Modotti. Photo by Edward Weston, 1924.
Courtesy of The Museum of Fine Arts, Houston;
The Target Collection of American Photography,
museum purchase with funds provided by Target
Stores. Used with permission.

raphy quickly. Though his influence is clear, she also learned from experimentation. She explored cropping and enlarging photos, as well as the potential of multiple exposures and photomontage (Hooks 9–10). In 1923, Modotti and Weston lived together in Mexico, where she began taking her own photographs (Loos 24). However, Modotti became more politically involved, which contributed to the breakup of her relationship with Weston. In addition, he missed his children, and returned to America in 1926 (Hooks 12).

Modotti stayed in Mexico, and she became increasingly involved with art and politics. Her circle of friends included the major muralists **José Clemente Orozco, David Alfaro Siqueiros**, and **Diego Rivera**; the painters Jean Charlot, Roberto Montenegro, and Miguel and Rosa Covarrubias; and the writers Anita Brenner and Frances Toor (the latter editor of the magazine *Mexican Folkways*). Modotti also became good friends with

Frida Kahlo. It was through her friendship with Modotti that Kahlo joined the Communist Party and met Rivera (Herrera 80, 86). Later, however, their friendship became strained when Modotti was a model for one of Rivera's murals at the National Agricultural School in Chapino. It was rumored that the two had an affair (Herrera 85).

Like her contemporaries Imogen Cunningham and Margrethe Mather, early in her career Modotti chose to use form and transcendent beauty to reveal truths. But her best work arose from her desire to express her Communist views through more direct and illustrative images. Still focusing on the beauty of the form, she selected objects symbolic of her cause (e.g., the hands of a working-class person or still life, a hammer, an ear of corn, and a sickle (Lahs-Gonzales 83).

Modotti's photographs after Weston returned to the United States are some of her best. They include *Mella's Typewriter* (1928), *Hands Resting on Tool* (1927), and *Mexican Peasants Reading* El Machete (1928). Modotti took photographs for pure pleasure, as well as for wealthy clients, which helped pay her bills (Hooks 14), but it was the work she did for the Communist newspaper *El Machete* that was her passion. In 1928 Modotti published a series of photographs under the title "The Contrasts of the Regime." She showed images of poverty juxtaposed with the decadence of wealth. On May Day 1929 she covered a protest march for the Mexican Communist Party. The images she captured that day, from the relaxed beginning of the march through the streets of Mexico City to its violent end at the U.S. embassy, are some of her best. They mark a transition from her carefully composed compositions to images more like photojournalism. She became obsessed with the impromptu photograph as opposed to still studies (Hooks 20–21).

One of Modotti's last staged photos is *Yank and Police Marionette* (1929), in which the subject is puppets of Luis Bunin, an apprentice of Rivera's. They are from Bunin's rendition of Eugene O'Neill's play *The Hairy Ape*. Shadows create prisonlike bars over the puppets as they perform in a stark corner. While this photograph is not directly related to the Communist cause, it does make a strong statement about power and oppression (Lahs-Gonzales 88).

Modotti's life is as compelling as her photographs. She lived intensely, had many lovers, and sometimes found herself involved in dramatic situations. For example, in 1929 she was accused of murdering her lover, Julio Antonio Mella, a Cuban revolutionary. She was acquitted after numerous people, including Diego Rivera and Frida Kahlo, came to her defense and wrote letters to assist her (Williams 56). In 1930 Modotti was arrested for an alleged attempt on the Mexican president's life, and was deported to Europe. There she studied in Berlin with the Bauhaus school of photographers, but she was uncomfortable in her new setting. After six months she went to Moscow, where she spent her time fighting fascism by partic-

ipating in the activities of the International Red Aid. In 1939, after Franco's victory in Spain, she returned to Mexico but did not take photographs. She died in 1942, reportedly of a heart attack (Hooks 24–28).

Modotti passionately pursued her life, having many exceptional experiences that make her an interesting individual to study. Several books have been written about her, and a movie based on her life is being planned. In 1995, fifty-three years after her death, the Philadelphia Museum of Art coordinated a retrospective exhibition of Modotti's work that was funded in part by the pop singer Madonna. Many critics thought it gave her long overdue recognition (Cahill 13).

Places to See Modotti's Work

Brooklyn Museum, New York City

George Eastman House, International Museum of Photography, Rochester, N.Y.

Getty Museum of Art, Los Angeles

Museum of Fine Arts, Houston: *Das Erwachen der Massen in Mexiko [The Awakening of the Masses in Mexico]* (1928); *Julio Antonio Mella* (1932); *Rene d'Harnoncourt Puppet* (1929)

Museum of Modern Art, New York City

Philadelphia Museum of Art

Saint Louis Art Museum, St. Louis, Mo.

State Museum of Guadalajara, Jalisco, Mexico

Bibliography

Albers, Patricia. *Shadows, Fire, Snow: The Life of Tina Modotti*. New York: Clarkson Potter, 1999.

Cacucci, Pino. *Tina Modotti: A Life*. Translated by Patricia J. Duncan. New York: St. Martin's Press, 1999.

Cahill, Timothy. "Woman Photographer Once Overshadowed by Famous Mentor Achieves Recognition." *Christian Science Monitor*, November 6, 1995, p. 13.

Constantine, Mildred. *Tina Modotti: A Fragile Life*. New York: Chronicle Books, 1993.

Herrera, Hayden. *Frida; A Biography of Frida Kahlo*. New York: Harper & Row, 1983.

Hooks, Margaret. *Tina Modotti: Photographer and Revolutionary*. New York: Da Capo, 1993.

Hooks, Margaret. *Tina Modotti*. New York: Aperture Books, 1999.

Kuspit, Donald B. "Tina Modotti." *Artforum International* 34 (February 1996): 88.

Lahs-Gonzales, Olivia. "Defining Eye/Defining I: Women Photographers of the Twentieth Century." In *Defining Eye: Women Photographers of the Twentieth Century*. By Olivia Lahs-Gonzales and Lucy R. Lippard. Introduction by

Martha A. Sandweiss. St. Louis, Mo.: St. Louis Art Museum, 1997. Pp. 15–130.

Loos, Ted. "La Comradessa: Two Biographies of an Enigmatic Photographer and Revolutionary." *New York Times Book Review* (May 2, 1999): 24.

Modotti, Tina. *The Letters from Tina Modotti to Edward Weston.* The Archive. Tucson, Ariz.: Center for Creative Photography, 1996. No. 22.

Philadelphia Museum of Art. *Tina Modotti: Photographs.* Edited by Sarah M. Lowe. New York: Harry N. Abrams, 1996.

Williams, Adriana. *Covarrubias.* Edited by Doris Ober. Austin: University of Texas Press, 1994.

Jesús Bautista Moroles

(b. 1950)
Mexican-American Sculptor

Jesús Bautista Moroles is known for his large-scale granite sculptures that explore texture and form. He was born in Corpus Christi, Texas, and he now lives and works in Rockport, Texas. His father, José Moroles, was an immigrant from Monterrey, Mexico. When Jesús, the eldest of six children, was in elementary school, the family moved to Dallas, where they lived in public housing. Their next home was a run-down house that Jesús helped to renovate. He spent several summers during his youth in Rockport with his uncle, a master mason. Here, Moroles worked on construction jobs including a Gulf Coast seawall.

From a very early age, Moroles had an interest in art, and his parents were supportive of his talent. At Crozier Tech in Dallas, a vocational school, he studied commercial art. After he graduated, he was drafted into the U.S. Air Force. In 1973 Moroles returned home and began taking art courses at El Centro Junior College. He completed his B.A. in 1978 at North Texas State University in Denton, with the goal of becoming a sculptor (Beardsley and Livingston 213). He has stated, "I chose sculpture at first because the only 'B' I made in college was in that class. . . . I had to keep taking sculpture because I thought it was a weakness for me. When I got to stone carving it was the hardest thing I had ever done" (Walkup 16). During his college career, he worked with **Luis Jiménez**, a well-regarded sculptor ("ArtsEdNet"). Although the works of these two artists differ greatly—Moroles works with traditional materials and architectural forms, whereas Jiménez is influenced by popular culture and uses industrial materials—Moroles benefited greatly from this experience (Beardsley and Livingston 213).

Moroles's art is now a family effort, created with the help of his par-

Jesús Bautista Moroles by his sculpture *Moonscape Bench*. Photo
Credit: Ann Sherman Photography. Courtesy of the artist. Used with
permission.

ents, José and María, his sister Suzanna, and his brother-in-law Kurt Kan-
gas. His main studio is in Rockport, but he also has studios in Barcelona,
Spain, and at the Cerrillos Cultural Center near Santa Fe, New Mexico.
The studio in New Mexico is designed to help give other artists exposure,
especially artists from other countries (Walkup 15, 17).

Vanishing Edge (1985), made from Georgia granite, was one of the works
in the 1987 exhibition "Hispanic Art in the United States: Thirty Con-
temporary Painters and Sculptors," organized by the Museum of Fine Arts
in Houston. Standing thirty inches high, it is small in comparison to many

of Moroles's more recent works. It appears to be stacked slabs of stone. They are not uniform in length or thickness, but their placement creates a pleasing rhythm and movement. *Texas Façade* (1986), carved from Texas granite, is less abstract, representing the front of a templelike structure. Four vertical, doorlike openings repeat the lines of the five lines of stone extending upward from behind the roof (Beardsley and Livingston 214–15). Other works use curved lines, sometimes juxtaposing them with straight, polished forms. Some works can be hung from the ceiling, creating tension between the heavy mass and the floor line. When they are displayed together, there is timelessness to the works that encourages meditation and reflection.

Moroles' work tests the limits of stone. Using granite, he explores new relationships of texture and form. Finished surfaces may be rough or polished. His tools include diamond power saws, drills, grinders, mallets, chisels, and picks. His granite—one of the hardest materials for an artist to work with—is carefully selected (Walkup 15).

Moroles's creative process is partly intuitive: "I don't draw first and I don't make models. . . . When I decide what it is, I draw on the stone" (Walkup 16). About his goals for the future, he said:

> I've decided I'm going to do more important works, things that you can't walk past, things that will just knock you down. They're going to be big, massive, larger than human scale. That's why I travel. My work evolves from that experience. Everything we do, I do, we all do, is a combination of things we've seen and experienced. (Walkup 16)

Moroles has received many prestigious awards, including the University of North Texas Distinguished Alumnus Award (1996), the American Institute of Architects, Houston, Artist Award (1995), the University of North Texas President's Citation Award (1992), and a National Endowment for the Arts grant to work at the Birmingham Botanical Gardens in Alabama (1984) ("ArtsEdNet"). His work can be seen all over the world, engaging people in the visual aspects of granite's form and texture.

Places to See Moroles's Work

Albuquerque Museum, Albuquerque, N.M.

Corpus Christi City Hall, Corpus Christi, Tex.

Dallas-Fort Worth Airport

Dallas Museum of Art

Edwin A. Ulrich Museum of Art, Wichita State University, Kan.

Fred Jones Jr. Museum of Art, University of Oklahoma, Norman

Mint Museum, Charlotte, N.C.

Modern Art Museum of Fort Worth, Fort Worth, Tex.

Museum of Contemporary Art, Osaka, Japan

Museum of Fine Arts, Houston, Tex.

Museum of Fine Arts, Santa Fe, N.M.

Museum of Modern Art, New York City

New Orleans Museum of Fine Art, New Orleans, La.

Old Jail Art Center, Albany, Tex.

Palm Springs Desert Museum, Palm Springs, Calif.

Philharmonic Center for the Arts, Naples, Fla.

Rockport Center for the Arts, Rockport, Tex.

San Antonio Museum of Art, San Antonio, Tex.

Smithsonian American Art Museum, Washington, D.C.

University of Houston

Bibliography

"ArtsEdNet: Jesús Bautista Moroles: Granite Weaving." December 28, 1999. http://www.artsednet.getty.edu/ArtsEdNet/Resources/Maps/granite.html.

Beardsley, John, and Jane Livingston. *Hispanic Art in the United States: Thirty Contemporary Painters and Sculptors*. With an essay by Octavio Paz. Houston, Tex.: Museum of Fine Arts; New York: Abbeville Press, 1987.

Dickinson, Carol. "Artyard, Denver, Exhibits." *Artnews* vol. 92, no. 4 (1993): 140.

"Jesús Bautista Moroles: Granite Sculptor." June 17, 2001. http://www.moroles.com

Lucie-Smith, Edward. *Art in the Eighties*. New York: Phaidon, 1990.

McCombie, Mel. "Hispanic Art in the United States." *Artnews* vol. 86, no. 9 (1987): 156.

Robinson, Joan Seeman. "Davis/McClain Gallery Houston." *Artforum* 27 (February 1989): 139.

Walkup, Nancy. "Testing the Limits of Stone: Jesús Bautista Moroles." *School Arts* 98 (April 1999): 15–17.

Manuel Neri

(b. 1930)
Mexican-American Sculptor

Manuel Neri is well-known for his gouged and fragmented sculptures made in plaster, marble, and bronze. His figures seem to be being created and destroyed simultaneously.

Neri's parents came to the United States as adults, settling in southern California after threats against the life of his father, a lawyer. Manuel's father insisted that Manuel and his two siblings speak Spanish at home, so the boy grew up bilingual. His father died when Manuel was nine, and soon afterward the family moved to northern California, where Manuel's mother worked hard to raise the family.

When Neri graduated from high school, he thought he would become an engineer; at that time he had had no academic experience with visual art. At San Francisco City College he took what he expected to be an easy ceramics course taught by Roy Walker. He later visited Clyfford Still's painting classes at the California School of Fine Arts (now the San Francisco Art Institute) and met the ceramic sculptor Peter Voulkos, who was studying at the California College of Arts and Crafts. These experiences caused Neri to abandon the study of engineering in order to become an artist (Beardsley and Livingston 217–18). He enrolled in the California College of Arts and Crafts in 1952 but in 1953 he was drafted into the army and sent to Seoul, Korea, where he remained until 1955. When he returned home, he re-enrolled at the California College of Arts and Crafts, then studied for two years at the California School of Fine Arts. He taught there from 1959 to 1964, then was a visiting lecturer at the University of California at Davis (Nieto 53–54).

Influenced by the Beat poets in the mid-1950s, Neri found his way to the center of the Beat movement in San Francisco. Jazz clubs and coffee-

Manuel Neri working on bronze sculpture at studio,
Bencia, California, 1983. Photo Credit: M. Lee Fath-
eree. Courtesy of Charles Cowles Gallery, New York
City. Used with permission.

houses were meeting places, and assemblage, improvisation, and the intuitive process became more important than any preconception of a final product. As the director of San Francisco's Six Gallery, Neri organized Allen Ginsberg's first full reading of his famous poem "Howl," which was published in 1956. The reading became central in a censorship trial that brought attention to the gallery and, in turn, the area's visual artists (Paglia 65).

Neri is part of the Bay Area Figurative Movement, which has its roots in classical Greek sculpture, as well as in the sculpture of Michelangelo and Rodin. In keeping with the ideas of the Beats, early in his career he liked using found objects, because they gave a feel for the street and a sense of raw emotion (Tanguy 64). Today he is known for works, most often made in plaster, marble, and bronze, that are fragmented, gouged, and painted. His work does not follow any prescribed rules. It is layered work: erotic and violent, heroic, and, as Margarita Nieto put it, existing within the pathos of the human condition (53).

Neri married his first wife, the painter Joan Brown, in 1962; the union was short-lived, as were his three later marriages (Beardsley and Livingston 218; Paglia 65). Other San Francisco area second-generation Figurative artists worked on integrating an abstract expressionist approach into their work. Neri's work is perhaps the most complex of all the Bay Area Figurative Movement artists'. He is known for hacking off parts of statues, rendering them partial figures. Often working with a white plaster surface over a wire and wood armature, he slashes at the surface in a violent, almost savage manner. In his *Untitled Standing Figure* (1957–58), he removed the hands, feet, and head, leaving a stick of wood to protrude from a shoulder, as if it were an arm bone (Morris 97). Standing about the same height as the artist, this work becomes a form for psychological investigation. In other words, it makes one think about what is on the inside and the outside of the human form; questions may arise about the fragility of the human, both physically and spiritually. The wet plaster covering is malleable, easily allowing for addition and subtraction, creation and destruction, of what Neri calls a "dead white" quality. This continual use of whiteness, according to Tanguy, pertains to several investigative themes Neri has explored over the course of his career. One has been the "white goddess thing," Neri's phrase for the female figure's magical powers, which go back to ancient times. Neri's slashing and dismemberment of the female form, however, cannot simply be viewed as awe-inspired. These forms also represent a troubling male domination, aggression, and abuse (64–65).

Neri uses a non-Western approach to proportions in his figures. *Chula* (c. 1958–60), for example, is chubby and twisted, with a potbelly and a maternal heaviness suggesting pregnancy. This figure, like many of his others, challenges the European idea of beauty (Nieto 54). At the same time, ancient Greek figures have had a lasting influence on him: "I went

to Greece, and the characters of those old pieces knocked me out. The head is gone, the arm is chopped off, the nose is gone, and the figure has even more power with what is left over" (Tromble 20). Neri addresses Western aesthetics in other ways as well. For example, by painting his pieces, those made of bronze and marble as well as of plaster, he reminds us that the white classical Greek sculptures we now see were once painted in colors. His painting and sculptural techniques also make reference to artists such as Willem de Kooning, with his slashing approach to the canvas, and Picasso, with his Cubist fragmentation of objects (Nieto 54–55).

Neri has made frequent trips to Europe since 1961. He has a home in Carrara, Italy, where he spends part of the year, working the famous local marble (Beardsley and Livingston 218). Although he waited a long time for major recognition, especially in New York City, he persevered in exploring a recognizable subject, the figure, in a contemporary way. In 1993 he said, "The figure is mainly a vehicle for other ideas that I want to play with. More and more, I'm talking about myself in the figure. All my figures are my size" (Tromble 20). But he makes it clear that these figures are not self-portraits. They have a kind of magic for him, in that they hold the attraction of the opposite sex. He reflected that "listening to Joseph Campbell and reading his books influenced me a lot, and I've decided to let the female form speak for me" (Tromble 20). Campbell's identification of universal themes in art and mythology, such as goddesses figures, led Neri to make work that can communicate to others, undefined by time and space; it deals with how we create meaning out of our existence. For many critics, he has succeeded in his goal of addressing issues of the figure better than many other artists from the San Francisco area (Paglia 65). Neri's art is exhibited and collected internationally.

Places to See Neri's Work

Des Moines Art Center, Des Moines, Iowa

Hirshhorn Museum and Sculpture Garden, Smithsonian Institution, Washington, D.C.

Honolulu Academy of the Arts

Laumeier International Sculpture Park, St. Louis, Mo.

Memphis Brooks Art Museum, Memphis, Tenn.

Mexican Museum, San Francisco

Oakland Museum, Oakland, Calif.

Palm Springs Desert Museum, Palm Springs, Calif.

R. L. Nelson Gallery, University of California, Davis

San Diego Museum of Art

San Francisco Museum of Modern Art

San Francisco International Airport

Seattle Museum of Art

Sheldon Memorial Art Gallery, Lincoln, Neb.

University of Colorado, Boulder

Whitney Museum of Art, New York City

Bibliography

Albright, Thomas. "Manuel Neri's Survivors: Sculpture for the Age of Anxiety." *Artnews* vol. 80, no. 1 (1981): 54–59.

Albright, Thomas. *Art in the San Francisco Bay Area, 1945–1980*. Berkeley: University of California Press, 1985.

Barron, Stephanie, Sherri Bernstein, and Ilene Susan Fort. *Made in California: Art, Image, and Identity, 1900–2000*. Los Angeles: Los Angeles County Museum of Art; Berkeley: University of California Press, 2000.

Beardsley, John, and Jane Livingston. *Hispanic Art in the United States: Thirty Contemporary Painters and Sculptors*. Houston, Tex.: Museum of Fine Arts; New York: Abbeville Press, 1987.

Burkhart, Dorothy. "Working Together: Joan Brown and Manuel Neri, 1958–1964." *Artnews* vol. 94, no. 10 (1995): 157.

Chipp, Herschel B. "Exhibition in San Francisco." *Artnews* vol. 59, no. 10 (1960): 50.

Clifford, Katie. "Manuel Neri." *Artnews* vol. 98, no. 3 (1999): 134–35.

Coplans, John. "The Nude: Drawings by Alvin Light, Manuel Neri, Gordon Cook, Joan Brown." *Artforum* 2 (November 1963): 39.

Fuller, Mary. "San Francisco Sculpture." *Art in America* vol. 52, no. 6 (1964): 52–59.

Heartney, Eleanor. "Manuel Neri at Charles Cowles." *Art in America* vol. 79, no. 5 (1991): 175–76.

Katz, Vincent. "Manuel Neri at Charles Cowles." *Art in America* vol. 83, no. 10 (1995): 129–30.

Morris, Gay. "Figures by the Bay." *Art in America* vol. 78, no. 11 (1990): 90–97.

Nieto, Margarita. "Manuel Neri." *Latin American Art* 1 (Fall 1989): 52–56.

Paglia, Michael. "The Beat Goes On." *Westward* (December 6–12 1995): 65.

Pincus, Robert L. "The Making of Manuel Neri." *Sculpture* 13 (January–February 1994): 34–37.

Radcliff, Carter. "And the Beat Goes On." *Art in America* vol. 84, no. 3 (1996): 62–67.

Tanguy, Sarah. "Manuel Neri: Early Works 1953–1978." *Sculpture* 16 (May/June 1997): 64–65.

Tromble, Meredith. "A Conversation with Manuel Neri." *Artweek* (April 8, 1993): 20.

Hélio Oiticica

(1937–1980)
Brazilian Painter, Sculptor, and
Interactive Sensory Environment Artist

Hélio Oiticica pushed the limits of traditional meanings and functions of art from the isolated object curated by the museum to emotionally charged experiences in the streets. He was born in Rio de Janeiro and spent the majority of his life there until his death at age forty-three. His father, José Oiticica Filho, was an entomologist, photographer, and painter; his grandfather, José Oiticica, was an anarchist. Oiticica taught children's classes at the School of the Museum of Modern Art in Rio de Janeiro while he was a student there (Binder 2). His painting teacher was Ivan Serpa, who greatly influenced Oiticica with his approach to the Neo-Concretist style and his philosophy about art and making art.

In 1955, Oiticica joined Serpa's Neo-Concretist group, Grupo Frente, of which **Lygia Clark** was also a member. Though Clark and Oiticica never collaborated, they maintained a lifelong dialogue about art (Brett, "Reverie" 111). The artists of Grupo Frente sought to produce an art that rejected realistic and purely representational imagery. Oiticica's involvement with the group led to his inclusion in the first of several group exhibitions in Rio de Janeiro, São Paulo, and Zurich from 1959 to 1961. Although Oiticica did not seek mainstream acceptance, economic success, or even formal gallery representation for his art, he was able to maintain a full-time career as an artist for the majority of his adult life (Brett, "Reverie" 111).

Oiticica and other Neo-Concretist artists referred to the linear simplicity of Geometric Abstraction and Minimalism as a framework to create an abstraction with new intentions (Brett "Reverie" 114). In particular, Oiticica was influenced by the work of the Dutch painter Piet Mondrian, who divided his canvas with black lines to form balanced spaces filled with

primary colors (Witte de With 1). The series *Penetráveis* (Penetrables, late 1950s) shows a clear stylistic connection to Minimalism. For example, *Bilateral* (1959) represents an attempt to break the two-dimensional picture plane with monochromatic reliefs on canvas. The work is suspended in air, forcing viewers to share the space with the work, since they must walk around it in order to see all sides (Mesquita 215). As the viewers move, their role shifts from passive to active.

Penetráveis was followed by *Bólides* (Meteors, Fireballs, or Nuclei, mid-1960s). In this work, Oiticica wanted to create a contained reality or "energy center" for the spectator to metaphorically enter and feel psychological respite from the chaos of everyday life. The volatile political status of his country motivated him to build a sacred space, protected from the harshness of everyday conditions. The *Bólides* are constructed from various containers, such as boxes, bags, bottles, basins, cans, nests, and beds, that hold colored sand, earth, and gauze. Because Oiticica was concerned about Brazil's poverty, he deliberately used raw materials to represent and make visible the impoverished architecture of the *favelas* (shantytowns) (Lucie-Smith 136–37).

The series *Parangolés* (Capes, 1965) was first presented at the Museum of Modern Art in Rio de Janeiro. In it, Oiticica fully integrated the audience with the art object; spectators were asked to wear colorful capes, banners, and tents printed with messages such as

> Why impossibility/ crime/ existence in searching/ search for happiness/ Of evil/ I am the mascot of *Parangolé*/Sex, violence, that's what pleases me/ Cape of liberty/ Out of your skin/ grows the humidity/ the taste of earth/ the heat/ I embody revolt/ Of adversity we live/ I am possessed/ We are hungry (Brett, "Reverie" 117).

The words conjure a variety of feelings within those wearing the capes. The size, weight, and texture of the garment also affects the experience. The participants wear the *parangolés* as they walk and dance about the streets. Oiticica maintains that color is a separate energy or reality, a view similar to his approach to the contained color in *Bólides*. Whereas the color was encased and static in the containers of the *Bólides*, it now becomes active, embracing the person wearing the *parangolé*.

Oiticica paid homage to Brazil by representing the "tropicalism" of his homeland in *Parangolés*. The capes are meant to recall costumes in the parades of Rio's Carnival and the movement of the samba. His interest in and study of the samba inspired the movements in *Parangolés*. Using the samba, a native dance of Brazil in which all people can participate, expands the accessibility of his work to nearly all Brazilians. Through his personal study of the samba, Oiticica became a skilled dancer, achieving the status of *passista* (lead dancer) in 1965 (Ades 352). During this time, he partici-

pated in the annual Rio Carnival parades and the local samba festivals (Binder 1). The height of his representational tropicalism is evident in the 1967 installation *Tropicália*. The environment is filled with parrots, plants, sand, texts, and a television set, a satirical statement on Brazilian culture and the clichéd clash between technology and tradition in many developing countries (Binder 1). His aesthetic connection to life and culture is reminiscent of **Tarsila do Amaral**, an early-twentieth century Brazilian painter who represented the daily life of the people in her homeland (Lucie-Smith 137).

The art critic Guy Brett closely followed Oiticica's life and work. He succinctly stated the complexities of meaning and intent of the *Parangolés*:

> Oiticica brought together his refined assimilation of European Constuctivism, his advanced notions of "participation" (questioning the status of the object, the nature of representation and the passive behavior of the audience), Brazil's body culture, his own sexuality and the exaltations and sufferings of the mass of people as he intuited them. ("Reverie" 116)

Throughout the 1960s, the Brazilian art scene welcomed the avant-garde, including the environments of Oiticica and Lygia Clark. However, the military dictatorship of the 1970s brought fear, censorship, and self-censorship, pushing controversial art out of mainstream culture and forcing many artists into exile (Goldman 44). During this period Oiticica left Rio de Janeiro for an extended period, living in New York City for six years. He transformed his city apartment into a "nest" for himself, safe from the dangerous externalities of life (Brett, "Reverie" 111). His life mimicked his art.

In 1992, the first retrospective of Oiticica's work was presented at Witte de With, the Center for Contemporary Art in Rotterdam. The exhibition traveled to the Jeu de Paume in Paris, the Antoni Tápies Foundation in Barcelona, the Center of Modern Art of the Calouste Gulbenkian Foundation in Lisbon, and the Walker Art Center in Minneapolis. This international exposure brought widespread attention to his work and financial support for the Hélio Oiticica Project (Witte de With 2). Since his death, family and friends have organized the majority of his oeuvre into the Hélio Oiticica Project in Rio de Janeiro. Many art scholars are just discovering his work. He continues to engage, intrigue, and challenge us to reconsider the traditional definition and purpose of art.

Places to See Oiticica's Work

Museu de Arte Moderna, Rio de Janeiro: *Bólide 18, B331: Homenagem a Cara de Cavalo* (Meteor 18, B331: Homage to Cara de Cavalo) (1967)

Museum of Modern Art, New York City

New Museum of Contemporary Art, New York City. *Hendrix War* (1970s)

Projeto Hélio Oiticica, Rio de Janeiro: *Box Bólide 9* (1964); *Bólide 5 (Homage to Mondrian)* (1965); *Cape 6 ("I Am the Mascot of Parangolé/Mosquito of Samba")* (1965); *Cape 11 ("I Embody Revolt")* (1967); *Cape 13 ("I Am Possessed")* (1966); *Cape 17 ("Guevaluta" to José Celso, Guevara + Fight)* (1968); *Glass Bólide 4* (Earth) (1969); *Spatial Relief 3* (1960)

Whitechapel Gallery, London

Witte de With Art Center, Rotterdam, Netherlands

XXIV Bienal de São Paulo. http://www.uol.com.br/bienal/24bienal/nuh/enuhmonoiti01.htm *Bilateral* (1959)

Bibliography

Ades, Dawn. *Art in Latin America: The Modern Era, 1820–1980*. New Haven, Conn.: Yale University Press, 1989.

Binder, Pat. "Hélio Oiticica—Biography." In *Universes in Universe*. Berlin: Gerhard Haupt, 1993. http://www.universes-in-universe.de/doc/oiticica/e_oitic4.htm

Brett, Guy. "Hélio Oiticica: Reverie and Revolt." *Art in America* vol. 7. no. 1 (1989): 111–21.

Brett, Guy. "Museum Parangolé." *Trans* 1, no. 1 1995. http://www.echonyc.com/~trans/museum/parangole.html

Goldman, Shifra M. *Dimensions of the Americas: Art and Social Change in Latin America and the United States*. Chicago: University of Chicago Press, 1994.

Lucie-Smith, Edward. *Latin American Art of the 20th Century*. New York: Thames and Hudson, 1993.

Mesquita, Ivo. "Brazil." In *Latin American Art in the Twentieth Century*. Edited by Edward J. Sullivan. London: Phaidon Press, 1996. Pp. 201–32.

Osthoff, Simone. *Lygia Clark and Hélio Oiticica: A Legacy of Interactivity and Participation for a Telematic Future*. 2000. http://www-mitpress.mit.edu/e-journals/Leonardo/isast/spec.projects/osthoff/osthoff.html

Witte de With. *Hélio Oiticica*. Rotterdam, Netherlands: Witte de With Center for Contemporary Art, 1992. Exhibition catalog. http://www.wdw.nl/Eng/text/projects/OITICICA/oiticica.htm

José Clemente Orozco
(1883–1949)
Mexican Muralist

José Clemente Orozco, best known for his murals, overcame disapproving parents and financial hardship to become an artist. He was born in Guzman, Jalisco, Mexico, and the family moved to Guadalajara, the capital of Jalisco, when he was two years old. In primary school, Orozco exhibited both skill and interest in art. He recalled watching the popular Mexican graphic artist, **José Guadalupe Posada**, with great awe at his printing establishment, the Vanegas Arroyo, which was located near Orozco's elementary school. Although his parents were reluctant to support his art endeavors, at the age of seven he was adopted as a part-time student at the popular Academy of San Carlos, where he took drawing classes.

After high school, Orozco's art instruction was interrupted when he followed his parents' wishes and enrolled at the San Jacinto School of Agriculture, where he took courses in cartography and agriculture. Inspired by his course work, Orozco aspired to become an architect, and decided to complete his education at the National Preparatory School. During this time two major life events occurred that would change the direction of his career forever. First, he lost his left hand and wrist in a gunpowder explosion, and second, his father died, putting an end to his funding for school (*¡Orozco!* 11). These events motivated Orozco to reconsider his career plans and to leave the National Preparatory School and return to the Academy of San Carlos. Fortunately, he had not lost the hand he wrote and painted with. Possibly the loss of his hand led him to pursue his true dream of becoming an artist, for it demonstrated that in an instant everything could change. Orozco explained his decision to become an artist: "My obsession with painting led me to drop my preparatory studies and return to the Academy . . . this time with a sure knowledge of my vocation" (Elliot 11).

Having lost his father's financial support, he was forced to work to pay for his art classes and supplies. Even though his training was limited at that point in time, Orozco's natural drawing abilities won him a job as an illustrator.

At the academy, Orozco soon became enthralled with one instructor, **Dr. Atl**, a painter who was also a political revolutionary fighting for freedom from a restrictive artistic style and a return to pride in traditional Mexican culture. Dr. Atl persuaded Orozco and other students to join his campaign. He spoke passionately about the "evils" of colonialism, how outsiders had forced their cultural beliefs on Mexico: "We would learn what the ancients and the foreigners could teach us, but we could do as much as they, or more. It was not pride but self-confidence that moved us to this belief, a sense of our own being and our destiny. Now for the first time the painters took stock of the country they lived in" (Orozco *An Autobiography* 20). Orozco would listen to Dr. Atl talk about the great murals of Italy, which inspired his later extensive exploration in mural painting, along with **Diego Rivera** and **David Alfaro Siqueiros**.

Before launching his career as a mural painter, Orozco made numerous small paintings, drawings, and caricatures similar to those of Posada, his first artistic influence. In an untitled political cartoon from 1915, he uses the *calavera* (skull and skeleton imagery), much the way Posada did in *Revolutionary Calavera* (c. 1910), to represent a failure of Revolutionary reform parties (*¡Orozco!* 7). In 1916, he had his first solo exhibition in Mexico City, at the Libreria Biblos Gallery, where 123 fanciful works were displayed in three sections: drawings of schoolgirls, watercolors of prostitutes, and political caricatures.

Orozco's participation in the Mexican Revolution included writings and illustrations for Dr. Atl's political publication, *The Vanguard*. He also lived with Dr. Atl and other painters in an artists' commune, Centro Artistico, for several months (Helm 12). However, Orozco claimed not to have had any political influence or strong opinions (*¡Orozco!* 16). Eventually, the poor economy and lack of work due to the war drove Orozco to move to the United States, where he worked first as a sign painter and then at a factory, painting doll faces (Lucie-Smith 56).

In the early 1920s, he returned to Mexico and immediately began participating with Rivera in painting murals. He was commissioned by the National Preparatory School to paint the mural *The Reactionary Forces* (1924). This political mural portrays figures similar to those in his caricatures, with exaggerated features and animated forms. In one panel of the mural, *Social Justice*, he addressed the differences between the economic classes by depicting the rich in grossly extravagant clothing and the poor as victims exploited by the rich (*¡Orozco!* 16).

The conservative students at the National Preparatory School were displeased with the controversial mural, and launched a protest that forced

Orozco to leave before completing his work (Lucie-Smith 56). During the two years he was gone from the school, students defaced his mural (it was later partially restored). Upon returning in 1926, he began work on the second major mural for the school, *Destruction of the Old Order* (1926–27). At the school he was often overshadowed by the powerful personality of Rivera, and his frustration led him to move back to New York City (Lucie-Smith 58).

While in New York, Orozco was commissioned to create murals throughout the United States. From 1932 to 1934, he painted *The Epic of American Civilization* in Baker Library at Dartmouth College in Hanover, New Hampshire. This twenty-four panel narrative mural illustrates the history of the Americas from the Aztec migration into Central Mexico to the evolution of an industrialized society ("The Epic of an American Civilization" 1). The panels are presented chronologically to depict social progress in the Americas. For instance, in the third panel, *Ancient Human Sacrifice*. Indians in traditional costume are performing a pagan ritual, and in the eighteenth panel, *Modern Human Sacrifice*, the machine of industry overtakes man.

By the mid-1930s, Orozco was once again in Mexico, where he stayed until his death in 1949. These years were productive ones; he continued to paint murals and received commissions from the Palace of Fine Arts, the Supreme Court of Justice, and the church at the Hospice Cabañas, all in his childhood hometown of Guadalajara. Orozco, who wanted to be a painter above all else, overcame great odds to pursue his dream, and left behind walls covered in his expansive narratives.

Places to See Orozco's Work

California State University, Long Beach: *Mujeres I* (Dead Woman) (1935); *Mujeres II* (Two Heads) (1935)

CDS Gallery, New York City

De Young Museum, San Francisco: *Inditos* (c. late 1920s); *Three Generations* (1926)

Escuela Nacional Preparatoria, Mexico City: *Destruction of the Old Order* (1926–1927); *The Reactionary Forces* (1924)

Galería Enrique Guerrero, Mexico City

Gary Nader Fine Art, Coral Gables, Fla.

Hood Museum of Art, Dartmouth College, Hanover, N.H.: *The Epic of American Civilization* (1932–1934)

Hospicio Cabañas, Guadalajara, Mexico

Mary-Anne Martin Fine Art, New York City

Mary Ryan Gallery, New York City

Museo de Arte Carillo-Gil, Mexico City: *The Hour of the Gigolo* (1913)

New School University for Social Research, New York City: *The Table of Brotherhood* (1930)

Pomona College, Claremont, Calif.: *Prometheus* (1930)

Bibliography

Charlot, Jean. *Mexican Art and the Academy of San Carlos, 1785–1915*. Austin: University of Texas Press, 1962.

Elliot, David. "Orozco: A Beginning." In *¡Orozco!* Oxford: Museum of Modern Art, 1980. Pp. 11–17.

"The Epic of the American Civilization." Hood Museum of Art. 2001. http://www.dartmouth.edu/~hood/collections/orozco-murals.html

Folgarait, Leonard. *Mural Painting and Social Revolution in Mexico. 1920–1940: Art of the New Order*. New York: Cambridge University Press, 1998.

Helm, MacKinley. *Modern Mexican Painters*. 2nd ed. New York: Harper & Brothers, 1941.

Lucie-Smith, Edward. *Latin American Art of the 20th Century*. New York: Thames and Hudson, 1993.

¡Orozco! Oxford: Museum of Modern Art, 1980.

Orozco, José Clemente. *An Autobiography*. Translated by Robert C. Stephenson. Austin: University of Texas Press, 1962.

Orozco, José Clemente. *The Artist in New York*. Translated by Ruth L. C. Simms. Austin: University of Texas, Press, 1974.

Reed, Alma M. *Orozco*. New York: Oxford Press, 1956.

Schmeckebier, Laurence E. *Modern Mexican Art*. Minneapolis: University of Minnesota Press, 1939.

Pepón Osorio
(b. 1955)
Puerto Rican Installation Artist

Pepón Osorio is known for installation art (an assemblage of items constructed in a gallery space for a specific exhibition). His installations are excessive, densely packed, full of kitsch, and politically charged. Osorio is an artist who is internationally recognized, yet locally rooted. Though born in Puerto Rico, he is best known for his visual commentary on life in the South Bronx in New York City. Playing on and exaggerating stereotypes with elaborate decoration and endless repetition, he entices the viewer into his work while ingeniously communicating social commentary (Hass 96).

Osorio came to New York City in the mid-1970s. He earned a degree in sociology from Lehman College, and for five years he was a Child Protective Services worker in the Latino community. During this time he visited many homes and had lengthy conversations with nurses, undertakers, and family members with troubled lives (Fusco 101). His interest in healing communities continues to be a driving force in his work. In 1992 he stated:

My work responds to important issues in our communities, where our reality is, how it is lived by us, and not how it is seen by others. Most of my art work reflects experiences and testimonies combining pain, violence, frustration, humor, and the anger behind it. I attempt to voice concerns that are important to my immediate community, some of which have existed for decades. Lately, the context of my work has focussed on specific issues reflecting the vivid reality and restless intensity of the South Bronx experience. My work also emerges from collective experience. Therefore, the process involves the expertise of party favor makers, and auto glass repairmen, among others with whom I have become involved in a creative dialogue and

Pepón Osorio. Photo Credit: Peggy Jarrell Kaplan. Courtesy Ronald Feldman
Fine Arts, New York City. Used with permission.

exchange of experience. . . . I have become interested in creating installations
that make social comments and portray the behind-the-door living condi-
tions of my communities. (Osorio n.p.)

As a child in Puerto Rico, Osorio helped his mother decorate elaborate
cakes that she baked for local events. He was also fascinated by jewelry
worn by his "second mother," Juana Hernandez, a teenage orphan who
came to live with his family and cared for him when he was little. She in-
fluenced one of his most powerful pieces (Fusco 101). *La Cama* (The Bed,
1987) is a lavishly decorated bed in a white lace bedroom. This installation
is a tribute to Juana, who died in 1982. It recognizes her difficult life while
lovingly giving her material opulence in gratitude for the spiritual richness
she gave Osorio. The light pink bedspread is covered with hundreds of
the souvenirs that are given at Puerto Rican weddings, baptisms, and an-
niversary celebrations. On the headboard are pictures of Pepón and Merián

Soto, the woman he later married. In this way Orosio introduced Juana to Merián (Torruella Leval 13).

Sometimes Osorio works with Merián Soto, who is a dancer and performance artist. Together they often enact stereotypes; Soto powders her skin white, and Orosio combs his hair into a thick Afro. Reflecting on the pain these stereotypes cause them in day-to-day life, they emotionally act out their feelings, ending in an exhausted but tender embrace (Torruella Leval 21; Fusco 100). Orosio's work acknowledges his political identity as he negotiates to expand, adopt, and manipulate it from a position centered within his Latino community. As his cultural positioning changes, outside stereotypical views are also transformed.

The politically charged Caribbean practices associated with carnival are evident in Osorio's work. Characterized by some as kitsch, his art often consists of furniture or everyday items found in the home: couches, chandeliers, beds, clocks, or trophies. These larger items are then overlaid with mass-produced objects such as decals, toy cars, plastic flies or dolls, fake grass, patterned fabrics, lace, and American and Puerto Rican souvenirs. The excessiveness of his work flies in the face of a Puritan dislike for decoration as well as the Minimalist focus on simplicity and sparseness. He presents his culture like a bright and colorful spectacle as he subverts it by remaking and reinterpreting it. The Puerto Rican immigrant experience of marginalization is seductively made central (Fusco 98–99).

Osorio's interest is not only in the oppression that occurs from outside the Latino community; he skillfully portrays the pain that exists within the community. For example, in his 1995 installation *Badge of Honor*, he creates two adjoining rooms belonging to a father and a son. One is a prison cell; the other, a teenager's bedroom decorated with kung fu posters, Nike shoes, and photos of looming father figures. Based on a real-life situation, the installation contained video footage of the father/son dialogue, the presence of each filling the other's physical space (the room) and mental space (thoughts). This work, like many of his installations, has been open to various interpretations. For example, when displayed in the United States, this piece seemed to communicate family pain that results from crime; and when it was shown in Johannesburg, South Africa, the New York curator Dan Cameron claimed that it was about apartheid (Hass 98–99). Osorio's art, though grounded in his ethnic experience, transcends its specificity. Osorio is an artist who succeeds in ways that many other artists working today do not.

The artist Fred Wilson, reflecting on Osorio's ability to comment on social issues with clearly communicated aesthetic interest, observed that he "is somehow able to look at the festive side of the Latino community in a really accomplished way and still let you see the sadness and the pain beneath it" (Hass 98). Pepón Osorio is an artist with a political and social mission. While enticing the viewer into his work with opulence and mind-

boggling excess that is rooted in his Puerto Rican heritage, he transcends space and time with stories about isolation, pain, and sadness. But within all this is the celebratory message that life can heal as we learn from our troubles and hardships.

Places to See Osorio's Art

Bernice Steinbaum Gallery, Miami, Fla.

National Museum of American Art, Washington, D.C.

Ronald Feldman Fine Arts, New York City

Walker Art Museum, Minneapolis, Minn.

Whitney Museum of Art, New York City

Bibliography

Aponte-Parés, Luis, Joseph Jacobs, and Berta M. Sichel. *Project 5: Pepón Osorio. Badge of Honor Insignia de Honor*. Newark, N.J.: Newark Museum, 1996.

Fusco, Coco. "Vernacular Memories." *Art in America* vol. 79, no. 12 (1991): 98–103, 133.

Fusco, Coco. *English Is Broken Here: Notes on Cultural Fusion in the Americas*. New York: The New Press, 1995.

Hass, Nancy. "The Secret of His Excess." *Artnews* vol. 98, no. 6 (1999): 96–99.

Heartney, Eleanor. "Photography: Between Horror and Hope." *Art in America* vol. 79, no. 11 (1991): 75–79.

Leffingwell, E. "Pepón Osorio at Ronald Feldman." *Art in America* vol. 79, no. 11 (1991): 139.

Osorio, Pepón. "Artist's Statement." In *El Velorio (The Wake): AIDS in the Latino Community. Brochure for the Exhibition, October 9 Through December 6, 1992*. Philadelphia: Pennsylvania Academy of Fine Arts, 1992. n.p.

Sichel, Berta. "Pepón Osorio: No Crying Allowed." *High Performance* vol. 4, no. 68 (Winter 1994): 46–47.

Torruella Leval, Susana. *"Con To' los Hierros." Pepón Osorio*. New York: El Museo del Barrio, 1991. Pp. 5–21.

Ramón Oviedo
(b. 1927)
Dominican Painter

In his native country, Ramón Oviedo is revered as the Master Dominican Painter for his prominence as an artist, which is supported by his large body of work and lifelong pursuit of artistic achievement. Born in the small town of Barahona, he grew up with his grandmother. Before the age of ten, they moved to the capital city of Santo Domingo. Because of the family's modest economic resources, young Ramón was forced to work. Oviedo attributes his early passion for art to his father's work as a draftsman at the Ministry of Public Works: "I remember that when I was very little, I used to scribble with sticks, or with my fingers, attracted by graphics and painting. And then I got the stimulation of my father" (Tolentino 71).

The combination of his father's inspiration and the exposure to various jobs in the art field motivated Oviedo to dedicate his life to creating art. He did not have the financial means to attend art school, so he assisted commercial artists in a variety of capacities, learning through observation and experience. His jobs ranged from running errands for a photoengraving workshop to designing advertisements for a local agency (Tolentino 71). As a young adult, he became the most skilled mapmaker in the Dominican Republic (Ocaña 1).

Instead of traveling to Europe or studying artists' slides in a dark classroom, Oviedo memorized art reproductions on postcards. He closely observed the artistic techniques and styles of the painters Goya, Rembrandt, and Velázquez, whom he admired the most. Oviedo taught himself to draw by spending hours a day practicing his skills while creating portraits that he gave away because he felt he was not yet a "real" artist. He sketched

Ramón Oviedo. Photo Credit: Max Pou. Courtesy of the Ramón Oviedo Foundation, Santo Domingo, Dominican Republic. Used with permission.

every day, often while sitting on a park bench, quickly capturing the faces of those passing by (Ocaña 1).

In 1961, the Dominican Republic's dictator, Rafael Trujillo, was assassinated; several years of bloodshed and political unrest ensued, increasing anarchy and rebellion among the people. Many artists, including Oviedo, distributed literature for democracy and expressed their ideals through art. He joined the artists' group Proyecta (Project), established in support of a new form of expression that explored abstraction, collage, and other techniques. With other group members, Oviedo developed an abstract style referred to as Social Expressionism (Miller 111). His painting shifted from portraiture to depicting the horrific reality of war, in life and death (Miller 104). Oviedo's interpretation of Social Expressionism results in extremely abstract canvases in which layer upon layer of rich color contrasted with fine lines. The content may not be apparent without the guid-

ance of titles, but with the descriptions the emotional compositions become poignantly meaningful.

During the civil war that followed Trujillo's death, Oviedo used his paintbrush to illustrate his feelings. The *24th April* (1965), his most acclaimed painting of this period, represents the day that citizens demanded democracy and took over the Dominican National Palace (*Ramón Oviedo* 2). This painting won first prize in an art competition held during the revolution. At first glance, *24th April* appears fanciful, resembling a super-hero comic strip in which bold, thick outlines reveal an animated scene. But another look reveals the horror of that tragic day in Dominican history. The central figure runs toward the cannons, one hand held up in protest and the other, holding a weapon, raised for defense. Another figure cries out in anguish, and yet another lies dead on the ground, palm open to expose a large rock meant to be used as a weapon. In contrast to nearly all his other works, the canvas is shockingly stark, devoid of color but full of life and action. Oviedo credits Pablo Picasso's painting *Guernica* (1937), depicting the German bombing of that Spanish town, as his inspiration to create *24th April* (Tolentino 61).

Along with many other Latin American artists, Oviedo was influenced by Mexican murals. The majority of murals in the Dominican Republic were less politically charged than those composed by Mexico's **Diego Rivera, David Alfaro Siqueiros**, and **José Clemente Orozco**. Oviedo has been commissioned to paint murals by several Dominican businesses, including the BHD bank of Santo Domingo. There, he painted *Sinfonía Tropical* (Tropical Symphony, 1987), a visually stimulating and colorfully energetic work in which "movements and hues, tones and cadences, visual rhythms also express a tribute to music" (Tolentio 67). In a virtual montage of imagery, musicians play while dancers smile and move to the beat against a tropical background. This mural exemplifies a popular style in Dominican painting, *Dominicanidad*, which is the inspection of Dominican roots, specifically a blending of Spanish and African cultures (Miller 104). While many Dominican artists painted murals, Oviedo was the only one to create them overseas, including a commission for the UNESCO Headquarters in Paris (Tolentino 67).

Oviedo shows great precision in his realistic portraits and expresses a strong sense of color, texture, and balance in his highly developed abstract paintings. Art critics link his work to that of highly skilled and educated artists, such as Pablo Picasso (Barnes 216). Oviedo has received many awards recognizing his achievement in art, including the first prize for the León Jiménez Annual Art Contest (1969, 1970), the title "honorary professor" from the Autonomous University of Santo Domingo (1995), and the prize for the best international exhibit of a Dominican painter (1998).

Most notably, Oviedo was honored by the Dominican Congress as Illustrious Master of Dominican Republic Painting in 1997. Antonio Ocaña

established the Ramón Oviedo Foundation in 1998 to represent the artist and to manage the vast collection of works he is still producing. During an exhibition in 2000, at the Crealdé School of Arts in Winter Park, Florida, Ocaña represented the artist, who was unable to attend because of an upcoming election he did not want to miss. Most recently, he has created several murals in the Dominican Republic, including *Next to the Fifth Dimension* (2000) for the Banco de Reservas de la República Dominicana, the government-owned bank; *Bolívar Is America* (2001) for the Venezuelan embassy; *Independence* (2001), at the headquarters of the secretary of the armed forces; and *Justice*, completed in 2000, at the new Palace of the Supreme Court of Justice. Now in his mid-seventies (as of 2002), Oviedo continues to be a source of artistic energy through his paintings and commentary on the state of society in his homeland.

Places to See Oviedo's Work

Andrés Gallery of Santo Domingo

Artspace/Virginia Miller Galleries, Coral Gables, Fla.

Central Bank Headquaters, Santo Domingo, Dominican Republic

Headquarters of the Organization of the American States, Washington, D.C.: *Mamamérica* (1982)

House of the Americas, Havana, Cuba: *Crucifixión, Siglo XX* (1984)

Metropolitan Museum of Panama, Panama City

Museum of Modern Art of the Dominican Republic, Santo Domingo

National Museum of Nicaragua, Managua

Ramón Oviedo's Web page: www.ramonoviedo.com

UNESCO Headquarters, Paris: *Petrified Culture* (1992)

Bibliography

Barnes, Nancy. "Ramón Oviedo." *Artnews* vol. 99, no. 7 (Summer 2000): 216.

Bishop, Phillip. "Dominican Drama." *Orlando Sentinel*, Calendar, May 26–June 1, 2000: 36.

Miller, Jeannette. "Dominican Republic." In *Latin American Art in the Twentieth Century*. Edited by Edward J. Sullivan. London: Phaidon Press, 1996. Pp. 103–18.

Ocaña, Antonio. "Re: Master Ramón Oviedo." E-mail to Kara Kelley Hallmark. May 5, 2001.

Poupeye, Veerle. *Caribbean Art*. London: Thames and Hudson, 1998.

Ramón Oviedo: Dominican Master Painter. Winter Park, Fl.: Crealdé School of Art, 2000.

Tolentino, Marianne de. *Oviedo: Un pintor ante la historia*. Translated by Véronique Viala de Gallardo. Santo Domingo: Antonio Ocaña, 1999.

Amelia Peláez
(1896–1968)
Cuban Painter and Ceramist

As an artist responsible for innovations in Cuban art, Amelia Peláez was concerned with the compositional development of images in the process of making a painting. Born in the small town of Yaguajay, on the north coast of Cuba (Blanc 17), she was one of nine children. Her father was a country doctor and her mother was the sister of the poet Julián del Casal (Ades 353). Her mother's family had once been prosperous through owning sugar mills. Peláez was taught to read and write by her mother. She was fascinated by her brother's colorful marble collection; later she was intrigued by the bright and elaborate kites that are traditionally flown in the countryside, and she began constructing them. After that, she began to draw and create watercolors of flower arrangements she saw in magazines and in the countryside (Blanc 17).

Peláez moved with her family to Havana in 1915 (*Latin American Spirit* 323). She studied art at the Academy of San Alejandro in Havana from 1916 to 1924, and at the Art Students League in New York City later in 1924. From 1927 to 1934 she studied in Paris at the Academy of the Grande Chaumière, the School of Fine Arts, and the School of the Louvre. During these years she traveled to Spain, Germany, Italy, Czechoslovakia, and Hungary (*Latin American Spirit* 323). She was intrigued by Cubism and other abstract works and her European travels allowed her to make a prolonged study of modernist styles. She was especially influenced by the works of Ingres, Seurat, Cézanne, Picasso, Braque, and Matisse. Her studies in 1931 at Fernand Léger's Contemporary Academy, with the Russian artist Alexandra Exter, inspired her to create more flattened organic shapes. When she returned to Cuba in 1934, her work conveyed a unique synthesis

215

of what she had learned in Europe, then applied to the subject matter of her native land and to her earlier style of painting (Ades 136–37).

Unlike many other Latin American artists of the early to mid-twentieth century, Peláez was unconcerned with promoting any political ideology, except the freedom to explore art from a formalist perspective (Angel 282), within the context of celebrating Cuban culture. Her primary concern was with the elements and principles of design. Her inspiration came from the ornamental motifs in her Cuban surroundings.

In a rare 1936 interview she explained how she approached her painting:

> I am not interested in copying the object. Sometimes I ask myself, why paint oranges realistically? What matters is the relation of the motif with oneself, with one's personality, and the power the artist has to organize his [her] emotions. This is the reason I deliberately broke with appearances. One of the major acquisitions of today's artists is that of having found expression through color. (Blanc 32)

In the late 1930s Peláez painted many Cuban fruits, using a colorful palette (Blanc 27). These were clearly related to Parisian still lifes created with a Cubist influence. Flattened planes, multiple perspectives, and abstract compositions characterized the work. In the 1940s she painted many works depicting women that employ more vigorous movement and emotional intensity than her earlier figurative portrayals (Blanc 45).

Although she traveled a great deal and lived in many places, Peláez's work always has a Cuban look to it. For example, *The Hibiscus* (1943) employs festive colors, local plants, patterned curtains, and cane-bottom chairs (Angel 282). Her works often incorporate plants from her garden and tropical birds from her collection. Architectural elements from her surroundings, such as porch columns and iron railings, appear in her work (Chaplik 123–24). Her garden was such a special retreat for her that sometimes it is compared to Monet's garden at Giverny in France (Blanc 19).

A high point in Peláez's career was the 1944 Museum of Modern Art exhibition "Modern Cuban Painters." Except for **Wifredo Lam**, who declined to participate, all the major living Cuban artists were represented (Blanc 51).

In Cuba, Peláez lived a relatively quiet life with her mother and sisters. She consistently worked at her art until her death. While most of her effort went into easel paintings, she also produced ink drawings and ceramic tile murals for Havana's buildings. Peláez also painted murals in fresco (Chaplik 124), created by mixing pigment with water and applying it directly to wet plaster.

In the 1950s Peláez's interest in ceramics led her to set up a workshop. It was close enough to her home that she could walk there whenever she pleased. Here she created objects with exquisite designs that place her

among the top ceramists of the twentieth century (Blanc 55). By the end of the 1950s, she had frequently shown her work internationally, and she and Wifredo Lam were probably the most highly regarded artists living in Cuba.

Amelia Peláez is a notable artist for several reasons. Her works are beautifully composed, and her innovative use of color and composition is important. She was a major influence on Cuban artists who followed her. The intensely decorative aspect of her work was liberating to many artists, who followed her cue by exploring sensuous design and bold artistic freedom (Angel 282). She is also seen by some as the most important Cuban woman artist, shaping the field of art as much as the great artist Wifredo Lam had done (Camnitzer 161).

Places to see Peláez's Work

José Miguel Gómez School, Havana: Fresco (1937)

Ministry of the Interior (formerly Comptroller's Office), Havana: Ceramic Tile Mural

Museo Nacional de Cuba, Havana: *Flores Amarillas* (Yellow Flowers, 1964); *Gundinga* (1931); *The Hare/La Liebre* (1929); *Las Hermanas* (The Sisters, 1943); *Naturaleza Muerta* (Still Life, 1961); *Naturaleza Muerta con Piña* (Still Life with Pineapple, 1967)

Museo Nacional, Palacio de Bellas Artes, Havana: *The White Cloth* (1935)

Museum of Modern Art, New York City

Museum of Modern Art of Latin America, Washington, D.C.: *Dama Esperando* (Waiting Lady, 1944); *The Hibiscus* (1943)

National Museum of Fine Arts, Havana

Normal School for Teachers, Santa Clara, Cuba: Fresco (1937)

San Francisco Museum of Modern Art

Bibliography

Ades, Dawn. *Art in Latin America: The Modern Era, 1820–1980*. New Haven, Conn.: Yale University Press, 1989.

Amelia Peláez, 1896–1968: A Retrospective/Una retrospectiva. Essays by Eloísa Lezama Lima, Giulio V. Blanc, and Angel Gaztelu. Miami: Cuban Museum of Arts and Culture, 1988. (In English and Spanish.)

Angel, Félix. "The Latin American Presence." In *The Latin American Spirit: Art and Artists in the United States, 1920–1970*. Essays by Luis R. Cancel, Jacinto Quirarte, Marimar Benítez, Nelly Perazzo, Lowery S. Sims, Eva Cockcroft, Félix Angel, and Carla Stellweg. New York: Bronx Museum of the Arts in association with Harry N. Abrams, 1988. Pp. 222–83.

Blanc, Giulio V. "The Secret Garden of Amelia Peláez." In *Amelia Peláez, 1896–*

1968: A Retrospective/Una retrospectiva. Miami: Cuban Museum of Arts and Culture, 1988. Pp. 17–71.

Camnitzer, Luis. *The New Art of Cuba.* Austin: University of Texas Press, 1994.

Chaplik, Dorothy. *Latin American Art: An Introduction to Works of the 20th Century.* Jefferson, N.C.: McFarland, 1989.

Damian, Carol. "Amelia Peláez." *Latin American Art* 3, no. 2 (Spring 1991): 27–29.

The Latin American Spirit: Art and Artists in the United States, 1920–1970. Essays by Luis R. Cancel, Jacinto Quirarte, Marimar Benítez, Nelly Perazzo, Lowery S. Sims, Eva Cockroft, Félix Angel, and Carla Stellweg. New York: Bronx Museum of the Arts in association with Harry N. Abrams, 1988. Pp. 313–26.

Martinez, Maria Clara. "Amelia Peláez." *Art Nexus* 5 (August 1992): 126–27.

Poupeye, Veerle. *Caribbean Art.* New York: Thames and Hudson, 1998.

André Pierre
(b. 1916)
Haitian Painter

André Pierre, like **Hector Hyppolite**, is a Vodou priest who took up painting in his middle life (Rodman, *The Miracle* 77). Born in Port-au-Prince, he was orphaned at the age of five. He was raised by an aunt in l'Anse-a-Veau, and later studied at the Jean Marie Guilloux School in Port-au-Prince. He then returned to the countryside where he farmed his father's land with an uncle (*André Pierre*). He began painting by decorating ritual gourds, ceramic bottles, and temple walls, as part of his duties as a priest. In 1949 Maya Deren, a filmmaker and author of a book on Haiti titled *Divine Horsemen*, who knew Pierre and his talent due to research she was doing in his hometown of Croix-des-Missions, introduced him to the activities at the Centre-d'Art in Port-au-Prince. He then began to paint on canvas and masonite (Stebich 167). His well-organized paintings portray a rich array of markets, colorful dress, rich and varied foliage. He rarely mixes his colors, making them bright and intense. Vodou ceremonies are depicted in elaborate detail (Sebich 167).

Using a bright palette for his painting, Pierre depicts Vodou rituals and *lwa* (deities or spirits). Often his *lwa* are elaborately costumed, engaged in ceremonies or presenting offerings to the gods and goddesses of the sea (Barnitz 125). Vodou is not only a religion, but a way of life. In 1942–43 the ruling class attempted to repress it with an anti-superstition campaign. However, in 1946 Vodou was legalized, and art related to it flourished (Poupeye 81).

Despite being recognized as a successful artist, Pierre claims he doesn't know how to make a picture because, for him, painting is something he does to serve the Vodou deities. In this context, in the 1960s he painted the four walls of the holiest part of Croix-des-Missions, in Croix des Bou-

quets. He depicted *lwa* in halved calabash shells, which are used during ceremonies. These images are more isolated than the deities in his later paintings, which are generally nestled in richly colored jungle scenes (Rodman, *Where Art Is Joy* 162). Explaining how he approached his creative process at the Croix-des-Missions, he said, "I painted, as I always do, not to make a painting but to demonstrate the truths of my religion" (Rodman, *Where Art Is Joy* 162). He then modified that comment to say that he paints not only for his religion, but for all religions (Rodman, *Where Art Is Joy* 162).

One of Pierre's first paintings with a jungle background is *Maitresse La Sirène of the Sweet Waters* (c. 1964). This goddess, adorned with bracelets, her knee-length, wavy black hair falling all around her, reaches to the sky. In one hand she holds a fish; in the other, a trumpet that she blows to other *lwa*. Black and white birds watch her from the trees on one side of the painting, and snakes coil around trees on the other. These serpents wind their way down the palm trees, which are a metaphor for freedom. Reflecting on this part of the painting, Pierre said that freedom is essential for life. It is achieved by enlisting the help of the *lwa*. Crosses and *vévé*, ritual drawings on the ground, are placed throughout the scene (Rodman, *Where Art Is Joy* 88, 165; Stebich 79). In this painting, as in many others, he includes trees with sawed off limbs, which, he said, were designed to help the deities who live in them move in and out with ease.

In his 1969 oil on canvas, *L'Offrande Remise aux esprits de mer: Cérémonie Agoué* (Offerings Given to the Spirits of the Sea: Ceremony for Agoué). Pierre places Agoué, god of the sea, near a boat with a fish in it. People gather round, bringing fruits and vegetables, while musicians on the bank play their instruments (Barnitz 125–126). *Triptych* (1973), a series of three paintings, includes Grand Brigitte (the *lwa* of love) on one end, and Baron Samedi (the *lwa* of death) on the other end; in the middle is Sirène of the Sweet Waters. Here, love and death also represent the physical and the spiritual. These paintings are small, inviting the viewer to come close to enjoy an intimate relationship with the *lwa* (Stebich 78–79).

For a while Pierre painted at an easel in Port-au-Prince, where tourists could watch. But the regulation of the hours and the business of city life displeased him, and he returned to his home at Croix-des-Missions. He paints continuously, trying to fill numerous orders and commissions (Rodman, *Where Art Is Joy* 166). His painting is his religious activity. Each piece is approved of and consecrated in a ritual that calls on divinities. In this way, his paintings are religious icons. Although most of his work is purchased by people who do not practice Vodou, this does not disturb him. In his mind, he is sending his paintings all over the world as part of his religious mission. Because Vodou lacks a written scripture, the visual representation of the faith is passed on as his paintings hang on walls in many lands (Stebich 167).

Places to See Pierre's Work

Croix-des-Missions, Croix des Bouquets, Haiti

Milwaukee Art Museum, Milwaukee, Wis.

Musée d'Art Haïtien, Port-au-Prince

Bibliography

André Pierre. June 8, 2001. http://www.haitianpainting.com/images/paintings/
 PIERRE_ANDRE/

Barnitz, Jacqueline. *Twentieth-Century Art of Latin America*. Austin: University of
 Texas Press, 2001.

Cosentino, Donald J., ed. *Sacred Arts of Haitian Vodou*. Los Angeles: Fowler Mu-
 seum of Cultural History, University of California, 1995.

Galembo, Phyllis. *Vodou: Visions and Voices of Haiti*. Berkeley, Calif.: Ten Speed
 Press, 1998.

Nunley, John W., and Judith Bettelheim, with Barbara A. Bridges, Rex Nettleford,
 Robert Farris Thompson, and Dolores Yonker. *Caribbean Festival Arts: Each
 and Every Bit of Difference*. Seattle: University of Washington Press in as-
 sociation with the Saint Louis Art Museum, 1988.

Poupeye, Veerle. *Carribbean Art*. New York: Thames and Hudson, 1998.

Rodman, Selden. *The Miracle of Haitian Art*. Garden City, N.Y.: Doubleday, 1974.

Rodman, Selden. *Where Art is Joy: Forty Years of Haitian Art*. Fort Lauderdale,
 Fla.: Museum of Art, 1988.

Stebich, Ute, ed. *Haitian Art*. New York: Brooklyn Museum, 1978.

José Guadalupe Posada
(1852–1913)
Mexican Graphic Artist

José Guadalupe Posada was an extremely prolific artist, creating about 15,000 prints in thirty years (Traba 15). He spoke to and for the everyday person. Inspired by ballads, native history, and folklore, as well as the political struggle of his day, Posada's work has inspired generations of printmakers who came after him. He is perhaps best known for his representations of the *calavera*, the skull or skeleton, popularized in Day of the Dead celebrations on November 1 and 2, when the dead are invited to return to their families for a visit.

Born in León, in the state of Guanajuato, to a middle-class provincial family, he lived during a time when Mexico had a well established tradition of printing satirical newspapers. In 1871 he worked in his hometown as head lithographer for a weekly periodical called *El Jicote*. It failed after fewer than a dozen issues, and he moved on to work at other presses as the popularity of illustrated papers increased (Ades 111–14). Posada provided illustrations for various mass-produced publications besides newspapers, including songbooks, children's stories, parlor games, and playing cards (Carmichael and Sayer 11, 126).

In 1888 he moved to Mexico City, where most of his work was done for the publisher Antonio Vanegas Arroyo, who had a successful and stable business (Brenner 186–88). Under Arroyo's direction, Posada created illustrations for sensational news stories, such as a collision of a streetcar and a hearse, a mining disaster, and a story about a woman who supposedly gave birth to three babies and two iguanas. He drew images of horrific deaths by firing squads and Robin Hood-style bandits. His popular *calaveras* were used in publications, and later were sold to the mostly illiterate public on street corners (Ades 117).

Posada's images of *calaveras* are X-ray versions of humans (and sometimes animals). They are dressed, ready to do their everyday work as soldiers, laborers, cooks, and various other jobs. These skeletal figures are also depicted drinking, eating, and playing musical instruments. They laugh and mock the upper classes, who will be equalized with the peasants in death. Posada's *calaveras* point out that wealth and position do not save one from dying. In the end, no matter how much status and money one has, death takes everyone. These witty and ironic illustrations allowed Posada to make statements that could not be easily put into words. His biting political criticism of the wealthy gave him wide appeal with the laborers and peasants (Ades 122–23).

While today all of Posada's varied kinds of images are praised, it is perhaps his illustrations of the *calavera* that have been most inspiring. By the time Posada began creating *calaveras*, they were already well established in Mexico's popular culture; however, it was Posada who developed them to their mocking extreme (Carmichael and Sayer 58). **Diego Rivera** and **Frida Kahlo**, along with other Mexican artists, followed his lead and put skeletons in their paintings. Rivera even copied Posada's *La Catrina*, the upper-class female *calavera* in a wide-brimmed hat, and placed her beside him in one of his murals, *Dream of a Sunday Afternoon in Alameda Park* (Poniatowska 57, 62).

Despite his success, Posada died in poverty, and his corpse was placed in a common grave (Garciagodoy 96–98). After his death, Arroyo continued to publish Posada's works. In the 1920s, the muralist Jean Charlot rediscovered him, and Rivera and **José Clemente Orozco** continued to help keep his work visible (Carmichael and Sayer 126). However, the ones who were most clearly influenced by Posada's work were members of the **Linares family**. They have re-created many of his two-dimensional renderings into highly praised papier-mâché sculptures that continue to satirize the foibles of the Mexican people (Masuoka 90).

Posada is remembered not only as a great artist but also, through his work, as a cultural critic. He had a great love for Mexico's working-class people. He never married; instead, he spent his lifetime making political and cultural statements about what was happening in his country. Grounded in traditional folklore, his over-the-edge depictions of events, both real and imagined, played an important role in Mexican society in the late nineteenth and early twentieth centuries. Today, Posada is internationally known, and his work is reproduced frequently.

Places to See Posada's Work

Arizona State University Art Museum, Tempe
Fine Arts Museum of San Francisco

Fowler Museum of Cultural History, UCLA, Los Angeles

Metropolitan Museum of Art, New York City: *Las Bravísimas Calaveras Guatemaltecas de Mora y de Morales* (The Brave Guatemalan Calaveras of Mora and Morales, 1907); *Calavera Tapatía* (c. 1890); *Revumbio de Calaveras* (A Noisy Gathering of Calaveras, n.d.)

Phoenix Art Museum, Phoenix, Ariz.

The Ransom Center at the University of Texas, Austin

Bibliography

Ades, Dawn. *Art in Latin America: The Modern Era, 1820–1980.* New Haven, Conn.: Yale University Press, 1989.

Berdecio, Roberto, and Stanley Appelbaum, eds. *Posada's Popular Mexican Prints: 278 Cuts by José Guadalupe Posada.* New York: Dover, 1972.

Brenner, Anita. *Idols Behind Altars.* New York: Biblo and Tannen, 1967.

Carmichael, Elizabeth, and Chloë Sayer. *The Skeleton at the Feast: The Day of the Dead in Mexico.* Published in cooperation with British Museum Press. Austin: University of Texas Press, 1991.

Garciagodoy, Juanita. *Digging the Days of the Dead: A Reading of Mexico's Días de Muertos.* Niwot: University Press of Colorado, 1998.

Masuoka, Susan N. *En Calavera: The Papier-mâché Art of the Linares Family.* Los Angeles: Fowler Museum of Cultural History, UCLA, 1994.

Mexico: Splendors of Thirty Centuries. New York: Metropolitan Museum of Art, 1990.

Poniatowska, Elena. "The Great Cemetery of Dolores." In *Día de los Muertos.* Edited by René H. Arceo Frutos. Chicago: Mexican Fine Arts Center Museum, 1991. Pp. 56–64.

Rothenstein, Julian, ed. *Posada: Messenger of Mortality.* London: Redstone, 1989.

Traba, Marta. *Art of Latin America, 1900–1980.* Washington, D.C.: Inter-American Development Bank; Baltimore: Johns Hopkins University Press, 1994.

Tyler, Ron, ed. *Posada's Mexico.* Washington, D.C.: Library of Congress, 1979.

Martin Ramírez
(1885–1960)
Mexican-American Mixed-Media Artist

Most of what is known about Martin Ramírez comes from the man who was his psychologist for many years, Dr. Tarmo Pasto. It is believed that Ramírez was born in the state of Jalisco in west central Mexico. He came to California sometime around 1900, hoping to find work. One report says that he worked in a laundry in Mexico, and that when he came to the United States, he was half starving (Beardsley and Livingston 223). He probably found work on the railroads, since so many of his drawings are of trains. In 1930 he was found homeless in a Los Angeles park. He was then diagnosed as a chronic paranoid schizophrenic, and was institutionalized in De Witt State Hospital for the rest of his life (Maresca and Ricco 185). It was in the hospital, around 1945, that he began to create his mixed-media drawings (Johnson and Ketchum 259).

Ramírez had an extremely difficult life; he said little about his early years, and reportedly, around 1915, he stopped speaking altogether (Maresca and Ricco 185). He is widely celebrated for his many highly prized paintings and drawings, made with enamel, tempera, pencil, colored pencil, crayon, and collage. At the time of his death he left behind works that included about 300 mixed-media drawings (Temkin 98). Robert Bishop, a specialist in folk art, once called Ramírez "the most significant 20th-century southwestern folk artist" (Johnson and Ketchum 259).

Ramírez gave Dr. Pasto a bundle of his drawings—work he did secretly, since previous drawings had been taken by the hospital staff and destroyed. Dr. Pasto was intrigued by his work, and used it to present theories on art therapy in classes he taught at Sacramento State University. Through these classes, the work gained visibility (Maizels 100).

It was later discovered that Ramírez had been hiding bits of paper in

his clothes, under his mattress, and behind the radiator, going to great lengths in order to make and save his precious drawings (Johnson and Ketchum 223). Ramírez's early works were, therefore, made with the most primitive materials: paper bags or pieces of scrap paper glued together with a paste the artist made of potatoes and bread mixed with his own saliva. Later work was done with higher-quality materials, given to Ramírez by Pasto (Maresca and Ricco 185). His works are both large and small. Large ones were created on rolls of paper, like scrolls. He would place the paper on the floor, between cots, exposing only one portion of the paper at a time. Although he did not speak, when he worked he would sometimes hum, as if he were happy or pleased with himself and his work (Johnson and Ketchum 226).

Ramírez's works have an unmistakable style. Often framed with repeating contour lines, they feature female figures, lone horsemen, cars, trucks, and trains. He used a tunnel-like perspective that has been interpreted to represent caves or escape, or perhaps to have some kind of sexual significance (Maizels 100).

Temkin claimed that Ramírez's work could be read as an autobiography. The figures are almost always placed in some kind of landscape or cityscape that is monumental and exquisitely choreographed with repeating lines and disproportional scale. Rhythm and movement are strong design elements, making the work immensely pleasing (98). Temkin described the collaged trains, cars, and buses as winding their way across the page in order to entice the viewer to travel with Ramírez: "Sometimes the lines articulate hills and valleys, castles and cathedrals, arcades and roadways. Sometimes a rich concentration of tunneling lines alone can provide the sense of great depths and distances containing unknown possibilities" (Temkin 99).

Jim Nutt, who taught at Sacramento State with Pasto, was captivated when introduced to the work of Ramírez. Together, in 1969, Nutt and Pasto arranged for an exhibition at their university. Nutt and a gallery dealer, Phyllis Kind, purchased the entire exhibition. Since that time Ramirez's work has been displayed in numerous exhibitions, and in 1985–1986 the artist was given a retrospective at the Goldie Paley Gallery at Moore College of Art in Philadelphia. The exhibition was titled "The Heart of Creation: The Art of Martín Ramírez" (Johnson and Ketchum 226).

Many art critics claim that Ramírez's work reflects his Mexican and Mexican-American cultural heritage. For example, Johnson and Ketchum, in connection with drawings such as *Our Lady of the Immaculate Conception* (n.d.), observe that they seem to acknowledge an awareness of *retablo* (altarpiece) paintings, which depict and honor saints.

Perhaps Ramírez's work is thought to be inspired by his physical and psychological confinement; this possibility has fascinated psychologists, art therapists, and others for years. The process of creating art with his trav-

eling lines, trains, and men on horseback may have allowed the artist to live the life he most wanted, one of infinite freedom and exploration.

Places to See Ramírez's Work

Abby Aldrich Rockefeller Folk Art Center, Williamsburg, Va.

Intuit, The Center for Intuitive and Outsider Art, Chicago

Moore College of Art and Design, Philadelphia

Museum of American Folk Art, New York City

Phyllis Kind Gallery, Chicago

Smithsonian Museum of American Art, Washington, D.C.

Bibliography

Beardsley, John, and Jane Livingston. *Hispanic Art in the United States: Thirty Contemporary Painters and Sculptors*. With an essay by Octavio Paz. Houston, Tex.: Museum of Fine Arts; New York: Abbeville Press, 1987.

Goldman, Shifra M. *Dimensions of the Americas: Art and Social Change in Latin America and the United States*. Chicago: University of Chicago Press, 1994.

Hartigan, Lynda Roscoe. *Made with Passion: The Hemphill Folk Art Collection in the National Museum of American Art*. Washington, D.C.: Smithsonian Institution Press, 1990.

Johnson, Jay, and Willam C. Ketchum, Jr. *American Folk Art of the Twentieth Century*. Foreword by Robert Bishop. New York: Rizzoli, 1983.

Maizels, John. *Raw Creation: Outsider Art and Beyond*. With an introduction by Roger Cardinal. London: Phaidon Press, 1996.

Maresca, Frank, and Roger Ricco, with Lyle Rexer. *American Self-Taught: Paintings and Drawings by Outsider Artists*. Foreword by Lanford Wilson. New York: Alfred A. Knopf, 1993.

Rosenak, Chuck, and Jan Rosenak. *Museum of American Folk Art Encyclopedia of Twentieth-Century American Folk Art and Artists*. New York: Abbeville Press, 1990.

Rosenak, Chuck, and Jan Rosenak. *Contemporary American Folk Art: A Collector's Guide*. New York: Abbeville Press, 1996.

Sellen, Betty-Carol, with Cynthia J. Johanson. *Self-Taught, Outsider, and Folk Art: A Guide to American Artists, Locations and Resources*. Jefferson, N.C.: McFarland, 2000.

Temkin, Ann. "Martin Ramírez." In *Self-Taught Artists of the 20th Century: An American Anthology*. Foreword by Gerard C. Wertkin. San Francisco: Chronicle Books; New York: 1998. Pp. 98–101.

Armando Reverón
(1889–1954)
Venezuelan Painter and Sculptor

A leading figure in Venezuelan art history, Armando Reverón produced work considered to be a preeminent example of Impressionist painting in Latin America (Castro 5). He was born in Caracas and was raised in Valencia by a foster family (Ades 35). He had an early interest in art and received art lessons from his uncle, Ricardo Montilla, who had studied in New York City. At age nineteen, he enrolled at the Academy of Fine Arts in Caracas. While a student there, Reverón was expelled for participating in a strike protesting the school's curriculum. He was later reinstated, and graduated with honors in 1911 (Ades 149). Desiring a European education, he went to Madrid, Spain, where he attended the Academy of San Fernando from 1912 to 1913. In 1914, before returning to Venezuela, he traveled to Paris, where he saw the work of the French Impressionist Paul Gauguin (Carvajal 140). He was deeply impressed with the striking use of color and the soft edges on forms, portraying the subject matter in an expressive manner rather than a realistic one.

After his return to Venezuela in 1915, Reverón joined the artists' group Circle of Fine Arts. Founded in 1912, it opposed the confining style of the Academy of Fine Arts. He worked at the Circle until the Venezuelan government ordered the studios to close and the group to disband because they were perceived as an anarchist threat. Juan Vicente Gómez, Venezuela's dictator from 1908 until his death in 1935, strongly enforced censorship of all media and artistic expression (Carvajal 138). Under the rule of Gómez many Venezuelan artists encountered direct government opposition to their work.

As he moved away from French Impressionism, Reverón began to develop his own version of the style that is commonly referred to as Latin

American Impressionism (Castro 5). Intensely interested in color and how light changes color, he felt that the natural landscape was the best environment in which to discover the relationship between natural light and color. He dedicated his work to depicting the natural scenery of his homeland.

In 1921, he left Caracas with his companion and model, Juanita Ríos. Together, they settled in the small village of Macuto on Venezuela's Caribbean coast. His life there was simple. He built his home, a modest *rancho* (small hut), from found materials: palm fronds, tree trunks, branches, earth, stones from the sea, and burlap. He also made basic furniture and paintbrushes from similar materials (Carvajal 140). Over the years, he kept adding on to his home, which he affectionately referred to as his *castillete* (little castle). Reverón filled the home with his creations: masks, musical instruments and scores, wings, a birdcage, a telephone, and life-size dolls.

The life-size dolls, made by Reverón and Juanita, are of special interest. Crudely assembled in a way that is disturbing, the dolls are not beautiful in the traditional sense, and have been described as having "roguish, often grotesque, expressions and realistic genitals" (Lucie-Smith 33). Some biographers focus on the paintings that include the dolls, claiming that this work was central throughout the 1930s (Carvajal 140). It is obvious that Reverón used the dolls for models in such compositions as *Self-Portrait with Dolls and Beard* (c. 1949). In this charcoal and chalk drawing on cardboard, he places himself in the center with the dolls encircling him, in much the way he has been described as surrounding himself with the dolls in his home. Other accounts discuss the dolls in relationship to his daily life, explaining their use in fantasy games and playacting in which Reverón regularly engaged. His use of the dolls as subjects was short-lived and sporadic; the landscape of Macuto's beaches is the primary inspiration of most of his paintings.

Seeking to reproduce the blinding sun of the Caribbean, Reverón nearly abandoned color altogether (Lucie-Smith 31). His canvases are filled with white and sepia tones. For example, in an oil and tempera painting on burlap, *Macuto Beach* (c. 1934), the only recognizable form is the hazy outline of palm trees that grounds the swirling shades of whites, suggesting the hazy break between the ocean and shoreline. Many other works exemplify his dramatic use of white to express the blinding sun. *Dawn at the Pozo de Ramiro* (c. 1938), another monochromatic landscape, gives the viewer the sensation of stepping onto the sand and instantly being swept away by the brilliant light.

In many ways, Reverón represents what is stereotypically considered the "bohemian artist." His lifestyle on the beach was rustic and isolated, and over the years his appearance became increasingly unkempt. His life in Macuto and his preference for quiet and detachment from mainstream society is compared to Paul Gauguin's time spent in Tahiti (Ades 149).

Free from the demands of city life, Reverón focused almost exclusively on making art. He is known for unusual exercises to inspire and control his creative process. For instance, he would rub his arms with rough fabric until they bled, then go outside to warm his eyes with the blinding sunlight and the vast panoramic view around him. He always worked scantily dressed, so the color of the clothing would not interfere with the natural light he was attempting to re-create. He would tightly bind his limbs and the lower half of his body with ropes so reflex movements would not disturb his calculated brush strokes (Lucie-Smith 33).

Although he spent the majority of his life in seclusion, Reverón continued to participate in large exhibitions, including the annual Official Salon of Venezuela, where he won first prize for his work in 1940 (Ades 149). After suffering on and off from depression and other mental illness, he spent his last year in a psychiatric hospital. In 1953, he was admitted to San Jorge Sanatorium in Caracas, where he died the following year from undisclosed causes (Ades 35). He is fondly remembered for his eccentric lifestyle, but his expansive body of work speaks for itself, proclaiming Armando Reverón a pioneer in Latin American Impressionism.

Places to See Reverón's Work

CDS Gallery, New York City

Fundación Museo Armando Reverón, Macuto, Venezuela: *Aviary* (c. 1940)

Galería de Arte Nacional, Caracas: *Coco-Palm* (1944); *Five Figures* (1939); *Self-Portrait with Dolls and Beard* (c. 1949)

Museo de Bellas Artes, Caracas

Bibliography

Ades, Dawn. *Art in Latin America: The Modern Era, 1820–1980*. New Haven, Conn.: Yale University Press, 1989.

Armando Reverón: Diez Ensayos. Caracas: Consejo Municipal del Distrito Federal, 1975.

Carvajal, Rina. "Venezuela." In *Latin American Art in the Twentieth Century*. Edited by Edward J. Sullivan. London: Phaidon Press, 1996. Pp. 137–58.

Castro, Roberto Montero. *Thirty Years of Art—The Fifth Journey*. 2001. www.embavenezus.org/cultural/art.html

Catlin, Stanton L., and Terence Grieder. *Art of Latin America Since Independence*. New Haven, Conn.: Yale University Press, 1966.

Goldman, Shifra. *Dimensions of the Americas: Art and Social Change in Latin America and the United States*. Chicago: University of Chicago Press, 1994.

Lucie-Smith, Edward. *Latin American Art of the 20th Century*. New York: Thames and Hudson, 1993.

Traba, Marta. *Art of Latin America 1900–1980*. Washington, D.C.: Inter-American Development Bank. Baltimore: Johns Hopkins University Press, 1994.

Diego Rivera
(1886–1957)
Mexican Mural Painter

Diego Rivera, undoubtedly one of the twentieth century's most influential artists, graced public walls with large-scale murals depicting his social ideologies. A radical in life and art, he left behind rich imagery that tells a story of the working class.

Rivera was born in Guanajuato, Mexico, in 1886. The exact date of his birth is unknown; several sources cite different dates or mention the discrepancy, offering a variety of reasons for the mystery. Oddly, the exact year of his death is uncertain as well; it is listed as both 1956 and 1957. The family moved to Mexico City by the time Rivera was six years old. He was encouraged by his parents to make art throughout his childhood. They were teachers at a small liberal school, and had a deep understanding of their son's need for visual expression.

As a young adult in Mexico City, Rivera attended art classes at the Academy of San Carlos (Alcántara and Egnolff 20–21). He left Mexico for Europe sometime between 1907 and 1910 to further his studies in art. In Europe, he socialized with the Cubist artist Pablo Picasso and Georges Braque, and became a leading Cubist himself (Sullivan, "From Mexico" 104). Oil paintings on canvas, such as *Two Women* (1914), are distinctly Cubist and reflect works by both Picasso and Braque. Critics argue that Rivera was equally influential in the early Cubist period himself (Sullivan 105). The most significant painting from Rivera's Cubist period may be *Zapatista Landscape* (1915). Sullivan claims that *Zapatista Landscape* is "the undisputed masterpiece of his five-year romance with Cubism" ("From Mexico" 103). In this painting, Rivera depicts the Mexican folk hero Emiliano Zapata, a prominent political figure who controlled portions of southern Mexico (Downs 100). *Zapatista Landscape* is recognized for its

importance in Rivera's body of work due to the political content, which foreshadows the politically charged subject matter of later paintings. Another of Rivera's Cubist works, *Motherhood—Angelina and Our Child Diego* (1916), is personal. This painting depicts Rivera's first wife, Angelina Beloff, and his first child, who died of the flu at two years of age (Alcántara and Egnolff 22). Toward the end of World War I, Rivera struggled to survive financially, and began to abandon Cubism for artistic approaches that proved to be more appealing to commissioning patrons (Downs 101).

Rivera returned to Mexico in 1921, and was soon hired by the Mexican government to paint murals. These murals, although often stylistically classified as Modern Realism, continued to reveal a Cubist influence. *Indigenismo*, an organized Latin American movement of the 1920s through the 1940s, that sought to preserve Mexican traditional culture, motivated much of Rivera's work illustrating the daily life of Mexican people (Sullivan, "From Mexico" 105). Aesthetically, he preferred traditional Aztec and Mayan forms (Sullivan, "From Mexico" 105). *Tortilla Makers* (1926), a portrait of two Mexican women preparing everyday food, probably for their families or village, exhibits this stylistic influence.

Rivera's involvement with the Mexican Communist Party is often portrayed in paintings and public murals, yet he frequently accepted commissions from capitalists, thereby adding to his mysterious and contradictory persona. At times, Rivera clashed politically with his financial patrons. For instance, when Rockefeller insisted that Rivera change the face of Lenin in the mural being painted at Rockefeller Center in New York City, Rivera suggested replacing Lenin's face with that of Abraham Lincoln. Rockefeller ignored Rivera's suggestion, and work stopped on the mural, which was covered with canvas just before it was destroyed (*Diego Rivera Web Museum*). At other times, Rivera recognized that his commission work conflicted with his political views. His inner turmoil drove him to resign as the secretary-general of the Mexican Communist Party (Marnham 216).

In the United States, Rivera created murals in San Francisco, Detroit, Chicago, and New York City. In 1932, he was chosen by the Ford Motor Corporation to paint murals related to the automobile industry. After spending time in the factories and seeing the struggle of the workers firsthand, Rivera became even more disillusioned by capitalism. Ford union members inspired the fresco, that took eight months to produce with the help of several assistants. The mural depicts workers' hardships and their battle against oppressive conditions resulting from capitalism. Ironically, Rivera's strong socialist message was funded by one of the great U.S. capitalists, Henry Ford. Today, unlike the Rockefeller mural, the Detroit murals remain intact and preserved.

Consistent with the ambiguity about Rivera's life are several accounts of how he met his third wife, the Mexican painter **Frida Kahlo**. Alcántara and Egnolff suspect that **Tina Modotti**, the Italian-Mexican photographer,

introduced them (28). Modotti had been Rivera's model, and had been intimately involved with him during his second marriage (Alcántara and Egnolff 28). Rivera's sexual relationship with Modotti was on and off and more than likely occurred while he was married to Kahlo. Arguably, the relationship between Rivera and Kahlo was profound and tumultuous for both of them; they were married twice. This relationship affected both their personal lives and their art. While Kahlo's work is full of personal angst and sorrow, caused by a host of personal tragedies (including her relationship with Rivera), his work is most often public and highly visible (Marnham 243). Rivera painted Kahlo and their friends, along with political leaders, in scenes that were vehicles for public messages rather than personal portraits. For example, *Insurrection* (1928), in the Ministry of Education in Mexico City, pictures Kahlo front and center, distributing guns to nationalist fighters.

During the last years of his life, Rivera became more focused on himself, painting self-portraits similar to those painted by Kahlo throughout her career. Also like Kahlo, Rivera wrote an autobiography, *My Art, My Life*. And while Kahlo's diary is highly personal, Rivera had public intentions for his book and filled the pages with fictional stories and contradictory facts (Marnham 314). He seemingly worked at constructing the mystery that continues to surround his persona and life. Marnham contends that "in abandoning the role of propagandist and assuming that of the myth-maker, Diego Rivera turned a political failure into a magnificent artistic success" (317).

Following the death of Frida Kahlo in 1954, Rivera publicly displayed his grief and verbally acknowledged his often cruel treatment of her: "When I loved a woman, I wanted to hurt her the more I loved her; Frida was the most evident victim of this despicable character trait of mine" (Alcántara and Egnolff cover). Diego Rivera—Mexican muralist, political activist, and enigmatic persona—left behind colorful paintings and frescoes that beautifully illustrate the story of the Mexican working class in early twentieth-century Mexico and the United States through the eyes of an artist.

Places to See Rivera's Work

City College of San Francisco

City Lunch Club, San Francisco

Detroit Institute of Arts: *Detroit Industry* (1932–1933)

Diego Rivera and Frida Kahlo Museum, Mexico City: *Dream of a Sunday Afternoon in Alameda Park* (1947–1948)

Ministry of Education, Mexico City: *Night of the Rich* (1928)

Museo de Arte Alvar y Carmen t. de Carrillo Gil, Mexico City: *Motherhood—Angelina and Our Child Diego* (1916)

Museo de Arte Moderno, Mexico City

Museo Nacional de Arte, Mexico City: *Zapatista Landscape—The Guerrillero* (1915)

Museum of Modern Art, New York City

National Palace, Mexico City: *The Large City Tenochtitlán* (1945)

San Francisco Art Institute: *The Realization of a Fresco* (1931)

San Francisco Museum of Modern Art: *The Flower Carrier* (1935)

Bibliography

Alcántara, Isabel, and Sandra Egnolff. *Frida Kahlo and Diego Rivera*. New York: Prestel Library, 1999.

Diego Rivera Web Museum. November 11, 1999. http://www.diegorivera.com

Downs, Linda B. "¡Viva Zapata!" *Art News* vol. 98, no. 6 (1999): 100–101.

Leffingwell, Edward. "Latin Soliloquies." *Art in America* vol. 81, no. 12 (1993): 72–83.

Lucie-Smith, Edward. *Latin American Art of the 20th Century*. New York: Thames and Hudson, 1993.

Marnham, Patrick. *Dreaming with His Eyes Open: A Life of Diego Rivera*. New York: Alfred A. Knopf, 1998.

Museum of Modern Art. *Diego Rivera: The Age of Steel*. New York: Kultur Video, 30 min. (n.d.)

Museum of Modern Art. *Diego Rivera*. New York: Arno Press, 1972.

Sullivan, Edward J. *Latin American Art in the Twentieth Century*. London: Phaidon Press, 1996.

Sullivan, Edward J. "From Mexico to Montparnasse—and Back." *Art in America* vol. 87, no. 11 (1999): 102–09, 153.

"Radical Rivera." *Art Journal* 58, no. 3 (1999): 112–13.

Frank Romero
(b. 1941)
Mexican-American Painter

Frank Romero was a member of the artist collective Los Four, and received artistic recognition associated with Chicano activism. However, he did not identify himself as a member of a minority group until joining the collective when the other members influenced him by the political nature of their work. He was born in Los Angeles to parents of Spanish and Mexican heritage. Romero attended racially mixed public schools and lived in a neighborhood with Eastern European Jews, Japanese, and White Russians, as well as Mexicans (Serwer 84). He spoke English at home and only learned Spanish later in life.

After drawing whenever he had a chance and enjoying art in school, Romero earned a scholarship to the Otis Art Institute in Los Angeles. He then attended California State University, Los Angeles, where he met Carlos Almaraz, a political activist in the Chicano community. In 1968–69 Romero lived with Almaraz in New York City, where he frequented the museums and explored the art scene (Beardsley and Livingston 232–33). He soon returned home, however, finding the atmosphere there "too cerebral, too conceptual. New York art seemed to lack passion," he claimed, "which is what I thought art should be about" (Beardsley and Livingston 233). Artists such as Richard Serra were employing Minimalist approaches to their work, stripping to bare essentials, and work that was colorful and figurative did not fit in with the times (Serwer 86).

When Romero and Almaraz returned to Los Angeles, they found their hometown in the midst of political organizing, rioting, and an energized Chicano movement. Although Romero claimed his work was always more about art than politics, he was readily identified as a political artist (Serwer 86). In 1991 he said of his career:

I came to prominence as a member of a Chicano art collective called Los Four. Although I was not well known as an individual artist, I was able to exhibit widely as a member of that group. The work of Carlos Almaraz reflected the political issues of the farmworkers and other causes, and Gilbert Luján's work celebrated the Chicano life-style. My work and that of "Beto" de la Rocha were more concerned with art issues. Ten years or more passed before I did my first political painting, *The Closing of Whittier Boulevard*, in 1984. I have been dealing with barrio issues and, recently, with Central American issues ever since. (Griswold del Castillo et al. 356).

Los Four saw their art as having a political base, but they also wanted it to sustain them economically. Their work was characterized by the use of spray paint, graffiti, and Chicano subject matter: low riders, pre-Columbian motifs, and the crucifix. In their 1974 traveling exhibition to several California museums, they included an altar, constructed like an Aztec pyramid, layered with objects from Chicano popular culture: masks, toy cars and airplanes, skeletons, plastic palm trees, and a toy slot machine. Along the side walls were archival cases holding historical documents about the group (Gaspar de Alba 148).

Before he gained wide visibility with the 1974 Los Four exhibition, Romero painted murals, and continued to do so in the 1980s. In 1984, for example, he painted a 22 × 103-foot mural for the City of Los Angeles, titled *Going to the Olympics* (Serwer 86). Full of cars, palm trees, and hearts, it is a joyful expression of participation. The activist nature of this work might be identified as the visibility of the Chicano aesthetic, represented by the mural art form, the use of bright colors, and the love of cars.

Influenced by folk art from the southwestern United States and Mexico, Romero's paintings are brightly colored and thickly textured. While working as a designer for Charles Eames in the late 1960s and early 1970s, Romero developed an enthusiasm for well-designed toys ranging from inexpensive to upscale items (Beardsley and Livingston 233).

Perhaps Romero's best-known painting is *The Death of Ruben Salazar* (1985–86). It depicts an event that took place on August 29, 1970, when thousands of Vietnam War protesters marched through East Los Angeles, then gathered at Laguna Park. The sheriff responded by sending in hundreds of deputies, reportedly in reaction to a nearby attempted theft. Deputies bearing tear gas and clubs forcefully broke up the demonstrators' gathering. Five hundred officers moved through the streets in a violent and deliberate manner. Later in the day, after the crowd had dispersed, Salazar, an investigative reporter for the local Spanish-language television station, joined some friends for a beer at the Silver Dollar Bar. Deputies, still looking for people who might cause any kind of disturbance, searched for a man with a rifle. They surrounded the bar and shot a 10-inch tear gas shell into the building, hitting Salazar on the head. He died, and the

police were later exonerated of any wrongdoing. Romero depicted this event as a political crime. The painting, colorfully executed with bold brush strokes, radiates energy and horror (Serwer 91).

Though Romero is best known as a painter, he also works in printmaking, ceramics, and sculpture. His best-known works explore social and political issues, but he also depicts experiences that celebrate life's everyday pleasures. He lives with his family in Los Angeles and Arroyo Seco, New Mexico.

Places to See Romero's Work

Carnegie Art Museum, Oxnard, Calif.

Collection of the City of Los Angeles

Los Angeles County Museum of Art

Smithsonian American Art Museum, Washington, D.C.: *Death of Ruben Salazar* (1985–86)

Bibliography

Beardsley, John, and Jane Livingston. *Hispanic Art in the United States: Thirty Contemporary Painters and Sculptors*. With an essay by Octavio Paz. Houston, Tex.: Museum of Fine Arts; New York: Abbeville Press, 1987.

Chattopadhyay, Collette. "A Conversation with Frank Romero." *Artweek*, September 3, 1992, P. 23.

Cockcroft, Eva Sperling. "Chicano Identities." *Art in America* vol. 80, no. 6 (1992): 84–91.

Durland, Steven. "Frank Romero and Los Four." *High Performance* 35 (1986): 43.

Durland, Steven, and Linda Burnham. "Art with a Chicano Accent: An Interview with Denise Lugo-Saavedra on the History of Chicano Art in Los Angeles." *High Performance* 35 (1986): 41–44, 50.

Gaspar de Alba, Alicia. *Chicano Art: Inside/Outside the Master's House. Cultural Politics and the CARA Exhibit*. Austin: University of Texas Press, 1998.

Griswold del Castillo, Richard, Teresa McKenna, and Yvonne Yarbro-Bejarano. *CARA. Chicano Art: Resistance and Affirmation, 1965–1985*. Los Angeles: Wight Art Gallery, University of California, Los Angeles, 1991.

Marrow, Marva. *Inside the L.A. Artist*. Los Angeles: Peregrine Smith Books, 1988.

Plagens, Peter. "Review: Los Four." *Artforum* 13 (September 1974): 87–89.

Serwer, Jacquelyn Days. *American Kaleidoscope: Themes and Perspectives in Recent Art*. Washington, D.C.: National Museum of American Art, Smithsonian Institution, 1996.

José Sabogal
(1888–1956)
Peruvian Painter and Muralist

José Sabogal is known for presenting images of Andean native people and their landscape. He was born in Lima, and was of Spanish, not Indian heritage. The influences upon him were varied and many. He traveled throughout Europe and North Africa between 1908 and 1913, and studied at the National School of Fine Arts in Buenos Aires from 1913 to 1918. His interest in Indians was piqued by a trip to the towns around Lake Titicaca in 1918, while he was living in Cuzco (Barnitz 95).

Like **Martín Chambi**, Sabogal was part of Peru's *indigenista* group, made up of intellectuals and artists interested in promoting pre-Columbian life and culture. He took a leadership role in this movement, not only with his paintings but also by teaching at the National School of Fine Arts, which promoted *indigenista* ideals. Later, from 1933 to 1943, he was the school's director (Goldman 46). In these ways he was seen by some to be the leader of Peru's *indigenista* movement (Scott 210). However, others, like Lucie-Smith, claim that Sabogal did not lead a new wave of thinking, but continued the work of Francisco Laso (1823–69) (146). Indeed, a similar approach to subject matter can be seen in Laso's *Indio de la Cordillera* (Inhabitant of the Cordillera, 1855) where in which a single Indian, centered on the canvas, holds a portrait jar of the Moche (or Mochica) an ancient Indian group (Barnitz 8).

Sabogal became an *indigenista* during a trip to Mexico in 1922. Here he saw the strong impact of muralists on the Mexican people (Goldman 111). He met **Diego Rivera, José Clemente Orozco**, Manuel Rodrigue Lozano, and Abraham Angel, and had the opportunity to see work by, among others, **David Alfaro Siqueiros** and Amado de la Cueva. This trip influenced him to become one of the first modern Peruvian artists to create

murals and to promote Peru's indigenous culture (Barnitz 94–95; Traba 36). Sabogal encouraged his students and other Peruvian artists to look to the history and culture of the Andean people for their inspiration. He also urged them to ignore European art movements such as Fauvism, where artists explored using bright, clashing colors, and Cubism, and instead to favor approaches from their own historical context (Lucie-Smith 76), For Sabogal, favoring the indigenous culture primarily meant rejecting new movements from Europe.

Sabogal's work was first rejected in Peru because of its native themes—paradoxically, one of the major reasons it was later so valued. In fact, at first he was dismissed as the "painter of the ugly." But after showing his work in a 1919 exhibition in Lima, his reputation grew as a result of rave reviews (Majluf 193–94).

Perhaps one of Sabogal's best known paintings is *Varayoc, or the Indian Mayor of Chincheros* (1925). A proud Indian man, dressed in bright red, fills the left side of the canvas with a Peruvian landscape in the background. The colors are unified, and the composition is forceful (Majluf 193–94). In his painting *Victoria Regis* (1938), a woman carries a piece of pottery on her head. Sabogal was attracted to Indian crafts such as pottery, incised gourds, and textiles, depicting them in his paintings and often writing about them as well (Barnitz 95). Later in his life he experimented with woodcuts and painted ceramics (Catlin and Grieder 195).

From a historical vantage point, not everyone thinks Sabogal was successful in realizing *indigenista* goals in his paintings. Lucie-Smith, for instance, claimed that although he had some success in planting a seed about the importance of native art and life in the minds of those who surrounded him, "his connection with Indian culture remained superficial" (77). And Goldman scolded him for perpetuating the idea of "the proud and grand Inca . . . instead of a depiction of the actual misery within which Indians lived" (46). Another look at *Varayoc, or the Indian Mayor of Chincheros* would justify this criticism. Concerning Sabogal's style of painting, Barnitz observed that although his "representations of Indians had some of the formal simplifications of *indigenismo*, they did not have the compressions and distortions present in the work of the Mexicans and some Ecuadorians" (95). She further stated that he utilized some of the European Modernist characteristics, despite the fact that he had verbally rejected them (Barnitz 95).

No matter how his work is criticized today, Sabogal's influence remains unquestionable. The *indigenista* movement, of which he was a leader—if not *the* leader—clearly changed the way artists and critics approached painting in Peru. Native populations became more visible, and under his direction, newer generations of painters, including Enrique Camiono Brent, Julia Codesido, and Camilo Blas, looked to the Indian cultures for subject matter and inspiration (Barnitz 95).

Places to See Sabogal's Work

Art Museum of the Americas, Washington, D.C.: *Haunca Indian* (1930)

Museo de Arte, Lima

Museum of Modern Art, New York City

Museum of Modern Art of Latin America, Washington, D.C.

Pinacoteca Municipal Ignacio Merino, Lima: *Varayoc, or the Indian Mayor of Chinchero* (1925)

Bibliography

Barnitz, Jacqueline. *Twentieth-Century Art of Latin America*. Austin: University of Texas Press, 2001.

Catlin, Stanton Loomis, and Terence Grieder. *Art of Latin America Since Independence*. New Haven, Conn.: Yale University Press, 1966.

Goldman, Shifra M. *Dimensions of the Americas: Art and Social Change in Latin America and the United States*. Chicago: University of Chicago Press, 1994.

The Latin American Spirit: Art and Artists in the United States, 1920–1970. Essays by Luis R. Cancel, Jacinto Quiratte, Marimar Benitez, Nelly Perazzo, Lowery S. Sims, Eva Cockcroft, Felix Angel, and Carla Stellweg. New York: Bronx Museum of Arts in association with Harry N. Abrams, 1988.

Lucie-Smith, Edward. *Latin American Art of the 20th Century*. New York: Thames and Hudson, 1993.

Majluf, Natalia. "Peru: Latin American Art in the Twentieth Century." In *Latin American Art in the Twentieth Century*. Edited by Edward J. Sullivan. London: Phaidon Press, 1996. Pp. 191–99.

Scott, John F. *Latin American Art: Ancient to Modern*. Gainesville: University of Florida Press, 1999.

Traba, Marta. *Art of Latin America, 1900–1980*. Washington, D.C.: Inter-American Development Bank; Baltimore: John Hopkins University Press, 1994.

Doris Salcedo

(b. 1958)
Colombian Sculptor

Doris Salcedo reaches out to Colombians in crisis and hears their stories; those stories in turn shape the motivation for her emotionally charged assemblages. Born in Bogotá, she lived there until graduating from the University of Bogotá Jorge Tadeo Lozano in 1980, with a B.F.A. degree. Her early interest in sculpture led her to seek instruction in three-dimensional art at the university. However, the sculpture department was not very challenging, so she acquired her first art experience in painting, performance, and other disciplines. She delved into theater for a short time, experimenting with stage set design as her first major sculptural work.

After graduating from the university, Salcedo went to the United States, where she took sculpture classes at New York University and received an M.F.A. degree in 1984. In New York she came into contact with, and was deeply affected by, the work of the German sculptor Joseph Beuys. She spoke of his approach to art content and its socially significant meaning, as opposed to the "art for art's sake" attitude of Modernism:

> Encountering his work revealed to me the concept of "social sculpture," the possibility of giving form to society through art. I became passionately drawn to creating that form, which led me to find sculpture meaningful, because merely handling material was meaningless to me. Placing a small object on a base seemed completely vacuous. That is why Beuys is so important to me. I found the possibility of integrating my political awareness with sculpture. I discovered how materials have the capacity to convey specific meanings. (Princenthal et al. 10)

Shortly after finishing school in New York, Salcedo returned to Colombia and became the director of the School of Plastic Arts of the Institute of Fine Arts in Cali. A year later, in 1988, she moved back to Bogotá, where she was a professor of sculpture and art theory at the National University of Colombia until 1991. Thereafter, she chose to live mostly in seclusion. Her time in New York had given her the experience of living on the fringes of society. She recognized the value of this perspective and how it gave her the freedom to critically observe the community:

> [An] important experience was coming to terms with being a foreigner. What does it mean to be a foreigner? What does it mean it mean to be displaced? When I returned to Colombia, I continued to live as an outsider because this gave me the distance that one needs to be critical of the society to which one belongs. (Princenthal et al. 9)

Audiences in the United States first experienced Salcedo's work in 1992, when the Brooke Alexander Gallery in New York City hosted her solo exhibition "La Casa Viuda" (The Widowed House). The installation featured two mixed-media sculptures constructed from old furniture and other recycled materials. The two pieces were placed far apart in a relatively large, empty space, that ask the viewer to move carefully and quietly through the gallery while pondering the intensity of the haunting sculptures (Hirsch 136). Doors, dressers, and small chair parts were embellished with items such as bones, zippers, and a lace skirt that transformed them into lonely symbols of the people who used to walk through the doors, sit in the chairs, and put clean clothes in the dresser drawers. Drawers and shelves, once open, with personal possessions on display, were now filled with concrete, permanently closed. Salcedo refers to real people in Colombia who have encountered personal loss and suffering. At times the viewer is conscious of the specifics, and at other times the details are missing, but the overwhelming feeling of affliction is always present.

For her group of sculptures titled *Unland* (1997), Salcedo mentioned the names of the people whose stories she tells:

> The children who suffer from the violence in Colombia have been witnesses to gruesome events. Orphans such as Beatriz Helena Quirruz, Iván Calderón, and Angel Antonio Mosquera, among others, have shown their reality. Their experiences and memories have been by my side in bringing this work to completion. For this reason, I consider this work not only my own, but also belonging to them. Without these children, it would not have been possible. (Cameron, *Unland* 4)

For *Orphan's Tunic*, the first in the *Unland* series, Salcedo obtained a simple dress from a young girl whose parents had recently died. Directly

following their deaths, the girl wore this same dress for many days. Salcedo learned that her mother had made that dress, and she was inspired to express a connection between objects and their meaning even after the people who owned or made them have died. *Orphan's Tunic* is a long, wooden table that is isolated and at first seems simple and plain. Upon close inspection, the intimate details of the work are revealed; animal fur and the remnants of the girl's dress delicately adhere to the middle of the table's surface in a transformative way.

The theme of violence is always just below the surface in Salcedo's work, both literally and figuratively (Pini 177). For example, in her installation *Atrabiliaros* (Intimations of Melancholy, 1991–92), shoes were placed in small niches, then covered with transparent animal skin crudely sewn down to trap each shoe. The shoes, like the furniture and clothes in other works, represent the people who wore them and are now dead. The shoes, which often had been owned by specific people Salcedo refers to, were not always presented in pairs. A single shoe spoke about the person left behind (Cameron, *Unland* 11).

Today, Salcedo lives and works in Bogotá. Her work continues to earn critical acclaim and economic success. She was awarded a Penny McCall Foundation grant in 1993 and a Solomon R. Guggenheim Foundation grant in 1995. Living mostly in seclusion, she rarely makes public appearances. However, the 1999 killing of the Colombian humorist Jaime Garzón, which brought on national mourning, motivated Salcedo to act publicly. Along with a group of local artists, she created a wall of 5,000 hanging roses in front of the house where Garzón had lived. This act spurred students to do the same when a professor at the national university was killed on campus one month later (Basualdo 33).

The work of Doris Salcedo refers to specific tragedy and sorrow, telling the stories of everyday people and everyday occurrences that are often pushed aside or quickly forgotten by the public.

Places to See Salcedo's Work

Albright-Knox Art Gallery, Buffalo, N.Y.

Alexander and Bonin Gallery, New York City

Art Gallery of Ontario, Toronto: *La Casa Viuda II* (1993–1994)

Art Institute of Chicago

Biblioteca Luis Angel Arango, Bogotá, Colombia

Carnegie Museum, Pittsburgh: *Carnegie International* (1995)

Fundaçio "La Caixa," Barcelona: *Unland: The Orphan's Tunic* (1997)

Institute of Contemporary Art, Boston: *The Absent Body* (1992)

Israel Museum, Jerusalem: *La Casa Viuda VI* (1995)

Los Angeles County Museum of Art

Museum of Contemporary Art, Chicago

Museum of Contemporary Art, San Diego

Museum of Fine Arts, Boston

Museum of Modern Art, New York City

New Museum of Contemporary Art, New York City

Progressive Corporation, Cleveland, Ohio: *Atrabiliaros* (1992–1993)

Rhona Hoffman Gallery, Chicago

San Francisco Museum of Modern Art: *Unland: Irreversible Witness* (1995–1998)

Sculpture Garden, Smithsonian Institution, Washington, D.C.

Tate Gallery, London

Worcester Art Museum, Worcester, Mass.: *La Casa Viuda I* (1992–1994)

Bibliography

Basualdo, Carlos. "Carlos Basualdo in conversation with Doris Salcedo." Princenthal, Nancy, Carlos Basualdo, and Andreas Huysson, eds. *Doris Salcedo*. London: Phaidon Press, 2000. Pp. 8–35.

Bond, Anthony. *Embodying the Real Body*. Sydney: Bookman Press, 1997.

Cameron, Dan. "Absence Makes the Art: Doris Salcedo." *Artform* 33, no. 2 (1994): 88–91.

Cameron, Dan. *Doris Salcedo: New Museum of Contemporary Art, SITE Sante Fe*. New York: New Museum of Contemporary Art, 1998.

Cameron, Dan. "Doris Salcedo." *The Robert J. Shiffler Foundation Web page*. 2000. http://www.bobsart.com/html/salcedo_new.htm

Eickel, Nancy, ed. *The Hirshhorn Collects: Recent Acquisitions 1992–1996*. Washington, D.C.: Smithsonian Institution Press, 1997.

Hirsch, Faye. "Doris Salcedo at Brooke Alexander." *Art in America* vol. 82, no. 10 (1994): 136.

Pini, Ivonne. "Colombia." In *Latin American Artists in the Twentieth Century*. Edited by Edward J. Sullivan. London: Phaidon Press, 1996. Pp. 159–78.

Princenthal, Nancy, Carlos Basualdo, and Andreas Huysson. *Doris Salcedo*. London: Phaidon Press, 2000.

Mario Sánchez
(b. 1908)
Cuban-American Painter and Relief Carver

Mario Sánchez, well known for his portrayal of Cuban life in Florida, was born in Key West, Florida, and still lives there today. He is an unofficial local historian who documents the streets, houses, and events that are a part of his daily life in Key West. Historians have affirmed the accuracy of the scenes depicted in Sánchez's work, from details of local buildings to the direction of parades moving through the streets (Rothermel 47). The images are also autobiographical, for he paints only what he has experienced firsthand. To look at his work is to see a snapshot of Sánchez's memory. In many ways, his work can be compared with the memory paintings of **Carmen Lomas Garza**, who vividly portrays her Chicana childhood in Texas.

The Sanchez family came to Key West from Cuba in 1869. His grandfathers and father, trained in cigar making, worked at a local factory. His father, Pedro Sánchez, who was bilingual and spoke clearly, was hired as a reader by the cigar factory employees. He read daily to those who were willing to pay for his services. Sánchez's painted carving *El Lector* (The Reader, c. 1963), shows his father standing on a box, reading to a room filled with listeners. Sánchez speaks very highly of his father's labor. He explained the importance of the reader to the factory workers: "It was an education for the cigar makers, an instructive and cultural entertainment. . . . Few cigar makers ever left Key West, but most of them could talk about Europe and other faraway places they learned about from the books that were read to them" (Proby 24).

The Sánchez family was prominent in the Cuban community of Key West. His paternal grandfather, Antonio Sánchez, owned a small grocery in town. He was also a musician, and encouraged other musicians to gather

Mario Sánchez at home in Key West, Florida. Photo Credit: Tina Bucuvalas. Courtesy of Florida Department of State—Division of Historical Resources. Used with permission.

on the corner by his store and play late into the evenings (Proby 10). Young Mario did not follow in his father's or grandfathers' footsteps; instead, he discovered an interest in wood carving. As a child, he would whittle pieces of driftwood that he collected from the beach (Rothermel 44). While growing up in Key West, Sánchez played in the streets of Gato's Village, a Cuban neighborhood named for the cigar factory that made the world-famous cigar Gato 1871. In *Mario's Birthplace in Gato's Village* (1979), Sánchez portrays the neighborhood as it was when he was young. This painted carving is composed of five scenes of children engaged in the most popular games of his youth, including baseball, jumping rope, rolling a hoop, and flying kites.

Sánchez never received formal education in art. For this reason, among others, his brightly painted wooden relief carvings are often characterized as folk art. He feels strongly about not being influenced by others in his art, and that this is the right approach to the development of his unique creativity: "None of this is very academic, I sort of just made it up. . . . I don't know so much about what other people do, how they paint. I don't read art books, either. . . . They might influence my style" (Rothermel 46).

After attending public elementary school and St. Joseph's College for Boys in Key West, Sánchez earned a degree in stenography from the Otto L. Schultz Business Institute in 1925. Soon after graduation, he worked as a clerk in Tampa (Proby 16). While living in Ybor City, a Tampa com-

munity, Sánchez met Rosa De Armas, also a Cuban-American, who lived next door to his mother's home. They were married in 1929, when Sánchez was twenty-one and Rosa was eighteen. They lived with Rosa's mother in Ybor City until 1930, when they all moved back to Key West. There, Sánchez accepted a position as a court reporter and translator at the Monroe County Courthouse (Proby 16). For the sixty-five years of their marriage, he and Rosa lived in Ybor City in the summer and Key West the remainder of the year. Although the Key West paintings often receive the most attention, the scenes of Ybor City are equally inventive and historically precise.

During his first several years back in Key West, Sánchez spent his leisure time writing short skits for the San Carlos, a playhouse that presented performances in Spanish (Proby 18). Though he often had political content, he insists that the skits were all in fun: "They were takeoffs on topics of the week: on the WPA [Works Progress Administration], the gas meterman, the gossips. Not political. I don't like politics. Our plays were sort of a protest just like the theater is today. Today's theater is often harsh, while ours was light comedy" (Proby 18). In addition to the theater, he enjoyed pitching for the local Cuban baseball team (Lesko 288).

Initially, Sánchez's carvings portrayed native fish of the Florida Keys: yellowtail, snapper, porgy, trout, and grunt. At his mother-in-law's suggestion, Sánchez started to paint scenes of everyday life, and the supply of subject matter became as vast as his memory (Rothermel 44). Parades and funerals are two of his favorite subjects, along with the dynamic characters of the streets in both Key West and Ybor City (Lesko 288). *The Pee-roo-lee Man* (1974) was named for the candy vendor who walked the streets, blowing a whistle that sounded like "pee-roo-lee" (Proby 58). At the urging of his brother Blas, one of his biggest fans, Sánchez sold his first painting in 1946 to a local business owner, who later became an avid collector of his work. Soon his art drew national attention from critics and collectors alike. It was not long before the Key West and Tampa communities recognized his work. The El Kiosko Gallery and the East Martello Gallery and Museum in Key West offered Sánchez his first formal gallery representation in 1961. The Tampa Museum of Art held an exhibition in 1986 of the work that represents his memories of Ybor City. In 1991, he received the Florida Folk Heritage Award from the Florida secretary of state and the Florida Folklife Program.

Sánchez's output lessened when Rosa fell ill and died in 1995. Nevertheless, he worked until recent months in his outside studio, next to the worn, hand-painted sign that reads "Mario's Studio Under the Trees." It is next to his cement block garage, where his supplies and current projects are housed. Inside the studio, another hand-painted sign proudly states, "Sé que mi modesto arte no es bueno, pero gusta" (I know that my modest art isn't good, but it pleases).

Places to See Sánchez's Work

Coral Gables Metropolitan Museum of Art, Coral Gables, Fla.

El Kiosko Gallery, Key West, Fla.

Fort Lauderdale Museum of Art, Fort Lauderdale, Fla.

Jessie Wilson Art Galleries, Anderson College, Anderson, Ind.: *Pee-roo-lee Man* (1974)

Key West Art and Historical Society, Key West, Fla.: *A Familiar Landmark: Convent of Mary Immaculate* (c. 1960); *A Famous Key West Landmark: Hemingway House* (1979); *A Loaded Washtub* (1970); *Apricot Sherbert Two Cones for a Nickel* (c. 1983); *Bicentennial America #8: Viva Boza y Su Comparsa* (1980); *Birth of a Rumor* (date unknown); *Old Island Days: Funeral #9* (1970); *El Lector* (The Reader, c. 1963)

Tampa Museum of Art, Tampa, Fla.

Bibliography

Duffy, Brian. "Fame Carved with Dime-Store Tools." *Miami Herald*, October 17, 1982, pp. 1L, 7L.

Kubicek, Margaret. "Sanchez Will Be Honored for Art." *The Citizen*, Key West, Florida. April 21, 1995, pp. 1A, 14A.

Lesko, Diane. "Mario Sanchez: Folk Artist of Key West and Tampa." In *Spanish Pathways in Florida: 1492–1992*. Edited by Ann L. Henderson and Gary R. Mormino. Sarasota, Fla.: Pineapple Press, 1991. Pp. 280–301.

Mario Sanchez: Ybor City Memories. Tampa, Fla.: Tampa Museum of Art, 1986.

Mormino, Gary R., and George E. Pozzetta. *The Immigrant World of Ybor City: Italians and Their Latin Neighbors in Tampa, 1885–1985*. Urbana: University of Illinois Press; 1987.

Proby, Kathryn H. *Mario Sanchez: Painter of Key West Memories*. Key West, Fla.: Southernmost Press, 1981.

Rothermel, Barbara. "The Art of Mario Sanchez." *Folk Art* 21, no. 3 (1996): 42–48.

Andres Serrano

(b. 1950)

Afro-Cuban, Honduran-American Photographer

Andres Serrano is best known for transforming body fluids into an art medium, at times resulting in highly controversial works. He was born in New York and lived there throughout his childhood. He attended the Brooklyn Museum Art School from 1967 to 1969, but did not have his first exhibition until nearly twenty years later. In 1985, the Leonard Perlson Gallery in New York hosted the first of three exhibitions for Serrano. His photographs were also included in two important New York exhibitions, "Myth and History," at the Museum of Contemporary Spanish Art, and the Biennial, at the Whitney Museum of Art.

Most of Serrano's work is grouped into series. The first grouping, *Tableaus*, shows an early interest in working with bodily fluids. In this series, he experimented with fluids as an alternative medium, but did not put them at the center of his work. For instance, he posed a bloody stuffed coyote to sit with mouth agape in *The Scream* (c. early 1980s), making reference to Edvard Munch's famous painting of the same title. Though his exact intention in this work is unknown, the viewer is challenged to speculate about the meaning, ranging from animal rights issues to connections to Munch's painting. Following *Tableaus* came *Nomads* (mid-1980s), a collection of portraits of homeless people who ride the subways and walk the streets of New York City late at night. These portraits, taken in his studio, exude dignity rather than degradation.

Serrano attracted the most attention for his *Fluids* series, created from 1985 to 1990. In some works, the fluids are the materials and provide the content as well, as in *Milk, Blood* (1986). One side of the vertically divided canvas is painted with milk, while the other is covered with blood, a pairing that represents white and red, light and dark, cool and warm, life and

Andres Serrano. Courtesy of the Paula
Cooper Gallery, New York City. Used with
permission.

death. Without the title, the work would be reduced to Minimalist color
and shape without specific meaning. Serrano, who had a Catholic upbring-
ing, is deeply in touch with his religious roots and often addresses his
relationship with the church through art. He feels that religion is closely
aligned with the body and its fluids: milk, blood, and urine (Oliva and
Eccher 131).

Serrano's controversial photograph *Piss Christ* (1987), part of the *Fluids*
series, aroused furious controversy. The title is powerful enough to incite
anger even before people see the image. Despite the emotions the title
arouses, the work is breathtaking. The warm, red background is lit by the
golden image of Christ sacrificed on the cross. Serrano stresses that *Piss
Christ* was an experiment with color and urine. He was interested in what
would happen to the color if the image was dipped in an acidic, natural
liquid; after photographing a crucifix, he submerged the photograph in a
bucket of his own urine (Weintraub 161).

The uproar over *Piss Christ* started when an offended viewer contacted
the conservative Republican senator from North Carolina, Jesse Helms.
The outrage was centered on the fact that taxpayers' money had funded
the project. In 1997, Serrano received a $15,000 grant from the National
Endowment for the Arts (NEA), a fact that caused attacks to extend to the
NEA as well. With Alfonse M. D'Amato, a Republican senator from New

York, Helms spoke before the U.S. Senate regarding Serrano and the NEA grant: "What this Serrano fellow did, he filled a bottle with his own urine and then stuck a crucifix down there—Jesus Christ on a cross. He set it up on a table and took a picture of it. For that, the National Endowment for the Arts gave him $15,000, to honor him as an artist" (D'Amato and Helms 3). The speech drew intense attention from the media. Questions were raised about art, art materials, artists, and who decided what these terms mean. Outrage ensued, and the work was attacked with baseball bats by two viewers at Australia's National Gallery, which later dismantled the entire Serrano exhibition ("A Take on *Piss Christ*" 1).

Art historians have argued that it is the title which incites such anger; the very nature of the word "piss" is aggressive (Piteri 1). When asked about the public reaction to *Piss Christ* and the controversy surrounding it, Serrano replied: "To this day, I am the artist but I'm the audience first, I do it for me. But I've realized that I don't simply work in a vacuum; the work does go out there to the real world and people will react to it, but at the time I was just concerned with photographing the ideas and images in my head" (Weintraub 161). This version of Christ has been compared with Paul Gauguin's *Yellow Christ* (88). Gauguin's painting attracted attention and criticism for abandoning the prevailing tradition of Realism for a stylistic approach to form with a bright palette, and most notably for coloring Christ's skin sunshine yellow (Weintraub 162). Serrano has a deep respect and love for the Christian God he knew as a child in the Catholic Church. His issues with religion are guided toward the structure and "rules" set by the church.

Serrano's series *Masks* consists of portraits of Ku Klux Klan members; the title refers to the hoods they wear to conceal their faces. In it, he wanted to use art to reconcile tensions between himself and a group that hates and inflicts racist violence on races such as his own (Weintraub 164). Serrano talked about his experience working with members of the Klan: "Being who I am, racially and culturally, it was a challenge for me to work with the Klan, as much for me as for them, that's why I did it" (Weintraub 164). His photograph *Klansman (Imperial Wizard)* (1990) is a portrait of a hooded Klan member from the shoulders up. The photograph is imposing at five feet by four feet.

All of the Klan portraits are poignant and represent a violent power that has had a long and, unfortunately, lasting presence in the United States. Yet some of the photographs are much more confrontational than the others. In *Klansman (Grand Klaliff II)* (1990), the portrait is a close-up revealing just one eye peeking through the protection of the white hood, against a solid black background.

Serrano's next major work, *The Morgue* (1992), is a group of photographs taken of bodies brought to a morgue over a three-month period. They are old bodies, young bodies, people who died of natural causes and people

who died in accidents, all captured without discrimination or specific mission. *The Morgue* was first exhibited in 1993 at the Venice Biennale "Aperto 93," and later that year at the Paula Cooper Gallery in New York City. Again, his work was criticized, to which he responded, "[my] work is like a mirror—each spectator responds differently depending on his or her approach" (Oliva and Eccher 135).

Despite intense attacks from viewers, galleries, museums, the media, and government officials, Serrano's work continues to be shown around the world. Serrano portrays images that represent things in life which can make us feel uneasy and repulsed, or waken a new awareness about ourselves.

Places to See Serrano's Work

Bayly Art Museum, University of Virginia, Charlottesville

Cristinerose Gallery, New York City

Fundación Proa, Buenos Aires

HyperArt.com, New York. www.hyperart.com

International Center of Photography, New York City

Lance Fung Gallery, New York City

Modern Art Museum, Fort Worth, Tex.: *Nomads (Bertha)* (1990)

Museum of Contemporary Art, Chicago

New Museum of Contemporary Art, New York City

Paula Cooper Gallery, New York City

Spencer Art Museum, University of Kansas, Lawrence

Weisman Art Museum, University of Minnesota, Minneapolis

Bibliography

Archer, Michael. *Art Since 1960.* New York: Thames and Hudson, 1997.

D'Amato, Alfonse M., and Jesse Helms. "Comments on Andres Serrano by Members of the United States Senate." May 18, 1989. http://www.csulb.edu/~jvancamp/361_r7.html

Deckman, T. R. "Disputed Artist Explains Works." *The Digital Collegian.* October 2, 1996. http://www.collegian.psu.edu/archive/1996_jan-dec/1996_oct/1996–10–02_the_daily_collegian/1996–10–020101–001.htm

Karsnick, Alex. "Andres Serrano at the Kansas City Art Institute." *Kansas City Visual Arts Connection.* September 28, 1996. http://www.kcvac.com/reviews/serrano.htm

Oliva, Achille Bonito, and Danilo Eccher, eds. *Appearance.* Milan: Edizioni Charta; Bologna: Galleria d'Arte Moderna, 2000.

Piteri, Rita. *The Andres Serrano Controversy.* 1997. http://www.home.vicnet.au/~twt/serrano.html

Andres Serrano

"A Take on *Piss Christ*." *Shoot the Messenger*. February 1998. http://www.igloo.
itgo.com/1_pisschrist.htm
Weintraub, Linda, Arthur Danto, and Thomas McEvilley. *Art on the Edge and
Over*. Litchfield, Conn.: Art Insights, 1996.

David Alfaro Siqueiros
(1898–1974)
Mexican Mural Painter

David Alfaro Siqueiros, best known as the youngest of the three great Mexican mural painters of the early twentieth century, was often distracted from art to fight for political causes both in combat and with his written word (Lucie-Smith 62). Born in Chihuahua, he began both of his lifelong endeavors as a child: to be an artist and to be a soldier. Because his father was a successful attorney, Siqueiros could afford to take evening art classes after attending elementary school during the day. He studied at the esteemed Academy of San Carlos until it closed in 1911 because of a students' strike against its conservative style guidelines. The school promoted traditional and realistic approaches to subject matter, whereas the students wanted to explore the latest techniques from Europe. His involvement in the strike led to his first time in jail, an abrupt ending of his childhood innocence (Helm 90). This was the first of several times Siqueiros was imprisoned for political actions.

After being released from jail, students at San Carlos were left to find instruction elsewhere because the academy had been temporarily closed; many, including Siqueiros, joined Mexico's first open-air painting studio in Santa Anita. While there, he became deeply involved with a student anarchist group, Batallón Mama (Babies' Brigade), which was rebelling against rich, conservative forces in the Mexican Revolution. In the young students' many battles, Siqueiros acted as a sergeant, and within a year, with much combat experience under his belt, was promoted to lieutenant by age fifteen (Helm 90). In 1917, he organized the artists' group Congress of Soldier Artists in Guadalajara. The artists spent time painting together but devoted many hours to talking about local and European politics, especially concerning World War I and what was happening in Europe. In

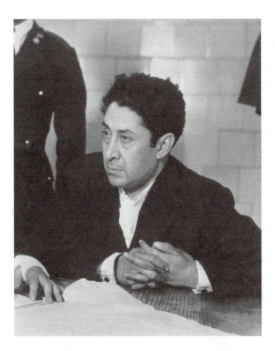

David Alfaro Siqueiros, 1939. Courtesy of
and © Bettman/CORBIS. Used with per-
mission.

1920, Siqueiros left Mexico for Spain, where he wrote and published *Manifesto to the Artists of America* (c. 1920), in which he encouraged artists to look to the future for inspiration: "Let us love the modern machine which provokes unexpected plastic emotions" (Lucie-Smith 62). He wanted to express his fascination with and appreciation for Modernism and the next generation, embracing technology and innovative artistic styles emerging in the early twentieth century.

Like his fellow mural painters **Diego Rivera** and **José Clemente Orozco**, Siqueiros felt that it was important to revive the traditions of Mexican culture in art. Yet, unlike them, he was in favor of moving toward a technologically advanced society and, in art, toward a style that respected past cultures while embracing modern techniques and approaches. Siqueiros wrote about his strong feelings on the subject:

Understanding the wonderful human resources in "black art," or "primitive art" in general, has given the visual arts a clarity and depth lost four centuries ago along the dark path of error. Let us, for our part, go back to the work of the ancient inhabitants of our valleys, the Indian painters and sculptors (Mayas, Aztecs, Incas, etc.). Our climatic proximity to them will help us to assimilate the constructive vitality of their work. They demonstrate a fundamental knowledge of nature, which can serve as a point of departure for

us. Let us absorb their synthetic energy, but avoid those lamentable archaeological reconstructions ("Indianism," "Primitivism," "Americanism") which are so in vogue here today but which are only short-lived fashions. (Lucie-Smith 62–63)

After returning to Mexico in 1922, Siqueiros followed in the footsteps of many other Mexican artists who taught at and were commissioned by the National Preparatory School. He was at the school until 1924, when Orozco was ousted by the protests of conservative students. Siqueiros's mural was left unfinished; today the line drawings and pale paint of its beginnings are barely visible (Helm 91). By the mid-1920s, he was directing his energy toward organizing a trade union of technical workers, painters, sculptors, and engravers, for which he edited the newspaper, *El Machete*. The union disbanded when it could not reach a consensus on even one point. Siqueiros was doubly disappointed when Mexico's minister of education outlawed *El Machete* (Helm 91).

Siqueiros spent the next several years as director-general of all trade unions in the state of Jalisco. However, he was involved in picketing and other controversial trade-union activities, which led to multiple arrests and a year in jail (1930) (Helm 92). Restricted to his prison cell, Siqueiros produced many small canvases, such as *Siqueiros por Siqueiros* (1930). This small self-portrait, 39 × 31 inches, conveys a dark and powerful image of a man larger than life. The face has distinctive Indian features that are exaggerated by a geometric quality much like that of Pablo Picasso's women in his early Cubist painting *Les Demoiselles d'Avignon* (1907).

From 1931 to 1939, Siqueiros lived in Brazil, the United States, and Spain, lecturing and painting several commissioned murals. *América Tropical* (Tropical America, 1932) was one of his first works completed in the United States. This politically controversial Los Angeles mural generated tremendous attention for Siqueiros and created international interest in his painting (Kamps 187). The mural depicts the Crucifixion with a Latin American figure as Christ and an American eagle looming overhead, representing the colonizing conqueror.

Like the Mexican painter **Dr. Atl**, Siqueiros was in search of a new medium for his paintings, one that would create a "plastic look." He chose to use Duco, an industrial-strength paint that formed a glossy, textured surface, giving a three-dimensional quality to his paintings. In 1935, a Mexican art dealer exhibited Siqueiros's Duco paintings, the first to be made by a Mexican artist (Velázquez Chávez 252). His painting was interrupted again when he went to Spain to fight in the civil war against the Loyalists (republicans) (Kamps 187). He returned to Mexico in 1939, and that year created one of his largest murals, for the Mexican Union of Electricians, *Retrato de la Burguesía* (Portrait of the Bourgeoisie) (1939).

This mural makes a social comment about the excessive wealth and greedy behaviors of the rich.

Through his continued interest in local and foreign politics, around 1939 Siqueiros became involved in a plot to assassinate the Russian Communist leader Leon Trotsky; its failure caused him to flee to Chile. Back in Mexico by the mid-1940s, he spent the next fifteen years publishing radical pamphlets and organizing artists. From 1960 to 1964 he was imprisoned by President Adolfo López Mateos because he was a radical presence in the community through his writings and lectures, and was considered a political threat to the government (Kamps 188).

After being released, Siqueiros lived in Mexico City until his death in 1974. These years were fruitful; he painted murals and established his art school, Taller Siqueiros, where he both taught and painted. Siqueiros, most acknowledged for his mural painting, dedicated his life to fighting for his ideals.

Places to See Siqueiros's Work

Adani Gallery, Dallas, Tex.

Chauinard School of Art, Los Angeles: *The Struggle* (1932)

Escuela Nacional Preparatoria, Mexico City: *Untitled* (unfinished mural) (1922–1924)

Hospital No. 1 de Seguro Social, Mexico City: *Por una Seguridad Completa para todos los Mexicanos* (Toward Complete Security for All Mexicans, 1952–1954)

Mary-Anne Martin Fine Art, New York City

Mexican Art Gallery, Mexico City: *Indian Boy* (1929)

Museo Nacional de Historia, Mexico City: *La Nueva Democracia* (The New Democracy, 1944–45); *La Revolución contra la Dictadura Porfiriana* (The Revolution Against the Porfirian Dictatorship, 1952–1954)

Museum of Art, University of Maine, Orono: *Cara* (c. 1936); *Mexican Suite* (Mother and Child) (date unknown)

Palacio de Bellas Artes, Mexico City: *Cuauhtémoc Revivido* (Cuauhtémoc Brought Back to Life, 1951)

Plaza Arts Center, Los Angeles: *The Tropical Race* (1932)

Bibliography

Charlot, Jean. *Mexican Art and the Academy of San Carlos, 1785–1915*. Austin: University of Texas Press, 1962.

Folgarait, Leonard. *Mural Painting and Social Revolution in Mexico, 1920–1940: Art of the New Order*. New York: Cambridge University Press, 1998.

Goldman, Shifra M. *Dimensions of the Americas: Art and Social Change in Latin America and the United States*. Chicago: University of Chicago Press, 1994.

Helm, MacKinley. *Modern Mexican Painters*. 2nd ed. New York: Harper & Brothers, 1941.

Kamps, Toby, ed. *Frida Kahlo, Diego Rivera, and Twentieth Century Mexican Art: The Jacques and Natasha Gelman Collection*. New York: Distributed Art, 2000.

Lucie-Smith, Edward. *Latin American Art of the 20th Century*. New York: Thames and Hudson, 1993.

Orozco, José Clemente. *An Autobiography*. Translated by Robert C. Stephenson. Austin: University of Texas Press, 1962.

Schmeckebier, Laurence E. *Modern Mexican Art*. Minneapolis: University of Minnesota Press, 1939.

Velázquez Chávez, Agustín. *Contemporary Mexican Artists*. New York: Friede, 1937. Repr. Freeport, N.Y.: Books for Libraries Press, 1969.

Fernando de Szyszlo
(b. 1925)
Peruvian Painter

Fernando de Szyszlo, known as a leader in Peruvian Modernism, paints what he knows: his Peruvian culture, and a life entwined with poetry and presented with a keen awareness of the world around him. He was born in Lima to a Polish father and a Peruvian mother. After studying at the School of Fine Arts of the Catholic University of Lima from 1944 to 1946, under the direction of the Austrian-born painter Adolfo Winternitz (Barnitz 159), he decided that what he had been taught wouldn't help him become a great artist, and he started copying artists like Rembrandt and Titian. Szyszlo realized that in order to get a certain shade of red, an artist might first have to paint an orange or a light red, and then apply a dark red glaze over it. This method results in a vibrant red. On the basis of this exploration, he now builds his paintings with layered, textured colors by means of thickly applied paint (Barnitz 159). Because of this attention to color, he is primarily known as a colorist (Colle 173). The innovations in his painting have led to his being known as the leader of the new Peruvian movement in art (Lucie-Smith 147).

From 1949 to 1955, Szyszlo lived in Paris and Florence, and from 1956 to 1960 he was a consultant to the Pan American Union's Department of Visual Arts in Washington, D.C. He has taught painting at several U.S. universities and has received wide international recognition (Barnitz 159).

However, when Szyszlo first exhibited his abstract paintings in 1951, they were denounced by critics who claimed that they were "un-Peruvian," "decadent," and "immoral." Not until the 1960s was his work accepted in Peru, after he had had considerable acclaim abroad (Barnitz 159). Many artists have been influenced by Szyszlo's work, including the Peruvians

Venancio Shinki, Enrique Galdós Rivera, and Arturo Kubotta, as well as the Puerto Rican Luis Hernández Cruz (Traba 90).

Szyszlo likes to name his paintings for poems by poets such as Saint John Perse, Octavio Paz, and an anonymous sixteenth-century poet. Poetry excites him, and he has many friends who are poets (Colle 171). He is especially influenced by the sixteenth-century Quechua (a language spoken in the Andes) elegy *Apu Inka Atahuallpamam*, which was first published in Spanish in 1942. Atahualpa was the last Inca emperor, and his death is embedded in many of Szyszlo's paintings (Barnitz 160). His paintings are also inspired by Peruvian sites, such as *Cajamarca* (Barnitz 159), the place where Atahualpa was murdered by the Spanish (Barnitz 161). Titles of paintings also use the proper names of Incas, Peru's Indian people, such as the martyred revolutionary Tupac Amaru (*The Execution of Tupac Amaru, XII*, 1965). This triptych (set of three paintings) has a dark, brooding circle on the middle wooden panel. The application of the paint tells a turbulent tale, not literally but through its sense of emotion (Scott 220).

In Szyszlo's 1968 painting *Inkarri*, a heavy, black oblong shape hovers in a deep red field of paint above what appears to be an altar made of feline paws. These paw shapes, which reoccur in Szyszlo's work, also appear on ancient Peruvian and Bolivan pottery, textiles, and temple facade reliefs; they were believed to have supernatural powers. As in paintings by Mark Rothko, compositions by Szyszlo create a kind of balance, but his work is more tactile, and it employs more tonal modulations, than many paintings done by U.S. artists. *Inkarri*'s red color could represent the blood of Atahualpa, and the predominant black shape could be the sun, which darkened when the Inca civilization was overrun by the Spanish. The title *Inkarri* is a Quechua word that speaks of the Incas as brave people, and it refers to an Andean myth that says the Inca empire will return (Barnitz 159–61).

Like many other Abstract Expressionist painters, Szyszlo believes that the naturalistic representation of objects on a canvas can hide a deeper meaning. He stated that "form conceals its content. . . . To get a meaning that stirs you and is valid, you have to go to the depths. If your feeling comes from sufficiently deep within, it will have a glow that makes it legible" (Colle 173).

Szyszlo has a studio in New York City; there he listens to music, relishes looking at his Peruvian pre-Hispanic art, and takes walks with his wife, Lila. Though he enjoys comfortable surroundings, he is continually saddened by the poverty and turmoil in his home country. Whether working in New York or in Peru, he thinks about politics: "Aside from art, what preoccupies me most, and perhaps why I live in a country like Peru, is politics. . . . It is not possible to be indifferent, the frustration in seeing one's country worn away is so strong" (Colle 171).

Szyszlo is deeply enmeshed in his Peruvian environment. In his paintings

he buries pre-Columbian imagery, and his colors are hues found in ancient textiles, some of which hang on his walls (Lucie-Smith 148). He confided, "I am myself and my circumstances. I am the result of what I have lived; a result of my county, which is what substantially formed me" (Colle 174). If we look at his work from this perspective, we see a life that has had poetry, exuberance, and strong sensitivity to the world around him.

Places to See Szyszlo's Work

Blanton Museum of Art, University of Texas, Austin: *Inkarri* (1968)

Emporium Fine Art Galleries, Dallas, Tex.

Gallery de Arte Moll, Lima, Peru

Guggenheim Museum, New York City: *Huanacauri II* (1964)

Jack S. Blanton Museum of Art, Austin, Tex.

Museo de Arte de Lima, Lima, Peru

Museum of Art, Rhode Island School of Design, Providence: *The Execution of Tupac Amaru, XII* (1965)

Museum of Latin American Art, Long Beach, Calif.

Yale University Art Gallery, New Haven, Conn.

Bibliography

Barnitz, Jacqueline. *Twentieth-Century Art of Latin America*. Austin: University of Texas Press, 2001.

Catlin, Stanton Loomis, and Terence Grieder. *Art of Latin America Since Independence*. New Haven, Conn.: Yale University Press, 1966.

Colle, Marie-Pierre. *Latin American Artists in Their Studios*. With an introduction by Carlos Fuentes. New York: Vendome Press, 1994.

García Cisneros, Florencio. *Latin American Painters in New York*. Miami: Rema Press, 1964.

Lucie-Smith, Edward. *Latin American Art of the 20th Century*. New York: Thames and Hudson, 1993.

Medina, Alvaro. "Fernando de Szyszlo." *Art Nexus* 11 (January–March 1994): 60.

Parker, Robert A. "Szyszlo's Abstract Nativism." *Americas* 37 (November–December 1985): 40–43.

Scott, John F. *Latin American Art: Ancient to Modern*. Gainesville: University of Florida Press, 1999.

Sullivan, Edward J., ed. *Latin American Art in the Twentieth Century*. London: Phaidon Press, 1996.

Traba, Marta. *Art of Latin America, 1900–1980*. Washington, D.C.: Inter-American Development Bank; Baltimore: Johns Hopkins University Press, 1994.

Rufino Tamayo

(1899–1991)

Mexican Lithographer; Painter, Sculptor, and Stained Glass Artist

Rufino Tamayo dedicated his lifetime to art as an artist, teacher, collector, and benefactor. Born to Zapotec Indian parents in Oaxaca, Mexico, he was orphaned in 1907. At that time, he moved to Mexico City to live with his aunt and uncle. He worked with his aunt selling fruit in the city markets (Lucie-Smith 112). Tamayo later often discussed his experiences in the markets and recognized that many of his paintings reflect colors and subject matter that relate to them (Chaplik 138). For example, the watermelon is a recurring image in his fruit paintings: "I painted these [watermelons] because of their color, of their form, because they are a smile from Mexico, because I like them. . . . I lived among fruit. My family had a stand in the market of the *Merced* [open-air market]" (Colle 179–80).

As a teenager, Tamayo began his formal education in the visual arts by enrolling in drawing classes at the Academy of San Carlos. In 1917, he became a full-time student at the National School of Fine Arts in Mexico City. By 1921, Tamayo was head of the ethnographic drawing division of the National Museum of Archaeology. He held this position while teaching art classes at elementary schools in Mexico City (Alanís et al. 21). His experience working at the National Museum of Archaeology piqued his curiosity about pre-Columbian and Mexican folk art, both of which he enthusiastically collected throughout his life (Colle 179).

Tamayo began to receive recognition for his work before his thirtieth birthday. His initiation into the art market took place in the streets of downtown Mexico City where he exhibited and sold his art in 1926. His first formal exposure came later that same year when the Weyhe Gallery in New York City hosted a one-person show in which he exhibited some of the works that had been viewed by pedestrians in the streets of Mexico

Rufino Tamayo at his easel. Photo Credit: Irving Penn, 1947. Courtesy and © Inheritors of the artist in support of Fundación Olga y Rufino Tamayo, A.C., Mexico City. Used with permission.

City (Alanís et al. 21). In 1928, Tamayo furthered his career in teaching by accepting a position at the National School of Fine Arts, where he had been a student. There, he worked under the Mexican muralist **Diego Rivera**, the director of the school (Lucie-Smith 112).

Although rarely mentioned in documentation about the life and work of Rufino Tamayo, his relationship with the painter **Maria Izquierdo** was influential in the development of his style. The two artists met in 1929, while he was a teacher, and she was a student, at the National School of Fine Arts. Their intense four-year connection directly affected both artists' work. During the height of mural painting in Mexico, both of them turned to the easel instead. The content of Tamayo's painting shaped Izquierdo's compositions, and her strong stylistic forms challenged him to develop a distinct style of his own (Ferrer 12).

Diego Rivera, along with **José Clemente Orozco** and **David Alfaro**

Siqueiros, was a leader in Mexican muralism, the prevailing narrative style, which typically portrayed the political history and cultural struggles of Mexico. Although Tamayo developed a relationship with these three artists that lasted throughout their lifetimes, he asserted artistic independence from the confines of Mexican muralism. He often criticized their prescriptive style, claiming that the muralists became so preoccupied with presenting classically "Mexican" scenes that they were more engaged with the picturesque than with important content (Lucie-Smith 112). Tamayo preferred everyday scenes, speaking across cultures through his small easel paintings, to the wall-size Mexican historical narratives (Chaplik 138).

Even so, Tamayo was commissioned to create several public murals, which were mostly painted on movable canvases (Traba 64–65). His first commissioned mural, *Music and Song* (1933), at the National Conservatory of Music (now the Department of Prehistory of the National Institute of Anthropology and History), was an expansion of previous smaller easel paintings, which also portray universal themes. Tamayo explained the symbolism in *Music and Song*:

> The central figure of an Indian woman, standing, represents Music; the nude at the left is intuition, the gift of nature; while the figure of intelligence, above the head of Music, represents a form of work. Intuition and intelligence hold their arms straight up, the fists representing strength. A woman seated in the lower part of the panel symbolizes humanity. The panel on the left represents Song, the one on the right, instrumental Music; the instruments painted on the lower walls of the stairwell represent strings, woodwinds, and percussions [*sic*]. (Alanís et al. 9)

While painting this first mural commission, Tamayo met Olga Flores Rivas, a piano student at the conservatory. They fell in love, married later that year, and spent the remainder of their lives together (Alanís et al. 21). Although Tamayo worked against the predominant Mexican muralist style, he did not abandon the warm colors of his native country, which he acknowledged as being deeply rooted in Mexican culture: "My colors are the colors of the earth, simple, cheap. The real Mexican colors are inexpensive, those of the poor people, earth colors and the blues of *rebozos* [shawls]" (Colle 179). He expressed this attitude concerning color throughout his body of work, using bold and vibrant hues. *Young Man with Violin* (1990), painted the year before his death, is composed with blocks of reds, blues, and yellows; the man sits squarely in the center, holding his instrument as he directly confronts the viewer.

Tamayo left his teaching post at the National School in 1930, mainly due to creative differences with Diego Rivera and his opposition to Mexican muralism (Chaplik 139). He traveled to New York City, searching for other sources of inspiration and influence. Tamayo viewed Pablo Picasso's

1939 retrospective at the Museum of Modern Art, which increased his desire to learn more about the contemporary styles of Western modern art. Tamayo made New York City his primary residence from 1938 to 1950, but continued to spend summers in Mexico. He developed a mentoring friendship with the U.S. Cubist artist Stuart Davis, who inspired Tamayo to further his exploration in painting. In addition to Picasso and Davis, he studied the work of Paul Gauguin, Paul Cézanne, Henri Matisse, and Juan Miró (Lucie-Smith 113). His years in New York were productive. While teaching art at the Dalton School, he continued to produce art for several New York art galleries that exhibited his work.

Tamayo's choice of media was not limited to paint and canvas; he also worked with wood, iron, lithography, and stained glass. He constructed the fifteen-meters-high iron sculpture *Germ* (1980) for the cultural center at Mexico City's National Autonomous University. In it, triangles, semicircles, and rectangles come together, gracefully slicing through the sky.

The Tamayos, who had no children to inherit their vast art collection, felt strongly about sharing it with their community. On their fortieth wedding anniversary in 1973, the couple donated more than 1,000 ancient sculptures and artifacts to the city of Oaxaca (Chaplik 138). In 1981 they opened the Rufino Tamayo Museum of International Contemporary Art in Chapultepec Park, Mexico City; it contains the rest of their collection, including paintings, sculptures, drawings, engravings, and tapestries by more than 174 artists (Alanís et al. 24). The last years of Tamayo's life were spent in Mexico City. He continued to make art until the year before his death on October 31, 1991, from complications attributed to pneumonia. After Olga died in 1994, her ashes were placed next to her husband's at the museum they had founded (Alanís et al. 25).

Tamayo received many honors and awards in the later years of his life, including the Albert Einstein Prize awarded by the Technion Society of Israel, the Gold Medal for Merit in the Fine Arts awarded by King Juan Carlos of Spain, the Order of Christopher Columbus from the government of the Dominican Republic, and the Commendatore Medal from the Italian government. He supported education throughout his life. In 1989, the Rufino and Olga Tamayo Foundation was established to support the study of international contemporary art and to conserve Tamayo's work (Alanís et al. 25). Tamayo was an artist of talent and generosity whose work, foundation, and museum continue to inspire new generations of artists and art lovers.

Places to See Tamayo's Work

Adani Gallery, Dallas, Tex.

Bank of the Southwest, Houston, Tex.: *America* (1956)

Brewster Arts Limited, New York City

CDS Gallery, New York City

Dallas Museum of Art, Dallas, Tex.: *El Hombre* (1953)

Department of Prehistory of the National Institute of Anthropology and History, Mexico City: *Music and Song* (1933)

Foreign Affairs Ministry Collection, Mexico City: *The Mexican and His World* (1967)

James Goodman Gallery, New York City

Latin American Masters, Beverly Hills, Calif.

Museum of Cultures, Mexico City: *Revolution* (1938)

Museum of Modern Art, New York City: *Animals* (1941)

National Museum of Anthropology, Mexico City: *Duality* (1964)

Palace of Fine Arts, Mexico City: *Birth of Our Nationality* (1952); *Mexico Today* (1952)

Peter Findlay Gallery, New York City

Phillips Collection, Washington, D.C.: *Carnival* (1941)

San Francisco International Airport: *The Conquest of Space* (1983)

San Francisco Museum of Modern Art: *The Lovers* (1943)

Sanborn Restaurant, Mexico City: *Night and Day* (1954); *Still Life* (1954)

Smith College, Northampton, Mass.: *Nature and the Artist—The Work of Art and the Observer* (1943)

UNESCO, Paris: *Prometheus Bringing Fire to Men* (1958)

University of Central Florida, Special Collections, Orlando: *Untitled* (c. 1970)

University of Puerto Rico, Río Piedras: *Prometheus* (1957)

Bibliography

Ades, Dawn. *Art in Latin America: The Modern Era. 1820–1980.* New Haven, Conn.: Yale University Press, 1989.

Alanís, Judith, Gabriela E. López, Samuel Morales, and Antonio Niño de Rivera. *Rufino Tamayo.* Translated by Nicolás Papworth. Mexico City: Artes Gráficas Panorama and Museo Rufino Tamayo, 1989.

Catlin, Stanton L., and Terence Grieder. *Art of Latin America Since Independence.* New Haven, Conn.: Yale University, 1966.

Chaplik, Dorothy. *Latin American Art: An Introduction to Works of the Twentieth Century.* Jefferson, N.C.: McFarland, 1989.

Colle, Marie-Pierre. *Latin American Artists in Their Studios.* New York: Vendome Press, 1994.

Del Conde, Teresa. "Mexico." In *Latin American Art in the Twentieth Century.* Edited by Edward J. Sullivan. London: Phaidon Press, 1996. Pp. 17–50.

Ferrer, Elizabeth. *The True Poetry: The Art of María Izquierdo.* New York: Americas Society Art Gallery, 1997.

Lucie-Smith, Edward. *Latin American Art of the 20th Century*. New York: Thames and Hudson, 1993.

Traba, Marta. *Art of Latin America 1900–1980*. Washington, D.C.: Baltimore: Johns Hopkins University Press, 1994.

Francisco Toledo

(b. 1940)
Mexican Painter, Engraver, and Sculptor

Francisco Toledo creates imaginative art, yet his most profound accomplishment may very well be his philanthropy for the arts in his hometown. He was born to Zapotec Indian parents in the small village of Juchitán, Oaxaca. His father worked as a shoemaker to support the family. As a child, Toledo showed an interest in the arts. He first took art courses at the Oaxaca School of Fine Arts. Later, after moving to Mexico City, he studied at the Free Engraving Studio. He received international attention for his work at the age of nineteen, when the Art Center of Fort Worth, Texas, hosted a solo exhibition of his paintings. That same year, he was honored with a second solo exhibition at the Galería Antonio Souza in Mexico City.

Using funds provided by a Mexican government grant, Toledo went to Paris in 1960 for additional training in engraving, and worked for five years with the engraver Stanley William Hayter (Ades 358). During that time, he was exposed to European modern art and was impressed with the work of the French painter Jean Dubuffet and the Swiss painter Paul Klee (Lucie-Smith 187). Jean Dubuffet coined the term *art brut* (raw art) to categorize art created by the self-taught, the insane, or the otherwise non-traditional artist. Toledo was drawn to Dubuffet's "pure" or "raw" art, which was unaffected by outside influences. Since finishing art school, Toledo has sought to create his art, unaffected by societal demands. Like Klee, who created geometrical compositions inspired by his dreams and imagination, Toledo creates what he conjures from his imagination. While in Paris, he participated in the Salon of Paris in 1963 and 1964. In 1965, he returned home, where he was once again surrounded by the Mexican culture, landscape, animals, and myths that continue to affect his work (Ades 358). Drawing from European influences, Mexican culture, and his

imagination, Toledo creates his own rendition of the Magic Realism style (Del Conde 39). Magic Realism is fascinated with distorting the common, banal, or everyday into something weird, strange, or mysterious.

In his oil painting *Woman Attacked by Fish* (1972), feather-like gills engulf the brown and gold hues of the canvas. Closer inspection reveals the profile of a female form within the fish encircling her. Her head has undergone a metamorphosis that has become half-human, half-beast with a pointed, beaklike nose and blunt horns along her skull. She is lunging forward, as if trying to flee. A large fish head emerges from the bottom of the composition with mouth agape, reaching for the woman. Here, Toledo seems to be making a statement about nature overtaking humanity, when in reality humanity dominates and abuses nature. However, the art historian Christian Viveros-Fauné suggests a more intimate and fearful interpretation: that the fish represent phallic symbols of aggression and are trying to rape the woman (133).

In his engraving *Muerte con Cangrejo* (Death with Crab, date unknown), a skeleton runs toward a giant crab; in its hand is a spear, aimed to kill. The crab, found on Mexico's beaches, is grossly exaggerated, like the giant spiders and insects from 1950s horror films. The skeleton image is hauntingly reminiscent of the work of Toledo's predecessor, the Mexican engraver **José Guadalupe Posada**. Posada popularized the skeleton and skull imagery in his early twentieth-century political posters, newspapers, and prints.

Although his style does not directly mimic that of the Mexican painter **Rufino Tamayo**, Toledo's art is considered a direct descendant of Tamayo's (Lucie-Smith 187). Tamayo was a contemporary of the "great three" Mexican mural painters—**José Clemente Orozco, Diego Rivera**, and **David Alfaro Siqueiros**—who created wall-size paintings embodying a political spirit. Tamayo, however, stood apart with his easel-size paintings of everyday life in Mexico. Toledo's work also speaks of personal and even imaginative themes on a smaller scale, which links him to Tamayo.

Toledo's commitment to giving back to his community is extraordinary. In his home state of Oaxaca, he contributes significant financial resources. He was instrumental in the establishment of several arts organizations, including a vast arts center. Toledo supports the Museum of Contemporary Art in Oaxaca, the Graphic Arts Institute, and the Jorge Luis Borges (an important writer of Magic Realism) Library for the Blind, which Toledo built after observing a group of blind people visiting a local art museum (Viveros-Fauné 131). He also funded the **Manuel Álvarez Bravo** Photographic Center (named for the famous Mexican photographer), Ediciones Toledo (a printing house), the Santo Domingo Cultural Center (a botanical garden, art restoration center, and library), and Pro-OAX (a local environment and cultural preservation group for the state).

Toledo's work has been exhibited in Paris, New York, London, Geneva,

Hannover (Germany), and Mexico City, to name just a few locales. He participated in the International Biennale of Graphics in Tokyo (1972) and at the Spoleto Festival in Italy (1973), and more recently was presented Mexico's National Arts Award in 1998. Toledo is rarely interviewed, and chooses to work free from the influences of the art world and critics (Kamps 192). Working mostly in seclusion, he divides his time between Paris, New York, Mexico City, and Juchitán. Toledo creates compelling works in his own creative version of Magic Realism, and supports the arts and his community through his philanthropic efforts.

Places to See Toledo's Work

Adani Gallery, Dallas, Tex.

Galería Arte de Oaxaca, Oaxaca, Mexico

Galería Juan Martin, Mexico City

Galería López Quiroga, Mexico City

Galería Quetzalli, Oaxaca, Mexico

Mary-Anne Martin Fine Art, New York City

Museo Rufino Tamayo, Mexico City: *Woman Attacked by Fish* (1972)

Museum of Modern Art, New York City

National Museum of Modern Art, Paris

Tate Gallery, London

Bibliography

Ades, Dawn. *Art in Latin America: The Modern Era, 1820–1980*. New Haven, Conn.: Yale University Press, 1989.

Del Conde, Teresa. "Mexico." *In Latin American Art in the Twentieth Century*. Edited by Edward J. Sullivan. London: Phaidon Press, 1996. Pp. 17–50.

Goldman, Shifra M. *Dimensions of the Americas: Art and Social Change in Latin America and the United States*. Chicago: University of Chicago Press, 1994.

Kamps, Toby, ed. *Frida Kahlo, Diego Rivera, and Twentieth Century Mexican Art: The Jacques and Natasha Gelman Collection*. New York: Distributed Art, 2000.

Lucie-Smith, Edward. *Latin American Art of the 20th Century*, New York: Thames and Hudson, 1993.

Peden, Margaret S. *Out of the Volcano: Portraits of Contemporary Mexican Artists*. Washington, D.C.: Smithsonian Institution Press, 1991.

Viveros-Fauné, Christian. "Toledo's Metamorphoses." *Art in America* vol. 89, no. 2 (2001): 130–33.

Rigoberto Torres

(b. 1960)

Puerto Rican Sculptor

Rigoberto Torres is well known for the sculptural casts he and his partner, John Ahearn, created of his neighbors in the borough of the Bronx in New York City. Rigoberto Torres now lives and works in Florida. Although Ahearn and Torres work independently, they often collaborate in colorful, life-size sculptures of everyday people, often their neighbors, friends, and family. In the Bronx, the works were installed on exterior building walls and in indoor public spaces, such as waiting rooms. Many of the casts are in the homes of their subjects. The work, therefore, is notable not only for the product that results, but also for the way in which it is created and displayed.

Torres was born in Aguadilla, Puerto Rico, to a close-knit family who moved to New York City when he was four years old. His family members are very important to him, for they often help him with various parts of the artistic process. His children are frequently his subjects (Hoeltzel 8).

Torres's sculptures, described as humanistic naturalism as they are reflective of how someone looks, are made of plaster and fiberglass. They are of real people and are presented in public spaces, often as street events taking on an element of performance art. The Bronx neighborhood where Torres produced his first major works is associated with extensive poverty, crime, and drug problems. It is also a center of hip-hop, break dancing, graffiti, and rap (Hoeltzel 5). The castings portray the movement and everyday activities of the people who volunteer to be subjects. The process requires that plastic gel be poured over the subject's face after straws are inserted in the nostrils for breathing. The dried impression is then lifted off the body and used as a mold (Cameron 13). Torres may cast only a head or a hand, but he also makes full body casts, in the round.

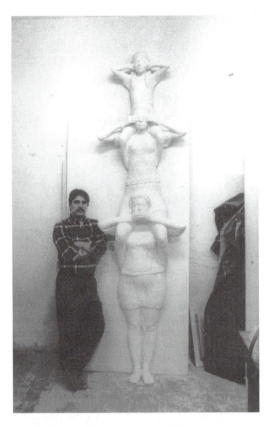

Rigoberto Torres next to his sculpture, *Hear No Evil, Speak No Evil and See No Evil.* Photo Credit: Marty Cooper, 2001. Courtesy of The Web Gallery, City Island, New York. Used with permission.

Torres and Ahearn met in 1979 when Torres went to see what Ahearn was doing in a Bronx storefront art gallery called Fashion Moda. Because Torres was working in his uncle's statuary factory, creating statues of saints for botanicas (stores that sell herbs and religious articles) and reproductions of figures from art history, he had extensive experience working in casting. He quickly suggested to Ahearn that they cast local people living on Walton Avenue, and in 1980 Ahearn moved to the Bronx to work with Torres. Community involvement is important to both men, and the spontaneity of the process and the enthusiasm of the participants mark their works (Hoeltzel 7; Steinman 194). The entire process, from subject selection to display, often involves community participation.

Though Ahearn and Torres do castings together, each is also known for his individual work, which is quite distinct. Ahearn's work relates more to

the academic art world, whereas Torres's is more rooted in his Puerto Rican cultural aesthetic (Kramer 59). As their work progressed, they expanded from busts to full-length figures in the round (Hoeltzel 7). Each artist enhances the other's process. Ahearn claims that Torres opened up his life. When introducing Torres, he often says, "This is Robert, the key person" (Kramer 60). Kramer said that in their Bronx collaboration, "It was Robert who was his [Ahearn's] Spanish voice and his Spanish credentials, Robert who took him home to Walton Avenue and made him family . . ." (60). Their first joint exhibition, *South Bronx Hall of Fame*, took place at Fashion Moda in 1979. This was the same time and place that many graffiti artists made the transition from street painting to canvas. Other kinds of collaborations between street artists and trained artists took place, including Jenny Holtzer, and Lady Pink, and Tim Rollins and KOS (Hoeltzel 6).

The *South Bronx Hall of Fame* grew into spontaneous neighborhood events that seemed more like huge street parties than a New York art world experience. People began lining up to be cast, and this participation signaled to neighbors a kind of bravado and rite of initiation that drew the community together (Steinman 194). Other important partnership projects completed during the early 1980s are *"Banana" Kelly Double Dutch* (1981–1982), *We Are Family* (1981–1982), *Life on Dawson Street* (1982–1983), and *Back to School* (1985) (Cameron 17).

Torres's work is significant for many reasons. It is collaborative; if not with Ahearn, then always with the person who is being cast. He identifies with his subjects, and always allows them to be themselves. The public castings he does are evidence of his ability to work well with others around him: he answers questions, tells stories and jokes, and assures the safety of and respect for his collaborators. The work is narrative, both in the character it portrays and in the artistic process that is presented. It also concerns rethinking what art can be, how it can be made, and how it can function in a community. What Torres's work conveys is important: it depicts the precariousness of life in an elegant manner. Cameron points to this aspect of Torres's sculptures in *The Rescue* (1993), in which "a fireman, framed by the pillars of an 'old law' tenement, risks his life to save the child who is cradled in his arms" (20).

In 1995 Torres had a severe asthma attack that caused a lapse of memory and prevented him from working (Hoeltzel 8). When he began to recover, he explained that he had to relearn how to be an artist. Due to his asthma, he and his family moved to Kissimmee, Florida. Torres continues to work around the world, both independently and with Ahearn, but more of his subjects are now Florida based (Congdon, personal communication).

Torres has had numerous solo exhibitions and joint exhibitions with Ahearn in places such as New York City; Portland, Oregon; Tempe, Ar-

izona; Baltimore; Washington, D.C.; Houston, Texas; and Agudilla, Puerto Rico. Increasingly, works by Torres and Ahearn are seen throughout the world.

Places to See Torres's Work

Baltimore Museum of Art

Brooklyn Museum of Art, New York City

City College of New York, New York City

Contemporary Arts Center, Cincinnati, Ohio

The Lannan Foundation, Los Angeles

The Metropolitan Museum of Art, New York City

Museum of Contemporary Art, Chicago

Museum of Fine Art, Boston

Witte de With, Rotterdam, Netherlands

Bibliography

Cameron, Dan. "Grace Under Pressure." In *The Works of Rigoberto Torres*. New York: Lehman College Art Gallery, 1995. Pp. 13–22.

Congdon, Kristin G. Personal communication. October 1, 2000. Kissimmee, Fla.

Goldstein, Richard, Michael Ventura, Marilyn A. Zeitlin, and Suzanne Delehanty. *South Bronx Hall of Fame: Sculpture by John Ahearn and Rigoberto Torres*. Houston, Tex.: Contemporary Art Museum, 1991.

Herzberg, Julia P. "People from Real Places." *Kunstforum International* 112 (March–April 1991): 312–313.

Hoeltzel, Susan. "The Works of Rigoberto Torres: Introduction." In *The Works of Rigoberto Torres*. New York: Lehman College Art Gallery, 1995. Pp. 5–9.

Kramer, Jane. *Whose Art is It?* Durham, N.C.: Duke University Press, 1994.

Kuspit, Donald. "John Ahearn and Rigoberto Torres at the Contemporary Art Museum." *Artforum* 30 (January 1992): 110.

McCormick, Carlo. "John Ahearn with Rigoberto Torres: Brooke Alexander." *Artforum* 25 (February 1987): 115–116.

Smith, Paul. "John Ahearn with Rigoberto Torres at Brooke Alexander." *Art in America* vol. 75, no. 2 (1987): 153.

Steinman, Susan Leibovitz. "Directional Signs: A Compendium of Artists' Works." In *Mapping the Terrain: New Genre Public Art*. Edited by Suzanne Lacy. Seattle, Wash.: Bay Press, 1995. Pp. 187–285.

Storr, Robert. "John Ahearn and Rigoberto Torres at Brooke Alexander." *Art in America* vol. 71, no. 11 (1983): 224.

Joaquín Torres-García
(1874–1949)
Uruguayan Painter and Sculptor

Joaquín Torres-García was one of the first Latin American artists to achieve international acclaim (Enriquez 129). He was born in Montevideo, Uruguay, to Joaquín Torres, a Catalan immigrant, who was a shopkeeper and carpenter, and María García, a young Uruguayan woman. The family lived in Montevideo until just before his seventeenth birthday, when they moved to his father's homeland in Catalonia, Spain. In 1891, two years after his arrival in Spain, Torres-García enrolled in art school to study drawing and painting in Barcelona, first at the School of Fine Arts and then at the Baixas Academy. His art gained public recognition in 1901, when it was reproduced in color on the front cover of *Pel e Ploma*, a popular magazine in Barcelona (Perazzo 107).

Torres-García's early paintings, from about 1896 to 1904, although descriptive and realistic, show an interest in abstraction and symbolism, foreshadowing his later style (Fletcher 103). Over the next twenty years, he developed his own style, gathering knowledge about art from around the world, dating from antiquity to the present. From 1919 to 1928, he moved between the cities of Barcelona, New York, and Paris. During this time, Torres-García focused on easel painting, creating and painting wooden toys, and illustrating design books. In 1920, he moved his family to New York City hoping to sell his handmade wooden toys to a large manufacturing company. Although his efforts to achieve success in the toy industry were not productive, New York provided a dynamic backdrop for Torres-García to produce a vast array of paintings and sketches. For example, *New York* (1921) is a colorful oil painting that shows the crowded streets in loose geometric form with dark outlines. A grocery store is full of shadows of people; above its door, in bold letters is a hand-painted sign that reads "groceries."

Even in his early years as an artist, Torres-García contemplated the meaning of art. His personal studies included reading about art and aesthetics. He aligned his own theories to the Neoplatonic notion that suggests art should go beyond the regularities of everyday life (Fletcher 103). He continued his writings and experimented with modern art styles, such as Cubism, Geometric Abstraction, Surrealism, and Futurism, which led to what became his own style, Universal Constructivism (Fletcher 103–104). Universal Constructivism is a vein in Modern Abstraction that uses basic geometry to situate form and lines, and combines them with symbols ranging from antiquity to present. At the same time, the symbols are real in that they represent themselves, and do not mimic something from nature; they are dreamlike or magical in that they suggest the unconscious; they are universal in that they express world unity.

In 1930, with the critic Michel Seuphor, Torres-García founded the philosophical artists' group Circle and Square. Although the group lasted for just a year, it catalyzed an intense and long relationship between art and aesthetics, with philosophical thinking and writing. Torres-García developed friendships with other modern artists experimenting in abstraction, including Piet Mondrian and Hans (Jean) Arp, who were both members of Circle and Square (Ades 147). Although these artists were experimenting with Geometric Abstraction, the direction of his art took a different turn. Torres-García distanced himself from them and directed his art toward an abstraction that dealt with the opposing forces of reason and nature (Ades 147). He experimented further with his Universal Constructivism.

In 1934 Torres-García returned to Uruguay. The following year, he and some former members of Circle and Square established another group, the Constructivist Art Group. His use of symbols became increasingly primary in his work, and he made deliberate use of and established meaning for those symbols. Defining his meaning of symbol in his book *Universalismo Constructivo* (1944), he wrote that a "Symbol that can be transformed into language, into idea, is not what we understand by symbol. Our symbol is that which originates in intuition, and is interpreted only by intuition" (Maslàch 149). Here, Torres-García is referring to images we recognize but are unable to describe verbally. Along with the Constructivist Art Group, he published the review *Circle and Square* (1936–1943), which served as a platform for leading Constructivist artists to voice their theories and show images of their latest work (Ades 144).

Torres-García's Universal Constructivism is based on a union of the artist with the cosmic order of the universe. About this idea, he wrote:

A sign carved on a stone is something separate from nature. It is the sign of man, the mark of Reason. Reason is Man. The tradition of Reason is an impersonal tradition, which departs from nature. It looks toward what is

general: the idea. Instinct looks inward and delves into the unconscious and ancestral memory; it is nature that must be transformed and ordered in thought, within an intellectual framework. (Perazzo 115)

Torres-García's symbology was based on the Western alphabet and numerical system, along with symbols native to pre-Columbian, Peruvian, African, and Native North American cultures (Perazzo 115). His affinity for pre-Columbian symbols is evident in his public sculpture *Cosmic Monument* (1938), at the Parque Rodó in Montevideo. The stone sculpture wall, carved with geometric symbols and designs, lends itself to a variety of interpretations. Initially, the sculpture appears to be a recovered map or inscription from an ancient culture; then it becomes clear that the markings are mixed, pulled from many different cultures and times.

Torres-García remained in Montevideo until his death in 1949. His last years proved to be some of the most important of his career, for he produced significant art, writings, and lectures (Traba 77). He published several books, including his autobiography, *Historia de Mi Vida* (The Story of My Life, 1939), and the text expounding his artistic theory, *Universal Constructivism* (1944). He opened a teaching studio in Montevideo where he gave over 600 lectures on his theories to students and artists throughout the 1940s. Today, most of his unpublished writings are preserved in the Torres-García Foundation's archives in Montevideo. As one of the leading artists of the early twentieth century, Torres-García made a considerable contribution to the teaching and writing of modern artistic theory.

Places to See Torres-García's Work

Adriana Indik Art Gallery, Buenos Aires

Albright-Knox Art Gallery, Buffalo, N.Y.: *Abstract Art in Five Tones and Complementaries* (1943)

CDS Gallery, New York City

Hirshhorn Museum and Sculpture Garden, Smithsonian Institution, Washington, D.C.: *Composition* (1931)

Jack S. Blanton Museum of Art, University of Texas, Austin: *Constructif en Rouge et Ocre* (1931)

Jan Kruger Gallery, New York City

Joaquín Torres-García Web page: www.ceciliadetorres.com

Leonard Hilton Galleries, New York City

Mary-Anne Martin Fine Art, New York City

Museo Nacional Centro de Arte Reina Sofia, Madrid: *New York* (1921)

Museu de Arte de São Paulo, São Paulo, Brazil

Rachel Adler Fine Art, New York City

Santa Barbara Museum of Art, Santa Barbara, Calif.: *Composition* (1932)

Yale University Art Gallery, New Haven, Conn.: *New York City—Bird's Eye View* (c. 1920)

Bibliography

Ades, Dawn. *Art in Latin America: The Modern Era, 1820–1980.* New Haven, Conn.: Yale University Press, 1989.

Carlisle, Cristina. "Buenos Aires: Rising Star." *Artnews* vol. 94, no. 12 (1995):41.

Chaplik, Dorothy. *Latin American Art: An Introduction to Works of the 20th Century.* Jefferson, N.C.: McFarland, 1989.

Enriquez, Mary Schneider. "Joaquín Torres-García." *Artnews* vol. 96, no. 9 (1997): 129.

Fletcher, Valerie. "Joaquín Torres-García." In *Crosscurrents of Modernism: Four Latin American Pioneers.* Edited by Valerie Fletcher. Washington, D.C.: Hirshhorn Museum and Sculpture Garden in association with the Smithsonian Institution Press, 1992. Pp. 103–25.

Maslach, Adolfo M. "On the Esoteric in the Art of Joaquín Torres-García." In *Crosscurrents of Modernism: Four Latin American Pioneers.* Edited by Valerie Fletcher. Washington, D.C.: Hirshhorn Museum and Sculpture Garden in association with the Smithsonian Institution Press, 1992. Pp. 149–63.

Perazzo, Nelly. "Contructivism and Geometric Abstraction." In *The Latin American Spirit: Art and Artists in the United States, 1920–1970.* New York: Bronx Museum of Art in association with Harry N. Abrams, 1988. Pp. 106–19.

Traba, Marta. *Art of Latin America (1900–1980).* Washington, D.C.: Inter-American Development Bank; Baltimore: Johns Hopkins University Press, 1994.

Tilsa Tsuchiya
(1929–1984)
Peruvian Painter

The painting of Tilsa Tsuchiya combines the style of European Surrealism with the content of Indian mythological themes. She was born Tilsa Tsuchiya Castilla, to a Japanese father and a Peruvian mother in Lima, Peru. The year of her birth, ambiguously documented, is between 1929 and 1936. Tsuchiya had an early interest in art and by the time she was eight, family and teachers were impressed with her drawing skills. While she was a young girl, her family relocated to Lima, where she began taking art classes. Off and on, from 1947 to 1957, she studied with Carlos Quispez Asin, a mural painter; **Fernando de Szyszlo**, a figurative Abstract Expressionist painter; and Manuel Zapata Orihuela, a Realist painter of indigenous subjects, at the National School of Fine Arts in Lima. In 1959, Tsuchiya was awarded the annual Great Prize of the National School for her paintings.

Tsuchiya was most affected by the stylistic teachings of Szyszlo and the subject matter of Orihuela's paintings. She learned about her father's culture, especially Japanese art and haiku. This poetry about nature inspired her soft and delicate approach to painting (Tilsa Tsuchiya Web page 1). Her work did not reach its full development, however, until after she had spent time in Paris (Lucie-Smith 183).

In 1960, Tsuchiya traveled to Paris, where she was deeply affected by European Surrealism, even though by then it had all but died out in Western art. While in Paris, she took free art history courses at the Sorbonne and studio classes in engraving at the School of Fine Arts. She met and lived with Charles Mercier, who fathered her son, Gilles (born in 1963). In 1966, the Cimaise Gallery hosted a solo exhibition of her paintings. Later that year, she and Gilles returned to Lima.

By the 1970s, Tsuchiya emerged as an important Peruvian Surrealist (Majluf 198). Her painting *Soledad* (Solitude, 1971) depicts a dark brown and black geometric form in the foreground that is unrecognizable and mysterious; a hazy, lavender shadow looms in the background. *Soledad* is a transition from her previous paintings, converting old imagery into something that has been described as "erotic and poetic" (Majluf 199). Her works focus on dreams, like Surrealist compositions, but the shapes, animals, and symbols are reminiscent of pre-Columbian Indian forms.

For instance, Tsuchiya often painted the *huaca*, a sacred place or object where unsettled spirits wait for adulation and for people to come to worship. *Moment in Red* (date unknown) portrays a horned animal spirit, resembling a cross between a bear and a wolf, sitting atop a mountainous *huaca*. A glowing sun in the upper left corner illuminates the dark canvas. An oversized cactus grows out from the side of the mountain, mimicking the shape of the animal spirit. *Moment in Red* is one of the most frequently reproduced paintings in Tsuchiya's body of work.

Tsuchiya's 1976 series of paintings possibly best depicts Peruvian Indian myth in a distinctly European Surrealist style. In a painting from this series, *Myth of the Bird and Stones*, a spirit in the shape of an armless woman sits high on a mountain. This work poses questions about why the woman has no arms. It seems as though she is trapped, left with no choice but to wait for adulation or praise as she sits on the *huaca*. Tsuchiya's figures, like the woman creature in *Myth of the Bird and Stones*, are pure fantasy, and have been compared with works by older feminist and Surrealist Mexican painters **Remedios Varo** and **Leonora Carrington** (Goldman 354).

Unlike other artists working with pre-Columbian forms, Tsuchiya did not focus on a historical or political theme. Her work is a complex amalgamation of Pre-Columbian myth, European Surrealism, her own mixed heritage, and her identity as a woman.

In 1978, Tsuchiya was diagnosed with uterine cancer. Until her death in 1984, she continued to work even though her pace was significantly slowed. In 1979, she was chosen to represent Peru in the XV Bienal of São Paulo. Her work has been viewed by audiences in Europe, Mexico, the United States, and throughout South America. Today, the work of Tilsa Tsuchiya is heralded as an important example of Peruvian Surrealism that emerged in the 1970s.

Places to See Tsuchiya's Work

Camino Brent Gallery, Lima

Cimaise Gallery, Paris

Galería de Arte Moll, Lima

Gary Nader Fine Art, Coral Gables, Fla.

Indianapolis Museum of Art, Indianapolis, Ind.

Institute of Contemporary Art, Lima

Museo de Arte de Lima

Bibliography

Ades, Dawn. *Art in Latin America: The Modern Era, 1820–1980*. New Haven, Conn.: Yale University Press, 1989.

Barnitz, Jacqueline. *Twentieth-Century Art of Latin America*. Austin: University of Texas Press, 2001.

Goldman, Shifra M. *Dimensions of the Americas: Art and Social Change in Latin America and the United States*. Chicago: University of Chicago Press, 1994.

Lucie-Smith, Edward. *Latin American Art of the Twentieth Century*. New York: Thames and Hudson, 1993.

Majluf, Natalia. "Peru." In *Latin American Art in the Twentieth Century*. Edited by Edward J. Sullivan. London: Phaidon Press, 1996. Pp. 191–200.

Sanjurjo, Annick, ed. *Contemporary Latin American Artists*. Lanham, Md.: Scarecrow Press, 1997.

Scott, John F. *Latin American Art: Ancient to Modern*. Gainesville: University Press of Florida, 1999.

"Tilsa Tsuchiya." *Latinart.com*. 2001. http://www.latinart.com

Tilsa Tsuchiya Web page. 2001. http://tilsa.perucultural.org

Traba, Marta. *Art of Latin America 1900–1980*. Washington, D.C.: Inter-American Development Bank; Baltimore: Johns Hopkins Press, 1994.

Meyer Vaisman

(b. 1960)

Venezuelan Sculptor

Meyer Vaisman uses nontraditional media to create art ranging from small, tabletop sculptures to room-size installations that address gender identity, ethnicity, culture, religion, and politics in an offbeat and often humorous way, provoking thought about ourselves and society. Born Meyer Vaisman Eidelman to a Russian father and a Romanian mother, he experienced ethnic diversity as part of his daily life in Caracas. Though Vaisman was raised in an upper-middle-class Jewish family, he received additional cultural and religious influences from one particular household servant:

> I grew up in a Jewish home. It was run-of-the-mill concerning religious practices. Major holidays and such. Emilia, the housekeeper, would come into my room in the middle of the night and quietly slip a crucifix on my neck, say a few words in Latin, and leave just as quietly as she came in. This procedure was repeated in reverse first thing in the morning. A Jew by day, a Catholic by night. (Weintraub 210)

Vaisman's family gave him the financial and emotional support necessary to pursue his artistic interests. After high school, Vaisman left Venezuela to attend the Parsons School of Design in New York City. He stayed in New York after finishing art school. In the early 1990s, he created a series of small sculptures by transforming stuffed turkeys with lace, jewels, wigs, and fur. The dressed-up turkeys are at first hilarious, then challenge us to look more closely at what is considered to be art. In these works, he mocks Western modern formalism, much as Marcel Duchamp had done when he presented a urinal as an art object (Johnson 115). He deliberately chose the turkey for his spoofs; a duck would be too cute, and connotes the

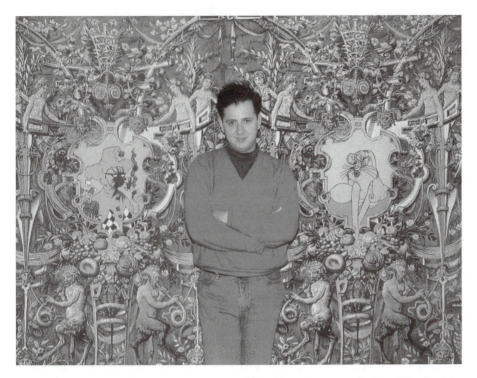

Meyer Vaisman. Courtesy of Leo Castelli Gallery, New York City. Used with permission.

"bathroom rubber ducky"; and the swan is too beautiful, and recalls the ballet *Swan Lake*. In colloquial language the turkey is used to label someone "silly" or to say that someone is the "brunt of a joke." Vaisman uses this as a point of departure to incite laughter and thought about smug suburbanites and social climbers, and especially institutions that control and influence the elitist art world (Weintraub 206).

For example, in *Untitled Turkey XIV* (1992), the turkey is covered in long, finely combed Icelandic lambs' wool to such an extent that it is almost unrecognizable underneath. It can cause the viewer to wonder why one animal would need the fur from another. Vaisman's message easily translates to the excessive killing of animals by humans for financial gain or for opulent display (Weintraub 209). In *Untitled Turkey VII* (1992), the stuffed bird wears a black lace veil, mimicking a "mourning turkey." Another one wears a bright red wig with tight curls, and another has blond locks, "personifying" vanity and the striving for physical perfection. The mixed-up turkeys symbolize struggles people encounter as individuals and collectively as communities.

Linda Weintraub described the turkeys as "allegories of interracial households, multiethnic matings, rearranged genders, and spliced genes. He [Vaisman] proclaims, 'we are all mongrels' " (Weintraub 209). Wein-

traub addresses Vaisman's mixing of gender characteristics to create a sense of ambiguity. He has openly discussed his inner conflict regarding gender identity: "I was so pretty as a newborn that the nuns who took care of [me] told Mom [that] I should have been a girl. There have been many times in my life that I wished I was a girl" (Weintraub 209). His experimentation with "humanizing" the turkeys in various ways was a way to produce giggles and convey messages about social snobbery, and also to serve as an exploration of the self. Presented in 1992 at a group exhibition at the Leo Castelli Gallery in New York, these "lovely" turkeys gained attention for their comic inventiveness (Johnson 115).

Although he has been a resident of New York City since the 1980s, Vaisman has frequently spent time in his hometown of Caracas; it was not until the early 1990s that he was honored with an exhibition in Venezuela. The Consolidated Cultural Center hosted his first solo exhibition, held at the National Art Gallery in Caracas, where he presented a work made specifically to represent Venezuelan culture. *Verde por Fuera, Rojo por Dentro* (Green on the Outside, Red on the Inside, 1993) is an installation work that represents the poorest slums in Caracas on the exterior and a middle-class bedroom on the interior. Red, coarse, hollow bricks enclose a pristine child's bedroom. Concrete blocks barricade the door, and windows framed in human pelvises made of terra-cotta create a barrier between the poor and rich. The viewer must come close to the frail home and peer through human remains, representing Venezuelan poverty, to get a glimpse of the unreachable, safe existence of middle-class life. The room's interior is lined with books and knickknacks belonging to a child who is well provided for—a symbol of Vaisman's childhood (Hollander 82).

In 1996, Vaisman re-created the installation at the 303 Gallery in New York City. In this rendition of *Verde por Fuera, Rojo por Dentro*, he added the caption "MY parents Closet." He deliberately varied the capitalization to make an obvious self-reference. Much like the first installation, the exterior was crudely constructed of clay blocks with a metal roof and a small opening for the audience to peer inside, again to see a neat, clean bedroom with freshly painted walls. Though this piece specifically addresses Vaisman's personal history, it also speaks of Venezuela's social and economic concerns (Carvajal 154).

Vaisman's work has been viewed by audiences at the Museum of Modern Art in New York City, the Walker Art Center in Minneapolis, the Museum of Contemporary Art in Helsinki, Finland, and the 24th International Biennal of São Paulo, Brazil as well as in his native Venezuela. Multicultural and multiethnic experiences have contributed to the development of his varied perspective of himself and community. Vaisman has been described as "a one-man, walking, talking multicultural artifact" (Weintraub 210). Since 1990, Vaisman has jolted the art world with his fanciful fowls that poke fun at conventional ideas about art, society, and ourselves, as

well as with his personal commentary on the effects of economic separatism in his native country.

Places to See Vaisman's Work

Alternative Museum, New York City

Galería Camargo Vilaça, São Paulo, Brazil

Galería de Arte Nacional, Caracas: *Verde por Fuera, Rojo por Dentro* (Green on the Outside, Red on the Inside, 1993)

Jay Gorney Modern Art, New York City

Museum of Modern Art, New York City

San Francisco Museum of Art

Tel-Aviv Museum of Art: *Untitled Turkey XV* (1992)

303 Gallery, New York City

Bibliography

Carvajal, Rina. "Venezuela." In *Latin American Art of the Twentieth Century*. Edited by Edward J. Sullivan. London: Phaidon Press, 1996. Pp. 137–58.

Hinchberger, Bill. "Meyer Vaisman." *Artnews* vol. 98, no. 12 (1999): 192.

Hollander, Kurt. "The Caracas Connection." *Art in America* vol. 82, no. 7 (1994): 78–83.

Irving, Sandler. *Art of the Postmodern Era: From the Late 1960s to the Early 1990s*. New York: Icon Editions, 1996.

Johnson, Ken. "Meyer Vaisman at Leo Castelli." *Art in America* vol. 80, no. 12 (1992): 115.

"Meyer Vaisman." *LatinArt.com*. 2001. www.latinart.com

Weintraub, Linda, Arthur Danto, and Thomas McEvilley. *Art on the Edge and Over*. Litchfield, Conn.: Art Insights, 1996.

Kathy Vargas
(b. 1950)
Mexican-American Photographer

Kathy Vargas's photo-based work explores issues of identity, and ideas about life and death, through cultural imagery. She was born in San Antonio, Texas, and still lives there. She received her B.A. and M.F.A. degrees from the University of Texas at San Antonio, and has traveled and lectured throughout the United States and Mexico (Henkes 226). Often the subjects of her photographs are things that have died, and are distanced from mainstream culture because of the adverse response death often receives. About her repeated depictions of death, she said, "I love life, but we really have to see the end to love the middle" (Lippard, *Mixed Blessings* 85).

Vargas was raised in the Catholic faith. Her grandmother was a teller of ghost tales, and her father told stories about the pre-Columbian past. The Aztec religion and the concept of duality fascinated her. For Vargas, like Octavio Paz and many Mexicans, life extends into death and death extends into life. Thus it makes sense to her to openly explore various aspects of death (Henkes 220–21).

An example of her analysis of death can be seen in *I Was Playing Out My Fantasies When Reality Reared Its Ugly Head* (1989). This hand-colored photograph reflects a childhood memory of seeing a picture of frog musicians in a restaurant in Mexico. Vargas coupled this with the idea of eating frogs' legs, as well as with the more generalized notion about how one country seems to consume another. Dollar signs come out of the instruments as the frogs play with arms nailed to the horns and guitar. The background consists of sheet music and *Wall Street Journal* stock reports, which, Vargas said, indicates "where our priorities are and what tunes we dance to" (Lippard, *Mixed Blessings* 85). This piece, like many of hers, is

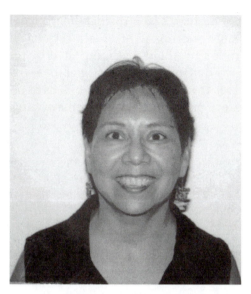

Kathy Vargas. Courtesy of the artist.
Used with permission.

inspired by the Day of the Dead, the Mexican celebration on November 1 and 2.

In 1990–91, Vargas did a series of works titled *Oración: Valentine's Day/ Day of the Dead*, dedicated to two friends who died of AIDS. One of them met his partner on Valentine's Day, and the other enjoyed participating in Day of the Dead rituals. "Their two favorite days seemed unfortunately 'appropriate' to AIDS; to die from love," she said (Latin Collective 61). The images, which look like X-rays or film negatives, are filled with skeletal figures and *milagro* figures (small charms used to make a petition to a saint or to the Blessed Virgin), which Vargas says she sent to their partners, hoping for miracles to save their lives. When these specific prayers weren't answered, she wrote that the *milagros* turned into prayers for others who await miracles (Latina Collective 61).

In the 1990s, Vargas did a series titled *Sites and Accompanying Prayers*. In *Sites and Accompanying Prayer No. 9* (1992), she created a diptych (art consisting of two parts, usually hinged together) memorializing a friend who had died an agonizing death. Among its symbols, a heart represents hope for a miracle, and nails symbolize pain and the suffering of Christ. Vargas often develops her ideas in a series of works that may be viewed either as a group or individually (Henkes 223).

Vargas's exploration of identity in relationship to life and death extends to tourist sites and the activities that take place in them. In her series *My Alamo* (1995), Vargas analyzes the space from the perspective of an insider/

outsider, a Chicano/mestizo. Since this landmark is in her hometown, it is especially poignant. She reveals it as a place that has been explained from the perspective of an Anglo myth, repeated by the Daughters of the Republic of Texas, who manage the site (Lippard, *On the Beaten Track* 43). Reflecting on the fact that Mexican-Americans have not been included in the interpretive history presented, on one of the photographs in the series, she wrote:

> Then there's the Order of the Alamo with their duchesses, princess and queen at the Fiesta time. Beautiful dresses my mom would let me wave to until I finally said, "When I grow up I want to be one of them." My mother explained why I couldn't: expensive dresses and "old" families. My mother never used the word "racism," only "money" and "lineage." But it was the first time I looked at who I and my family were honestly. (Lippard, *On the Beaten Track* 16)

The photo includes a mother with a child and an image of the Alamo. Strings of buttons flow throughout the surface of the work. Vargas explained that when you view a war memorial, you see yourself on one side of the war or the other, either because you make that choice or because history dictates that you have no choice (Lippard, *On the Beaten Track* 43). Vargas is both Chicana and Tejana—a Texan—and has traced her ancestry back to her great-great-grandfather, Juan Vargas, who fought on the side of Santa Ana in the battle for Texas's independence. Her friends and family posed for portions of this series, and she tells a humorous tale that includes Juan Vargas, Davy Crockett, the Daughters of the Republic of Texas, and a visit to the Alamo by the rock star Ozzy Ozbourne, who urinates on the revered Texas memorial (Edwards n.p.).

In her photographs, Kathy Vargas copes with the unpredictability of life. Much of her work resembles the shrines that are ubiquitous in Mexican and Mexican-American communities (Henkes 219). Her photographs are layered with meaning and symbolism, requiring contemplation of some of life's most daunting issues.

Places to See Vargas's Work

Casa de las Américas, Havana, Cuba

Center for Chicano Studies, University of California, Santa Barbara

Hill Country Arts Foundation, Ingram, Tex.

Mexican Museum, San Francisco

Museum of Fine Arts, Houston, Tex.

San Antonio Museum of Art, San Antonio, Tex.

Texas Lutheran College, Sequin, Tex.

University of Colorado, Boulder

Women's Center, University of California, Santa Barbara

Bibliography

Edwards, Jim. Brochure for the exhibition "Contemporary Texas Artists: Connie Arismendi, James Cobb, Melissa Miller, Kathy Vargas." Weil Gallery, Center for the Arts, Texas A&M University, Corpus Christi, October 15–December 1, 1998.

Frankel, David, ed., with Lucy R. Lippard. *The Sniper's Nest: Art That Has Lived.* Annandale-on-Hudson, N.Y.: Center for Curatorial Studies, Bard College, 1996.

Henkes, Robert. *Latin American Women Artists of the United States: The Works of 33 Twentieth-Century Women.* Jefferson, N.C.: McFarland, 1999.

Kathy Vargas: Photographs, 1971–2000. Essay by Lucy Lippard, introduction by MaLin Wilson-Powell, foreword by William J. Chiego. San Antonio, Tex.: Marion Koogler McNay Art Museum, 2000.

Latina Collective, ed. "Kathy Vargas." *Heresies* 7, no. 3 (1993): 61.

Lippard, Lucy R. *Mixed Blessings: New Art in a Multicultural America.* New York: Pantheon, 1990.

Lippard, Lucy R. *On the Beaten Track: Tourism, Art, and Place.* New York: The New Press, 1999.

"Oral History Interview with Kathy Vargas." November 7–25, 1997. Washington, D.C.: Smithsonian Archives of American Art.

Remedios Varo
(1908–1963)
Spanish-Mexican Painter

Remedios Varo, who was born in Anglés, Spain, but adopted Mexico as her home, is most commonly considered a Mexican Surrealist. The youngest of three children, she was raised by a conservative Catholic mother and an atheist father who worked as a hydraulic engineer. While she was attending a strict convent school, her father encouraged Varo to study science and develop technical drawing skills that she had already begun to exhibit (Ades 358). Greatly influenced by her father's guidance, Varo learned a traditionally male-dominated discipline and explored ideas outside of mainstream thinking. She practiced drawing throughout her life, but did not seriously explore easel painting until she lived in Mexico. She was one of the first women to enroll at the Academy of San Fernando in Madrid, where she studied alchemy in 1924. Her lifelong interest in alchemy, a medieval chemistry that is chiefly geared toward the discovery of a magic potion for everlasting life, is suggested in her mature paintings.

After graduating from San Fernando in 1932, Varo moved to Barcelona, where she supported herself as a commercial artist. While there, she associated with avant-garde Surrealists and joined the artists' group, Grupo Logicophobista (the Logicphobic Group). In 1936, she met the Surrealist poet Benjamín Péret, whom she later married. Even though she was not yet working full-time on her paintings, Varo's compositions were accepted by other Surrealists and were included in the 1938 International Surrealist Exhibition in Paris. That same year, Varo and Péret were forced to leave Spain for Paris, after the Falangists, led by Francisco Franco, won the Spanish Civil War. However, their peace in Paris was short-lived, and in 1940 she was imprisoned by the Germans on suspicion of hiding a French army deserter ("Remedios Varo" 2). At the end of 1941, Varo and Péret

left Europe for Mexico. While other countries were enforcing strict immigration limits, Mexico's President Lázaro Cárdenas welcomed tens of thousands of Europeans, offering asylum and a permanent place in the Mexican community. Although the Mexican president had welcomed the immigrants, the Mexican art community did not extend such a warm reception. The Mexican painter **Frida Kahlo** felt strongly about European art and artists: "I detest Surrealism . . . They [French Surrealists] make me vomit. They are so damn 'intellectual' and rotten that I can't stand them" (Kaplan 113).

Varo and Péret lived in Mexico until 1947, when they divorced. Later that year, Varo joined a scientific expedition in Venezuela that lasted over a year; she did not return to Mexico until 1949. In 1952, she married the publisher Walter Gruen, an Austrian expatriate. Soon afterward, she began to dedicate all her time to painting. Her friendship with the British artist **Leonora Carrington**, a Surrealist writer and painter who moved to Mexico and still lives there, became important to her work and life. Perhaps their connection was formed because they both experienced rejection by Mexico's inner artistic circles. Varo and Carrington shared an intense interest in the occult, magic, and ancient mysticism, prompting amateur experiments and practical jokes, which they regularly performed from their kitchens on unsuspecting guests (Kaplan 114).

In a journal/sketchbook Varo, who applied a Surrealist style and approach in all her paintings, wrote a fictitious and humorous letter to an unknown psychiatrist concerning her feelings about Surrealism:

> Permit me to write to you . . . my distress is great. . . . It began six months ago. I was enthusiastically painting a scene with a lovely prairie, some sheep, some cows walking serenely . . . but then little by little an irresistible force pushed me to put a little ladder on the back of each sheep . . . and some piles of well-folded handkerchiefs on the cows. . . . I hid this painting and began others but I always felt it necessary to introduce unexpected elements . . . until the day I accidentally spilled some tomato sauce on my pants and found this stain so moving that I quickly cut the piece of fabric and framed it. . . . Is it a sudden triggering of my subconscious that wishes to free itself . . . or am I simply crazy? (Kaplan 116–17)

In Surrealism, the artist attempts to depict a time/space that is somewhere in between reality and dreaming. Varo accomplished this goal, but was dissatisfied with the traditional role of women in Surrealist painting: female as the muse or object. In her work, she shifted the role of woman to embody the heroine, explorer, and creator.

In her painting *The Creation of the Birds* (1958), the central character is half human, half bird. The sex is unknown, but the features are predominantly delicate and feminine. The "bird creator" sits at a desk and, using

a paintbrush, creates the birds. On the desk sits a unique and intricate paint dispenser, a reference to her father's profession as a hydraulic engineer. As the violin around the "creator's" neck plays and the light from a faraway star streams through the window, the birds spring from the pages and fly out the window. The suggestion of combining mystical processes to create life alludes to Varo's interest in alchemy (Heller 156). Her paintings are connected in style and theme, with repeated characters. In *The Encounter* (1962), the "bird creator" from *The Creation of Birds* is standing just inside a slightly open door as a ghostlike woman approaches. The ghost stands with one arm outstretched toward the "bird creator" and its other hand holds a severed head; a snake crawls from beneath her robe. This character is mysterious and the intention of her message is unclear. The "bird creator" stands timidly, unsure about the visit. Varo created these morphed characters from her own perspective on the world as woman, as scientist, and as mystic. The dark background sets an eerie stage for the ethereal characters painted with fine lines and light hues and whites.

Although her style did not reflect a Mexican aesthetic or culture, the Mexican public embraced Varo's painting. In 1956, she was honored with her first solo exhibition in Mexico City. Interest in her paintings continues to increase. A major retrospective exhibition, hosted by the Museum of Modern Art in Mexico City in 1994, was a public success, attracting a large and diverse audience (Del Conde 30). Her first solo exhibition in the United States, "The Magic of Remedios Varo: 2000," was held at the National Museum of Women in the Arts. The exhibition showcased seventy-seven drawings and paintings that were created during the last ten years of her life.

Although recognized as an important Mexican Surrealist, Varo never adopted a Mexican aesthetic; instead, she portrayed a world full of dreams, science, mysticism, and personal reflection (Lucie-Smith 104). She created a vast body of work in just ten years; she died suddenly from a heart attack, at age fifty-five. Crafted with technically proficient and delicate lines, Varo's paintings reflect her Surrealism, defined by exploration of science, fantasy, and the self.

Places to See Varo's Work

Mary-Anne Martin Fine Art, New York City

Museo de Arte Moderno, Mexico City: *La Huida* (The Flight, 1961)

Museum of Fine Art, Chicago

The National Museum of Women in the Arts, Washington, D.C.

Remedios Varo Exposition: http://www.geocities.com/SoHo/Museum/4736/expo1.html

Bibliography

Ades, Dawn. *Art in Latin America: The Modern Era, 1820–1980*. New Haven, Conn.: Yale University Press, 1989.

Chadwick, Whitney, ed. *Mirror Images: Women, Surrealism, and Self-Representation*. Cambridge, Mass.: MIT Press, 1998.

Del Conde, Teresa. "Mexico." In *Latin American Art of the 20th Century*. Edited by Edward J. Sullivan. London: Phaidon Press, 1966. Pp. 17–50.

Goldman, Shifra M. *Dimensions of the Americas: Art and Social Change in Latin America and the United States*. Chicago: University of Chicago Press, 1994.

Heller, Nancy. *Women Artists: An Illustrated History*. 3rd edition. New York: Abbeville Press, 1997.

Kaplan, Janet. "Subversive Strategies: The Work of Remedios Varo." In *A Woman's Gaze: Latin American Women Artists*. Edited by Marjorie Agosín. Fredonia, N.Y.: White Pine Press, 1998. Pp. 110–28.

Lucie-Smith, Edward. *Latin American Art of the 20th Century*. New York: Thames and Hudson, 1993.

"Remedios Varo." *Varo Registry*. 2001. http://www.varoregistry.com/varo

GLOSSARY

Abstract Expressionism—A term used to describe an art movement that began in New York City in the mid-twentieth century. Artists who worked in this style shared a common spirit of revolt against prescribed procedures for painting. The movement is associated with artists such as Willem de Kooning, Jackson Pollock, Lee Krasner, and Arshile Gorky, whose work reflects spontaneous freedom of expression that is clearly seen in the Action Painting (often called drip painting) created by Pollock and the color field works of Mark Rothko.

aesthetics—Broadly speaking, the philosophy or theory of taste; it can relate to a response or experience in reaction to something either pleasurable or not pleasurable. Originally, it referred to the science of perceptible beauty, which may be found in nature as well as in art. The word was coined by the German philosopher Alexander Baumgarten, to mean the science of sensory knowledge.

Antropofágia ("Cultural Cannibalism")—The early twentieth-century Brazilian philosophy, introduced by **Tarsila do Amaral**, that focuses on the "devouring" of European (particularly Portuguese) culture and ideology, and a return to the native culture of Brazil.

archetypes—The psychologist Carl Jung's term to denote images and myths that reoccur over time and space. For example, Jung pointed out that the Cinderella character and her story are told in various ways in numerous cultures. Other universal figures include the trickster, the fairy godmother, and the wise man.

art brut—A term meaning "raw art," coined by the French artist Jean Dubuffet to categorize art created by self-taught, mentally ill, or otherwise nonacademic artists.

Art Nouveau—Stylistic movement that flourished from about 1890 to 1920 in Western Europe and the United States. It was ornamental and known for its use of asymmetrical lines resembling plant forms.

asphaltum—A blackish-brown solution of oil or turpentine mixed with asphalt.

automatic painting—A way of creating paintings in which the artist allows the unconscious, rather than the conscious, to control the movements of the hand. It is an approach to art associated with the Surrealists and the Abstract Expressionists.

avant-garde art—Art that is "on the edge," innovative, and different.

Beat generation—A 1950s counterculture literary movement, centered in the United States, in which jazz, Zen Buddhism, and improvisation were valued and primary to the formation of ideas. Key writers and poets were Allen Ginsberg, Jack Kerouac, John Ashbery, Norman Mailer, and Henry Miller. They created their own "hip" vocabulary to define their experience, which was a struggle against conformity, materialism, and mechanization.

botánica—A store that sells articles and goods used in New World African religions.

Bréton, André (1896–1966)—French poet who was the key theorist of the Surrealist movement. He published the first *Manifesto of Surrealism* in 1924. He is also known for his assemblages of "poem-objects," in which he juxtaposed seemingly unrelated objects.

Chicana/Chicano—A self-designation for a politicized individual of Mexican descent in the United States. It came to prominence in the mid-1960s along with the Chicano civil rights movement.

collograph—An impression made from a board or hard block to which three-dimensional materials are attached. The surface is sealed with shellac and then printed on damp paper with an etching press.

collective unconscious—The psychologist Carl Jung's theory that humans share a common realm of ideas that manifest themselves in mythology, dreams, and art.

Colonization—The forceful domination of one nation, society, or culture by another, in which the dominant group attempts to change the dominated group to be more like itself. In this text, the term most commonly refers to the colonization of Indian or indigenous cultures by European settlers.

Conceptual Art—A term that describes various kinds of art in which the idea is more important than the finished product—if there is one. The work of art is more about the artist's ideas or concepts than about the object, which is mostly a catalyst for the communication of the artist's ideas. Marcel Duchamp is credited with originating this approach to art in the early twentieth century. Conceptual Art became widespread throughout Latin America in the 1960s.

Constructivism—Post–World War I art movement, primarily of the 1930s, established by the Constructivist Art Group, which was organized by **Joaquín Torres-García** in 1935. The style is abstract, with an emphasis on the mathematical aspects of geometry and on depicting an arrangement of symbols ranging from ancient to contemporary.

contemporary art—Generally speaking, art of the present day. The term is often used to differentiate works from modern art, which generally focuses on for-

mal aspects of composition whereas contemporary art is often more conceptual. Installation art is often associated with contemporary art.

Cubism—An early twentieth-century art movement originated by Pablo Picasso and Georges Braque. In its formative years (1907–1914), Cubism was a radical departure from the prevailing idea that art was an imitation of nature. Traditional ideas of realism and correct proportion and perspective were exchanged for new ways of depicting three-dimensional images on a flat canvas. Many and varying perspectives can be seen at the same time. The movement influenced numerous artists who experimented with ideas of representation.

culture—Learned and shared patterns of living that include education, art, folklore, religion, science, and social organizations. Ways of living among a given group of people or culture are maintained and changed by shared beliefs, values, and behaviors.

Day of the Dead—A Mexican celebration and a national holiday, on November 1 and 2, when the souls of the dead come back to visit the living. Feasts are planned, rituals are held at the cemeteries, and offerings are made to the deceased to help them on their journey in the next life.

diaspora—The scattering of a cultural group to diverse regions, usually brought on by oppression, violence, or even war that forces a group to leave their native country.

diptych—A work of art or a picture with two parts to it. They are usually hinged together like the pages of a book.

Dominicanidad—The examination of Dominican roots, which appears in the blending of Spanish and African races and cultures.

Duco—Industrial-strength lacquer paint that creates a thick, layered texture.

easel painting—Small-scale painting on canvas or other surface that rests on an easel while being painted.

economically developing country—Commonly, societies that are predominantly poverty-stricken.

folk art—A category of art that has varied and conflicting definitions. While some people refer to folk art as self-taught art, in this book it refers to art that is traditional to a culture and is generally learned within the community.

found objects—a term used to describe everyday goods that have been used as art materials. Folk artists have recycled household products into art media for generations. Modern artists, such as Dadaist Marcel Duchamp, made the term widespread in the 1950s and 1960s. Duchamp is well-known for mounting a bicycle to a chair and calling it sculpture. More recently, many contemporary artists are incorporating everyday objects into their artwork.

fresco—A technique of creating paintings on walls in which pigment is applied to a wet lime-plaster surface. This technique has been used for centuries in many parts of the world.

Futurism—An art movement founded in Milan in 1909 by the poet Emilio Filippo Tommaso Marinetti (1876–1944). Futurists celebrated industrialism and

progress, believing that modern technology would free Italy from its oppressive past. It glorified speed, machinery, and violence in a series of writings or manifestos.

Geometric Abstraction—An art style developed in the early twentieth century at about the same time as Cubism. Geometric Abstraction is a nonfigurative style where math is an integral component to the composition; angle dimensions and the equation relationship of lines are central to the work. Russian painter Casimir Malevich, Dutch painter Piet Mondrian, and Uruguayan artist **Joaquín Torres-García** are artists who produced work representative of this movement.

gesso—A chalky white liquid used in the Middle Ages and Renaissance as ground preparation to prepare a panel or canvas for paint; it is used by artists today, primarily as a covering on canvas readied for paint. The **Linares family** members use gesso to prepare their papier-mâché sculptures for painting.

Huaca—In Peruvian Inca culture and mythology, a *huaca* is a sacred place or object where unsettled spirits wait to be worshiped or released.

Humanistic Naturalism—An attempt by the artist to produce an exact replication of the human form in painting.

Impressionism—An art movement that began in France in the 1860s; it is strongly associated with Claude Monet, Pierre-Auguste Renoir, and Edgar Degas. Impressionist artists aimed to capture the immediate visual impression rather than the more permanent aspects of a scene. The artist was to record fragments of nature with an objective or scientific spirit. The subjects of their paintings were pleasant landscapes and scenes from daily life.

Inca—Indigenous Indian peoples in the Andes Mountains of South America. They were formed by many groups of early people.

indigenista **school**—School in Cuzco, Peru, in the early-to-mid-twentieth century that focused on Indian, and especially Inca, culture and values. Central to the *indigenista* movement, of which the school was a part, was a demand for social justice.

installation—A term that came into use in the 1970s, referring to an assemblage or environment created by an artist especially for a gallery space.

Jung, Carl (1875–1961)—A Swiss psychologist who studied under Freud in the early twentieth century. He developed the idea of a collective unconscious full of archetypes common to all people.

kitsch—A term of German origin, first used in the 1920s to mean "trash." Often used to denigrate tourist souvenirs, it is also used to describe "low class" art that pretends to be valuable. Some contemporary artists, such as **Pépon Osorio** and **Guillermo Goméz-Peña**, incorporate kitsch items in their work in an effort to make political and social commentary on the hierarchical structure of so-called fine art that devalues certain cultures.

Lakota—A Native American tribe located primarily in South Dakota. The tribe is often referred to as the Lakota Sioux.

low rider—A customized vehicle with hydraulic jacks that can be used to lower the chassis closer to the road. It is often distinguished by having lots of shiny

chrome and specialized interiors and paint jobs, which often include murals. The term most often refers to a car, but has been extended to include pickup trucks, motorcycles, or bicycles lowered to within a few inches of the ground.

lwa—Vodou deity or spirit. Lwa is both the singular and the plural.

Magic Realism—An art style that culminates in the distortion of the common, banal, or everyday. Ordinary objects are made into something weird, strange, or mysterious. It is a style, predominantly in Latin America, that gradually was incorporated into literary works, primarily from the mid-1940s through the 1970s. The Mexican artist **Francisco Toledo** is most commonly associated with this style.

manifesto—A written document that explains the theoretical bases of a movement.

mestizo—A person of mixed race; in Latin America, especially an individual of Native American and European ancestry.

milagros—Miracles or charms, usually of silver, brass, or copper, used to make a wish to a saint. Common *milagros* are in the form of body parts, domestic animals, trucks, and taxicabs.

Minimalism—A mid-twentieth-century movement in painting and sculpture in which only elementary geometric forms are used. Reacting against emotion, it is slick and impersonal. Its key exponents are Carl Andre, Donald Judd, and Tony Smith.

Modern Abstraction—A term that encompasses a wide range of art styles within the twentieth-century modern art movement, including but not limited to Cubism, Constructivism, Abstract Expressionism, Geometric Abstraction, and Minimalism. These various modern styles all distort or abstract reality in some fashion.

modern art—Refers to most Western art created from the late nineteenth century to roughly the 1970s. It is generally associated with abstraction and formal analysis (which focuses on the elements and principles of design). Some modern art movements include Impressionism, Expressionism, and Abstract Expressionism.

Modernist—A descriptive term used to denote an attitude or approach to art that is grounded in the early twentieth-century movement in Europe and the United States. It focuses on that which is original and self-referential in that it is to be seen and understood in an isolated fashion. In its purist form it has no narrative; it is art for art's sake.

Modernista—Early twentieth-century art movement in Brazil that derived from European Cubism. **Tarsila do Amaral** and **Anita Malfatti** developed their own version of Cubism by incorporating Brazilian themes, which resulted in a "Brazilian Cubism," or what is known as Brazilian Modernism.

Modern Realism—A style that emerged in the midst of the twentieth-century modern art movement, where abstraction was the prevailing style. A group of painters continued to work in the Realist tradition, portraying life in a photographic quality. Among them were American artists Will Barnet, Nancy Grossman, and Edward Hopper.

mural painting—Painting on a large-scale surface, most commonly a fixed wall. The subject matter often depicts historical and/or political messages.

Neo-Concretism—A late 1950s movement that proposed that artists create works which speak of natural subject matter, using an intuitive approach to art production rather than following a formulaic representational style. **Lygia Clark** and **Hélio Oiticica** were among the leaders in this movement.

Neoplatonic—Theory of art which suggests that art can represent a higher ideal than everyday sensory experiences.

oeuvre—An artist's portfolio or body of work, usually spanning a long period of time, often an entire lifetime.

photograms—A kind of photograph made by placing objects between light-sensitive paper and a light source. This process produces shadow-like images. It has been used in mapmaking, as well as by artists such as **María Martínez-Cañas**, Man Ray, and László Moholy-Nagy.

Pop Art—A late modern art style from the 1950s to the 1970s whose central themes dealt with popular culture and mass consumerism, primarily that of the United States. Pop art was a large movement in the United States, with artists like Robert Rauschenburg and his randomly mismatched found objects, Jasper Johns and his recreation of the American flag, Andy Warhol and his portrayal of the repetitive Campbell soup can, and Roy Lichtenstein's large-scale comic strip paintings.

post-Impressionism—A term used to describe an art movement that reacted against Impressionism and its momentary approach. Impressionists often concentrated on depicting the effect of light on a landscape, whereas post-Impressionists took more varied approaches to their artwork. For example, Cézanne concentrated on pictorial structure and Gauguin used line and color in a symbolic manner.

Poto mitan—Sacred pole in Vodou temples where the *lwa* or deities are said to enter.

psychoanalysis—The science of how psychological thought processes develop. Sigmund Freud is often credited as the "father of psychoanalysis."

public art—Site-specific works placed in public areas such as parks, libraries, government buildings, and other general gathering places.

Quechua—A language spoken in the Andes mountains of South America.

Quincentenary—The controversial 1992 celebration in the United States and Spain that marked the 500th anniversary of Columbus's landing in the New World.

ready-mades—Everyday objects isolated from their normal context and presented by the artist as a work of art. Marcel Duchamp is the artist who created the first ready-mades.

Realism—An art style that predates the widespread use of the camera. Artists are primarily concerned with capturing an essence of "real life" on the canvas, trying to mimic what they see. Notable Realist artists are French painters Gustave Courbet and Honoré Daumier.

relief carving—Raised sculpture that projects from a background surface as opposed to standing freely.

retrospective—An exhibition of an artist's work created over his or her career. A retrospective generally takes place late in an artist's life or after his or her death. It is intended, in part, to show the artistic progress and changes that have taken place over time.

Santería—A New World African-based religion originated in secrecy by Nigeria's Yoruba people while enslaved in Cuba. It combines traditional African deities with Catholic saints.

santero—An artist who creates *santo* figures in the tradition of early Spanish settlers in the Southwest, who carved statues of Catholic saints because there were no stores where they could be purchased.

santos—Traditional figurines of saints.

sepia—A brownish gray.

Sirène—Goddess of the sea in Haiti's Vodou religion. The painter **Hector Hyppolite** claimed to be married to her.

Social Expressionism—An abstract painting style from the Dominican Republic that depicts contemporary social conflict. **Ramón Oviedo** is most noted for this artistic style.

Spanglish Art—A term used by the Uruguayan artist **Luis Camnitzer** and others to define art created while living in one place (the United States) and thinking about another place (the artist's native country). More specifically, Camnitzer calls this a hybrid art that results when an immigrant from a Latin country lives and works in the United States.

Surrealism—A movement in art and literature that originated in France in the early twentieth century. Surrealists had a fascination with dream imagery and with the bizarre and irrational. It is closely associated with Freud's psychoanalytic theories. André Breton was the principal leader of the movement. Automatic painting or writing was one of its components. Unexpected items were often placed together to shock the viewer and to encourage a new way of looking at reality.

Symbolism—In visual art, the use of letters, numbers, and pictures, all of which can hold a variety of meanings.

triptych—A work of art presented in three sections, usually hinged side by side, the side panels being less important than the central one. Triptychs are associated with religious imagery.

Universal Constructivism—An early twentieth-century art movement/style that combined Modern Abstraction with symbols ranging from ancient to modern.

vèvè—Ritualistic Vodou drawing in the sand, created to evoke the lwa.

Vodou or Vodoun—Haiti's most prominent religion and way of life; its roots are African.

Works Progress Administration (WPA)—U.S. government-funded program in the 1930s developed in part, to create jobs for artists.

Zapotec—An Indian nation indigenous to Mexico.

INDEX

About the Authors

KRISTIN G. CONGDON is professor of art and philosophy at the University of Central Florida. She has a Ph.D. in art education from the University of Oregon and has published extensively on the study of folk arts, community arts, and contemporary art issues. She is editor, with Doug Blandy, of *Art in a Democracy* (1987) and of *Pluralistic Approaches to Art Criticism* (1991). With Doug Boughton, she edited *Evaluating Art Education Programs in Community Centers: International Perspectives on Problems of Conception and Practice* (1998), and with Paul Bolin and Doug Blandy, *Remembering Others: Making Invisible Histories of Art Education Visible* (2000) and *Histories of Community-Based Art Education* (2001). In addition, she has written and edited *Uncle Monday and Other Florida Tales* (2001) and written *Community-Based Art Programming* (2003). She is the 1998 and 1999 recipient of the Manual Barken Memorial Award for scholarship from the National Art Education Association, and the 1988 recipient of the Ziegfeld Award from the United States Society for Education Through Art for international work in the arts.

KARA KELLEY HALLMARK is a doctoral student in art education, with a minor in women's studies, at Florida State University. She has a graduate certificate in gender studies and a master's degree in art education from the University of Central Florida, and a bachelor's degree in art history from Southern Methodist University. In 2000, she edited and wrote several essays for the University of Central Florida graduate student House of Blues folk art project, *Affirmations: Artists Speak* (2000).